Southern Single Blessedness

WOMEN IN AMERICAN HISTORY

Series Editors
Anne Firor Scott
Susan Armitage
Susan K. Cahn
Deborah Gray White

*A list of books in the series appears
at the end of this book.*

Southern Single Blessedness

*Unmarried Women
in the Urban South,
1800–1865*

CHRISTINE JACOBSON CARTER

University of Illinois Press

URBANA AND CHICAGO

Library of Congress Cataloging-in-Publication Data

Carter, Christine Jacobson. Southern single blessedness :
unmarried women in the urban South, 1800–1865 / Christine
Jacobson Carter.
p. cm. — (Women in American History)
Includes bibliographical references and index.
ISBN-13: 978-0-252-03011-6 (cloth : alk. paper)
ISBN-10: 0-252-03011-7 (cloth : alk. paper)
1. Women—Southern States—History—19th century. 2. Women—
Southern States—Social conditions—19th century. 3. Single
women—Southern States—History—19th century. 4. Single women—
South Carolina—Charleston—History—19th century. 5. Single
women—Georgia—Savannah—History—19th century.
I. Title. II. Series.
HQ1438.S63 C37 2006
306.81'53'0975'09034—dc22 2005006667

For my parents and my children

Contents

Acknowledgments

This has been a labor of love made possible by so many people who took an interest in me and in the women of this study. First, I am grateful to have found these fascinating women. Their lives and words easily have sustained me for more than a decade, and I can still happily read and re-read their comments. I am immensely thankful for their diaries and letters and for their family members who placed the writings in archives.

This book grew out of my 2001 dissertation at Emory University, an unusually supportive and pleasant place to spend nearly ten years. Generous financial assistance provided by the graduate school there and an Andrew W. Mellon Predoctoral Fellowship in Southern Studies gave me critical support. The staff at the Robert W. Woodruff library at Emory University is excellent, and Marie Nitschke especially is a remarkable resource with a willing spirit.

The history department at Emory was also very good to me. Rosalyn Page, Becky Herring, and Patsy Stockbridge demonstrate more patience than I can ever hope to muster. My fellow graduate students were careful readers and caring friends, particularly Ellen Rafshoon, Diane Mutti Burke, Naomi Nelson, Stacey Horstmann Gatti, Anthony Clay, Sarah Gardner, Belle Tuten, Ruth Dickens, Peter Martin, and Jeff Young. I am proud to know them now as scholars and professors in their own right. Lisa Roy was of enormous help to me in the final stages of this project, and professors Elizabeth Fox-Genovese, Mary Odem, and Jonathan Prude provided critical guidance and input along the way. Jim Roark, my advisor, role model, and friend, has seen me through years of intellectual, professional, and personal successes and struggles. His substantive intellectual and scholarly contributions to my work, his generous editorial critiques, his gentle requests for more research or more

thought on my part, and his profound kindness have meant so much. Indeed, looking for some models of acknowledgments to follow, I found that Jackie Jones also thanks Jim for his help in shaping her first book! His generosity has reached many. And Jackie is the person who, as my thesis advisor at Wellesley, started me down this professional path. I treasure her guidance, friendship, and awesome example.

Across the South, I benefited enormously from the assistance of archivists who initially were perplexed, but then enthusiastic and resourceful, when I asked them which of their collections included never-married white women. Individuals at the Georgia Archives (especially Dale Couch), the South Carolina Historical Society, and the Georgia Historical Society were particularly helpful. Mary Amanda Lee and Barbara Orlitz were late-stage colleagues who made it possible for me to include one more interesting woman in this study. On one research trip to Savannah, I had the exceedingly good fortune to meet the city's (probably the world's) leading expert on the Telfair family, Charles Johnson. His help with the details of Mary Telfair's life was immeasurable, to say nothing of his friendship. Carolyn Clay Swiggart also became a great resource and friend. Other friends also inquired faithfully about this study, and I am grateful particularly to Allison Towne DiMatteo, Justine Green, and Annika Eichenlaub.

When this project at long last made it to the University of Illinois Press, I found myself in competent and caring hands again. Laurie Matheson was a steady and friendly guide, and Mary Giles was patient, kind, and very sharp. I also thank Anne Scott for her initial interest in this study, and two anonymous reviewers gave thoughtful feedback that made it possible for me to improve the manuscript significantly. In the midst of these revisions I was fortunate to teach at Georgia State University, where I found an impressive and supportive faculty, staff, and student body.

Finally, as it was for the women of this study, everything begins and ends with family. I began to study history because of Carl G. Jacobson and Elsbeth Yantis Jacobson, who loved history and who dragged my sister and me across the continent, stopping at what seemed like every museum and historical marker. They supported, loved, and inspired me. My sister Sandy and brother Julien have been loyal and helpful every step of the way. I (too infrequently) thank my husband, Rob, for his endless encouragement, generosity, and good humor. His support of my endeavors made it possible for me to mix writing and motherhood. Mary and Fred Godley (Rob's super-aunt-and-uncle); my two wonderful children, Susanna and Jeb (who put it *all* in perspective); my right-hand women Jessica Moore and Dara Percely; and our dependable and thoughtful friends—fellow mommies and daddies—have all made special contributions for which I am eternally grateful and much happier.

Southern Single Blessedness

Introduction:
"More Purity and Active Goodness"

"Two people coming together in holy wedlock always reminds me of two Birds in a cage. Unless they sing in concert, what *discord* ensues," wrote Savannah's best-known nineteenth-century unmarried lady in one of her many missives on the institution of marriage. Mary Telfair concluded that the birds were "far better to *chirp* & tune their notes on some lonely spray, *unseen unheard* in 'single blessedness'; for *solus* well performed is preferable to an indifferent *Duet.*" A wealthy, well-educated, well-traveled, and opinionated woman, Telfair claimed in 1827, at the age of thirty-six, that even the man who had been deemed "the best match in Georgia" would not have proven an acceptable cage-mate for her. As she confided to her friend, a woman who also never married, "I always feel inclined to yawn when he talks to me—next to George Glen he is the greatest *mental anodyne* I have ever encountered." Revealing her dim opinion of most men whom society considered to be good matches, or possibly her skepticism about most marital unions in general, she concluded, "But stupid men are often *the best matches.*"[1]

In nearby Charleston, a contemporary of Telfair's, who was similarly privileged and unmarried for life, agreed that marriage did not ensure a woman's happiness. In 1848, at forty-one years of age, Ann Reid remarked to her brother that she was busy and content, working on benevolent causes and tending to her growing nieces and nephews. "[I]f I live to see next Tuesday week, I will be forty-two years old, can it be possible[?]," she noted. "The other day a Lady told me, she heard that I was engaged *to be married,* and that another Lady had said it *must be so,* because I looked so *well* and so *happy,* but I told her she was quite mistaken, that I was enjoying the *inde-*

pendence of my *Spinstership,* and that godliness with contentment was great gain, and I should be very sorry to think, that *only* those who were to be launched on the sea of Matrimony, were happy." Reid went on to describe a friend who married an Episcopal priest but had a difficult life ahead of her nonetheless. Even marriage to a man of God could not guarantee contentment. Of course, that Reid had to explain her remarkable happiness indicates that unmarried southern women sometimes had to defend their lives—even to themselves.[2]

Women like Telfair and Reid are exceptional and provide a unique perspective on a culture that practically required that dependent daughters become dependent wives. The women who managed to live their lives without husbands tell us a great deal about women's roles and relationships, family dynamics, and the places that they lived. Indeed, unmarried southern women did not fit the mold. The well-known Sarah Grimké of Charleston recalled that girls were "taught to regard marriage as the one thing needful, the only avenue to distinction." And the often-quoted proslavery ideologue George Fitzhugh commented, "A husband, a lord and master, whom she should love, honor and obey, nature designed for every woman, for the number of males and females is the same." No wonder, then, that the majority of white southern women became wives and did so at younger ages than their northern counterparts. White Charleston women were half again as likely to be married by the age of twenty-five as women in Boston.[3]

The myth of the Southern Lady held that white women be pure, weak, and dependent on men, usually as wives. As such, white women took responsibility for domestic tasks within their homes, supervision of household slaves and servants, care of family members and slaves, and reproduction and nurturing of the next generation of white southerners. Even in urban areas, southern women of means and social standing had very few vocational or professional alternatives to marriage. If they did not marry, these women were supported financially by men or at least by income-producing sources such as plantations, stocks, or savings that were established generally by men.

Southern culture depended on the sanctity and predominance of marriage. Nothing less than the entire southern system depended on the unequal marriage of a man and a woman as its foundation. A man's mastery over his household, which included a dependent wife, dependent children, and often slaves, was both a right and a responsibility that defined southern manhood and the region. In this paradigm, southern intellectuals, religious leaders, and writers inextricably braided together marriage, the subordination of women in that institution, and slavery in an effort to endow slavery with the

legitimacy and ideological weight of the family and to protect the southern way of life. Slavery, and the South by extension, depended on marriage. Moreover, linking marriage and slavery functioned to keep women safely within their roles as dependents.[4]

Given the weight and pervasiveness of marriage in the South, it is impressive that a significant number of women did not marry, and their records are often richer because they avoided, intentionally or not, this powerful institution. Due to limitations in antebellum census records, historians do not know exactly how many white southern women remained single, and historians' estimates vary widely. At one end of the spectrum, a census of Charleston in 1848 included a rare look at the city's "domestic condition" and revealed that more than half of the city's white women were not married. Although 45 percent of the roughly 4,800 white women over the age of fifteen had husbands, 37 percent were unmarried, and nearly 19 percent were widowed. Half of those over the age of twenty were unmarried or widowed. Offering similarly high percentages for the South generally, one scholar has speculated that in the region at large, between one-fifth and one-fourth of adult white women were unmarried for life. These are stunning figures for a society so dependent on marriage. Other studies, however, have been less generous with their numbers. One examination of 750 members of the planter elite born between 1765 and 1815, for example, found only 2.1 percent of women never marrying. And, finally, in the United States as a whole, one historian has suggested that the percentage of native-born unwed women hovered around 7.5 percent between 1830 and 1850.[5]

Whatever their numbers, the southern women who braved what was referred to as "the world's dread laugh" and remained single have a great deal to teach us about their lives and society. Indeed, these women without husbands and children often had the time and inclination to write countless letters and diaries, sources which reveal that unmarried women lived and wrote from a unique vantage point within a constellation of aging parents, adult siblings, siblings-in-law, and nieces and nephews. Historian Michael O'Brien describes single southern women as ones who "stood a little aside, acquiring thereby the advantages of a double vision, of being in but not of the domestic world."[6] Therefore, they described at length both their own comings and goings and those of their families and their communities. They complained and praised, gossiped and shared, and mourned and celebrated in ways that were different from married women—and often in much more detail. Without a husband to serve or children to nurse, these women could express themselves quite freely. In addition, the lives they led were filled with a fascinating spectrum of southern society, from the most intimate family

dynamics, births, deaths, marriages, and personal triumphs and failures to the sweeping dramas of national crises. Their numbers may have been few, but there were more of them, especially in the cities, than previous assumptions have allowed. Most important, their lives were full and their records, rich.

Women without husbands had much to offer their communities and families, and over the course of the century increasing numbers of observers praised and encouraged them. Americans celebrated their devotion to their families and beckoned the well-to-do among them into service to communities and churches. One writer for the *Southern Literary Messenger* lauded unmarried women in 1837, explaining, "Instead of being a bye-word of ridicule, they would, if the world were just, be a synonyme of *useful virtue*." He continued, "According to *my* observation—and it has not been narrow, lazy, or brief—they, as a class, have among them more purity and active goodness, than any other set, either in Christendom or in Heathenesse." Unmarried women not only observed life from a special place but they also had much to contribute, given their unique physical, spiritual, and financial resources.[7]

* * *

This study explores the lives of unmarried white southern women for what they tell us about themselves, their families and communities, and the South from 1800 to 1865. Because women of the planter and professional classes left rich manuscript sources, which lend themselves well to this study of identity and community, and because these women's wealth probably facilitated spinsterhood with a disproportionate frequency in the antebellum South, the work focuses on well-to-do white women. The women here were all born between 1774 and 1840, thereby ensuring that the transformative Civil War did not skew the sample's views of antebellum marriage and southern society. Finally, this examination highlights women in Charleston and Savannah, where my research repeatedly led me to enclaves of elite women who enjoyed the attractive social setting and their family residences, a sense of community with other like-minded women, and opportunities for church and other benevolent work. Indeed, Charleston and Savannah provided a unique setting where well-to-do white southern women could fulfill a moderate number of relatively pleasing familial obligations, enjoy a surprising degree of mobility, maintain lifelong female friendships often in lieu of marital partnerships, participate in urban benevolence, and observe the dramatic social and political effects of the Civil War.

In fact, all things being equal, Charleston and Savannah were nearly ideal places to be a single, white, southern female of some means. For well-to-do whites, the cities were relatively clean, attractive, and interesting. The evils

of slavery and the slave trade unmistakably marred the cities, at least for many visitors, but having slaves gave the women of this study the freedom and resources to enjoy their urban settings and the community of like-minded, bright, cosmopolitan, and active citizens. A well-to-do unmarried woman could surround herself with friends and acquaintances, fill her social calendar, and throw herself into a myriad of benevolent organizations, church activities, and charitable causes. Circulating in an environment that valued activity, connection, devotion, civic-mindedness, benevolence, virtue, education, and intelligence in women as well as in men, and which discreetly overlooked a woman's unmarried state, these women without husbands found plenty to do and to enjoy in Charleston and Savannah. Of course, the uniqueness of these urban settings naturally limit, or at least qualify, generalizations about women's experiences there to other areas, but they remind us that the region was a complex and diverse place. In addition, the settings had limitations, and many independent-minded southern women lamented the scrutiny they experienced in a close-knit urban setting that may have seemed insular and parochial compared to New York or Philadelphia, where they vacationed and had friends. But the benefits clearly outweighed the limitations, and never were the cities' importance and value clearer than when the single southern women had to leave them.

* * *

Although American women's, family, and southern history have all made remarkable strides since the 1970s, antebellum unmarried women have remained on the periphery of scholarship just as they were somewhat on the periphery of their families. Given demographic realities and the relatively young career of southern women's historiography, our understanding of white southern womanhood has been dominated by analyses of married plantation mistresses.[8]

Moreover, all of the full-length published studies of never-marrying American women describe northern women, whose lives differed markedly from their southern sisters'. The classic text on the subject remains Lee Chambers-Schiller's study of more than one hundred New England women who never married. She argues that between 1780 and 1840 a "Cult of Single Blessedness" emerged alongside the often-discussed Cult of Domesticity. The latter celebrated women's critical and far-reaching roles within their families. The ideology of Single Blessedness held that remaining single and useful to others was better than marrying the wrong man for the wrong reason and that women achieved their highest purpose and happiness in service to others. In the North, this rhetoric allowed women new avenues

for education, vocation, autonomy, and intimacy outside marriage as it elevated the unmarried state as one of purity, disinterest, and service. Seeking liberty, which was to them "a better husband," unmarried northern women struggled against the constraints and obligations family members made of them, looking instead for economic security, rooms of their own, and expanded intellectual horizons.[9]

Chambers-Schiller suggests that a similar opening for single blessedness ideology occurred later in the South, when women born in the 1840s and 1850s came of age during the Civil War era and found new opportunities as a result of wartime demands. Certainly, numerous historians of the war and of the New South have proven what Chambers-Schiller postulated in 1984. Indeed, the Civil War challenged assumptions about womanhood, forced women to organize and take on new types of labor and leadership, and allowed them a new voice independent of their men. Well before the Civil War, however, urban southern women had opportunities to choose or to accept single blessedness; find meaning in their lives as daughters, aunts, and sisters; enjoy intimate female friendships; organize for benevolent causes; and travel extensively. The extent to which one's antebellum single state was a choice varied from one individual and set of circumstances to the next, but personal wealth and the validating rhetoric of single blessedness, which had spread to Savannah and Charleston, created an experience of "spinsterhood" that was relatively acceptable, even palatable, for many women.[10]

Of course, the key to an unmarried woman's happiness and usefulness lay chiefly in her family's situation, in her personality, and in her location, but like the women in Chambers-Schiller's study, many urban southern women in this study managed familial obligations alongside work, usually for churches or charitable organizations but sometimes for more "professional" endeavors as well. A few of them wrote and published, and one Savannah woman became a successful, if iconoclastic, physician. Similarly, women in both the urban North and urban South enjoyed intimate female friendships and communities of other women. In fact, many of these southern women knew, or at least knew of, well-known unmarried women in elite northern circles. What made *southern* single blessedness distinctive, however, and the experiences of elite southern spinsters unique, was that their places within families and their understandings of themselves as daughters, sisters, and aunts still shaped their identities. Entrenched within their social status and conservative mentality, they did not pine for economic independence or vocational purpose like the middle- and upper-class northern women in Chambers-Schiller's study did. And thanks to the roughly two

and a half million slaves in the South in 1840 (and nearly four million in 1860), no elite spinsters ever spun. While their northern counterparts became early female professionals as teachers and reformers, unmarried southern women were professional daughters, sisters, and aunts who carved out special and important places in families and communities.[11]

These elite southern women already had a socially acceptable form of what Chambers-Schiller's more middle-class northern women craved: economic security (although it was within their families); often rooms or even houses of their own; and a wealth of opportunities for intellectual pursuits though reading, correspondences, and discussions with other well-read women and sometimes men in their families. They were not divided internally between writer and sister, advocate and daughter, reformer and surrogate mother. Because these southern women saw themselves as womanly caretakers first and foremost, they lacked the internal anguish and sense of divided self and also the complex self-definition and self-possession that may have come with having a vocation. Furthermore, because they embraced conservative southern culture—presenting no significant challenge to the status quo—and benefited their communities and families, they found spaces and roles in their families and among the urban American elite. As Drew Faust has explained, "Marriage provided southern women with a social place and an identity; courtship offered them an occupation and a purpose." This study suggests that a third category, permanent singlehood, at least in Savannah and Charleston, offered occupation and purpose. Women's original families, instead of new ones with husbands who might not be trusted, ensured them their social places and identities.[12]

Despite contemporary assumptions to the contrary and subsequent neglect by historians, unmarried southern women were significant actors in southern society, particularly in these seaboard cities. They were often the glue that helped keep elite social networks as well as individual families intact. As communicators, caretakers, surrogate mothers, family servants, and benevolent women extending feminine virtues to individuals and organizations, these southern women struggled to solidify their places as good, useful, necessary women, deserving of praise, not pity. Through these roles, unmarried urban women saw themselves as not outside the mainstream or the bounds of southern womanhood but well within the expectations of womanly piety, usefulness, and devotion to family. Marriage was the usual road to these virtues, but a few urban women made their way along the same road—and without a husband.

* * *

A study such as this, which looks at women's lives and relationships with one another, must engage the question of a woman's culture. Since women's history took root in the academy many years ago, scholars have explored the extent to which women had a distinct set of values and priorities, different from men and possibly transcending race or class differences. One of the first and most bold assertions of a women's culture in the antebellum South was a study of a city. Suzanne Lebsock, in *The Free Women of Petersburg,* demonstrated how women there made choices about marriage, work, and property that revealed a distinctively female value system and a critique of the limitations imposed on nineteenth-century women. Twelve years later, another scholar of southern women revisited the woman's culture debate, which had been largely abandoned by recent scholarship. Emphasizing southern women's frustration, sadness, fear, and denial about the southern systems of patriarchy and slavery, Joan Cashin agrees that southern women did indeed have a female culture, which she defines as a "culture of resignation." Acknowledging and submitting to injustices, both around them and to them, southern women embraced a set of behaviors and attitudes quite unlike their middle-class northern sisters, whose culture embraced reform and often challenged the male-dictated status quo.[13]

Well-to-do, white, unmarried women in Charleston and Savannah did have values, priorities, and goals that were, to varying degrees, different from their men's. Like Cashin's, this work finds southern women sometimes resigned to, but also often content with and privileged by, conservative southern society. Southern women's lives were distinct from northern women's and southern men's and common to one another's. Their culture was based on reciprocity, conservative Protestantism, female friendships, longing for the life of the mind, discomfort with northern organized reform movements, and the underlying ubiquitous institution of slavery.

Any discussion of a woman's culture, however, must be framed within specific class and racial contexts. The woman's culture of Savannah and Charleston explored here was enjoyed within elite, white, urban circles. The extent to which elite women's poorer neighbors and/or slaves shared their values and attitudes is the work of another project. Moreover, although these women were resigned to their lives, this should not suggest that they were resentful, angry, or melancholy about their gender or marital status. Indeed, urban southern spinsters made comfortable, if sometimes problematic, places for themselves within their social circles, families, and communities. The identities of these women were shaped by urban settings, benevolent work, and, most important, places within families. They enjoyed friendships with other women, expressed special concern for the needs of their cities'

women and children, and considered themselves indisputably different from their men. In fact, a few remained single to avoid men and the dangers they imposed upon women through marriage. What follows aims to peel back the layers of their identities and explore the communities, families, and activities that framed experiences of womanhood and singlehood.[14]

* * *

Within this framework, six chapters describe and analyze the lives of Savannah's and Charleston's well-to-do unmarried women. Because their class and urban milieus most significantly shaped their experiences, chapter 1 maps the unique and paradoxical physical settings of Savannah and Charleston, addresses the cities' important economic bases, and probes the complex social geographies of these urban centers. Both cities boasted a community of elite white women who socialized, volunteered, churched, and traveled together. Despite complaints about gossip or excessive socializing in the city, women, especially unmarried women, preferred city to country residence, in large part because the urban setting allowed opportunities for usefulness to the community, a general acceptance of their single state, and access to northern friends, relatives, and discourse. In addition, the communities of women there provided companionship, intellectual stimulation, creative expression, and remarkable leadership.

Although unmarried women in Savannah and Charleston gleaned a great deal from the social and physical offerings of their cities, they drew strength and validation from the nineteenth century's shifting perceptions of unmarried women. Chapter 2 demonstrates that as writers celebrated the domestic sphere, and extolled the virtues of having single women sanctify and support that sphere, unmarried southern women, especially in cosmopolitan and urban places like Charleston and Savannah, were emboldened and encouraged. Some even contributed to the proliferating print culture as authors of fiction, poetry, didactic pieces, and political commentary. Both explicitly through their words and implicitly through the acts of writing and publishing, these women writers, a disproportionate number of whom were unmarried or at least late-marrying, encouraged women to exercise moral judgment and trust their choices. They also created places for themselves and their unmarried readers, both rhetorically and pragmatically, in antebellum southern society.

Especially throughout the first two-thirds of the nineteenth century, southern women's principle place in society was within their families. Unmarried women, although they did not create their own new families, were no exception. Just as their marrying and mothering sisters did, they rooted their

identities in familial roles. In fact, single and married brothers, mothering sisters and sisters-in-law, aging and widowed parents, and maturing nieces and nephews needed these women all the more because family was so important to individuals and to the culture. Chapter 3 explores the many functions performed by unmarried women in their families and demonstrates not only that these women were indispensable helpers and leaders in those contexts but also that urban southern women without husbands could find fulfillment and purpose in those relationships and roles. Of course, the maiden aunt especially felt the limits of her authority over young relatives whom she loved dearly but were not *her* children. And family members could just as easily poke fun at an eccentric aunt as celebrate her virtue and contributions. Ultimately, brothers married, parents died, and nieces and nephews grew up. Moreover, nearly all human relationships could and did have the potential for conflict and pain. Unmarried women were especially vulnerable to criticism or neglect because, as much as they tried to serve their way into the center of their families and as much as their families took their help, these women were still somewhat on the periphery of things. Yet despite myriad liabilities, unmarried women often reveled in those relationships and found, as one Charleston woman commented after proudly describing her beautiful (and nearby) niece, "I still continue to think my Spinsterhood a very charming station."[15]

Friendships with other women were a natural extension of relationships with family members. Indeed, female friendships held a close second place in the hearts and minds of unmarried southern women, as chapter 4 details. From the time they were school girls until they matured into old age, women throughout nineteenth-century America formed important, often intense, relationships with one another. Similar life experiences, a shared language, mutual affection, and the ability to see, or at least write to, each other, brought and held well-to-do women together, whether within families or across familial and geographical divides. Understandably, those without husbands were particularly situated to desire and nurture such friendships, and they were the most likely to describe them in journals and letters. Rather than kindle anxiety that these romantic friendships would subvert the institution of marriage, however, lasting female relationships inspired reverence and nostalgia among a class of Americans that feared the shifting and democratizing tides of their society. Women in urban settings such as Savannah and Charleston were especially likely to be aware of these sentiments and benefit from the physically close-knit structure of urban life that supported frequent and regular contact among women. Of course, just as with familial relationships, personality conflicts and idiosyncrasies clouded most friend-

ships at one time or another, and marriage and men always threatened to weaken the bond between two women. Nevertheless, unmarried women in antebellum Savannah and Charleston prized these relationships with other women and drew from them support, validation, and affection in the absence of a husband.

Often buoyed by these relationships in the city, and satisfied that they were meeting the needs of their extended families, women of Charleston and Savannah moved next to broaden their spheres of usefulness and direct their energies to the growing number of benevolent organizations in their cities. Chapter 5 demonstrates that nineteenth-century women populated, supported, created, and even led a number of charitable organizations, both inside and outside their churches. This was especially so in bustling seaboard centers with relatively diverse and needy populations and sailors to be assisted and managed. Like Americans throughout the United States, Charleston and Savannah's well-to-do, with many women among them, established benevolent organizations aimed at aiding the sick poor, training indigent school-age girls, establishing homes for sailors, and a myriad other causes, including those the government had begun to address, such as orphan care and historic preservation. Finally, many urban women, like those across the South, felt compelled by religion and ideology to individual acts of benevolence within their households and communities. Although it is difficult to ascertain precisely whether individuals were single, married, and/or widowed, it is clear that unmarried women occupied critical and numerous places on membership rosters and in organizational records, often as leaders. In addition, urban churches and other organizations recognized that unmarried women constituted sizable, largely untapped, sources of revenue and volunteers. As a result, these churches and other organizations sought out their financial, physical, and mental resources. Herein lay another critical place where women could find both single blessedness and some degree of influence.

Building on this antebellum experience of benevolent work and on the rhetoric about unmarried women's unique contributions, unwed women in Charleston and Savannah joined their married sisters and met the sectional crisis and the Civil War with vigor, enthusiasm, and determination. A final chapter reveals the way that unmarried women were situated at the center of important cultural and gender shifts that have been ably described by numerous Civil War historians. The lives of Charleston and Savannah's well-to-do women, however, suggest that many wartime developments that historians describe were already underway before the war broke out.

The war gave urban women without husbands even more opportunities for usefulness in service to the Confederate cause and, ironically, even more

opportunities for energized socializing with other residents of the city. The war also brought into sharp relief the presence and the problem of women without husbands, especially as battle tolls rose. Unmarried women, young and old alike, marveled at the numbers of women who rushed into marriages during the war, as if to avoid at all costs a fate that many single women had deemed acceptable, even blessed, all along. Like never before, the issue of marriage and women's not marrying was on the minds and tongues of worried southerners.

Also like never before, southern women expressed their frustration with men's inability to protect them, their way of life, and their beloved cities. This stung the worst for Charleston's and Savannah's unmarried women when they had to leave their sea coast havens for supposedly safer, although certainly less interesting, upcountry refuges. It was startlingly apparent how much the cities had meant to these women when they had to leave them.

By the end of the war, many unmarried women, especially those who were still relatively young and needed the money (as most southerners did), moved into teaching and other occupations. The postwar South held vast new opportunities for work and service to be sure, but economic uncertainties made the hope of autonomy elusive for those who needed it most. Through it all, southern women's responsibilities to family members continued to dominate their identities and activities, just as they had during the antebellum period. Unmarried southern women were still, first and foremost, daughters, sisters, and aunts.

1. "Upon Those Shady Banks . . . to Stand and View the Busy World"

Unmarried Women's Antebellum Savannah and Charleston

Nineteenth-century Savannah and Charleston were attractive, verdant, bustling coastal cities. There were probably few better places to be an unmarried woman in the Old South. Both cities grew from colonial capitals into important centers for business and commerce, especially the export of cotton, rice, and naval stores, and the import of finished goods from the North and Europe. Unlike the rural regions that supplied them, Savannah and Charleston had what most American cities did: impressive architecture, lovely public parks, many religious institutions, numerous trades, waves of immigrants, a white working-class, communities of free blacks, and, of course, many slaves. They also offered large, healthy, and busy communities of white women. Well-to-do women especially appreciated the seacoast cities for their beauty and relative ease of access to northern travel destinations, as well as for the intellectual and religious stimulation and opportunities for benevolent work they offered. These women also enjoyed the busy social calendar, often organized and peopled by other women.

By the antebellum period, Savannah and Charleston had become unique centers for women's social, intellectual, and benevolent activity in the lowcountry. With a surprising concentration of unmarried ladies in a region that usually married off its young females with greater rapidity and frequency than the North, these urban centers provided unusual gendered spaces for women. Despite the restrictions on white women's activities, Savannah and Charleston offered many elite women the excitement and energy associated with close-knit urban living, ethnic diversity, intellectual inquiry, and economic activity. Countless women deemed the cities far better for day-to-day enjoyment than the rural areas nearby. Of course, anyone

who could afford to do so fled Savannah and Charleston during the sickly spring and summer months, but having a home there gave the well-to-do easy access to northern cities, fashionable travel destinations, and even Europe when it was time to leave. The urban environment also meant heightened scrutiny of women's activities (particularly when a woman's unmarried state indicated unconventionality) and possibly more public ostracism for indiscretions. Still, their communities of women, opportunities for meaningful activities, and intellectual culture all made Savannah and Charleston overwhelmingly attractive cities for women, especially unmarried ones. It is not surprising, then, that my initial research on southern maidens led me over and over again to these two cities.[1]

* * *

Mary Telfair described a close-knit and active group of women in her southern city of Savannah. Joined by her sisters and their friends, Telfair enjoyed a vibrant circle who strolled together, met to do needlepoint or read, occasionally worked on benevolent causes throughout the city, and regularly traveled north together. In 1830, for example, the thirty-nine year-old Telfair reported that she, her sisters, and their friends had recently gathered together with "no *man* to check us—we roamed at large, all our Canal jokes were reverted to—Lord Nelson not omitted we became at last *too witty*—and concluded we ought to designate our meetings 'the Wistar Club.'" She explained, "We generally meet with our work once a week at each others' houses—Scandal is prohibited but we *talk sentiment, tell anecdotes* and *make puns.*" Throughout her midlife, Telfair's innermost circle was intimate and sociable: "Our Coterie has been unusually flourishing this winter. We meet once a week at each others houses. Oyster suppers have been introduced which promote sociability—and our knot is the envy of the Town." Wanting to keep the meetings intellectually satisfying, Telfair recommended that her "club" supplement needlework activities with discussions about various readings. As she told Mary Few, "I have proposed reading a short piece each time by way of furnishing a new topic of Conversation even if it gives our conventions an air of pedantry alias *bluestockingism.*" Telfair was, after all, a wealthy and conservative southern lady. Even in an urban environment she always had to walk a fine and closely scrutinized line between feeding her intellectual needs and seeming unladylike, manly, or liberal.[2]

Telfair reveled in the "Sisterhood" she found in Savannah and the other seacoast cities she visited. Writing of these well-educated wealthy women, she observed, "I think when *divested of peculiarities* they are the most agree-

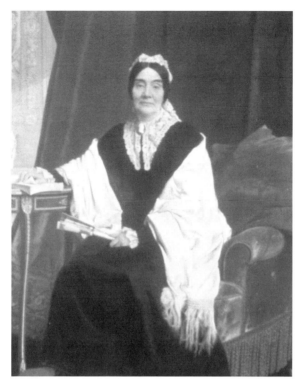

Mary Telfair, 1791–1875. Carl Ludwig Brandt painted this
posthumous portrait in 1896. He had spent some time
with Telfair but worked primarily from two photographs.
This, he wrote, was how she looked fifteen years before her
death. The cameo at her throat depicts the god Apollo.
(Courtesy of the Telfair Museum of Art, Savannah, Ga.)

able Women. Their minds are generally speaking cultivated and they possess
altogether greater mental resources than a married Woman." Never wanting
to overstate her unconventional commitment to single blessedness, how-
ever, she retreated. "Still I do not advocate single blessedness when I say
so—for the want of an object in it often compels an unmarried Woman to
seek for sympathy in books and elegant occupation which Women who have
children to train are independant of." After all, no matter how well con-
nected to friends and family, unmarried women had to face times of loneli-
ness and isolation. Fortunately, Savannah and Charleston were relatively
hospitable southern locales for women who needed "sympathy in books and

elegant occupation[s]" and wanted to share those activities with one another.[3]

Much of the reason that unmarried women needed and relied on one another was that they were often on the periphery of their families and society at large. Although Savannah and Charleston were relatively easy cities in which to be a single woman of wealth, the greater southern culture still expected that women marry. An 1818 letter in the *Charleston Courier* made clear, women should be entirely deferential to their husbands. Implicit in this, of course, was that women should be wives. "The first maxim, which you should impress deeply upon your mind, is never to attempt to control your husband, by opposition, by displeasure, or any other mark of anger," the father advised his daughter. "A man of sense, of prudence, of warm feelings, cannot and will not, bear an opposition of any kind." The admonishment continued: "When he marries her, if he be a good man, he expects from her smiles, not frowns; he expects to find in her one who is not to control him, not to take from him the freedom of acting as his own judgment shall direct; but one who will place such confidence in him, as to believe that his own prudence is his best guide. . . . A difference, in reality, with your husband, ought to be considered as the greatest calamity." More than three decades later, Judge Hershel V. Johnson told the graduating class of Wesleyan College in Macon, Georgia, that their education made them cultivated, charming, attractive, and "noble as wife and mother." Obviously, marriage and motherhood were the rule and urban spinsters, the exception.[4]

For that reason unmarried women had to prove themselves worthy, interesting, and useful to society, a task fairly easily accomplished in a city like Charleston or Savannah. Harriot Pinckney was Charleston's most fascinating and celebrated unmarried woman. Born in 1776, she was part of the older generation of unmarried lowcountry ladies during the antebellum period. Revered for her kindness and generosity, Pinckney was not incidentally the daughter of a famed Charlestonian, Charles Cotesworth Pinckney, a Revolutionary war hero, delegate to the Constitutional Convention in 1787, and American minister to France. Contributing to her mythic position as Charleston's First (unmarried) Lady, she was, according to observers, "plain to distinction, but how little it counted." Alicia Hopton Middleton, a young observer who eventually followed in Pinckney's maiden footsteps, remarked, "Her heart was as large as her body was small, and filled with all the beauty that nature had left out of her countenance; her kindness, her sympathy, her generosity, her love for everything and everybody, seemed literally boundless."[5] Despite, or perhaps due to, her plain appearance, Pinckney was able to combine her high social position and considerable wealth to serve others.

After all, her appearance perhaps both explained her lack of a husband and made her an even less threatening urban icon.

"She was, I suppose," Pinckney's nephew added, "much the wealthiest individual in the city; at any rate, she was generally looked upon as having an inexhaustible purse and deriving her chief source of happiness from acts of benevolence, and consequently among the indigent she was the first to come into their thoughts at time of need." Indeed, everyone who came across the old Miss Pinckney was said to regard her as an able and accessible resource for assistance. Not surprisingly, her "fine old mansion on East Bay . . . [became] the rendezvous for all the relatives far and near, and any traveler or stranger." She was known also for spoiling her servants. Upon the occasion of Pinckney's eighty-ninth birthday, Middleton's father penned and read the following lines:

> Loving heart and bounteous hand,
> Relict of the glorious days,
> Witness to a stricken Land
> Of the old heroic ways,
>
> Stay and cheer us with thy blessing,
> Soothe us with thy gentle mien,
> That, the casket still possessing,
> We may mark the jewel's sheen.
>
> Stay and smile upon our sorrow,
> Till we learn like thee to smile,
> And from feebleness may borrow
> Courage for ourselves the while.
>
> Near the court where age has bound thee,
> Love unsought shall still attend,
> And when death at length has found thee
> Only love shall mark the end.[6]

Although they were Pinckney's contemporaries and part of that older generation of unmarried women—those born before the turn of the century—Mary Telfair and her sisters did not fare as well in the public eye. In fact, the Telfair sisters were frequent subjects of gossip in Savannah, probably due to a combination of factors. They were extremely wealthy and from a most prominent family. They voiced what were increasingly considered old-fashioned attitudes and dressed according to those older preferences. They likely gave off airs of superiority. In addition, Mary never married, Margaret married very late in life, and Sarah, married and widowed young, never remarried.

As early as 1814, Mary Telfair was commiserating with her friend Mary Few about the gossip they both endured. "I am sorry to hear that the *Miss Fews* have established the same character for Pride in New York, that *the Miss Telfairs* have in Savannah, it is unfortunate but I know from Experience that it is impossible to do away with public opinion it is so very *inveterate*," she wrote to Few. "I like you think myself destitute of *false pride* it is a mean contemptible passion but there is a *proper pride* which every human being ought to posses." Telfair speculated, "Perhaps your unpopularity arises from the same cause of ours[:] you have not general acquaintance and are not deceitful enough to appear interested in people whose every word is calculated to create *a yawn,* there is not a greater *bore* than to be compelled to associate with beings who awaken no faculty either of mind or Soul."[7]

Just as Telfair was merciless toward the bores of her social universe, so they were unto her. One acquaintance, John Wallace Jr., reported to his sister in September 1814 when Mary Telfair was twenty-three, "The Pumpkin faced Telfairs were here a few days since,—they cut so many high flourishes, I could not refrain from comparing them to some of the country wenches I have seen in their sunday gowns." Half a century later, William B. Harden, librarian of the Georgia Historical Society, remembered how the Telfair sisters rode about in their carriage, exuding a sense of superiority. They were considered "characters," Harden indicated, and associated exclusively with a small group within the social elite. Unfortunately, Harden went so far as to describe the Telfairs as "dried up old women." Even the local newspaper reported after Mary's death that the Telfair sisters were "noted for their peculiar exclusiveness."[8]

Margaret Telfair married at the late age of forty-five, and again the sisters were watched and talked about. In 1842 they returned from a trip to Europe with Margaret's new husband, William Hodgson, an American diplomat and renowned Oriental scholar. Hodgson had been a forty-one-year-old bachelor without financial resources equal to the Telfairs'. Mary Telfair described the flurry of gossip and speculation about the match: "They greeted Mr. Hodgson with great cordiality, and were glad to see him look *so old,* for Gossip had spread its wings very wide in this direction, and some pronounced him to be twenty-two while others stopped at thirty-five." She complained, "There is a great deal of ill nature in the world and there are two events in life, [marriage and death,] which seem to draw poor human Nature from its secret cell, and cause every one to *publish* what they know or can imagine of the Individuals" who marry or die. Back in Savannah's fishbowl, Mary pined, "There is comfort in living in a large City where no one knows you—One of the *attractions* of Europe is, we can live *unknowing & unknown.*"[9]

It is no wonder that well-known, unmarried, eccentric urban women would receive heightened scrutiny and either extreme praise or extreme criticism for how they lived. Wealth, family history, religiosity, and urban milieu allowed some of them remarkable freedom and independence to come and go, largely as they pleased, and exert considerable influence in social circles, even with certain philanthropic endeavors. Savannah and Charleston were still deeply entrenched within the Old South, and the elite ladies of those cities both benefited from the privileges that society bestowed on their race and class and chafed under the restrictions on their activities. All of them required special handling in the public discourse because they had failed in the usual trajectory to mature womanhood.

<p style="text-align:center">* * *</p>

Much of what Telfair and others like her gleaned from urban life included a routine of stimulation, companionship, and opportunities for usefulness. The daily schedule was busy with visiting, supervising slaves and servants, and attending church or benevolent meetings. City ladies arose early, ate a large breakfast (prepared by slaves), said morning prayers, and then supervised household tasks. Unlike poorer women in the city and most women on plantations and farms, who performed physical labor in their households, kitchens, and gardens, urban women might stroll in their gardens, read, shop, or answer letters. Dinner took place around two in the afternoon and was an elaborate ritual for which men returned from their offices or business errands. In the afternoon or early evening friends visited for tea. Ladies could also take a late-afternoon walk, which in Charleston might be on the Battery, where they could see the rest of the fashionable set and enjoy the view of the harbor and Mount Pleasant. The younger women and men among Charleston's well-to-do might go horseback riding in Watson's Garden or on Sullivan's Island. The day ended shortly after dark, when everyone returned home for a light meal, some reading, writing, or visiting, and bed. Savannah's ladies passed their days quite similarly. Older ones like Telfair by mid-century might have attempted slightly fewer activities, but they kept busy with prayer meetings at church; lectures and sermons by various ministers of Protestant denominations; plenty of reading, letter writing, and journal keeping; occasional walks through the squares; and frequent rides in pony chaises or horse-drawn carriages. Entertaining became a relatively scaled-down affair, usually amounting to small dinner parties and visits to and from women friends.[10]

Of course, the social schedule had important long-term implications as young people met and socialized with one another, usually partnered, and

cemented lasting family connections and dynasties. Jane Caroline North, a young Charleston woman described by her biographer and editor as "a mature—even cynical—belle," documented the complex maze southern women had to negotiate as they made social calls, attended balls, and traveled to northern spas and vacation destinations. Masters (or mistresses) of social intercourse and polite conversation, appropriate and impressive dress, intense competitions and friendships with other women, and intricate and vital family fortunes and histories, elite southern women traversed an exhausting terrain of self-scrutiny and scrutiny by others. After all, nothing less than the future of one's family and fortune rested significantly on reputation and marital alliances, most of which were forged during social calls, balls, parties, and other events. During these rituals, the elite scrutinized one another's behavior and discussed topics of interest, including politics, society, and those not present. The urban component of the treadmill took place principally between the months of October and June, when families returned to Savannah and Charleston after months away at northern watering holes; following visits to Newport, Philadelphia, or Boston; or after time spent on nearby family plantations. Generally, the lowcountry cities harbored deadly epidemics from late spring to early fall, which the elite did well to avoid.[11]

In sharp contrast, the daily routines of women who were of the same social class and happened to live on plantations differed significantly. Because plantation mistresses have dominated the literature about white southern women until very recently, their routines and responsibilities are well-documented. Indeed, the image of the urban socialite is quite unlike the picture of the overworked, isolated plantation mistress: hair disarrayed, hoop off, bent over a salt barrel, and up to her elbows in brine. She arose early, supervised slaves in the preparation of breakfast and planned dinner, and ate with her family. For the rest of the morning she might tend to her garden (which could be quite extensive and critical to the family's nourishment) or throw herself into the planning, cutting, mending, and sewing that a house full of individual wardrobes, upholstery, linens, and slave clothing required. After a large mid-afternoon meal she might take a short rest, write a few letters, read, oversee family worship, and visit with guests. Interspersed throughout her routine were ongoing duties related to producing and caring for children, supervising children's education, cleaning, managing household finances, and tending to all of the seasonal tasks like winter slaughtering and candle and soap making. One historian has classified plantation mistresses' work into four categories: day-to-day and season-to-season continuation of domestic health and comfort; supervision of house slaves and domestic producers; domestic work they had to do themselves (cutting expensive fabrics,

preserving foods, or arranging flowers); and ongoing care for family members and slaves. Together, these tasks amounted to what one historian describes as "at best a never-ending series of challenges and at worst an overwhelming nightmare." The wealthiest lowcountry mistresses enjoyed a respite from this routine when they came to Charleston or Savannah, where smaller houses, fewer and more highly skilled slaves, and a community of women all around made their lives, at least on the surface, easier. No wonder some women avoided plantation life altogether.[12]

Surely, the overwhelmed plantation mistress had little sympathy for her urban sisters and brothers whose complaints were quite different. Many city-dwellers lamented that the busy social calendar became too much of a good thing. As early as 1801, one of Savannah's most prominent citizens remarked to his wife, "As usual in this place pleasure & dissipation are either crammed down our throats whether we will or not, or there is a total stagnation & we all become as dull as Stockfish—there has been no less than three balls." Similarly, one visitor from the upcountry complained to her son, "We have been so much in a constant flutter among the butterflys of Savannah, that I begin to feel like one myself." She explained disapprovingly, "The ladies in Savannah seem at a loss how to *kill time* and I suppose they expect some amusement from the awkward embarrassment of the *Crackers.* They therefore overload us with civilities, and draw us into parties which they justly think will excite our astonishment." Sounding much like the republican mother that she was in 1818, she continued, "Luxury and extravagance is carried to a greater excess than I ever expected it could have arrived at in America. We hear ladies with families of small children boast of having been out to parties 10 nights in succession until after midnight, and sometimes until 3 o'clock in the morning; and that they had not seen their husbands for a week." She went on to describe one party in particular, with its elaborate, multicourse meal, and concluded, "I shall therefore for the future decline going any more; how I have stood it thus long is a matter of wonder to myself."[13]

Even the young Mary Telfair expressed disgust that Savannah had so many balls and other examples of dissipation. Perhaps portending her permanent spinsterhood, at twenty-five years of age she could not feel comfortable in such superficial activities and wished for an alternative. Insisting that she could not "shake off that *frigid indifference*" she felt upon "entering a Drawing Room filled with *combustibles* of various descriptions," she reported to her friend in New York, "Savannah has been gay this winter if the idea of gaiety can be associated with *Tea Conventions, public Balls, and partys.* I have partaken very moderately of them, for they excite so little interest in me that

I always rejoice when the toils of the evening are over and never fail to wish that I could form a little society of those I admire for their mental endowments, and love for their amiable qualities, I should then be so selfish that I would never roam beyond that sphere."[14] Very likely, Telfair's disapproval sprang in part from her discomfort with an often-superficial social scene that had no good place for a woman like her.

Others despaired not only of the mental dissipation but also the social competitiveness of the urban scene. The frequent parties and balls, requisite social rounds, and scrutiny among peers worried many social critics that young women would stagnate there as flirtatious, vain, and foolish city belles. To some, this spiritual decline signaled nothing less than the fall of southern civilization. One historian who has examined the life and writing of three Charleston women writers at this time finds a sharp critique of this urban regimen and the rural alternative. The first, Caroline Gilman, an adopted southerner, used her novels to compare the peace and familiarity of the countryside to the rudeness and curiosity of the city. Charleston-born Susan Petigru King similarly criticized the falseness and self-display of the city's drawing rooms but concluded that the city was still preferable to the ignorance and insularity of country plantations. And, finally, Mary Chesnut strongly preferred the stimulation of the city to the forced intimacy and isolation of country living. All three writers, and countless others, knew that the city afforded a mixed blessing for women.[15]

Still, for well-to-do women, the cities' virtues outweighed the disadvantages. Urban centers offered countless opportunities for education, reform work, and personal autonomy. Moreover, women with independent wealth avoided altogether the cities' greatest liability: economic vulnerability. Without a family farm to fall back upon for the basics of food, fuel, and shelter, middling and poor urban-dwellers faced greater risk of poverty and mortality than rural residents. Wealthy women, by contrast, faced few financial risks as they had avoided, intentionally or circumstantially, dependence on a husband's wage or financial management.[16]

Possibly the most important virtue of city living for unmarried women was that it far surpassed the rural alternative. The maiden ladies of Charleston and Savannah frequently lamented time spent in the relatively isolated upcountry, where their families occasionally summered or their relatives lived. Mary Telfair, for example, described her boring routine at her family's plantation near Waynesboro, Georgia, during the War of 1812: "Here we are immersed in a wilderness far removed from the vortex of business and pleasure," she reported to Mary Few. "The life we lead is similar to a monastic

one only that we have *no nuns* or *Confessors,* and are permitted to range unmolested through the gloomy pine trees."[17]

Not only did the upcountry offer little in the way of activity and stimulation, but those who lived there were also, according to Telfair, boring, ignorant, and hopeless. When the Telfair sisters took over the education of their upcountry nieces, she commented, "The children in this part of the world are so *dragged* up, and neglected that it is a mercy when they are cast upon strangers for instruction." After all, *"up country* notions are the *antipodes* to ours. They seem to think *a little shew* all that is necessary in living & in education." Telfair saw no need to conceal her strong class and urban bias. Two years later, in 1830, when she accompanied her brother Alexander on a tour of the family's upcountry plantations, Mary described the trip as "a sojourn to Crackerland." As she described to Mary Few, the wife of one of their overseers "never combed her own hair or washed her feet." Indeed, "the indolence of that class of people in this country is unexampled." Telfair betrayed her true colors when she concluded in 1832, "Industry and management are only to be met with among the *Ladies* of our land—the *Women* are too, *too* lazy like the Medes & Persians they are so wedded to their habits that it is impossible to revolutionize them." Telfair's jarring dismissal of farm women betrays that her identity was rooted in the cosmopolitan and elite world of Savannah, with its strong ties to other urban American settings. In fact, after her brother's death left the (largely absentee) management of the family's plantations to the Telfair sisters, Mary Telfair acknowledged that she enjoyed playing *"Architect* . . . building new houses for our people and superintending a vegetable garden" and fancying herself a *"Farmeress."* But still, she concluded, "upon mature reflection I think I am better calculated for a *Town Lady."*[18]

Telfair's perspective was not unique. Many lowcountry elite ladies dismissed their rural neighbors. The prominent Charlestonian Elizabeth Allston Pringle remembered that when her mother became engaged to Robert Allston, a wealthy rice planter who lived year-round on his plantation, the female members of the family were stunned that the young Adele Petigru would "contemplate [leaving Charleston and] burying her beauty and brilliant social gifts in the country." Her older sister Louise particularly resisted the match, arguing, "You cannot think of accepting this young man. Mr. Allston lives winter and summer in the country. He will take you away from all your friends and family. That he is good-looking I grant you, and I am told he is a man of means; but it is simply madness for you with your beauty and your gifts to bury yourself on a rice-plantation." Comfortably married

and situated in her Charleston home, Louise explained, "Perhaps I would not feel so shocked and surprised if you did not have at your feet one of the very best matches in the city. . . . If you accept Mr. Blank, you will have one of the most beautiful homes in the city. You will have ample means at your command and you will be the centre of a brilliant social circle . . . I must ask why you are going to do this dreadful thing?" In later years, Adele's daughter, Elizabeth, naturally appreciated her mother's choice and praised the "brave thing" she had done "to face the lonely, obscure life, as far as society went, of a rice-planter's wife." Indeed, Adele was headed for a rural area far more challenging for a white woman than the upcountry farm land Mary Telfair had found so dull and backward. In the upcountry, at least, Elizabeth explained, "There were farms, . . . pleasant neighbors, the descendants of the French colony, . . . and each farmer had only one or two Negroes, as the farms were small." By contrast, the "rice country" along the coast, as Elizabeth knew, had massive plantations, hundreds of slaves, and few resident-neighbors. Obviously, many city ladies rejected this fate for either urban husbands or no husbands at all.[19]

Susan Matilda Middleton, thirty and single for life, confided her strong preference for city life over coastal plantation living to her also-unmarried cousin, Harriot Middleton. Upon learning that her family would likely lose their Edisto, South Carolina, plantation during the Civil War, she admitted, "I always disliked life at the plantation, it was so narrow and dull and deadening, taking it as *I* did, and I did not *want* to take it otherwise, and, although I am, in some sort, attached to the place at Edisto, I scarcely regret its present loss, except in the money point of view." Although she had no husband to convince to stay in the city, Middleton hoped to persuade her father to relocate permanently in Charleston.[20]

Unmarried women in particular could root their identities even more firmly in urban ground when they kept an eye on the rural alternative with its heightened isolation, lack of stimulating (i.e., well-read, refined, and like-minded) neighbors, and dearth of female community. City women could find what they needed to supplement, even replace, the duties and love of a marriage, but unmarried women in rural areas of the South often could not.

Two such women in Michael O'Brien's heralded collection *An Evening When Alone: Four Journals of Single Women in the South, 1827–67* encountered much loneliness and hopelessness in their lives. The Selma Plantation Diarist, who served as a governess on a plantation just north of Washington, Mississippi, in the mid-1830s, was intensely homesick. The thirty-year-old woman missed her family in far-away Pennsylvania and feared that she was passing

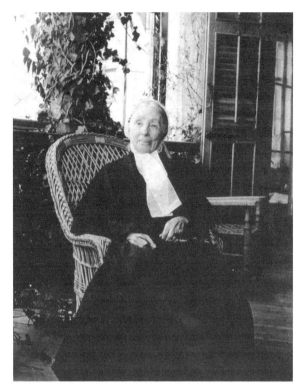

Harriot Middleton, 1828–1905, in later years. (Courtesy of
the South Carolina Historical Society, Charleston)

the age when marriage and motherhood seemed likely. The other, Ann Lew-
is Hardeman, was surrounded by an extended family in central Mississippi
during the 1850s and 1860s, but she was entangled by obligations in the home
of her brother and sister-in-law, caring for the six children of a sister who
had died. Overwhelmed by mothering duties but without the status or con-
trol that typically came with that role, Hardeman was dependent, overworked,
and, in many ways, alone. No wonder that in 1867 she advised her young
school-mistress niece to find the right man and marry him. "When the mar-
riage *vows* are *regarded* by *each*—they have nothing to fear," Hardeman wrote.
"Life moves on with 'a ripple on the stream'—but if trouble comes—two
can bear it better than one." Based on her experience, she insisted, "I wish
you to enjoy the life while it is granted to you—but I want you & [my neph-
ew] Edward to get married before you get old—take warning by me—here
I am left without any resource—& feel that I am a dreg to everybody & do

not know what to do with my self."[21] This was Hardeman's last piece of advice in her last surviving letter. She died one month later. Had Hardeman lived in Charleston or Savannah, she might have felt much less isolated and useless.

A key component of the urban experience, and the thing Hardeman sorely lacked, was a critical mass of women, a sustainable body that allowed individuals an unusual degree of control over social gatherings, benevolent work, and even religious communities. Antebellum southern women in general lacked the real political, economic, and social power in male-dominated society, but certain well-to-do ladies found considerable influence in urban social settings. Within the often competitive and sometimes enervating round of social engagements the elite ladies of Charleston and Savannah retained a degree of control even if they were under control themselves. At the Virginia spas, for example, where the elite from all over the South found recreation women both enforced and complied with the rules of social conduct. And at home in antebellum Charleston and Savannah an active cadre of well-to-do wives, widows, and daughters—kin to planters, merchants, and political leaders—initiated much of the socializing. Early in the century Robert Mackay described a powerful nucleus of Savannah ladies who maintained a busy social calendar and made very direct, persuasive invitations of him while his wife was in far-away Liverpool. In 1806 he reported to her that he had been invited to a "lady party" that included Mrs. Stiles, Mrs. Taylor, Miss Jackson, and Mrs. Gibbons. "Last night went to the Concert, about forty Ladies there, the Hunters & Bourkes with the Jones & Campbell concern—," he wrote to her the next year. Later that month he complained that "the Ladies are still insisting upon Mein & I giving them a tea party."[22]

According to Mackay, that July the ladies of Savannah were somewhat intoxicated by their social power and spiritual independence and took it upon themselves to lead worship and prayer meetings when the minister at their Independent Presbyterian Church left town. The self-righteous Mackay was indignant and a bit amused: "There have been some curious preaching concerns formed here since [Rev.] Mr. Kollock left us, a number of the Ladies of his flock formed a plan of praying & reading a Sermon in Church every wednesday, & subscribed their names to some paper, obliging themselves to hold forth in turn, it commenced with (I believe) Mrs. Taylor, but the thing was so talked of & so laughed at, & such multitudes were determined to go & hear out of curiosity, that it went no farther." Mackay wrote to his wife, "I was mortified beyond all description to hear that your Sister was one of the Subscribers to this Bedlamite piece of extravagance." Apparently, according to this early-nineteenth-century southerner, it was outlandish for

women to gather and organize their own religious leadership. They obviously exercised significant and acceptable leadership in urban churches, but that heady sense of female initiative should have limits.[23]

Churches were a central part of the physical and mental worlds of many southern women. Within these institutions, women congregated, worshipped, organized, taught and learned, and led. In addition, unmarried women found special roles and purposes within their churches, where they could enjoy friendships with other women and a sense of common purpose. Mary Telfair, for example, joined few official benevolent organizations but attended meetings at her family's Independent Presbyterian Church regularly. Like other southern women, she disregarded denominational differences when a particularly attractive minister was speaking at another Protestant church, usually the Methodist or Episcopal. Although she might venture to a more evangelical service in Savannah, Telfair rejected the revivals and the emotional carryings-on at evangelical camp meetings in Georgia's upcountry. Again betraying her urban bias, she told Mary Few, "Your description of a *Camp Meeting* interested me very much. I have never attended one, objecting to the manner in which they are conducted in the interior of our State." Perhaps, then, the common display bothered her more than the theology.[24]

Safely in the city limits of Savannah, an array of Protestant services did not offend Telfair's restrained sensibilities. True to her intellectual bent, in 1828 she attended a "very flourishing Female Bible Class" taught at the Episcopal Church. According to Telfair, the teacher posed surprisingly challenging questions to the class of women and demanded of them essays in answer to the questions. Afterward, the clergyman read the papers aloud to the entire class while protecting the anonymity of each writer. Telfair concluded, "I think writing Bible answers more improving than attending the best sermons." Sometimes women found the most meaningful theology within themselves. Urban churches and their learned ministers often fostered these high standards of erudition within the religious community.[25]

Charleston, too, offered a range of churches. Since before the American Revolution, the (Anglican and then) Episcopalian cathedrals of St. Philip's and St. Michael's maintained the highest social standing, the most powerful political ties, and much of the wealth in that city. As in Savannah, however, Presbyterians and Congregationalists also drew many wealthy members—a quarter of their congregations. Baptists and Methodists attracted those of more modest means, such as artisans and tradespeople, but their congregations were far larger overall than those of the more elite churches. Lutheran churches, St. John's and St. Matthew's, attracted most of the city's German immigrants. Jews found tolerance in Charleston and established one of the

largest Jewish communities in America there by 1820. There were Catholic churches as well, but Catholics encountered more prejudice and less tolerance than other religions.[26]

Because social and theological realms in Charleston and Savannah were so vibrant, and women's participation was so active (at least relative to the rest of the Southeast), the women who moved from those cities, as well as the relatives and friends of urban residents, established a sort of "satellite relationship" to them. When husbands and fathers wanted to move west, spend time on plantations in the Caribbean, or live in England for business purposes, the women connected to these men usually left reluctantly and held firm to ties to Savannah and Charleston. Probably with more longing than their male kin, they read Savannah and Charleston's newspapers whenever possible; exchanged visits as frequently as they could; and wrote letters back and forth, describing (or for those in the satellites, imagining) the gay and the familiar. The aging, unmarried sisters Margaret and Mary Ann Cowper, who lived principally on their family's plantation in Jamaica, wrote frequent letters to cousins in Savannah. Pining for the city's social life and kin networks, Margaret wrote to Eliza McQueen, "Savannah must be highly brilliant this winter." She admitted her envy of family and friends there who remained "surrounded by the family connections which are extensive and prosperous."[27]

Part of what made life in these southern cities particularly stimulating, even enviable, was that women there were intimately tied to many other like-minded well-to-do men and women all along the East Coast. As part of a seaboard elite, women and men of Charleston and Savannah circulated among other wealthy, well-read, and refined individuals from cities such as New York, Philadelphia, Boston, and Richmond. Given adolescent educations in the North, routine summer trips to Newport and various American spas, and opportunities to host northern elites who came South, lowcountry white women spent a considerable amount of their lives away from their town homes. The network of female friends that flourished along the eastern seaboard provided a sense of extended connection among women, of belonging to a wider circle of mutual acquaintances, and of shared information about one another. Maintained largely through correspondence and travel to popular vacation spots such as Newport and Saratoga Springs, this fluid exchange of acquaintances allowed unmarried women in particular an opportunity to meet their northern counterparts. These were the American maidens who tended to participate in public reform efforts, discuss openly the merits of singlehood, and follow generally the "Cult of Single Blessedness."[28]

* * *

The physical, economic, and intellectual topographies of Charleston and Savannah merit attention because they made up the terrain that unmarried women traversed, a social geography that constituted much of what made the areas so interesting and positive for them. Savannah, for its part, during the early and mid-nineteenth century, was a relatively small, lovely, carefully laid-out, largely walkable working city. Visitors and residents alike commented on its beauty as it sat perched above the Savannah River about eighteen miles from the coast. Wide, tree-lined roads allowed pleasant breezes to cool the city, and attractive homes overlooked pastoral squares. As the often-quoted British visitor Mrs. Basil Hall remarked in 1828, "Savannah is a very pretty place, quite like an English village with its grass walks and rows of trees on each side of the street. The gardens, too, are in great beauty and I have actually seen sweet oranges growing." Indeed, after 1810 the city council had paid $1,024, the largest appropriation up to that point, for beautifying the city, including the planting of expensive trees in the squares. Robert Mackay, one of the city's prominent citizens, noted that all of Savannah's squares were enclosed "with light cedar posts painted white & a chain along their tops, trees planted within, & two paved footpaths across, the remainder of the ground they are spreading Bermuda grass over." He concluded, "Upon the whole the Town looks quite another thing & very enchanting."[29]

In 1833 another observer, Sara Hathaway of New York, praised Savannah's beauty: "Savannah is a lovely city, not made so by architectural beauty, for there are very few fine houses here. What constitutes its beauty is the manner in which the city is laid out. There is one immensely broad avenue, about half way across the city, called South Broad Street, and extending the full length of it from east to west." She also appreciated the city's grassy squares, which make Savannah distinctive even today. "These . . . parks . . . are very picturesque and inviting, and highly suggestive of health and comfort," she noted. The English novelist William Thackeray was nearly as enthusiastic, describing the city in 1856 as "wide-streeted, tree-planted, with a few cows and carriages toiling through the sandy roads, . . . negroes sauntering here and there, a red river with a tranquil fleet of little merchantmen taking in cargo, and tranquil warehouses barricaded with packs of cotton."[30]

Ohioan John Tidball arrived in Savannah in April 1849 and was impressed by a "springtime of loveliness. The beautiful crepe myrtle bloomed in the yards of the wealthy while the lilac shed its fragrance around the abodes of the lowly. Roses, blooming and fresh, boarded the walks about the lawns, and from the wisteria twining itself over verandahs hung clusters of flowers in reckless profusion." The twenty-four year-old army lieutenant concluded, "All nature was smiling with the freshness of spring and I thought to myself

Savannah, 1855. The lithograph offers a northern view down Bull Street. Monterey Square is in
the foreground, St. John's Episcopal Church is in the left background, and the Independent
Presbyterian Church is in the distance. (Courtesy of the Georgia Historical Society, Savannah)

that I had landed in a haven of bliss." Residents were generally hospitable
and refined, contributing to Savannah's reputation as "one of the most de-
sirable posts in the army." The nicer homes had lush gardens that residents
could enjoy from the broad piazzas that wrapped around houses and shield-
ed families from the sun and from public gaze. For Tidball, Savannah was
urbane, cosmopolitan, clean, racially and ethnically diverse, fascinating, and
intoxicating.[31]

Another newcomer, Emily Pillsbury, left her native New Hampshire to
teach at Savannah's Female Orphan Asylum in 1840. She, too, noted the city's
graceful, shaded squares. She also noted six principal streets, all of which ran
parallel to and south of the Savannah River. Because the city was situated on
a high bluff, the first street along the river had a dramatic steep descent down
to the water. This was Bay Street, where most business of the city occurred.
No respectable families lived there, Pillsbury observed, and the buildings
consisted of stores, the homes of free people of color, and sailors' boarding-
houses. The seamen's chapel was at the south end of the street, not far from
a new Exchange building that occupied a prominent place and housed busi-

ness offices on its first floor and city government on its second. From the observatory at the top of the city exchange, Savannahians could watch ships arrive. According to Pillsbury, Bay Street was "always so thronged by sailors, slaves and rowdies of all grades and color that it is not safe for ladies to walk there alone." Well-to-do women could not go there safely, even in groups, unless accompanied by a gentleman. Still, Pillsbury braved excursions to Bay Street, where she relished the cool breezes coming off the water and the trees on each side of the street, which created a pleasant, shaded archway. "It was one of the greatest luxuries I could enjoy to escape the burning sands of the city and spend a few moments of pastime upon those shady banks and, while the soft cooling breezes from the ocean's bosom fanned our heated brows, to stand and view the busy world," she commented. From there, one could watch steamer ships, small skiffs, and the men who worked at the port, loading and unloading goods, cotton, corn, rice, and tobacco.[32]

Part of what made Savannah's geography and design so unique and appealing lay in its origins as a sort of utopian city and society planned by the colony's founder, James Oglethorpe. Envisioning the city as a sequence of wards, each surrounding a parklike square, Oglethorpe laid out what are now Johnson, Wright, Telfair, Ellis, Reynolds, and Ogelthorpe squares before he returned to England in 1743. The east-west sides of each were for public buildings and churches, and the north-south sides were for about forty private homes, to be owned by colonists. Each grouping, or tything, consisted of ten families. Oglethorpe's vision of a utopian, classless society, however, did not materialize. His laws forbidding slavery and ensuring peace with Native Americans were changed, particularly after the 1750s, when the rice trade took off and a real planter society took hold. Of course, Eli Whitney's invention of the cotton gin on a plantation outside the city in 1793 sealed the fate of Savannah and the South as a slave society devoted to the growth of cotton and its export, along with the region's peculiar institution.[33]

Even at the beginning of the nineteenth century Savannah remained small and young compared to other growing American cities, including its low-country neighbor Charleston. In 1820 Savannah's population hovered just under eight thousand compared to Charleston's of approximately twenty-five thousand. Twenty years later, Savannah's population had doubled, but it was still outmatched by Charleston's at forty-three thousand. In addition, Savannah residents were, on the whole, younger, less affluent, and less connected to their state's interior in terms of powerful kin networks than Charleston's. Savannah had a more modest mix of people, a greater percentage of whom came from the North.[34]

In other ways, however, Savannah was very much like other expanding

seaport cities. It is likely that many who effused about Savannah's beauty and charm did not visit the city's western and eastern fringes, where poor white immigrants, free blacks, and runaway slaves lived in squalor. In spite of these sections, or perhaps in part to keep attention focused away from them, Savannah continued to pour money into the beautification of its affluent areas. Leaders could spend those dollars largely due to the city's bustling economy. As Georgia's chief commercial center, Savannah ranked fourth behind New Orleans, Mobile, and Charleston in the export of American cotton. Although it experienced economic hard times and negligible growth during the 1820s, by the late 1840s the city was connected by the railroad to the prolific cotton fields of the piedmont. Indeed, of Georgia's roughly $22 million in exports in 1855 and 1856, $19 million came from cotton. As the state's cotton production skyrocketed from 408,381 bales in 1840 to 701,840 in 1860, the port of Savannah was the third-largest in the South by the eve of the Civil War. Moreover, the nation relied heavily on Savannah as a leading port for the export of lumber, most of which went to foreign countries, particularly the West Indies and later Great Britain. To meet the rising need throughout the antebellum period, Savannah's leaders erected warehouses along the Savannah River bluff and built railyards on the west side of town. Savannah's one "paved" street was a plank road connecting the railroad warehouses on West Broad Street and the cotton press along the eastern wharves. New manufactories and saw, cotton, and rice mills contributed to Georgia's emerging reputation as the Empire State of the South. Meanwhile, the city's population tripled from 7,773 in 1830 to twenty-two thousand in 1860. Of those twenty-two thousand, 13,875 were white and 8,417 were black; females outnumbered males by approximately 12 to 11 across races and classes.[35]

Not surprisingly, the many emerging urban centers in America felt a keen sense of competition with one another for markets, interior suppliers, and intellectual and social status. Southern cities engaged in intense economic rivalries, including those between Louisville and Lexington, Richmond and Norfolk, and New Orleans and Mobile. They also competed for social, demographic, and architectural prestige, even comparing themselves to those European cities where the elite often traveled for business and pleasure. Savannah competed with Charleston for trade with the upcountry and tried as well to keep pace with other, more fashionable American and European cities. As Robert Mackay boasted in 1810, "The streets of Savannah are completely crowded with Carriages, & most of them the neatest you can imagine, we far surpass Liverpool I assure you." Still, summer diseases continued to plague residents, and city leaders struggled to provide educational resources equivalent to those in larger urban centers. "I think it likely we shall fix

here," Mackay admitted to his wife. "I like Savannah very well & hope it will not be displeasing to you, the health & education of the Children is the only objection, we must do the best we can."[36]

<p style="text-align:center">* * *</p>

Even more than Savannah, Charleston was an important antebellum southern port city striving to compete in manufacturing, trade, and railroad development while its powerful citizens clung fiercely and ideologically to Old World values. Lying approximately ninety miles to the north of Savannah (as the crow flies), Charleston had nearly forty-three thousand residents in 1850 and about forty thousand in 1860. After 1817, travelers between the two cities could ride the weekly steamboat shuttle. When Mary Telfair visited Charleston on a trip north during the summer of 1832, she provided a somewhat biased, if generally positive, appraisal of her neighbor city. "I was very much delighted with the situation of Charleston; it is like that of New York. Some of the private buildings are immense and have a very venerable appearance. Except Boston I know of no City that contains so many *lordly mansions.*" Of the citizens, Telfair commented on their self-satisfaction, even arrogance: "The people appear to be very gay. I believe their strong local feelings and prejudices give a perennial flow to their animal spirits; they seldom travel, consequently see no deficiencies in themselves—they imagine that their City unites the advantages of Rome and Athens."[37]

Telfair was incorrect when she remarked that Charlestonians, at least the elite, rarely traveled. In fact, they traveled in the same East Coast elite circles that Telfair enjoyed. These networks grew out of northern educations; homes and vacations in Newport, Rhode Island, and at the various American spas; and occasional travel to Europe. She was correct, however, in noting the large mansions, which other observers also considered lovely and impressive. Charleston's stately houses were built of brick or wood painted white. On the ground level, the most expensive homes were surrounded by gardens with many varieties of flowers, shrubs, and trees framed by deep hedges. Surrounding the houses were graceful verandahs and terraces that wrapped around the upper stories, allowing occupants to enjoy cool breezes off the bay that surrounded the Charleston peninsula. Indeed, the finest homes were situated near the water and the Battery, a pristine promenade along the water's edge. The city's pride and joy, the Battery was carefully and attractively landscaped, offering pleasant walks, convenient benches, and spectacular views of the water. One English visitor during the 1820s and 1830s, Anne Jemima Clough, commented that it was Charleston's "Hyde Park, their Prater, and their Champs Elysees, and they are justly proud of it."[38]

Charleston, engraving done in the mid-nineteenth century. (From the Collections of the South Carolina Historical Society, Charleston)

While Savannah lies alongside the Savannah River, which feeds directly into the Atlantic Ocean, Charleston occupies a southern-pointing peninsula flanked by the Ashley River to the west, the Cooper River to the east, and the Charleston Bay to the south and southeast. The Battery along South Bay Street occupied the southernmost tip of the peninsula and boasted the finest homes with the best views of the harbor. Wharves and docks lined the lower eastern edge along the Cooper River. It was here that Charleston earned its reputation as a great trading port during the eighteenth and early nineteenth centuries. A bustling city market overlooked these docks, the marsh, and the river. The main north-south street that bisected the city was Meeting Street. Broad Street, an important east-west thoroughfare in the southern part of the city, demarcated the wealthiest areas to the south from the less-well-to-do north of this line.[39]

Charlestonians were proud not only of their Battery and their ports but also of their place as an important intellectual and cultural center in the Southeast. In fact, during the colonial and antebellum periods Charleston enjoyed a remarkably rich and increasingly troubled intellectual culture and community. On the one hand, the range, recognition, and influence of local writing expanded over the years, giving the region as a whole a way to define

itself in the mounting sectional crisis. On the other hand, however, Charlestonians were aware of losing their edge. They cursed their increasingly satellitelike position to the North (intellectually and economically), lamented the concurrent brain drain to the North, and complained of the city's lack of intellectuals. Conflicted between the desire to be modern and progressive, and addled more and more by northern attacks on slavery, Charleston's literary culture suffered. The work of leading intellectuals became more fearful, suspicious, and insular and less rigorous. Yet Charleston remained throughout the period the South's most vibrant intellectual and publishing hub.[40]

Meanwhile, the city was, like Savannah, striving to compete in, and profit from, the increasingly diversified and interconnected growth of industry and commerce in nineteenth-century America. A leading center for banking, trade, and manufacturing, Charleston by mid-century boasted "fourteen grist mills, six rice mills, six iron foundries, six turpentine distilleries, a railroad machine shop and depot, and numerous sawmills. There were six blind, sash, and door factories, . . . two umbrella factories; a cordage factory; a hatmaker; manufacturers of organs, stained glass, silverware, railway cars, paper, crockery, and furniture; a friction-match shop; several carriage and wagon shops, saddleries, brickyards, and tinware shops; eleven boat-builders; and several sail-making and rigging concerns," according to one of the city's historians. Fueling all of this industry, of course, was an expensive and lucrative railroad system that had been developed largely by the merchant-dominated city government.[41]

Antebellum urban leaders recognized that Charleston's economy, despite these manufacturing developments, was in decline. Once made rich by trade within the British Empire and positioned as an important regional leader during the young republic's founding, Charleston struggled in vain against a postrevolutionary tide that pulled it out to the periphery of a national economy and made competition increasingly difficult. The southern city built railroads, developed transatlantic and coastal shipping lines, expanded its banking systems, and revamped urban government. Charleston, however, the country's fifth-largest urban center to Boston's fourth place in 1820, saw its railroads falter in competition with other southern lines out of Savannah, Mobile, and New Orleans. The urban reorganization Charlestonians undertook was similarly stunted. And the city, despite its manufacturing diversity and commercial strength relative to the rural South, suffered from South Carolina's general problems of soil exhaustion, westward expansion, a drop in cotton prices between 1819 and 1833, depressed land values, emigration, and the slow development of back-country cities and towns. Even dur-

ing Charleston's peak as a maritime center (between 1856 and 1860), its exports and imports were less than one-fifteenth of New York's and less than one-third of Boston's. As South Carolina focused increasingly on staple crop production, and more and more of the state's finished goods were shipped in from northern ports, the Palmetto State, along with its neighbors, entered an increasingly colonial relationship to the North. Even with the expansion of the market for cotton, Charleston's maritime status, wealth, and exports all grew sluggishly compared to other antebellum U.S. cities. Not surprisingly, even the population growth leveled off and by the 1850s fell into decline. In the 1850s, when the American urban population grew by approximately 75 percent generally, Charleston's population declined from 42,985 to 40,522 during the decade. Of those urban-dwellers, only 2.1 percent worked in manufacturing in 1860 compared with 6.5 percent in 1848.[42]

* * *

The women of this study lived in urban areas of mixed cultures and ethnicities. As in northern cities, Charleston and Savannah had a rising tide of working-class immigrants during the antebellum period. In Charleston, by the mid-1850s approximately 40 percent of the white population of nearly twenty thousand were recent Irish or German immigrants; by 1860, 60 percent of the working class was foreign-born. In Savannah, by 1860 the same percentage (nearly 60 percent) of the entire adult white male population had been born in foreign countries; just over half were from Ireland, and about 10 percent came from Germany. Remarkably, the Old South in general was relatively hospitable to Jews. In addition, unlike in the North, where a few working- and middle-class whites could work their way up into the ruling economic classes over the course of a generation or two, the urban lowcountry power structure remained insular, inbred, and exclusive during this period. Approximately ninety families made up the elite of Charleston and, with a few exceptions, retained control over most aspects of the city from the colonial era to the Civil War.[43]

Both cities had important free black communities. Although free people of color made up only 1 percent of South Carolina's population outside of Charleston, free blacks constituted 8 percent of the antebellum population within the city. Moreover, with 33 percent of the state's free African Americans, Charleston was the unofficial capital of South Carolina's freed people of color. In 1820 they constituted roughly 6 percent of Charleston's population, with 1,475 individuals, and by 1830 it was 2,116 (7 percent). In 1850 free African Americans made up 8 percent of the city and numbered 3,441. The majority of those individuals were poor, and more than three-fourths of

them were propertyless, but enough free people of color were relatively well-to-do (about a fourth of them owned homes) to establish a thriving brown aristocracy in the city. This prosperous if small group formed mutual aid societies, led its own churches, and maintained critical ties to the city's white elite. Savannah, too, had a vibrant if less wealthy free African American community. These individuals worked in skilled and unskilled jobs; occasionally acquired real estate, sometimes including slaves; and participated actively in the strong and independent black churches there.[44]

The economic lives of both cities, and of course the individual lives of the well-to-do, rested squarely on the shoulders of thousands of enslaved African Americans. They labored in fields to produce cash crops, worked on rural farms and plantations and in townhomes, and toiled as skilled craftsmen and manual laborers in cities. As in all urban centers, masters often hired their male slaves out as carpenters, bricklayers, masons, cabinet makers, blacksmiths, sawyers, coopers, and stevedores. Although visitors to Savannah and Charleston appreciated the special beauty of these coastal cities, those from the North and Great Britain noticed the lives and work of slaves and the ways in which slavery colored local sensibilities. Harriett Martineau, the British writer, observer of America, and critic of the South, described a "moral gloom which oppresses the spirit of the stranger" who visited Charleston. Others disliked the nocturnal police presence in the city that enforced the black codes. To one observer, the police gave the city the eerie feeling of "an armed camp." Most disturbing to many visitors were the slave auctions that took place outdoors near the Exchange on Bay Street. One traveler noted, "The scene was most painful, humiliating, and degrading. I became quite affected myself and was obliged to hurry away, for fear of showing what I felt." Indeed, Charleston and Savannah were both major centers for the traffic in human lives.[45]

Some of the most stinging and powerful accounts of slavery's ills in Charleston came from two of the city's most famous (or infamous) elite white daughters, one who married late in life and the other who remained unmarried. Sarah and Angelina Grimké grew to deplore the horrors of slavery and eventually left their city to pursue antislavery and woman's rights work in the North. In one of her most effective antislavery pieces, published in 1839 as part of Theodore D. Weld's sweeping *American Slavery as It Is,* Sarah remembered what is now a familiar tale among students of southern history. She visited a family friend in Charleston, a pious and upstanding female member of her family's church. The woman had assembled her family for the daily scripture reading when Sarah saw the woman's mulatto slave, appallingly burdened with a heavy iron collar that had three long prongs

projecting from it. Sarah learned that the slave had run away several times, for which she endured harsh whippings at the workhouse and time on the treadmill. She was also severely beaten and had one of her sound front teeth removed, which was to serve as a mark. "She could lie in no position but on her back," Sarah remembered, "which was sore from scourgings, as I can testify from personal inspection, and her only place of rest was the floor, on a blanket. . . . This slave, who was the seamstress of the family was continually in her mistress' presence, sitting in her chamber to sew, or engaged in other household work, with her lacerated and bleeding back, her mutilated mouth, and heavy iron collar, without, so far as appeared, exciting any feelings of compassion." It was only the unusual southerner and the unaccustomed visitor who recoiled at this treatment. The mistress's lack of visible upset, sadly, was typical of her race and class.[46]

Visitors to Savannah similarly described the horrors of slavery there. One traveler recounted in 1838 how human chattel was auctioned at the same time as livestock and furniture. "Saw fifty-four men, women, and children sold as chattels, but not without emotion, to see the serious look, the falling tear, and the submissive will," he wrote. "There are three auctioneers selling at the same time. Sometimes one man is up for sale, sometimes three or more. Sometimes a woman and children, . . . Now, a plantation—now, a gun—now, an old man, wife and daughter. . . . The time for this traffic in slaves, and the souls of men, is the first Monday in each month." Another observer described the now-infamous sale of the slaves of Pierce Butler, a Georgian. In Savannah, Butler's many plantation slaves, in well-established family groups, were brought to auction, housed in horse stalls, examined like livestock, sold, and separated from one another.[47] Of course, some observers reported seeing contented, relaxed, well-loved slaves in Savannah, and undoubtedly there were some. But overwhelming evidence indicates that the evils of slavery, particularly commerce in humans, came into sharp relief in the close quarters of southern port cities.

Historians of slavery in southern cities have ably demonstrated that the urban environment provided a dual setting. On the one hand, as America's busiest slave port until 1808 when the slave trade was closed, Charleston especially was the capital of southern slavery and therefore the site of all crimes associated with the slave trade. A greater proportion of the population owned slaves in Charleston than in other southern seaport cities during the period. On the other hand, cities like Charleston and Savannah offered slaves a fluid, relatively permissive, and permeable environment that they used to mitigate some of the inherent evils and restrictions of slavery. Indeed, whites increasingly fretted over the growing numbers of slaves without white su-

pervision. Slaves often mingled among the countless runaways who had fled to the city. Herein lay a compelling and complex irony of antebellum southern cities; a history of open, comparatively permissive, tolerance for slaves' comings and going coexisted with increasing white anxiety in the city and with the South's overall and fierce ideological, economic, and individual commitment to human bondage.[48]

One reason for the overall mobility of, and flexibility afforded, the cities' slaves lay in the very large and diffuse black populations there. Indeed, Charleston blacks outnumbered whites in seven of the eight decades between 1790 and 1860. A British observer, Frederika Bremer, noted in 1853 that "negroes swarm in the streets [of Charleston]." A prominent Charleston minister, the Rev. John B. Adger, added, "They belong to us. We also belong to them. They are divided out among us and mingled up with us and we with them in a thousand ways." Another explanation for urban fluidity had to do with the city's manufacturing sectors, which along with its seaport activities meant that countless male slaves worked at jobs outside their masters' houses. Housing reflected this occupational segregation; 15 percent of these slaves lived away from their master's property by 1861. "In Savannah," a fugitive from Georgia remembered, "I saw many Black men who were slaves, and who yet acted as freemen so far that they went out to work, where and with whom they pleased, received their own wages, and provided their own subsistence."[49]

Often, and without too much difficulty, urban slaves could participate in an underground community made up of city slaves, rural runaways, and free people of color. Away from their masters' glances, slaves mingled with northern free blacks at the ports; pieced together rudimentary reading skills through their tasks and in clandestine schools; indulged in drink, cards, and gambling at various grog shops; developed independent churches in Savannah and auxiliaries of white churches in Charleston; and even occupied their own residences. In 1861 one of thirteen Charleston residences was occupied by a slave alone, and one of twelve either by a slave or both a slave and a free person of color. In Savannah, one estimate indicates that as many as 1,200 slaves, 15 to 20 percent of the city's slave population, lived as "nominal slaves"—that is, allowed to live as free, hiring their own time and living away from masters for years or indefinitely. Even if these numbers (which are based on claims to the Union Army after the Civil War) are inflated, they nonetheless attest to a remarkable diversity and flexibility within the slave system in Savannah.[50]

Of course, the other side of this coin was that slaveowning whites feared that this urban mix of fluidity and bondage could have deadly consequences for themselves, and so they kept their eyes pealed and their laws honed to catch indiscretions on the part of calculating slaves. To crack down on ex-

changes among northern free blacks and Charleston's slaves and free people of color, the Negroe Seamen's Act of 1822 forbade free black seamen from coming ashore and jailed those who did. Slaves were forbidden to traverse the streets past eight o'clock, to read or write, to watch a parade, to own a dog or a gun, to assemble except for worship, or to buy or sell liquor. When a slave was caught in (or suspected of) a violation of the law, punishment was often fast, severe, and, sometimes, public. Charleston's whipping house was notorious as the place that wealthy owners sent their slaves for agonizing abuse. Charleston and Savannah were clearly cities of extremes: grace, refinement, beauty and community amid repression, bondage, brutality, and isolation.[51]

Elite white southern women rarely commented on the evils of slavery until northern commentary drove them to their region's defense. Wealthy urban women in particular rarely mentioned the slaves who served them at home or whom they saw in the streets; none of the women discussed in this study ever compared their lots in life to those of slaves. In a strange twist, however, the urban environment offered well-to-do white women the dual promise of greater flexibility and independence *and* heightened scrutiny and public correction, much as it did slaves. Of course, elite white women were extremely privileged because of the labor of enslaved Africans. Their ways of life depended on slaves, and they never endured the kinds of horrors that slaves faced daily. Still, elite women knew, as did their slaves, that life in the city promised community, some independence, and stimulating activities, markedly different from that on a rural farm or even a plantation. With this freedom came increased attention and public commentary about one's activities.

Charleston and Savannah were on the periphery, both physically and socially, of a larger American culture. With a more than adequate economic base, ample population diversity, and intellectual leadership, these southern cities boasted a rich urban culture that was both open and closed, attractive and horrifying, permissive and restrictive. Unmarried women there certainly preferred their cities to the rural alternative, in part because they could enjoy opportunities for usefulness and autonomy. The wealthiest among them had little to fear about the increased economic vulnerability of city living. Moreover, the seaport cities provided ready access to northern and European cities, goods, and ideas. Because a sizable elite from Savannah and Charleston traveled extensively in other parts of the world, the cities developed ideologies that allowed an understanding of their unusual places in American society. At root, the cities were distinctively and steadfastly southern, but they also encompassed a blend of northeastern experiences and attitudes. When it came to the ideologies about white women's roles, specifically those of unmarried women, Charlestonians and Savannahians, true to form, developed their own ideas, which were at once southern and cosmopolitan.

2. "A Glory Such as Marriage Never Gave"

The Literature and Ideology of Urban Southern Single Blessedness

While the rich urban mix in Charleston and Savannah is well documented, the lives of, and ideology about, unmarried women there is not. The major surprise of this study has been that there were significant pockets of unmarried southern women in these cities and that the ideology about them was surprisingly positive. Given our understanding of patriarchy in the antebellum South and previous assumptions about "spinsters," it is clear that the ways Charlestonians and Savannahians thought about women, particularly unmarried women, was shaped largely by a wider seaboard culture of letters and ideas.

During the nineteenth century, southerners borrowed from evolving scripts about American women's lives, and the unmarried among them benefited from the increasingly favorable light shed on women without husbands. Indeed, maiden sisters and aunts ironically gained importance as the country, at least rhetorically, began celebrating the home and women's domestic contributions. Well-to-do southern women paid attention to literature by and about unmarried women, finding encouragement and justification in spinsterhood. Those women in seacoast cities were especially likely to acquire and devour the latest books and novels. In fact, a number of urban southern women themselves (a disproportionate number of whom were unmarried) contributed to this brightening trend as published authors who, implicitly and explicitly, claimed special moral authority for women. Moreover, a few among them even contributed to such traditionally male subjects as national politics and social policy in addition to writing about domestic issues.[1]

* * *

As early as the turn of the nineteenth century a few influential writers were beginning to challenge negative stereotypes about unmarried women. The widely read and enormously popular advice book *A Father's Legacy to His Daughters* by John Gregory acknowledged in 1782 that it was difficult to be an unmarried woman. "I know the forlorn and unprotected situation of an old maid, the chagrin and peevishness, which are apt to infect their tempers, and the great difficulty of making a transition with dignity and cheerfulness, from the period of youth, beauty, admiration, and respect into the calm, silent, unnoticed retreat of declining years," he admitted. Still, Gregory urged his daughters and readers to remain unmarried rather than marry the wrong man for the wrong reasons. Emphasizing human agency and virtue in women and in men, Gregory was like other Scottish Enlightenment writers who feared tyranny in any human relationships. "[H]eaven forbid you should ever relinquish the safety and independence of a single life, to become the slaves of a fool, or a tyrant's caprice," he warned. "Whatever your views are in marrying," he wrote, indicating that his daughters had a choice to make, "take every possible precaution to prevent . . . being disappointed." He saw the best hope for a happy marriage in a "good-natured generous man, who despises money and who will let you live where you can best enjoy that pleasure."[2] Gregory knew what the women of antebellum Savannah and Charleston did—*where* you lived had a major impact on your happiness.

Gregory's comments were somewhat unusual for his period. He was, in some ways, ahead of his time, but his views would be echoed more often and louder later in the century in America. At the turn of the century most American writers were less empowering of female readers. Although much of the published discussions originated in the North, well-read southerners knew that the majority of early-nineteenth-century depictions of unmarried women portrayed them as being useless, tiresome, negative, weak, and jealous old maids. As soon as they entered into society for courtship women were admonished not to become self-absorbed, silly belles lest they ultimately find themselves lonely and hated old maids. One such book, written by Peter Atall, was liberally entitled *The Hermit in Philadelphia: Second Series Containing Some Account of Young Belles and Coquettes; Elegantes and Spoiled Children; Dandies and Ruffians; Old Maids and Old Bachelors; Dandy Slang and Lady-Slang; Morning Visits and Evening Parties; Dress and Ornaments; Female Slanderers and Male Exquisites; Long Branch Letters and Prices Current; Lotteries and Quacks; Billiards and Pharo; Gambling and Sporting; Elections and Amusements; Theatricals and Horse Racing; Wife Selling and Betting; Boxing and Cocking; Dog Fighting and Bull Baiting, &c. &c. &c.* Published in 1821, it includes the story of Miss Heartstone, who "was the most beautiful

belle, and most determined Coquette in Philadelphia." Purposefully named, Heartstone studiously perfects her charms, hones her vanity, and arrogantly rejects every suitor. Four times she agrees to marry, and every time she changes her fickle mind at the last minute, causing one of the men, Mr. Trustall, to plunge into despair and commit suicide. Predictably, Atall observes, "Miss Heartstone found herself gradually gliding towards the ocean of insignificance . . . alone . . . hated . . . pitied . . . and despised by all." Neither is Atall flattering to older, unmarried women, whom he describes as "peevish, testy, . . . disappointed," and judgmental busybodies who have missed their opportunities to marry, sometimes because of not attending to treatable physical ailments such as worms. Clearly, Atall sees these women as a problem. Drawing on a century of rhetoric, he confirms that unmarried women are the unchosen ones, flawed and deficient.[3]

Fortunately, other writers were slightly less damning in their appraisals, albeit still critical of the defects that both caused and resulted from a woman's never marrying. One of these stories, which Savannah's Mary Telfair read with fascination in 1827, was *Retrospection, a Tale* (1822), the story of one unmarried woman's search for happiness in life. As the northern author Ann Martin Taylor (1757–1830) tells it, Miss Burrows is a young woman of a well-to-do urban (presumably northern) family; her mother dies, her brother goes abroad, and her father remarries an unscrupulous woman. Miss Burrows has few positive relationships in life. She escapes her stepmother's wrath by going to live with a modest farm family but cannot assimilate to the simple lifestyle there. The eldest son of the farm family, with whom she falls in love, is improving his class standing through education and inheritance. She alienates him, however, when she takes a girlfriend's bad advice about making him jealous. Lost, she tries working as a governess but resents the intrusions on her time and energy. She returns home when her stepmother is dying, and the older woman confesses to sabotaging many of Miss Burrows's relationships, including that with the farmer's son. Miss Burrows spends the rest of her days generally dissatisfied and quarrels with her brother, who returns after spending many years away. In the end, she begins to recognize her weaknesses, particularly the selfishness that contributed to her unhappiness and spinsterhood. By making her protagonist so shallow, self-righteous, and flawed, the author easily demonstrates the faults that unmarried women in particular need avoid, which include selfishness, lack of character, gossiping, irritability, and conceit. In this heavy-handed story, Taylor implicitly advises female readers, whether unmarried or not, to find usefulness, modesty, and character in their lives.[4]

Telfair did not take offense at Taylor's unflattering portrayal of her single

protagonist, probably because the very self-confident Telfair deemed her own behavior as beyond reproach. She praised Taylor for writing something "for the benefit of single Women." Acknowledging that unmarried women's "cares are so much lighter than those of married women [and] that they have more time to brood over ideal misery," Telfair concluded that "Miss Taylor is correct when she asserts that intellectual resources are essential to unmarried women." Only religion was more important than "[intellectual] cultivation which strengthens the mind and places it above those petty feelings which are so much indulged in by the ignorant." In other words, single women need to develop intellect as well as spirituality to keep their hearts and minds above the myriad disappointments of life, and unmarried women are particularly vulnerable to emotional spiraling into self-pity.[5]

Fortunately for unmarried women, the ideology and literature about them had begun to change within a decade or two of Taylor and Atall's works. Rhetorically at least, many writers—and, presumably, readers—were creating a place for unmarried women in society. Just as modern readers wonder why women might not marry, so, too, did nineteenth-century observers. A group of authors in 1835 sought to answer the question with a series of categorizations, definitions, and explanations very typical of the period. *Old Maids; Their Varieties, Characters, and Conditions* called for a near-scientific study of the existence, numbers, and reasons for nonmarriage. While reflecting the early-nineteenth-century drive to categorize almost everything, the book insists that women who did not marry, at least at that time, needed to be understood, defended, and encouraged. The authors begin the study by lambasting critics like Peter Atall, whose "cruel satire[s] upon the venerable sisterhood" they "threw down . . . with an angry *pish*." In their effort to put honor and glory on virginity and chastity and help unmarried women find peace and contentment, the authors intend to correct the false impression given by novelists and others who sketch women's "effect rather than truth." Rather than invite scorn, these women deserved gratitude and acceptance. "Her heart is a mine of sensibility, and it is not her fault if she is forced to expend its treasures on cats, china, or scandal," they observe in defense of unmarried women, "but her life is the oasis of the desert—her heart is a welling fountain of the purest sympathies." Such a woman aids her family in time of need, and the authors scold readers for thinking ill of unmarried sisters and aunts and taking advantage of them, putting their belongings in disarray, and making fun of them. By classifying, defining, and explaining the various orders of unmarried women they were to be returned to "Nature's painting." Indeed, the authors redefine the unnatural—females without mates—as natural and orderly.[6]

Typical of the genre, the study purportedly assembles a significant number of the unmarried women and arbitrarily establishes that the class of Old Maids includes "ladies who have passed their thirty-fifth year . . . without any appearance of a matrimonial alliance." Within that class are five genuses. Voluntary Old Maids are "ladies whose extreme delicacy, or caution, or coldness, have determined them to live a life of celibacy." Involuntary Old Maids are "Ladies possessing every requisite for the connubial state, and who have been anxiously striving to attain it, but, notwithstanding, still remain in single blessedness." Accidental Old Maids are "Ladies eminently qualified for matrimonial duties, and who have been repeatedly engaged, but by some *accident* still remain Old Maids." Inexplicable Old Maids are "Ladies who remain in a state of virginity, but for which no earthly reason can be assigned." And, finally, Literary Old Maids, receive no definition except for the seemingly obvious "ditto ditto." "Hard is the fortune of Literary Maidens," claims the authors, because "they are eyed suspiciously by their own sex, and avoided by the majority of ours." Still, the authors hail them for pursuing wisdom rather than happiness and trying to "vindicate the intellectual excellence of your sex." In conclusion, the authors hope they have provided comfort to young women who find themselves "wringing their hands and filling the air with cries of anguish," that they might find vindication and happiness in the title of Old Maid.[7]

Indeed, discourse about unmarried and married women was changing by the middle of the century as Americans, particularly those in the urbanizing North, began to shift their ideologies of women's place and roles. Women by and large continued to occupy the domestic sphere and roles, but as numerous historians have explained, a "cult of domesticity" sparked an all-out celebration of these roles and the nuclear family. Women's work as guardians of their homes and teachers of children gained newfound importance as husbands, especially northern ones, left their houses daily to work in developing industries.[8]

Rather than contributing to unmarried women's ostracism, however, this ideal placed an even greater value on the "reserve army" of available and unmarried daughters and sisters. The concurrent "cult of single blessedness" held that these indispensable spinsters could come into, or remain in, the homes of aging parents, ill siblings, and orphaned nieces and nephews. In addition, a fear that mothers might take their newfound domestic nurturing and child-focus too far and become excessively indulgent made unmarried aunts even more important to children's development. Lee Chambers-Schiller's work in particular has drawn largely on northern "old maid stories in ladies' almanacs, popular periodicals, gift annuals, and collections of fiction

from 1830 to the Civil War" to reveal a shift in the American attitude toward mothering. Although popular literature encouraged mothers to lavish sentimental love on their children, it also cautioned that too much maternal attention could smother independence in both sexes and emasculate boys. Maiden aunts were a solution to the dilemma because they represented "disinterested" child rearing. Due to emotional distance, they could attain necessary usefulness in life while imparting high ethical standards to nieces and nephews. Ideally, a maiden aunt was morally courageous, selfless, goodhearted, and clear-minded. A far cry from Peter Atall's cruel, career belle and Taylor's sniffling spinster, mid-nineteenth-century fiction depicted maiden aunts as wise, useful, and necessary.[9]

During the mid-nineteenth century, female fiction writers in particular began to write short stories that defended unmarried women from the negative stereotypes common during the first part of the century. Appearing first in popular periodicals (mostly in the Northeast), the newer, more positive stories confronted and rejected unflattering images and reappraised those middle-class white women who might otherwise be urged quite strongly toward marriage and motherhood. Such stories describe "the old maid . . . as more pure, more pious, more modest than other women; she is even seen as more maternal than women who marry and have children." Unmarried women were seen as virtuous, useful, and therefore still womanly. Moreover, many stories from the period presented a typical marriage as dependent on a competent and available single adult woman. In this way the married couple and the unmarried woman have something of a parasitic relationship; she helps them in times of need rather than the other way around (as when the maiden sister is a burden on her family.)[10]

It is easy to overstate the impact of this literary shift on the lives of women in antebellum Savannah and Charleston. The authors who began to urge reappraisal of unmarried women's lives were largely northern or British, and they wrote for a predominantly northern and British readership that was coming to terms with a vastly changing economic and social landscape of urbanization and industrialization. But it is indisputable that urban southerners also read these nonsouthern works; a number of them even contributed to the shifting perception of unmarried women. In an 1837 issue, for example, the *Southern Literary Messenger* out of Richmond devoted a lengthy essay to the subject of "Old Maids." The author admonished readers not to ridicule unmarried women but to recognize that they were the ones teaching Sunday schools, taking on benevolent reform work, visiting the sick, and nursing their families: "Some despised (or at least ridiculed) *old maid* is the person to brave the danger, and save others' lives at the peril of her own."

The author also remembered fondly his own maiden aunt, who was "nearer to perfection than any of the human race whom I have ever known: that she united, in larger degrees, *goodness of heart* with *cleverness* and *strength of mind.*" This was the person who taught him "more than even . . . my parents, of whatever traits or attainments . . . [that are] useful or valuable."[11]

Of course, even the new and improved roles and images that the largely nonsouthern writers created for women were not radical, indulgent, or liberating. Women could escape epithets only by devoting themselves to the needs of others in the all-important quest for usefulness. Not through intellectual development, inner peace, or self-awareness but only through usefulness to others could unmarried women save themselves from the long-held stereotype of the pathetic, barren, cold, and crotchety old maid. All of that notwithstanding, however, this relatively small pebble in the ocean of nineteenth-century literature made important waves in the American psyche, even as far South as Savannah and Charleston, where the well-to-do read widely in northern and British literature. In addition, the literary shift both reflected and suggested an important change in American understanding of women's lives and choices. Broadly and simply put, much of the literature emboldened women as advocates for domestic issues, both within their families and without. Because the well-to-do of the seaboard South prided themselves on staying abreast of northern and European goings-on, read many of the same books that their northern peers read, and attended many of the same schools, they were well aware of the evolving discourse about women. Some southern women even contributed to it. Indeed, reading and reacting to northern, southern, and European authors made southerners feel refined, intelligent, and cosmopolitan and enabled the unmarried women among them to be regarded as important, useful, and in good company.[12]

* * *

Once again, Mary Telfair serves as an enlightening example of how committed southerners borrowed the northern-born rhetoric of exalted domesticity and used it to shape their own identities as well-bred Americans, urban-dwellers, and good southern women. Telfair adored the Massachusetts author who inaugurated the domestic fiction of this era, celebrating the home and women's important roles within it. Catherine Maria Sedgwick fit her beau ideal of a single woman: conservative, intellectual, humble, and loyal. When Telfair wanted to compliment a friend one summer, she observed, "Miss Sedgwick is her Siamese." After all, "her mind is of the first order and her character pure and elevated." Generally speaking, Telfair mused, "It is delightful to meet with a Woman who can resist the influence of adulation and

can pass through the ordeal of fashionable society uncontaminated."[13] To Telfair at least, both Sedgwick and her friend seemed to stand tall above the petty gossip and insignificant busyness that entangled Telfair's elite social circles.

In fact, Catherine Maria Sedgwick, the beloved nineteenth-century author of numerous novels, had a great deal in common with Telfair. Born two years apart, in 1789 and 1791, Sedgwick and Telfair, respectively, each lived the paradox of exalting traditional domesticity and women's domestic roles while emphatically rejecting those roles (at least the ones of wife and mother) for themselves. The rhetoric they embraced about nineteenth-century marriage promised middle- and upper-class women important and gratifying roles as moral authorities, wise nurturers, teaching parents, and well-partnered wives. Sedgwick, Telfair, and many others, however, understood that such ideals of mutuality and collaboration were usually unattainable. In fact, the raised expectations placed wives at an even greater risk of being disappointed after the solemn vows were exchanged. Still, Sedgwick contributed to the mystique, glorifying the home as a stable and solid moral base in a changing and fragmenting world. Much of the contemporary fiction, including Sedgwick's, proclaimed that women would find purpose and happiness as wives and mothers, but, Sedgwick admitted, "I certainly think a happy marriage the happiest condition of human life. [Yet] it is the high opinion of its capabilities which has—perhaps kept me from adventuring in it." Fictional ideals left the realities of marriage and motherhood wanting.[14]

Like Telfair, Sedgwick never married, although she refused numerous proposals. Instead, both women found outlets for their maternal inclinations through their brothers and nieces and nephews. These relationships became surrogate marriages and parent-child bonds for women like Sedgwick and Telfair (chapter 3). Mary Kelley, a historian, could have been describing Mary Telfair when she wrote of Sedgwick, "[She] wanted to feel the embrace of familial intimacy without yielding her total self. She wanted intimacy *and* autonomy."[15] Despite Sedgwick's personal feelings about the limiting effects of marriage, and despite (or perhaps in part due to) her unmarried state, other erudite southerners admired her literary and moral contributions just as Telfair did. The same *Southern Literary Messenger* contributor who praised "old maids" and celebrated his maiden aunt counted Sedgwick among a class of unmarried female authors "who have enlightened and blessed . . . mankind." Sedgwick was in good company with "Hannah More—Elizabeth Carter—Elizabeth Hamilton—Jane Hamilton—Jane Taylor—Miss Edgeworth—spinsters, all!"[16]

Although Sedgwick's domestic fiction encouraged many women to marry, bear children, and devote themselves to the domestic circle, she was still able to defend women like herself and Telfair "against the miserable cant that matrimony is essential to the feebler sex." In fact, she railed against the assumption "that a woman's single life must be useless or undignified—that she is but an adjunct of man—her best estate a helm merely to guide the nobler vessel." In the preface to her last novel, *Married or Single* (1857), Sedgwick insists, "[With] an independent power to shape her own course" and "with grace and honor" unmarried ladies "brighten the whole world" as they follow "a mission of wider and more various range" than a wife and mother could pursue. Sedgwick refused to describe this mission, but lest she be misunderstood for an advocate of the woman's rights movement (which she was not), she assured unmarried women that they need not leave their domestic circles to fulfill their exalted destinies. They could fulfill their callings as "sister, friend, benefactor." Telfair and her unmarried contemporaries must have appreciated such an endorsement from a beloved American author and partner in maidenhood. That Sedgwick was so well-loved in both the North and the South was because of her conservative, unthreatening perspective. Well-read southerners such as Telfair considered themselves refined and well-connected to discuss her and justified and vindicated in emulating her. These same readers, however, had simultaneously to disassociate themselves from unmarried women authors like Harriet Martineau who criticized slavery. Yet Martineau sounded much like Telfair or Sedgwick when she commented, "The older I have grown, the more serious and irremediable have seemed to me the evils and disadvantages of married life, as it exists among us at this time; I long ago came to the conclusion that without meddling with the case of the wives and mothers, I am probably the happiest single woman in England."[17]

Another nineteenth-century maiden writer whom Telfair read devotedly was Hannah More, a well-known British educator, playwright, poet, and author of didactic books and religious tracts. Older than Telfair by forty-six years, More was born in 1745 into a well-connected and well-educated family of five daughters, all of whom remained unmarried. Telfair surely found an older role model in More, describing her as an *"oracle,"* largely because More found usefulness and purpose in life without a husband. Her writing defended the conservative pillars of her society, such as the church and family, while boldly asserting the need to care for England's growing class of poor, sick, insane, and imprisoned. Telfair remarked in 1835, "I have just finished the first volume of Miss More, and think her the *greatest* as well as the best of women—she certainly did more to promote the interest of Reli-

gion and Virtue than any Woman that ever lived."[18] No wonder then that Telfair read More's writing and the various biographies about her and quoted from her extensively in letters. Although More wrote during the late eighteenth and early nineteenth centuries, her popularity among American women during the middle of the nineteenth century indicates that her esteemed status as an important, useful, unmarried author provided encouragement and inspiration.

Well-read elite southern women's reading broadly included the most respected male authors in America and Great Britain. Using the written word as her lifeline to the rest of the cultural world, for example, Mary Telfair described what she was reading in correspondence almost as much as she talked about other people (which is to say, a lot). Her correspondents in the North were reading the same authors, and their dialogue connected the women across geographic and sometimes ideological divides. Telfair especially enjoyed her "much beloved" Lord Byron. On one occasion she and her sisters sequestered themselves for two rainy days to read Sir Walter Scott's *Ivanhoe,* which provided a "rich mental banquet." When her friend Alfred Cuthbert lent her *Glenvaron,* a less-than-flattering depiction of Byron, she denounced it as a "vile production." Telfair also kept abreast of the popular novels of the day but tried to avoid those that would overly absorb or excite her. "I know myself well enough to *avoid Oliver Twist,*" she explained to a friend. Perhaps she was like countless other southern women when she admitted, "My life is too secluded a one, and my temperament too excitable to allow myself to read works of absorbing interest." Indeed, many conservative Christian observers worried that novels (which were largely a turn-of-the-century development that proliferated all over the North and South and were written increasingly by women for women) would compromise the morality of readers. Novels, it was thought, evoked strong emotional responses and harbored potentially subversive messages.[19]

In part to avoid such risks, Telfair instead chose poetry, advice literature, and biographical studies. Soon after its 1825 publication she read Thomas Moore's account of Richard Brinsley Sheridan, the Irish-born English playwright and statesman. Similarly, she consumed Lockhart's biography of Sir Walter Scott, read a wife's biography of her husband during the English Civil War, especially enjoyed Washington Irving's biography of Christopher Columbus, and made her way through three volumes of the life and writing of Robert Burns. She read also the letters of essayist Charles Lamb and even spent a few months reading children's books, through which she happily "entered into a state of *second childhood.*"[20]

That urban southern women like Telfair read so widely in northern and

British literature and drew on that literature to define themselves as well-read, well-connected, refined, and urban demonstrates how elite southerners immersed themselves in an upper-class American society that transcended sectional boundaries. Physically as well, they traversed the sectional divides of the East Coast, traveling North to visit family and friends, pursue educations, and vacation. Yet, paradoxically as the nineteenth century wore on, southern Americans increasingly saw themselves and their homeland as unique, superior, and under assault. No matter how urbane and well-read, slaveholding men and women, with a few notable exceptions, felt keenly their southernness and all it came to represent, including tradition, familial obligation to a fault, female subordination, usually Christianity and a republican version of that, and, of course, slavery. Some of the brightest among them devoted much time and energy to defending their region and its peculiar institution. Indeed, southerners' passionate proslavery ideology, and later secession fervor, flowered in cities such as Savannah and Charleston. The South's cities embodied a fantastic paradox of national urbanity and sorority alongside regional identity and exclusivity.

The irony of southern cities being intertwined with the North—as well as separating from it—stemmed from the region being rural in overall composition and in its sense of self. The South's commitment to rural plantation slavery was more than a desire to protect the profitability of slavery. Cities were instruments of the greater plantation culture rather than instruments of rural dissolution, as in the industrializing North. In addition, the southern paradigm ensured a man's mastery over his household. Indeed, Stephanie McCurry has compared the institutions of marriage and slavery to show how the proslavery argument involved entire households and rested on the subordination of women. She quotes George Fitzhugh, who wrote, "Marriage is too much like slavery not to be involved in its fate."[21] Nothing less than the entire southern system rested on (most) women marrying and deferring to their husbands in all matters.

Although this conservative ideology encircled and permeated cities, urban southerners simultaneously created communities quite unlike the plantation culture. Seaboard urban centers such as Charleston and Savannah enveloped the stark contrast between rigid devotion to slavery and conservative ideology and a looser, more urban setting. This made for very rich soil, where unmarried southern women could root their identities as part of something both open and closed, fluid and rigid, daring and established, and cosmopolitan and insular. The duality allowed unique opportunities to contribute to the ongoing discourse about women's lives. Unmarried women took advantage of the paradoxes of urban southern living to comment on domestic-

ity as well as politics. Although they overwhelmingly celebrated women's domestic roles, Charleston's literary women, both explicitly and implicitly, legitimated women's public voices, claimed moral authority, and often created important roles for unmarried women in society.

One unmarried Charleston woman who simultaneously embraced women's domesticity and ventured outside of it in her own life was Sarah R. Rutledge. Drawing on her experiences, self-confidence, ample financial resources and leisure time, and the city's relatively accepting attitude about southern women writers, Rutledge put together a domestic advice and recipe book for presumably married women. Born in 1782 to Edward Rutledge (1749–1800) and Henrietta Middleton (1750–92), Sarah R. Rutledge was one of those impressively busy spinsters who moved many times, involved herself deeply in benevolent causes, and devoted herself to family members in need. During her early years she studied in Europe and then, after her father died, lived there for twelve years with her stepmother. In Charleston she made lifelong contributions to the Episcopal Sunday school, the Church Home for Orphans, and the Ladies' Benevolent Society. She also made numerous arduous journeys to visit her brother, sister-in-law, and their family in Nashville. In addition to her roles as the classic doting aunt and maiden sister as well as the useful benevolent lady, Rutledge found time to write *The Carolina Housewife; or, House and Home,* published in 1847, which offered more than 550 recipes as well as advice for young matrons.[22]

In the opening paragraph, this never-marrying woman boldly scolded those derelict southern wives whose houses could hardly be called homes, where "a man dares not carry a friend without previous notice to his wife or daughter, for fear of finding an ill-dressed, ill-served dinner, together with looks of dismay at the intrusion." Rutledge sought to rehabilitate "those dinners over which the mistress of the house cannot smile; they are too bad for dissimulation; the dinner is eaten in confusion of face by all parties, and the memory of it does not speedily die." Written principally for women who cooked family meals themselves or had American-born, working-class cooks, Sarah Rutledge's book included recipes for a myriad of soups, cakes, breads, fish, shrimp dishes, meats, poultry, sauces, vegetables, and desserts. She was not unlike the numerous domestic novelists of her day, including Catherine Sedgwick, who prescribed a female domestic script that bore little resemblance to their own lives. Here was a proper southern lady who deviated from the domestic norm, vindicated herself by pouring herself completely into her family and the city's needy, and capped off her accomplishments with a pointed and public scolding of lazy wives.[23]

Rutledge's domestic advice text was part of a rich and important vein of

domestic literature in both the North and the South during the middle of the nineteenth century. As divergences from Rutledge's direct how-to approach, many texts took the form of novels and short stories that gave women a measure of moral authority over their lives. At the same time, they celebrated women's domestic service to their families and communities. Here, however, northern and southern authors began to diverge. Northern domestic literature urged women to save American society from decline by imposing female values on the outside world, often through public reform work. Southern literature by authors such as Caroline Gilman (1794–1888), Caroline Hentz (1800–1856), Maria McIntosh (1803–78), Mary Virginia Terhune (1830–1922), Augusta Jane Evans (1835–1909), Mary Eastman (1818–87), Marion Harland (1830–1922), and Mary Howard Schoolcraft (ca. 1793–1864) typically kept female characters as wives and mothers who eschewed the kinds of public reform activities that northern women embraced. Growing out of the indigenous and popular plantation novels of the day, southern domestic novels featured heroines (even more frequently and powerfully than the northern ones) who found life's meaning in the traditional roles of wife and mother, at least until the war made marriage less assured. When women did not marry, both northern and southern novelists urged them to use their consciences and minds to find meaning in their lives, still in service to others. Rather than marry carelessly, women were urged to consider prospective husbands wisely and choose a life path that would lead to the greatest service to others. Still, domesticity was at the locus of women's lives.[24]

One Charleston author who urged women to take responsibility for domestic choices and trust innate and learned abilities was Caroline C. Gilman, who adopted Charleston as her lifelong home after moving there in 1819 from New England with her husband Samuel, pastor of Charleston's Unitarian Church. At that time she was twenty-five. Although a northerner by birth, Gilman defended southern society and women's domestic roles within it. She also criticized the fashion-conscious belles and "Ornamental Ladies" so prevalent in southern cities. Within her critique, however, was a powerful message that encouraged southern women to exercise moral authority and independence. They were to stake claims as morally upright, clear-headed, useful, and discerning individuals. Although she indicated in some of her fiction that women could best live out this ideal in the countryside rather than in the city's social whirlwind, Gilman's writing must have emboldened other unmarried urban women who searched for meaning in life once the days of courtship and fancy balls had passed. Here was an urban woman writing critically yet in support of southern women and advocating their importance to society as morally independent, unaffected, and mature.[25]

In addition to her fiction, in August 1832 Gilman also established the first American publication in Charleston for children. The weekly paper—*The Rosebud; or, Youth's Gazette* and later the *Southern Rose Bud* and later still the *Southern Rose*—ran for several years. It is not surprising that the periodical emerged in Charleston, because that city, and South Carolina in general, offered a plentiful array of periodical literature. As early as 1775, for example, South Carolina's white population numbered about sixty-thousand and the state had three newspapers, one to every twenty-thousand white people. The same year, Massachusetts had only one newspaper for every fifty thousand citizens. Numerous magazines were established in Charleston throughout the nineteenth century, many of which were targeted at women readers and offered women authors numerous opportunities to publish poetry, fiction, or prose.[26]

These journals and magazines provided an essential avenue for lesser-known female authors to gain recognition that would lead to wider publication. One never-marrying Charleston writer, Mary Elizabeth Lee, was born in 1816 into a well-to-do South Carolina family. Her father, William, was a lawyer, and her brother, Thomas, was a judge for the state. Mary Elizabeth Lee made a name for herself as a poet, publishing in *The Orion, Southern Rose, Graham's Magazine,* and *Southern Literary Messenger.* She also published a prose piece, *Social Evenings; or, Historical Tales for Youth,* in 1840. Like a number of unmarried female writers in the South, Lee had an affinity for the darker sides of life in her writing. One observer noted that death was her favorite subject. Still, she won a competition held by the Massachusetts Educational Board, and her work was introduced into school libraries.[27]

One of Lee's contemporaries, and another unmarried Charleston poet, Catherine Gendron Poyas, lived between 1813 and 1882 and gained recognition for three main works of poetry: *The Hugueonot Daughters, The Convert, a Sketch,* and *The Year of Grief,* all published between 1849 and 1860. She also published a poem upon the death of the Rev. C. P. Gadsden, rector of St. Luke's Church in Charleston. Poyas's mother, Elizabeth Ann Poyas, also published numerous pieces in the city.[28]

In addition to domestic literature and poetry, southern women made pointed, often stinging, social and political commentary in previously male forums, treatises, published essays, and thinly veiled narratives. Indeed, they contributed to an evolving ideology of urban southern single blessedness by writing more than fiction and domestic advice pieces. Bright, energetic, and available, many unmarried women took up their pens to further the political and social causes they held dear, including pro-South politics. Maria Henrietta Pinckney, for example, was born around 1783 to Charles Cotes-

worth and Sarah Middleton Pinckney (1746–1825, 1756–84). Not much is known of Maria's personal life except that she had three sisters. One, Harriot (1776–1866), was a well-loved Charleston icon and spinster (chapter 1); the other sister, Eliza Lucas Pinckney (d. 1851), married Ralph Izard but had no children. The three Pinckney girls lost their mother in 1784, and their father remarried Mary Stead in 1786. She died in 1812. As daughters of a prominent and wealthy father, the young women circulated among Charleston society, traveled extensively with others of their class, and participated in numerous benevolent societies and organizations. While Harriott was making a name for herself as a legendary benefactor, indulgent mistress, and able administrator of her father's plantations, Maria wrote at least two impressive essays intended for a wide audience. The first, *A Notice of the Pinckneys,* was a narrative genealogy of the family during the eighteenth century. It was up to this unmarried woman, it would seem, to preserve her family's history, a duty that usually fell to sons but could be undertaken by a dutiful—and available—daughter.[29]

Pinckney's second and most impressive work, which she intended for publication, was a political question and answer exercise on the Nullification Crisis. *The Quintessence of Long Speeches, Arranged as a Political Catechism; by a Lady, for her God-Daughter* was published in Charleston in 1830 and quickly became a standard nullifier text. Published anonymously under the pseudonym "A Lady," this catechism walks readers through a detailed and partisan explanation of the crisis. The first question, "What do we understand by the Federal Union?" begs and receives an answer about the agreement between sovereign states to exert power jointly. Pinckney then describes the Constitution, the power of Congress (which, she claims, has no sovereign power), and the meaning of sovereignty. Using classic states rights rhetoric, Pinckney argues that each state retains sovereignty, as does an individual who allows an agent to transact a portion of his business but retains agency and powers over that business. She defines rebellion as "the resistance of an *inferior* to the lawful authority of a *superior,*" concluding therefore that South Carolina was not in rebellion because the federal government and a state are equal sovereigns. Naturally, she defends nullification as "the veto of a Sovereign State on an unconstitutional law of Congress." The treatise continues for twenty-two pages, carefully examining every angle of the nullification question, including the Supreme Court (which, Pinckney said, was flagrantly increasing its own power); the "violated" Constitution; the "bribery" of the West by the North and East; the possibility of secession (which she thinks possible); and the likelihood of civil war (which Pinckney thinks unlikely).[30]

What is so remarkable about this small book, aside from its tidy and par-

tisan comprehensiveness, is the fact that a woman wrote it under the pretext that it was for another female's edification. Clearly, literate urban women were expected to understand the intricate web of the ongoing political tug-of-war between the South and the North. In addition, they were expected to internalize the southern rhetoric in support of nullification. Perhaps contemporaries assumed that a woman could best deliver this civics lesson to other women. In any case, Pinckney's catechism contributed to the rising tide of scholarship that argues that southern women were more involved in politics and the political process than previous assumptions have indicated. It indicates also that Charleston was a place where bright women, especially those without husbands, could participate on some level in the political culture of the city. Again, the cities had created a place for southern women to transcend conservative and traditional limits even as they did so in service to that conservative southern ideology and way of life.[31]

Indeed, urban southerners' ideas about women made room in the public discourse for women who supported the southern cause. In these cases, when women were not neglecting families to write and wrote to bolster the status quo, readers were generally appreciative. Northern domestic fiction, by contrast, aimed to advance the causes of antislavery and abolitionism, at least by mid-century. Well-read southerners were quick to point out the radical and dangerous connections between certain northern writers' domestic messages to readers and that region's social and political reform movements, including abolition. Southern writers, by contrast, usually held to traditional domestic values that kept women in their homes, sometimes at work on domestic issues or, occasionally, arguing for a conservative southern ideology.

One antebellum writer who deftly argued for this uniquely southern and conservative worldview was Charleston-born Louisa Susanna McCord. Publishing her work a couple of decades after Pinckney's nullification defense, McCord was widely known throughout the nation because she wrote prolifically during the time the South came under increased criticism from the North. As one historian has commented, "No other woman wrote with more force, across such a range of genres, or participated so influentially in social and political discourse. She was, beyond the South, among the leading conservatives in American thought." Through her articles on political economy and social theory and her poems and plays, McCord articulated a vision of southern society. She defended the South and slavery, argued for women's subordination to men, maintained white supremacy, supported secession, and attacked northern "radicals" such as Harriet Beecher Stowe and northern movements such as feminism and abolitionism. Surely, her elite southern

readers, like those of Charleston's Literary and Philosophical Society of South Carolina—who met with McCord's husband rather than with the author herself in 1853 (because women could not attend the group's meetings)—appreciated her work and its ardently conservative perspective.[32]

Although few southern women were educated enough to grasp fully McCord's more lofty pieces on political economy, undoubtedly the wives and daughters of those Charleston society men knew who she was and may have read her work. On a trip to Red Sweet Springs in 1851, for example, one Charleston belle reported having met the accomplished author. "Mrs. M'Cord paid us a visit this afternoon," Jane Caroline North recorded in her journal, "she is a masculine clever person, with the most mannish attitudes and gestures, but interesting & very entertaining." Southern women knew that McCord wrote on highly intellectual, and therefore traditionally male, topics, which set her apart from the growing number of female authors of domestic fiction and advice manuals during the middle of the century. Perhaps, too, her writing reflected her less-than-feminine appearance and vice versa. McCord argued that southern women should accept the range of their obligations to their families, race, and class. Perhaps the well-to-do southern women without husbands found assistance from McCord's work in grounding their identities in familial responsibilities and cultural heritage rather than in the distinctly female worldview that many northern women writers were beginning to encourage.[33]

McCord's biography—specifically, her urban roots, plantation experience, and unmarried years—indicates that she was uniquely situated to advocate her opinions so eloquently and extensively. She was born in 1810 to Charleston's eminent Langdon Cheves, a planter, statesman, and president of the Bank of the United States, and Mary Elizabeth Dulles Cheves, who came from a wealthy and well-established family. She spent a decade in Philadelphia during her adolescent years, where she was well educated. In 1830 her family moved back to South Carolina, settling in the area around Columbia and availing her of the rich intellectual culture surrounding South Carolina College. In 1833 McCord inherited a sizable cotton plantation, which she managed with her father's and brother-in-law's help. She married relatively late in life, at age thirty, to a lawyer, David James McCord, with whom she had three children. Her most intense literary activity came during the period from 1848 to 1854, when her children were young. Her husband died in 1855. After working tirelessly for the Confederate cause during the war years, McCord retired to Charleston in 1876, where she died in 1878. She made good use of her urban upbringing, exceptional education, and the eventual and expected roles as wife and mother. Her protracted spinsterhood during her

twenties allowed McCord to develop her intellectual abilities because she was not spending those formative years tending to the constant needs of a family. Moreover, both her life and her work confirmed the importance of all southern women to their families and communities. They also demonstrated that there was room for women in public discourse about southern identity, slavery, and women's roles, especially when the women's opinions supported the prevailing conservative trend in that discourse.[34]

Augusta Jane Evans was another southern woman writer who married relatively late in life and contributed to the evolving discourse about southern women and exalted a conservative vision of women's devotion to family and faith. Remarkably, Evans also found a key place for unmarried women within this paradigm. Born in 1835, twenty-five years after McCord, in Columbus, Georgia, Evans's family was quite well-to-do until her father went bankrupt in 1839 and moved the family to Texas and later to Alabama. Evans did not become engaged or marry during the typical span for most young women, probably due in part to her family's strained circumstances and her intellectual interests. Evans read widely and began to write during this period. Her first novel, *Inez, a Tale of the Alamo,* which was published in 1855 and described life in Texas and a family's lost fortune, brought her little recognition or acclaim. Evan's second novel, however, sold widely, bringing her both fortune and fame. Like McCord before her, Evans used her platform to defend southern culture and argue for women's important domestic roles within it. Published in 1859, *Beulah* is the story of an orphan girl who initially rejects her suitor in an effort to find independence as a teacher and writer. After years of struggling, Beulah regains her faith and emerges from her spiritual quest, aware of her love for her suitor and prepared to marry him. The novel is often compared to Charlotte Bronte's *Jane Eyre,* although Evans focuses on her protagonist's spiritual path.[35]

Evans's third novel, published in 1864, also addressed women's search for moral independence and self-realization, but given its wartime backdrop it even more directly offered a message to unmarried women, especially those whose marital prospects were dimmed by the war. "The quintessential war story for Confederate women," according to Drew Gilpin Faust, *Macarai; or, Altars of Sacrifice* follows two young women, both motherless, as they find meaning and usefulness in service to the Confederacy. Irene must resist the pressure her father puts on her to marry her cousin, whom she does not love, and also hide her devotion to her true love, separated from her by an old family feud. In the end the true love dies in battle for the Confederacy, and her father dies as well. Her friend, Electra Grey, is less attractive and less wealthy, but she, too, resists a loveless match and ultimately devotes herself

to the Confederate cause, going so far as to carry dispatches through the northern blockade. In the end, both characters devote themselves to their country and remain unmarried. When Evans wrote *Macaria,* an instant best seller, war had ripped apart her country and her land, and she, too, remained unmarried. She wrote on scraps of paper as she sat alongside bedridden Confederate soldiers. Evans's intent was to boost Confederate nationalism and provide women with models to emulate as they sought usefulness during and after the war. Unlike most southern heroines who preceded them, Irene and Electra remained unmarried but not for selfish reasons. Quite the contrary. They rejected the individualism and the bourgeois philosophies of the North and embraced an ethic of service to their country rather than to a husband.[36]

Herein lay the crux of Evans's contribution to the ideology of southern single blessedness and an important part of the problem that single women posed to the delicate house of southern cards. The northern economy was growing rapidly, fostering a system of unprecedented economic individualism and capitalistic self-interest that went hand in hand with urbanization, industrialization, and new social problems associated with immigration and urban poverty. The shifts precipitated a vast series of reform movements that drew women from their homes and prodded them to help fix society's ills. When these reform-minded women and men began attacking slavery and the southern way of life, the white South reacted as one might expect: defensively, indignantly, and fearfully. The South had its roots deeply planted in a different soil, one that abhorred these northern developments and held firm to a rural-based plantation model and, of course, slavery. In this worldview, selfishness was at the base of what had become of the North. Moreover, selfishness was even worse for women, whose devotion to family and the male-led household was the linchpin in the southern system. No wonder then that unmarried southern women had to disassociate themselves from the taint of selfishness. Their unmarried state had to result from accidents, extraneous circumstances, or individual choices that signaled no social threat. Most important, their lives had to serve others.

Very likely Evans was so apt at advising unmarried women because she remained one until her relatively late marriage in 1868, at the age of thirty-three, to a wealthy widower, Lorenzo Madison Wilson of Mobile. She continued to write until her death in 1909, but Evans struggled with her status as a literary woman and a wife. As she reflected to her friend Rachel Lyons in 1860, shortly after *Beulah*'s publication, "Literary women as a class, are *not as* happy, as women who have Husbands and Children to engage their attention and monopolize their affections." Only through "the faithful employ-

ment of their talents," Evans argued, do unmarried women "experience a deep peace and satisfaction, and are crowned with a glory such as marriage never gave." Those women whose talents are literary, and who become professional female writers, find profound fulfillment in writing, superior to that of marriage, but, in her experience, the two are mutually exclusive. "No loving wife and mother can sit down and serve two masters, Fame and Love—. It is almost impossible—." Given that her friend was not married, Evans said, "I wish you would *write*." Presumably, writing was a good remedy for depression and a suitable productive activity for unmarried women.[37]

That Evans counted herself among a literary class of women, and within that a southern subset, is in itself significant. By the time she wrote *Beulah* in 1859, several decades of southern women's writing had passed. Overwhelmingly, this literature defended southern culture, celebrated the domestic sphere, and portrayed women as contented wives or useful maidens. One unusual Charleston author, however, proved the exception in some ways. Perhaps more than any other, Susan Petigru King drew on her own, her mother's, and her sister's experiences of bad marriages and questioned the ideology of southern elite marriage. Rather than celebrate the domestic sphere, King advised of the perils of Charleston's social scene for young women and the dangers of marriage for all women. Still, she pessimistically concluded, there were few alternatives. Her own life proved it.[38]

Born in Charleston in 1824 to a well-to-do family, King attended the famous Mme. Ann Talvande's school for girls in Charleston with Mary Boykin (later Chesnut), whose Civil War diary is so well-known. Later, King attended a fashionable finishing school in Philadelphia. Her father, James A. Petigru, was a distinguished lawyer. A bit of a recluse by nature, the young girl read novels constantly—some have suggested even compulsively. When the family fell on hard times after the Panic of 1837 (as had Evans's), King's mother urged her daughters to marry wealthy men. Her sister complied, but Susan resisted, at least initially. In 1843, however, she agreed to marry Henry C. King, a short, stout, and physically unattractive man whose father was a prominent and wealthy lawyer. Predictably, both daughters were miserable with their husbands.[39]

In King's story "Old Maidenism vs. Marriage" (1853), six female characters describe their unhappy and ill-fated marriages. Ten years earlier the same group had been single. One cold night during the Christmas holidays, in an effort to amuse themselves, they drew up a compact, promising that those of them who remained unmarried ten years later would "meet in this very spot" and read letters written by the married ones. The wives would have to "[describe] their position as wives or widows." Anyone who refused her

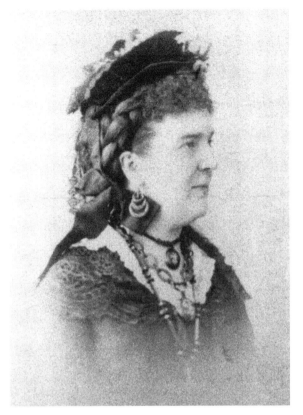

Susan Petigru King Bowen, 1824–75. (From the Collections
of the South Carolina Historical Society, Charleston)

obligation, forgot, lied, or would not "betray the secrets of her prisonhouse"
had to give each of the faithful subscribers a diamond ring.[40]

Ten years later only the party's hostess, Caroline Bloomsfield, remains
unmarried, and even she is considering an offer of marriage. Her friends'
letters are worrisome and depressing. The first describes a life of boredom,
unfulfilling motherhood, and marriage to a selfish, stingy man who dislikes
all that she loves: music, reading, and society. The second reports that her
husband had changed for the worse since they married, shunning music and
balls, which she enjoyed. The next has moved west with her husband and is
lonely and unhappy. "Ah, dearest Carry, it is very difficult to know people
before you come to live with them. If ever you are tempted to choose a hus-
band, bear this in mind," she warns Caroline. The fourth is widowed and
poor. The next has six children and feels extremely burdened. And the final

writer can not or will not bring herself to detail her experiences in her letter, but her silence indicates that married life is disappointing at best, and she promises to send Caroline a diamond ring.[41]

Shocked and saddened, Caroline understandably begins to think that she had best refuse her suitor's proposal. But first she decides to ask the opinion of her sister-in-law, a New Yorker named Dora. "To remain single, my dearest Carry, is all very well so long as, young and beautiful, you have shoals of admirers and crowds of friends," Dora explains. "[B]ut in ten or fifteen years from now, with your circle scattered, yourself wearied . . . your contemporaries grown old, and retiring, day by day, more into their own shells and houses, you will find yourself alone, and shut out from many privileges." The basis of a spinster's unhappiness, Dora insists, lays not only in her loneliness but also in the fact that no one depends on her. "No happiness [would be] twined closely with your own." An unmarried woman might do good works, be useful, fill her life with pleasant duties, and devote herself to nieces and nephews who would love her. But still, nieces and nephews will never have for her "that clinging tenderness that belongs to a child's love" for his or her mother. The best thing Caroline can do—"the rub" as Dora calls it—is choose a husband very carefully. As a final warning to her southern sister-in-law, Dora adds, "We northern women make better wives than you southerners. Southern women are apt to be either slaves or tyrants; and themselves aid in making their husband despots or Jerry Sneaks." Southern wives, she notes, have an especially difficult time not "losing their own individuality in the imposing grandeur of the 'he' and 'him' who is the arbiter of their destiny." Caroline has no time to respond to Dora, to debate the issue, or to ask questions, for just then her mother and suitor enter the room, asking for her answer. Despite the dire warnings of her six friends, Caroline tearfully (and happily, according to the storyteller) consents to marry the man who "looked with glistening eyes at his priceless treasure."[42]

King's keen and damning observations of southern society and the gender inequalities there did not earn her many friends in Charleston's social circles. When "Old Maidenism vs. Marriage" was published as part of her collection *Busy Moments in the Life of an Idle Woman,* it was quickly recognized as the work of a Charleston lady, despite a pseudonym. King had dared to mock the customs of Charleston's elite and embarrass her family. In her personal life, King further alienated herself by flirting shamelessly with young bachelor acquaintances, clearly chafing against the confines of her marriage.[43]

King's second work, a semiautobiographical novel entitled *Lily,* came out in 1855 and was similarly received. It compared the social intricacies and societal hazards of the city and its drawing rooms to the solitude and isola-

tion of the plantation. Ultimately, Lily, perhaps like her creator King, can be happy nowhere, and the novel, foretelling King's own life, ends rather sadly. King's next work was *Sylvia's Work, and Crimes which the Law Does Not Reach,* a novella and two short stories published as one volume in 1858. *Gerald Gray's Wife* followed in 1864. These later publications received slightly higher praise from Charleston reviewers despite King's continued and damning apprais al of southern marriage, of men's unfair power over women, and also of women's traumas of marriage. King's unconventional approach did not keep her from attracting readers, however. Her reputation reached the admired and unconventional William Thackeray, who read her work and visited her in Charleston. Still, King advocated resigning oneself to marriage despite her apparently futile warnings to the contrary. In this paradox lay King's central irony: Her stark observations and dire warnings were futile. Few women could avoid marriage altogether.[44]

There were some who could, but King's fiction and her biography indicate that there were many pitfalls for all women. According to one source, King's unhappy marriage led her to leave her husband at the outset of the war and go to work for the Republican-led federal government in Washington, D.C. Shortly thereafter, Henry King died in 1862 at the Battle of Secessionville, leaving his wife and their only child, a daughter. To support herself and her child, King gave public readings. When that produced too meager an income, she became a clerk in the post master general's office in Washington. In 1868 she published her last work, a novella for *Harper's Magazine.* Around the same time King married again. Christopher Columbus Bowen was a Repub- lican member of Congress from South Carolina from 1868 to 1871. Adding to his notoriety, Bowen was already married and stood trial for bigamy following his marriage to King. Moreover, Bowen had been a wanderer, presumably a gambler, and a forger during the Civil War. In the end, Susan P. King lost any sense of her community and family, alienated even from her only child. She died on December 11, 1875, of typhoid fever.[45]

Susan King's life and fiction reveal the limits to which a white woman could challenge southern society. To her peril, King dared to take advantage of the relative freedom of the urban South's literary culture, and instead of buttressing the southern way of life, she threatened to undermine it. Although she conformed to convention by marrying and becoming a mother, she still failed to embrace fully the ideologies of southern domesticity, even rhetorically, as most unmarried American women authors did. In fact, King's notoriety, contrasted with the admiration and respect garnered by Sedgwick, More, Rutledge, or Pinckney, reveals that marriage alone was not the path to southern respectability for a female writer. The ideology of white southern

womanhood was built on loyalty to the region; to conservative principles; to Christianity (for most southerners); and, above all, to usefulness to one's family. These were the keys unmarried women especially needed to possess in order to pass successfully into, and stay within, the social and intellectual culture of the region.

3. "At Home Where I Am a Very *Important* Personage"

Dutiful Daughters, Single Sisters, and Maiden Aunts

In August of 1843, Harriett Campbell, an aging, unmarried Savannah wom-an, received the distressing news that her older sister Lillie had died in the North. She promptly wrote to her nephew to convey her grief and share her dilemma. Everyone in the family needed her, and she could hardly decide to whom to attend first. Lillie's children wanted her to come to them: "I have received several letters from New Port, and my dear [nephew] George and his Sisters appear to wish for me very much . . . [George] said, 'if you can come on my Dear Aunt let me beg you to do so.'" Harriett felt compelled to go to them, but other family members needed her, too. "I am quite divided in feelings, knowing how much they wish for me, at the same time, my dear Brother says I am such a comfort to *him,* and in the delicate state of [his wife's] health, I think it best for me to remain entirely in her chamber," she explained to her correspondent. Meanwhile, a niece who lived nearby was also ill, so Harriett predicted, "I shall be obliged to take the entire charge of the house." Fortunately, she wrote, soon "Fenwick [an unmarried niece] will be here, when I shall feel they will be able to spare me better, for they all daily remark, 'we know not what we should do without you.'" Caught be-tween beckoning relatives, Harriett found herself both burdened with a sense of responsibility and infused with a sense of her own importance.[1]

Like many other unmarried women, especially those from elite, antebel-lum, urban families, Harriett used her role as maiden sister and aunt to achieve an integral place in the family. Embedded within the familial fold, she ministered to changing needs; rose to difficult and demanding occasions in times of trouble and sickness; fostered close relationships with adult sib-lings; and, especially after the death of a brother or sister, took on custodial

and mentoring relationships with that sibling's children. For many women in antebellum Charleston and Savannah, playing the part of the spinster sister and aunt could offer fulfillment, respect, and importance within the family. Through their roles as family caretakers and surrogate mothers, these white southerners shaped identities as useful, needed, and loved women and tried to cement places within their extended families. All the while, they remained within the bounds of southern womanhood, which may have expected marriage and motherhood but demanded piety, dependence, and service to others. Herein lay their core identities as daughters, sisters, and aunts.

* * *

The most significant relationship unmarried women in the antebellum South had with men usually involved a brother, particularly during the time when he, too, was unmarried. Especially for young women, brothers offered sisters male attention and companionship, the requisite escorts for travel, and sometimes opportunities to meet their male friends. As they aged, brothers could provide their sisters a means to experience vicariously opportunities for power, advanced education, or travel, all of which were often beyond the reach of southern women. Unmarried women, because they had no husband through whom to live vicariously and because they did not have their own children to occupy them, cherished relationships with brothers and enjoyed sharing in their adventures. One of Harriett Campbell's good friends in Savannah, Mary Telfair, also unmarried, felt a powerful connection to her brother. As she explained in 1832, she had been "*worried* and *flurried* for the last fortnight" because her brother, Alexander, was to deliver "the centennial birth day Oration" commemorating George Washington's birth. "As I always identify myself with him," she explained, "I was nervous and miserable until it was over." It was as if she herself had given the speech. That they were both unmarried likely heightened Mary's emotional identification with Alexander; he led the kind of life she would have led were she a man, and she filled the role of his pseudo-wife, living with, worrying about, and caring for him.[2]

Born on January 28, 1791, into one of the most prominent and wealthy families in Georgia, Mary Telfair had two younger sisters and three older brothers. The three boys, all educated at Princeton University, returned to Georgia, one as a planter trained in the law, the other as a lawyer-politician, and the third was a planter-businessman and civic leader. Two of the brothers had died, however, by 1818, when Mary was twenty-six. The one remaining, Alexander, born two years before Mary, lived the longest of the boys and maintained

the closest relationship with Mary. Active in Georgia and Savannah business and philanthropy, Alexander enjoyed the undisputed place as head of his family of women. Their father, former Georgia governor Edward Telfair, had died in 1807, and their mother in 1827. Mary, who cherished her travels north each summer, cheerfully acknowledged one spring, "We have no final plan for the Summer[;] it rests entirely with my Brother[,] his wishes are ours." As in most southern households, Alexander's authority as the dominant male meant that his plans and preferences commanded center stage. Nevertheless, Mary understood the reciprocal nature at the foundation of their relationship. She related to her friend that her brother "loves every one who is dependant on him—just like the Lords of creation." Still, Telfair insisted, "but I say they depend more on us *frail* beings than they are willing to acknowledge." Alexander's love for his sisters sprang in part from his sense of responsibility for the three unmarried women, although Mary knew well her importance in the relationship and his dependence on her. As in many cases of human exchange, mutual obligation mingled with love and affection.[3]

One benefit of this reciprocity was that her brothers invited her into their political discussions. "Among my numerous *female* acquaintances I find none who enter into the feelings which at present occupy my breast," began Telfair around the War of 1812. "I know not whether it is the case at the North but the Southern Ladies are so much engrossed by *domestic concerns* that they seldom think and talk of their Country and except with my Brothers I can never give scope to '*the unruly member*' and exercise it on *politics*." This isolation from like-minded female company led her to fancy that she and her northern correspondents "*were all three Men,* that we might fight our Country's battles." Telfair suggested playfully, "Say Molly how would you like to be a General and have your old friend for an aid, I would promise never to *desert,* or let *you surrender to an inferior force.*" Telfair then reminded herself, "But as a Woman I am the veriest Coward in existence and tremble at the sight of a wasp," and "how then could I hear the commons roar, and the savage yell[?]" Instead, she wrote, "I believe I should have to serve my Country in the Cabinet instead of the field, notwithstanding my prediliction for the latter." Later that year, during the War of 1812, she speculated, "I suspect all women are politicians now" and concluded, exasperated, "I *only wish I was a man* professing talents either for the cabinet or the field[;] I think I should be very active[;] do not smile Molly, for there is no danger of *petticoat* innovations." Obviously, Telfair could not run for office, give political speeches, or fight in battle, but her brothers gave her the opportunity and freedom to engage in political debates and imagine herself as a leader.[4]

Just as Telfair was devoted to Alexander, another young woman who never married, Harriott Middleton of Charleston, born in 1828, also shared a special relationship with her elder brother, Henry. Although Harriott remained at their Charleston home with her sisters and parents during her young adult years, Henry enrolled in Harvard University and traveled throughout the Northeast. After graduation in the late 1840s he moved to Mississippi, where he worked as a railroad engineer. Throughout their separations the two exchanged regular letters in which Harriott would tell Henry of home goings-on and he would tell her of his adventures in school, travel, and new acquaintances. In the spring of 1847, for example, Henry was living in Northampton, Massachusetts, which he described in detail to his captive reader. "Mounts Tom and Holyoke are seen with ease from our house . . . I have made up my mind to visit them the first clear day when the walking has become easier. Mount Tom is quite a good looking mountain, but Mount Holyoke seem[s] to be a dirty, muddy, dingy affair, with patches of snow every here and there." Henry also shared more politicized encounters in Yankee country. On one occasion, to distinguish himself from his northern friends and "to show my independance, and dislike of some Yankee customs," he told her, "I always eat [my eggs] in the shell, while everybody else turns them out into the glass." In other instances he seemed more or less persuaded by northern sentiments. "My landlord Mr Thayer is editor of an abolitionist newspaper," he told his sister, "and Mr. Ellis is another very strong antislavery man and so you must not blame me if I return home a thorough going abolitionist. I am half one already I must acknowledge." That Henry felt comfortable sharing such charged revelations with Harriott indicates the strength and intimacy of their relationship. Of course, Harriott would have known if he was joking, but even so this candor might best be shared with his sister rather than his prominent, slaveholding father or grandfather.[5]

Throughout his life Henry continued to write to Harriott and relate his adventures. In 1852, from Huntsville, Alabama, where he was working as an engineer and putting in a rail line, he reported, "I will have a tolerably good salary $35 a month & my board." In the same, he begged for more letters from her: "I have not heard from you for several weeks. [D]o not be afraid to write, for I assure you, your letters are perfectly charming. If I wished to be complimentary, I would say they are superior to a good newspaper filled with the latest of european news, but I am afraid you would be shocked by the comparison." Sadly, the siblings' correspondence was cut short by Henry's premature death at the age of thirty-two. Despite earlier references to abolitionist leanings, he fought for the Confederacy during the Civil War

and lost his life for it on July 27, 1861. Harriott, thirty-three, grieved deeply. "Henry was the one stable thing in our lives," she wrote to her cousin, Susan Matilda Middleton, in 1862. "I had for him the love that casteth out fear. I knew that if the foundations of the world gave way around me, he could not change, but would be the same calm, affectionate guardian, forgetful of himself and living only for us." Regrettably, Harriott could not feel as profoundly for her remaining brother, Frank, who was fighting for the Confederacy as well. "I am very fond of Frank, and as the only brother left he is very precious to us, but strange to say, none of us know exactly what his character is. He is very quiet, very reserved, perfectly amiable and unselfish towards us." Clearly, not all brother-sister relationships were created equal, but the right connection between siblings, particularly those between unmarried brothers and sisters, meant a great deal to those who desired companionship, devotion, support, and, sometimes, protection.[6]

Naturally, southern women had no monopoly on attachment to their brothers. Catherine Maria Sedgwick, an unmarried northern woman and beloved American writer, drew on her close relationship to her brothers and their children to fulfill one of the primary prescriptions she set forth in her fiction, that women should follow their domestic callings, usually as wives and mothers. In her own life, Sedgwick's brothers became surrogate husbands and her nieces and nephews, surrogate children. As Sedgwick explained, "The affection that others give to husbands and children I have given to my brothers." Recognizing that her choices were atypical, she observed, "Few understand the depth and intensity of my love for them." Indeed, Sedgwick's attachment to her brother, Robert, was especially profound. As she confessed to him in 1813, "I do love you, with a love surpassing that of an ordinary woman." Remarkably, Robert reciprocated her devotion, offering her his home and support in exchange for the example of moral and spiritual superiority that she set for him. He appreciated also her comforting presence in his life. "My dear Kate," he concluded, "I know not how I could live without you."[7]

Given their devotion to brothers, and certainly their fears of losing the brothers' attention, it is not surprising that many maiden sisters expressed anxiety about their brothers' choices of mates. Truly, many did not like the idea of siblings marrying at all. Whenever female acquaintances showed romantic interest in Alexander Telfair, for instance, Mary downplayed her brother's reciprocity. "Miss Hunter possesses many pleasing qualities but she has made not the slightest impression on a heart which has never yet yielded to the power of female charms," Mary related to another friend, Mary Few. "Besides I know several Girls who Alexander prefers to her, but as to marrying or soliciting the hand of any Woman at present he does not dream

of such a thing." Mary happily doubted that even "an angels Form & angels mind could tempt him to wear the chain of Hymen." Although he enjoyed the ladies and admired "soul beaming eyes, rosy cheeks, and coral lips," Mary believed that she spoke for her brother when she declared, "I belong to a family devoted to 'single blessedness.'" Not that she was an "enemy to the *holy institution*," she explained. "I approve highly of the state when two persons enter into it from disinterest and affection and where there exists a congeniality of character, but I have always thought the number of happy matches considerably less than unhappy and always conclude that there are faults on both sides among the whole circle of my acquaintance." Throughout her life Mary was quick to point to the faults of her one sister-in-law, her brother Thomas's wife, Margaret Long Telfair, of whom Mary never approved.[8]

Similarly, twenty-four-year-old Emma Holmes, a single Charlestonian, expressed dismay with her brother's wartime choice for a wife. "Willie writes that he is engaged to Mrs. Ben. Scriven, a widow with *five* children, & begs mother please to send his wardrobe as he will be married soon." Apparently, Holmes was not the only family member shocked, as her "Mother burst into tears," she wrote, upon reading the news. "If it was a young lady, we would not have felt it so much—but the idea of marrying a widow, who must be at least five or six years, if not more, older than himself—an idea so repugnant to my feelings." There was more: "Then the five children—such a heavy responsibility for so young a man. She must have some property, for he certainly cannot maintain a family otherwise," she concluded. Holmes, who frequently commented on "all the strange marriages & matches made by the war," declared "this takes the lead." Eight days later she noted in her diary the engagement of her "darling cousin" Willie to "a very warm-hearted, sincere girl, whom I have always liked, & I doubt not will make him an excellent wife." Still, she admitted, "[I] cannot help feeling rather jealous of *anyone*, for his marriage will necessarily make changes in our old associations and we will not see so much of him as we used to. We all look forward to 'our boys' getting married, but it is so hard to give them up when the time comes. When [my favorite cousin] Rutledge's turn comes, I expect to cry for a day." Another unmarried twenty-six-year-old Charlestonian, Susan Matilda Middleton, understood the situation well: "I always felt that if I had an only brother, and loved him well, I should not like anyone whom he married."[9]

While ever-single sisters watched carefully the choices their brothers made, the brothers, in turn, looked out for the material well-being of their sisters, even when the woman was quite wealthy in her own right. Mary Telfair lived

with her two unmarried sisters in the Savannah home their brother Alexander had built for them. Another unmarried woman from a less wealthy family, Ann Reid of Charleston, lived with her brother, who despite his pecuniary limitations refused to allow Ann to pay rent. "There are few Brothers like him, when we take every thing into consideration," she told her other, presumably less generous brother. Still, Reid assured him half heartedly, "Do not think in extolling my *Town* Brother I have forgotten my *Sumter* Brother." Years later, Reid planned a visit to her Sumter brother, but his lack of communication about the details of her trip convinced her that he ignorantly underestimated her important philanthropic commitments. "I wish to consult with you about the *said* visit," she began her pointed letter. "I wish you to tell me *what* arrangements you mean to make and *how soon*." She badly wanted him to understand how busy she was and how she needed ample notice to leave her various activities. She had already purchased a new dress and several other things for the trip but vowed, "I will not make *any* [more] preparations until I hear from you." Obviously, paying visits to brothers was not always without its frustrations for single women, especially when those brothers undervalued their importance.[10]

Other brother-sister relationships could be similarly tense, especially when resources were limited. One Savannah woman, whose middle-class family supported itself as owner-masons and builders, had to remind her brothers that she had tirelessly and dutifully nursed their dying parents. When they died, she and her widowed sister found themselves without adequate financial resources. As she told one brother, "I do not regret one step I have ever taken or one act ever done for [my father] or my mother whom I nursed two and a half years." But she did want him to realize that "I have worn myself nearly out in the service of the family compact." Yet because of the stipulations of her father's will, which he wrote long before he died, she complained, "My father left a plenty for all, and those who need it least have the most." She asked that her brothers "regard what I believe to be father's last wish concerning [his daughters] . . . and provide more for our support that we may have a home where we please." Apparently, this unmarried sister did not secure the funds she requested, because three years later, in 1859, she thanked her other brother for his wedding gift of $100 and explained that she was getting married, despite his resistance, because she was "tired of going about from place to place so much without a home." In addition, "I think Mr. Magie has the qualifications that would be necessary in a Husband to make one happy." He was a widower many years her senior and, she added truthfully, "I sincerely hope I may not be disappointed." Women from more modest circumstances understandably chose marriage in part for fi-

nancial security, whereas elite women who had their own resources lacked that impetus.[11]

Sometimes a brother's wife might shape the relationship between her nuclear family and her unmarried sister-in-law. Typically, busy wives and mothers appreciated some assistance from a husband's unmarried sister, someone with an unusual degree of mobility and freedom from child-rearing responsibilities. This made the maiden aunt an ideal candidate to aid her married siblings and their families. Sarah Rutledge, for example, routinely left her busy schedule of charity work and writing to travel to Tennessee, where her brother, Henry, had moved with his family in 1818 (chapter 2). Henry's wife, Septima, quickly began to rely on her sister-in-law's regular visits because she helped care for the many children, eased the isolation and scarcity of the Tennessee frontier, and brought news of Charleston society and family members. In addition to her benevolent work, Rutledge shared a home with her aging stepmother, who also may have relied upon her for care and companionship. Knowing this, Septima's extended family worried that Rutledge's "sense of duty" to her widowed stepmother would prevent her from visiting Septima in far-away Tennessee. But Rutledge consistently made the approximately six-hundred-mile trek nonetheless and was able to juggle numerous obligations to various family members yet all the while remain active in Charleston's benevolent organizations.[12]

Sometimes, however, a single sister did not have the freedom to travel to see a brother or help a sister-in-law because she lacked an available male escort. Occasionally, an unmarried woman could travel without a man, but doing so was generally unacceptable, especially when the woman (and the century) was young. The assistance and protection of a male relative or friend of the same social class were deemed necessary. That naturally created quite an impediment for elite women who wanted to be useful to others and perhaps to stave off loneliness but needed acceptable male escorts, usually brothers, to accompany them from place to place. Mary Telfair, then in her mid-twenties, complained to a friend in 1815, "If I could prevail upon that Bachelor Brother of mine Josiah to escort me as far as New York, I would then give him a *Furlough* to seek his pleasure, to roam at large. . . . [H]e promised Sarah & myself last summer to escort us to the Virginia Springs but when the time arrived his affairs required his presence and you know we Women cannot move *without a man*." Later Mary admired a strong, stoic single friend of hers who dared to travel "without *a Man* or Man Servant." Mary sighed, "how desirable it is to be able to act independantly of the Lords of creation." Similarly, one historian has described the profound frustration experienced by two unmarried sisters in Unionville, South Carolina, when

they could not persuade their male kin to escort them to see close female friends. The women once threatened their male cousin with a "thundering quarrel" if he did not provide them an escort. Ultimately, however, they acknowledged that their own travel was "entirely out of our power." An unmarried sister could offer her brother, and his family if he had one, much assistance, but she still usually lacked the real power to decide the terms of that relationship.[13]

<p style="text-align:center">* * *</p>

Unmarried southern women also maintained close relationships with parents and sisters, sometimes forgoing marriage to care for aging and/or widowed mothers or, more often, fathers. Mary Petigru, for example, was born in 1803, the fifth of nine children to William and Louise Guy Gilbert Petigrew. (All the children followed the eldest brother James's lead and changed the spelling of their name in 1812.) When Louise Petigrew died in 1826, her son, James, took the three youngest daughters to live with him and his new wife in Charleston. Mary, however, stayed with her aging father at the family plantation home, Badwell, in the upcountry near Abbeville, South Carolina. There she aided him with the management of the household until his death in 1837. After that she helped to run Badwell, for a time with the help and leadership of her older and widowed sister, Jane. Mary made periodic trips to Charleston to visit family, but she lived the remainder of her life at Badwell, where, relatives complained, she was increasingly capricious, unpredictable, and emotional with her slaves. In fact, one of her sisters pronounced "poor dear sister Mary" "by nature & habits most unfit." Obviously, devotion to a widowed father and the family homestead did not ensure a daughter appreciation and affection from the rest of the family. After the war she ran Badwell with the help of freedpeople (her former slaves) but continued to alienate relatives, as they put it, with her "peculiarly independent" manner and the "monopoly of power she highly enjoys." Whether misunderstood, overwhelmed, ahead of her time, or truly rancorous, her biographers indicate that no one was sorry when Mary Petigru died in 1867. A useful southern daughter could easily become a difficult spinster sister when she commanded significant family resources.[14]

Another curious and ultimately sad story of a southern father-daughter pair was that of Charles and Henrietta Augusta Drayton. Born in 1774, Henrietta lost her mother, Esther Middleton Drayton, in 1789 while the family was living in the now-famous Drayton Hall on the Ashley River outside of Charleston. At the age of fifteen, Henrietta assumed responsibility for the care of two younger sisters, thirteen and five, and a younger brother, four.

Until his death in 1820 Henrietta served as her father's helpmeet, caring for the children, running the household, sharing his interest in botany, and helping with his medical work. The few remaining letters suggest that Henrietta's load was made heavier by a strained relationship with her brother, Charles, who resented her instruction.[15]

Unfortunately for Henrietta, this difficult relationship would hurt her in years to come. When her father died in 1820, Henrietta, forty-six, lost her position as mistress of Drayton Hall and became dependent on the good will of this brother. Their father's will left Charles the majority of the family real estate, including Drayton Hall, but the younger Charles was to give Henrietta "an Asylum at Drayton Hall and a right to free ingress and egress, and to any two particular rooms in the House with suitable furniture" unless or until Henrietta married. He also left her funds from the sale of real estate, two slaves of her choosing, and all of her father's "older Silver spoons." In addition, the father included a well-meaning but ultimately weak provision "that for the better comfort of my said daughter, I trust to the affection and discretion of my Son." In the end, Henrietta was extremely vulnerable.[16]

Because there are no known remaining letters by Henrietta, it is difficult to follow her movements from about 1820. We know that she traveled to Philadelphia in 1822 with her sister and sister's family and that she was living in Charleston in 1825, but it is unknown where and with whom. In 1828, when her brother-in-law, Lewis Ladson Gibbes, died, she moved to Pendleton, South Carolina, to care for the five youngest children, who ranged in age from three to eleven. Gibbes's wife, Maria, who was also Henrietta's sister, had died two years earlier. By 1840 Henrietta was no longer living with the Gibbes family, perhaps because the children were mostly grown, but where she went is unknown. Letters to her in 1848, when she was seventy-four, indicate that she was somewhere in Charleston, relying on assistance from nieces and nephews. By 1850 she was listed in the census as residing in a Charleston boardinghouse. Ten years later the census listed Henrietta as insane and living with a thirty-three-year-old gardener from Ireland, his twenty-six-year-old wife, the couple's two sons, and another adult male gardener from Ireland. It is unclear why she was not living with her extended Drayton family in Charleston. She died at the age of eighty-seven in 1861.[17]

Henrietta's story is a strange and sad mystery. Her own will, written in 1835 when she was sixty-one, suggests that she wanted to protect, or at least assist, female relatives lest they become as vulnerable as she. She left her sister, Charlotte Drayton Manigault, $5,000 "for her own separate use benefit and behoof and subject to her disposal and free from the debts contracts and liabilities of her said Husband." Her two nieces, Esther Maria Gibbes

and Louisa Izard Gibbes, were to split the remainder of her estate. Moreover, Henrietta directed that the inheritance be "secured to [them] free from debts, contracts engagements and liabilities of any husband with whom [they] may marry." Her nephew, Lewis Reeve Gibbes, would serve as executor of her will. When Henrietta died in 1861, however, her sister and her niece Esther had died. The bulk of her estate went to her niece Louisa, who also never married.[18]

Yet another low-country father-daughter plantation management "team" reveals a happier tale. (Their slaves, however, had many unhappy stories; they were the ones whose dramatic sale was described in chapter 1.) The wealthy Savannah-area planter Pierce Butler lived from 1744 until 1822 and had five children. The eldest daughter, Sarah, married and, according to her father, proved a weak and irresponsible parent. The only son and youngest child, Thomas, also fell short of his father's expectations. That left three middle daughters, twins Frances and Anne Elizabeth, born in 1774, and Harriot Percy, born the following year. It was to these three unmarried daughters that Pierce Butler turned for help with plantation affairs. They took dictation and performed other secretarial and administrative tasks. Harriot Percy died in 1815, but Frances and Anne became the primary benefactors of their father's will when he died in 1822. In fact, he named Frances sole executrix of his sizable estate. Perhaps that daughter had the keener eye for the books; she was said to have had a "poor complexion" as a child and routinely sequestered herself from society. Her twin, Anne, must have been the nurturer. Their nephew Pierce Butler (who married Frances Kemble) remembered fondly upon her death in 1854 that she had "ever been a mother [to me] . . . throughout her whole life."[19]

In rare instances a daughter's devotion to male relatives proved disastrous. In the case of four sisters, daughters of the prominent South Carolinian Wade Hampton II, extraordinary affection for an uncle evolved into a drawn-out scandal, a political vendetta, and, possibly, was the cause of the girls never marrying. Ranging in approximate age from seventeen to twelve, Harriet, Catherine, Ann, and Caroline Hampton began spending increasing amounts of time with their uncle, Governor James Henry Hammond, around 1840. According to Hammond's account, when he visited the girls they flirted with him, playfully vied for his attention, and shared physical intimacies with him. As he remembered in his journal in 1846, "Here were four lovely creatures from the tender but precocious girl of thirteen to the mature but fresh and blooming woman nearly nineteen, each contending for my love." He described their encounters, with "all of them rushing on every occasion to my arms and covering me with kisses, lolling on my lap, pressing their bod-

ies almost into mine, . . . encountering warmly every portion of my frame, and permitting my hands to stray unchecked over every part of them . . . in the most secret and sacred regions." Remarkably, Hammond claimed that these sessions had taken place for more than two years. He pled for those who might later read his journal to understand, "Is it in flesh and blood to withstand this?" Indeed, he asked, "Am I not after all entitled to some . . . credit for not going further [with the girls]?"[20]

Hammond received no credit, understanding, or mercy from the girls' father, brothers, and other male Hamptons, who vowed to destroy Hammond politically after they found out about this activity. In April 1843 Catherine evidently told her father about an inappropriate incident with Hammond, and, according to Hampton, made him believe that Hammond had "made a gross attempt to seduce perhaps to force . . . Catherine." Hammond speculated angrily that women, who would "have given their own colouring," had filled Hampton's ears and mind with information about the incident and about Hammond. He wrote to the girls' father to rectify matters and in the letter even "spoke of my dalliances with his Daughters, using the plural, and that they had been long continued." Hammond hoped that this information would force Hampton to get to the bottom of the matter, to understand his daughters' fault, and presumably to pardon him, the errant brother-in-law. But that would not happen. In revenge, Hampton allowed news of the family feud to spread throughout the capital of South Carolina, enveloping Hammond in scandal, innuendo, and gossip. For about fourteen years Hampton successfully isolated him politically and prevented him four times from achieving his longtime goal of becoming senator. Only in 1857, more than a decade after the situation erupted, when Hampton was away in Mississippi and ill, was Hammond elected to the U.S. Senate. Hampton died in Mississippi in February 1858.[21]

Reflecting the gender disparities of the nineteenth century, the real and fascinating experiences of the four women remain clouded in mystery despite their direct role in the personal and political affair. They were at once powerful and critically influential and also powerless and probably victimized, if not by their uncle then possibly by subsequent events. We wonder how *they* might have characterized their time with their uncle. Was Catherine's admission to her father an intentional arrow aimed at her uncle or an impulsive and regrettable reaction that had unforeseen consequences? What were the women's lives like during and after the scandal surfaced, and how did they feel about never marrying? One historian has speculated that their mother's death in 1833, several years before Hammond's visits began, left them without proper maternal instruction. In fact, they had been known to

give "unmatronized" parties that illicited disapproval among the city's well-to-do. Whatever their role in bringing about the affair, it appears that their father's ardent and public defense of their honor—or, more accurately, his relentless drive for retribution—put them in the public eye in a way that ensured not marrying. As one state legislator commented, "After all the fuss made no man who valued his standing could marry one of the Hampton girls."[22]

What we do know about the women is that the eldest, Harriet, died in 1848 at the age of twenty-five. The others, like many unmarried women, took on caretaking roles within the families of their three brothers. Catherine became a surrogate mother for her brother Christopher's daughter, Annie, when Annie's mother died in 1848. Annie was three at the time. (Christopher looked after his sisters as well, seeing that they had a new home at the family homesite in 1865.) The next sister, Ann, cared for a niece when that girl's mother died in 1852. Seven-year-old Sally was the daughter of Ann's brother, Wade Hampton III, and his first wife, Margaret. The fourth sister, Caroline, was also a caretaker, nursing her brother Frank's wife, also named Sally, in her final illness in 1862. When Frank died in battle in 1863, Ann was named legal guardian of Frank and Sally's three surviving children. The youngest daughter, Mary, who was too young to be involved in the scandal, nevertheless did not marry. Like her older sisters, she helped care for the children of her brother Wade III and his second wife, Mary. Family legend holds that she died young, at thirty-three, after exhausting herself by nursing a former slave, Mauma Nelly, who had cared for Mary when Mary's mother died. The surviving sisters, Catherine, Ann, and Caroline, lived until 1916, 1914, and 1902, respectively, to the ages of ninety-two, eighty-eight, and seventy-four. Very likely their longevity stemmed in part from not marrying.[23]

* * *

The most glowing and the richest appraisals of relationships within families, particularly those between parents and daughters and between two sisters, come from the letters of young women on the eves of their marriages. With profound distress and at great length, young southern women approaching marriage reflected emotionally on the loving parents and sisters they left behind. Anna Maria Calhoun, for example, the daughter of John C. Calhoun, who served as her father's hostess and amanuensis while he was in Washington as a senator from South Carolina, surprised herself by accepting a proposal to marry Thomas Green Clemson in 1838; she was twenty-one. "You know there was no affectation in the determination I always expressed, never to marry," she wrote to a friend. "I thought there were duties enough in

life for me to perform. I felt I was useful to my father, and was not wholly without objects in life, while I contributed to his pleasure in the slightest degree." It was wrenching for Anna to "give up the cherished object of my life," her father. "[I took] a hearty cry at the idea, either that my place cannot be altogether supplied to him, or that it should be supplied by another," she confided to her friend. "You . . . know my idolatry for my father."[24]

Parents often reciprocated this devotion and mourned a daughter's allegiance transferred to her new spouse. In 1846 Sarah Gilbert Alexander, a Savannah mother of nine, felt rebuffed by her second-eldest daughter after the latter's marriage. Fortunately for the mother, she had the next daughter to lean upon. "I do not forget, my dear H—," she wrote, "to be thankful that I have you to supply her place to me, and that you not only occupy the position, but fulfill the duties of a daughter, and I am sure your best recompense would be found in knowing how my heart rests upon you in its hopes and expectations for the future." She added that she had the next daughter to rely upon as well: "My dear Cliff, too, I know as she grows older and has less to occupy her in the improvement of her mind will stand ready to be comfort and help to her parents, so that I need not say for many years yet, I hope, 'my house is left unto me desolate.'" Sarah recognized that all but one of her daughters was approaching the age of marriage because they ranged in age from sixteen to twenty-two. She expected them to marry and knew that before long she would miss their companionship and assistance.[25]

Sarah expected also that her daughters would embrace devotion to family, as did most southern women. When her daughter Harriet wrote to her other daughter, Mary Clifford, about the former's disdain for domestic concerns, Sarah opened Harriet's letter (without permission), read it, and quickly dashed off a letter in response to Harriet's misgivings. Nearing the time when she would be expected to marry, and watching her sisters marry, Harriet feared having to abandon the intellectual pursuits she enjoyed for the repetitive, mundane tasks of a homemaker, wife, and mother. Sarah sympathized with her daughter's anxieties but reminded her that God's vision of her "highest good" was that she "subdue [her] natural infirmities" and live in service to her family, either her original one or one with a husband. "I too, dear H—, have felt that sense of distaste for the common and ignoble occupations of life and care for the physical wants of a family, which take up so much time and thought," she tried to comfort her daughter. "I fancied myself made for higher and nobler pursuits, and as if my strength and energies, moral and intellectual, might be worthy a higher sphere of action, and fancied how much good I might do to myself and others, could I escape from this drudgery of life." Still, she reminded Harriet that God "marks out for

us our sphere of duty and action in life," and although "you may be deprived of the privilege of storing your mind with such knowledge as you would like to acquire," Harriet should remember that dealing with domestic concerns built one's character. She also should derive pleasure from "knowing how materially you contribute to the comfort and happiness of your parents and the highest good of those entrusted to your care, and are establishing yourself in their hearts a lasting claim upon their love and gratitude." Still, Sarah acknowledged, "Women in domestic life [need grace to help them] as much as . . . martyrs at the stake."[26]

Harriet must have accepted at least some part of her mother's advice because a couple of years later she accepted a proposal of marriage. On the eve of her marriage in January 1853, however, she was irritable and fearful. She informed Mary Clifford that she had "sorted over my old treasures—relics of my happy, childish days—and as I consigned one after another to the flames, I shut my eyes that I might not see the piteous sight." She acknowledged, "I am about as far from the tender, smiling, blissful mood in which young women in my condition are supposed to exist, as the east is from the west." Instead, she anticipated "the storm that is to rage in my soul, in the dread hour when that cake is cut and those floundering, flying, flapping petticoats are tied round me." Harriet knew that her family wanted her to marry and she accepted that purpose for herself, but she understood that marriage held numerous unknowns for a young woman who would have little legal or practical power over her husband or their life together. Sounding like many young southern women who anticipated but were unable to predict the realities of marriage, she confided in her sister, "I do not at all realize the change that is before me. It seems to me that something trying hangs over me, but I never realize what it is." Harriet also knew that to some extent she was leaving her family behind, causing "a sort of shadow . . . over the family circle—they are sorry to have me go—and I feel guilty when I see it, and wretched when I think of the parting." Harriet was experiencing firsthand what a magazine article claimed in 1835: "Marriage is to a woman at once the happiest and saddest event of her life; it is the promise of future bliss raised on the death of all her present enjoyment."[27]

Perhaps the most difficult separation for Harriet was that from Mary Clifford, with whom she shared precious memories and sacred confidences. The distress that many women expressed on the eve of their marriages reveals their deep attachment to their sisters and the temptation not to marry in order to retain those special bonds. Indeed, a decade before the marriage Harriet told her sister that she was her "second self," one to whom she could confide "just as I would write in my journal." She longed for the time when

they would be reunited, "when at length I can have some one to whom to tell every thought." Not surprisingly, upon her marriage Harriet was emotional and dramatic about what her nuptials meant to her relationship with Mary Clifford. "I come to say my last words to you," she began her last letter before the marriage. "Oh Cliff! what can I say to you to tell you all the love for you that fills my heart—all the sorrow that makes it throb and ache when I know that we are to spend no more happy months and years together in this dear home of our childhood." She vowed that she would not allow her marriage to separate them, but betraying her persistent fears to the contrary, concluded, "Oh Cliff! dearest, precious Sister—Goodbye—goodbye. . . . Goodbye." Although Harriet did make the painful break from her family, the ink spilled and angst felt during such transitions into married life indicate that it was a trying time for many young women. No wonder then that some who had ample resources, a reasonably supportive family, and an independent spirit chose to avoid the separation altogether.[28]

Another young woman who similarly vacillated on the eve of her marriage was Martha Foster of Tuscaloosa. In February 1851 she described her beau in her diary: "I like Crawford better than ever: a self-made, easy, every day kind of fellow." Still, this teacher worried about the implications of marrying him. "What will become of my school [and of my sisters] Sue and Sallie?" she fretted. Nevertheless, she had to check herself, noting, "However, that is not the question." A devout Baptist, she had to ask herself a more important and fundamental question: "What is [my] duty?" When Foster did marry in 1857 she was still agonizing: "But oh! my heart was wild with grief. Sometimes, when the reality of my situation would stare me in the face, my frame would convulse—my heart throb—my heart almost cease to beat. But God sustained me."[29]

Given the pain associated with leaving family behind in order to marry, it is not surprising that many women who remained unmarried did so along with a sister. Anecdotal evidence, genealogies, and census records are all replete with single sisters who resided together without husbands, with and without parents. Mary Telfair, who lived in a household of unmarried siblings, had two elder cousins who were sisters and grew old together, ever single. Perhaps they influenced Telfair to follow the call to single blessedness because she admired and visited them throughout her childhood. Eliza and Margaret Telfair lived in Beaufort District, South Carolina, and later in Philadelphia. The sisters left their home infrequently, prompting Telfair to compare them unfavorably to "cloistered Nuns." Still, Telfair respected their abiding devotion to one another. When Eliza died in 1844, Telfair commented, "They were so united in life, so dependant upon each other for comfort and happiness that in this case 'the Survivor dies.'"[30]

Like her cousins, Mary Telfair lived with her sisters all of their lives. When the eldest, Sarah, married in 1815, twenty-four year-old Mary mourned the loss. "Although I was happy to see Sarah united to the Man of her choice (who is amiable, generous & affectionate) still there was a void created in my heart by her marriage which I never before felt," she explained. "[S]he had been my constant companion for so many years, and although our dis positions were dissimilar, I always rested on her for support in all my little *troubles & difficulties* . . . I may in truth compare myself to *the Ivy* and Sarah to the *sturdy* Oak." The young Telfair knew that she could no longer lean on and intertwine herself with Sarah, acknowledging, "It would be unreasonable in me to expect to retain that portion of her affections which I once possessed." Unexpectedly, however, the sisters had their sturdy Sarah back in only two years because Sarah's husband and only child died shortly after her marriage.[31]

For the most part Telfair sank easily into the familiar comfort of her close-knit family, but on rare occasions she admitted that her family's *"mutual dependence,"* as she termed it, might be "productive of more misery than happiness." When she made this comment she had just returned home from a wonderful trip to Philadelphia, where she fantasized she would like to live. "I left Philadelphia with *the deepest regret*," she wrote to a friend. "[I]t suits my taste in every respect, and if it rested with me to make a choice of a residence I would select that place in preference to any in the whole world. I never had such *a struggle* between duty & inclination for I was *half* disposed to stay." Of course, her sense of responsibility to her family overcame her impulses. After all, "They would have missed me so much at home where (between us) I am a very *important* personage & then I am never happy separated from my own family any length of time."[32]

Despite any fleeting complaints the three Telfair sisters lived comfortably with each other without male kin from the time their last brother died in 1832 until the middle daughter, Margaret's, unexpected marriage in 1842 at the age of forty-five. Margaret's husband, forty-one year-old William B. Hodgson, was an American diplomat and Oriental scholar whom the sisters met on their first trip to Europe in 1842. Initially taken aback, Mary reconciled herself to her sister's decision because she knew that Margaret was happy and Hodgson was trustworthy. "I feel as if I had lived twenty years in the last nine months such changes!" Mary wrote from London. "[S]uffice it to say that *I am satisfied*—she appears to be very much attached to Mr. Hodgson and he has been devoted in his attentions to her—I trust that it will be productive of happiness and if she survives Sarah & myself she will not stand alone in this world." Most important for Mary, however, was that she need not fear losing much of Margaret's attentions. Hodgson returned to Savan-

nah with the sisters, where they all lived together in the Telfair mansion; Hodgson took over many of the women's plantation and business affairs. Just like the Unionville sister who believed that "all women [need] a 'congenial female companion' with whom to share their private 'joys and sorrows,'" Mary Telfair and her unmarried contemporaries relied on their sisters for companionship and intimacy.[33]

Another pair of unmarried sisters, Sarah and Angelina Grimké, similarly added a male to their twosome relatively late in life. Born in 1792 and 1805, respectively, Sarah and Angelina denounced their slaveholding society and left their home in Charleston, South Carolina, to pursue northern antislavery work and woman's rights. By the mid-1830s all appearances indicated that neither would marry. Sarah had rejected her only proposal from the one man she loved, a widowed Quaker named Israel Morris, because she feared that marriage would mean as confining and narrowing an existence for her as it had for most women she knew. Angelina, for her part, had accepted the attentions of her suitor, Edward Bettle, also a Quaker. She even moved out of Sarah's house and into her other sister's in order to be more accessible to him. But, sadly, he died. At thirty and forty-three, respectively, Angelina and Sarah accepted their spinsterhood and threw themselves more completely into reform work. Eventually, however, the sisters did accept a like-minded man into their lives. The famous abolitionist Theodore Weld and Angelina slowly developed a loving relationship, and at the end of one of their letters Sarah added a line that indicated her consent to the marriage. Angelina and Theodore married in 1838, and the three of them decided that Sarah would live with the couple indefinitely. This proved fortunate because Angelina became very ill with childbearing and needed Sarah to help her raise her children. Over the years Angelina increasingly leaned on Sarah, even accepting money from her. Unfortunately, as Sarah became the de facto female head of the household and developed close bonds with Angelina and Theodore's children, Angelina felt usurped. As the sisters approached old age their conflicts escalated, and Sarah moved out. Ultimately, however, she agreed to return because, she said, she missed the children. The three adults continued to live together until they died—Sarah in 1873, Angelina in 1879, and Weld in 1895.[34]

<div align="center">* * *</div>

Sarah Grimké's life provides a dramatic example of how adult women without husbands often moved beyond their relationships with siblings to take on central caretaking duties for brothers' and sisters' children. As surrogate mothers—and without the risks and benefits of a husband—these maiden

aunts experienced the sense of usefulness and importance, as well as the frustrations, which came from raising a child. In this way, maternal instincts, at least socially constructed expectations, could find expression without a man. In fact, Mary Telfair explained, "I should be apt to snatch [a child] up but as that is impossible and they are articles too precious to be given or sold I must covet them in vain. I never envied any woman her *Husband* but I have seen several children that almost made me wish to turn Gipsey that I might steal them." Echoing that enjoyment of children, maiden aunt Ann Reid of Charleston sounded much like an aging and proud parent when she reflected on her niece's newly attained maturity and its effect on Reid's sense of herself: "[My niece] has made her appearance in the Ballroom, and is quite delighted, she is much admired, and thinks she has the world and all in a string," she wrote to her brother. "I am beginning to feel quite settled down with such big nephews and nieces." Due in no small part to these relationships with nieces and nephews, she went on, "I still continue to think my Spinsterhood a very charming station, a contented mind is said to be a feast so therefore I cannot be otherwise than happy."[35] Contentment as an unmarried woman often came in part from meaningful relationships with nieces and nephews and a sense of fulfilling one's obligations to them.

Although their marital state meant that they would not have children of their own, many of these women loved children and wanted to have a special place in the lives of young people close to them. Just like their sisters who married, they craved the opportunity to play with a baby or visit with a bright child or have some important role in a developing life. Emphasizing that spinsters were sadly one step removed from those precious articles, Mary observed, "An advantage which Matrons have over Spinsters [is that] the former may return to *second childhood* in the meridian of life [but] the latter can only do [so] in *dotage.*" Indeed, Mary envied even childless friends who had more opportunities than she to dote on nieces and nephews, commenting that her unmarried friend "Sarah Cecil is living life over again in her great Nieces & Nephews—*lucky for her.*" But even Sarah Cecil had felt the limits of her influence with nieces and nephews. Years before she had been "extremely anxious," according to fellow spinster Harriett Campbell, "to have her nephews placed at Northampton" for school but did not know if their father could be persuaded.[36]

Persuasion, pleas, and demands often constituted a maiden aunt's only tools for effecting changes in the lives of beloved nieces and nephews. But everyone recognized that these were not particularly strong bargaining tools. Unmarried women often had little say in decisions about a child's education, or even about how and when a child might leave the care of his or her aunt.

Margaret Williford, for example, a thirty-five year-old unmarried aunt who had been caring for her infant nephew, Olly, from the time his mother died, keenly felt this vulnerability when her brother, Olly's father, decided to remarry. "As long as my dear little Olly is mine, I feel satisfied, but it would grieve me to death to be separated from him," she admitted to her mother in 1849. After all, "I do not believe any mother could love a child more than I do him." Fortunately, the new wife, Carrie Holmes, assured her would-be family that Williford's place would not be usurped. As Holmes wrote to Williford's mother, "Dear Maggie has been considerably troubled at first, I believe, fearing that little Olly would be taken from her, but I told *her* . . . that I thought it would be cruel to take him from her, as she had all the *cares* & *troubles* of him all his life." Still, Holmes did not want to shirk her new duties as a stepmother, claiming, "but at the same time I was willing to do my part." She professed to enjoy Williford and told her future mother-in-law, "You must not expect to have Maggie at home very soon, I cannot let her go, she really seems more like an own Sister to me, than any one I have ever met with. I love her *dearly*." Happily for Williford, she stayed with her brother, sister-in-law, and special nephew for many years, caring for Olly like a mother; supporting Holmes, who miscarried twins in 1850; and comforting both Holmes and Olly when his father died in 1858.[37]

Similarly, in one prominent antebellum Savannah family of eight sisters, the two who were unmarried dutifully stepped in to care for their nieces and nephews when a parent died. Maiden aunt Mary Helen Johnston moved into her brother-in-law William R. Waring's house to raise his five children after her eldest sister and their mother, Ann Moodie Waring, died in 1836. The other unmarried sister, Bellamy Roche Johnston, helped care for other nieces and nephews during various times of loss and illness. Bell, as she was called, lived alternately by herself and with her married siblings, who occasionally offered and received from her companionship and assistance. Harriett Campbell, Bell's friend and a fellow spinster, made clear the importance of this sort of support system for unmarried women when she documented Bell's untimely death. Bell's demise, according to Campbell, was precipitated by her needing or wanting to find her own house, separate from her siblings'. "The thursday before, [Bell] was at my house several hours," Campbell told her nephew. "She must have exposed herself very much on that day looking for a house, as Mrs. Marshall had given her notice that the rent of the one she was in would be raised to %600 in November." Because Bell's "Shoes, and Stockings were very wet . . . , [I] begd her to hurry home & change her clothing which she said she would do." Campbell regretted that her friend did not follow her recommendations and reported that Bell had died with-

in two weeks. "She always interested me very much, she looked so lonely," Campbell remembered in a letter to her nephew. In this case, the storyteller, also a maiden aunt, may have wanted her nephew to understand the perils faced by a woman who lived alone and perhaps lacked adequate attention from her family.[38]

Some unmarried women might admit, as Margaret Cowper did in 1809, "I can *love* children but don't know if I could take the trouble of them." As she told her mothering cousin in Savannah, "It must be so complete a sacrifice of one's own ease & humour." Even well-to-do, proper southern ladies recognized that despite conservative domestic ideologies prevailing at the time, motherhood was not for every woman. Still, most women, to some degree, valued the special innocence and potential of small children, and as maiden aunts and their nieces and nephews matured the doting elders continued to involve themselves in the lives of the younger generation. Three common tendencies characterized the involvement of these well-to-do southern spinster aunts, and Savannahians Harriett Campbell and Mary Telfair provide useful, uniquely well-documented case studies of those traits. First, the women assertively advised and instructed their nieces and nephews in the hope of molding them into responsible adults. Second, they carefully monitored and sometimes supervised the social lives and courtships of the nieces and nephews. And, finally, maiden aunts endured numerous raised eyebrows, family jokes, and other loaded comments that family members, including nieces and nephews, made about their single state and eccentric ways.[39]

During the decades between 1820 and 1850 Harriett Tatnall Campbell, then middle-aged, devoted herself to the three children orphaned by her sister in 1814 and by her brother-in-law in 1823. When their father died the Kollock children, Phineas Miller, Mary Fenwick, and George Jones, were nineteen, seventeen, and thirteen. Like many other maiden aunts, Campbell not only enjoyed the pleasures of instructing her young relatives but also felt an urgency about their development as good, well-educated, prudent adults. To this end, Campbell frequently wrote to her niece and nephews while they were away at school in the North. She admonished them to study, prepare themselves for life, and, of course, report to her frequently. In 1823 she scolded Phineas Miller for not returning her letters more promptly: "I regret extremely my dear Miller to disagree with you on any subject but . . . [I must] convince you what an *enemy* I am to procrastination [and] take up my pen to acknowledge the receipt of your *long expected* but *welcome* letter." Promising to try to come to Harvard University to see him receive honors, she explained, "indeed I have *fully* set *my heart* upon it therefore *do not* disappoint me."[40]

When the boys neared the completion of their studies, Campbell was quick with suggestions and warnings about their futures. She queried the young George in 1828, "What do you both intend doing with yourselves after [school? One] or two persons have mentioned to me that you both thought of studying law?" Campbell thought this an improvement over George's earlier plans: "I am very happy to find *you* do not still think of being a *Gentleman at large,* as the times continue to be very hard—even if you are fortunate to marry a Lady with a pretty *little sum of* $4000, or $5000—the profession will *always* come in *very well.*" Throughout her life and theirs Campbell was quick to offer the advice and guidance they would not receive from parents.[41]

Like Harriett Campbell, many other maiden aunts involved themselves in their siblings' families and were often frustrated by the limits of their control over younger family members. Aunts quickly realized that their assistance might be sought, but their advice and efforts at inculcation into adulthood might also be sorely rejected. Campbell's good friend Mary Telfair and her sister, Margaret, for example, struggled to supervise the educations of their nieces, also named Mary and Margaret. The daughters of Mary's brother Thomas, who died in 1818, and his wife Margaret Long, the two girls required plenty of direction, discipline, and training to make them into the kind of young ladies of whom the elder Mary and Margaret could be proud. Although their mother was still alive, the two aunts believed that she was not up to the task of raising them properly. "I have been playing *schoolmistress* for the last three weeks during the children[']s vacation," Mary explained to her friend. "Mary is Margarets pupil, and little Margaret mine. At first we thought it a hopeless undertaking, for though naturally good children, their tempers have been made irritable by excessive indulgence—and their Mother is perfectly blind to their defects—indeed she allows them to do exactly as they please (this is entre nous)." She continued, "to drill them into order was for the first two days a difficult task, never being accustomed to study before or look into a book at home—we found them a little refractory but Patience and Perseverance will in the end triumph." Although the two aunts felt keenly their nieces' need for formal training, the elder two wished not to overstep their boundaries as aunts. "I am in hopes [Mrs. Telfair] will become so sensible of the importance of a good education that she will allow Mary to go on to the North to school next summer. We feel the delicacy of our situation and cannot *urge* what we wish," Mary complained in 1826.[42]

The young girls' lack of discipline deeply troubled their Aunt Mary and probably their Aunt Margaret as well. After all, Mary wrote, "they are the representatives of a beloved Brother for whom I would have made any earthly sacrifice, and whose untimely loss I shall never cease to deplore." It was a

sad reality, according to Telfair, that the two "have not the *Telfair temper* either of them which *I* regret." As representatives of the family the girls tested their aunts' patience and devotion. The older one, Mary, "from possessing a slow mind, finds committing to memory an Herculean labor." The younger, Margaret, benefited from a quicker mind, "but she is careless, volatile, and indolent . . . the most singular child I have ever known." A couple of months later, Telfair continued working on young Margaret. Although the girl was "uncommonly attractive," Mary found her overly indulged, willful, and difficult, "but by never overlooking a defect of temper—and never allowing her to *command* a Servant—she is much improved." Telfair took credit for young Margaret's progress and rejoiced, "I have been so fortunate as to win the affections of my Pupil completely—she is very anxious to be christened over again that I might be her God Mother and begs me to adopt her." When their mother had been convinced of the value of a northern education, both girls enrolled in schools where their aunts' friends, also unmarried, kept an eye on them. "We are much indebted to you for your kindness to Mary and I am glad that you have interested yourself in her improvement," Telfair thanked a friend in New York. "She requires urging on, as much as a lazy Horse does a spur— . . . I was shocked at Mary's backwardness, for at eight years of age, I was farther advanced in my Education than she was at thirteen."[43]

Little is known of Telfair's relationship with her nieces as adults, but nearly twenty years later she extended her teaching and caretaking attentions to her great-niece, Alberta, the daughter of her troublesome niece Mary after the latter's death in 1839. "Berta is installed as my pupil for the winter—she took her first *lessons* yesterday and seemed interested in them, she is to come to me every morning from 9 to 1 o'clock," Telfair wrote in 1842 when she began her tutelage. Again, Telfair and her sister-in-law wrestled over the issue of the children's upbringing, and in this case Berta's education. Telfair was relieved when she enrolled Berta in Montpelier Institute, an Episcopal girls' school near Macon, away from her ineffectual guardian and grandmother, Margaret Long Telfair. Although she was pleased with Berta's progress at the school, for some reason Telfair withdrew her niece and personally took over her education in early 1843. "I am deeply interested in poor little Berta and would do any thing for her improvement," she explained.[44]

Ironically, despite her great aunt's careful guidance, or perhaps in part to rebel against it, Berta ultimately brought scandal and humiliation to her family, especially to her very proper aunt. Berta, nearly fourteen, was living with her grandmother when she dressed herself one morning, told the house slaves that her grandmother had given her permission to leave, and walked

off. According to Mary, at eight o'clock that evening she returned home and "with her cloak and bonnet on, went into her Grand Mothers room [and] told her that she had been married in the morning by Justice Bruen." Her husband, Charles Arnold, who was significantly her senior and motivated by greed, Telfair was sure, was waiting "at the door in a carriage to take her to the Charleston boat—hoped her Grandmother would forgive her, and tripped off."[45]

Telfair was aghast. "My dear friend, The deed is over, and Berta's fate is sealed," she began a letter to a friend, "and a miserable one it will be if I have any *prescience*." She could not believe Berta's cruelty to her grandmother and to the rest of the family. "I feel as if she were dead to every feeling of humanity as well as decency," Telfair wrote, "but what else could be expected from such a training[?]" Again, Telfair largely blamed Berta's grandmother, who had been raising her. "The Pupil of Sarah and companion of Negro's—no moral principles inculcated—permitted to run wild like an animal," Telfair remembered scornfully, "indeed I have often said to my Sister—it is the education of an Animal allowed to eat, drink, sleep, and frolic." Berta had long expressed her desire to marry Arnold, and, Telfair confided, "I think (*between us*) that [Berta's grandmother] wavered much about giving her consent to the marriage." Telfair believed "[i]t was better for the poor wretched child that she did not yield to her wishes." There was some concern about the property Berta owned not having been secured for her in a separate estate before the wedding. Establishing that legal protection, however, would have indicated her grandmother's consent to the marriage, and she "would justly have been condemned for permitting a child of fourteen to marry—and the reputation of her child would have been sacrificed to a marriage settlement." Quite sure she could have raised Berta better herself, Telfair remarked, "If she had been my charge I would have had her taken away by force to save her from an union with a villain, but Mrs. [Margaret] Telfair's want of decision & firmness has been the bane of her existence." Telfair claimed that Berta's hold over her grandmother "was super human—she could make her hate or love whom she chose." Saving her worst opprobrium for the cradle- (and fortune-) robber, Telfair blasted, "but I hope that she will never make her love the Wretch who has torn her child from her & blighted all her Earthly hopes."[46]

Nearly two months later Telfair continued to wonder what might have been with her great-niece. "I do regret that I took any part in trying to prevent an elopement which to every person of common sense & delicacy must have appeared a moral obliquity," she admitted to a friend. "Had I been permitted to have taken her to the North & superintended her education

until seventeen, she might have been a respectable & a useful & a happy woman. You know what has been the fatal result of growing up like a weed, & I very much fear from all that I hear a baleful influence will be spread wherever she goes." A couple of years later, living in the upcountry and separated from her husband, who was in Savannah, Berta engaged in an indiscretion so significant that Telfair refused to commit it to paper. Invoking the image of the ancient female Greek poet from the island of Lesbos who is known for her erotic lyric verse and exile to Sicily, Telfair predicted, "Sappho will yet be her ruin; if I am any Prophetess." Next, Telfair compared Berta to one of the kings of Israel who took the throne by murdering the reigning monarch: "The next imitation of Mrs. WB will be *a Divorce*. I look upon the first, *chariotteering,* as innocent but the *Jehu boldness* which is displayed invited coarse remarks, and there are Men always ready to say vulgar things of Women who dare to depart from the path of Delicacy."[47] It is impossible to ascertain precisely what Berta had done, but her aunt's allusions suggest that she had committed some sexual indiscretion, probably with a white man but possibly with a black man or a woman. Surely that would alienate her from the proper society of her humiliated aunts. Indeed, aging maiden aunts perceived themselves as guardians of propriety, family honor, and community standards even though they themselves had not followed the typical trajectory of southern women to marriage and motherhood.

Berta did divorce but managed to remarry and have children. Much to Mary Telfair's disgust, however, before she took a second man's name she began using the name *Telfair,* which was not her maiden name. When Telfair heard a gentleman remark that a "Mrs. *Addison* Telfair" was taking the boat to Charleston, Mary protested, insisting there was no one by that name. When she learned that this was Berta, who had taken her grandfather's name, Telfair balked, "I feel provoked at her taking a name she is [in] no way entitled to but I hope that she will change it soon." Telfair suspected that Berta's grandmother had encouraged her to take the name, probably for the social prestige and hoped-for new identity, but Mary saw no resemblance to Thomas Telfair in Berta, particularly given her "want of Truth" and "total want of sympathy with her species." Evidently, Berta routinely exhibited flagrant disregard for her aunt's conceptions of appropriate behavior. Indeed, Telfair made another unfavorable comparison of her niece, this time to the ignorant, arrogant, and masculine character, Harriet Freke, in Maria Edgeworth's novel *Belinda* (1801). "She is more like Harriette Freke in Miss Edgeworthes Novel of Belinda than any one else. *Half man, half Woman,*" Telfair remarked. The aging aunt believed that Berta was not a real Telfair and

certainly not a proper lady. Moreover, her horror and embarrassment were surely punctuated by the close tabs elite southerners kept on one another and their courtships, marriages, and family developments.[48]

Although she experienced nothing so scandalous in her own family, Harriett Campbell was similarly absorbed by the courtships and matches of family members. Unmarried women's correspondences in particular are full of discussions of who was courting whom, who was engaged to whom and whether these were good matches, and who was enduring an unhappy marriage. Campbell had the added responsibility of overseeing the social life of young Mary Fenwick Kollock when that niece came to live with Campbell after completing her northern education. Kollock delighted in Campbell's townhome, telling her brother, "Aunt Harriett lives delightfully, and has one of the handsomest houses I have ever seen; the furniture and every thing else about it is beautiful." Savannah came to be just as welcoming and comfortable. "Aunt Harriett and myself have just been talking about this *delightful place,* and have come to the conclusion that it is the most *charming* city to live in, for you can do just [as] *you please;* and no one asks why or wherefore. I never saw Savannah look as gay and fashionable as it does this winter," she wrote to her brother.[49] Kollock was quickly coming to appreciate the relatively open and social nature of Savannah society that made for such a hospitable setting for well-to-do unmarried women.

Interested in far more than Savannah itself, however, the young Kollock expressed an early and clear interest in meeting the eligible young men of the city. She had, for many reasons, no intention of following in her aunt's spinsterial footsteps. "Some persons predict a gloomy winter but I hope not . . . [military relocations] will produce quite a vacancy in the list of *beaux* which is not *very long* at any rate," she complained. Kollock's family, including her Aunt Harriett, tried to accommodate the young woman's desires. At the beginning of the new year Campbell worried that too few balls would be given to suit her niece. Perhaps in part because of this perceived dearth, the otherwise reserved Campbell, who disdained such "dissipation," threw Kollock a twenty-second birthday ball that March of 1828.[50]

Despite Kollock's early contentment in Savannah and her aunt's efforts to avail her of social opportunities, Kollock and her family were distraught as each birthday passed without a husband. By mid-1831, when she was twenty-five, she began to feel defeated, describing her quest as a *"forlorn hope."* Self-consciously and sarcastically, she compared her life of relative freedom to those of married women friends whose lives were dictated by their husbands: "Now behold the contrast! We of the *'Sisterhood,' unfettered* by the *matrimonial chains* can rove wherever our *inclinations lead,* and can

form our own *plans,* and *carry them into effect* without being *obliged* to consult any one else." She asked her brother rhetorically, "Now do you not wonder at the *bad taste* of any one, in preferring *matrimony* to *single blessedness?*" Despite her sarcasm, Kollock objectively understood the benefits of "the Sisterhood." She lived with an aunt firmly committed to the single state and probably socialized with Campbell's clan of ever-single friends. But the younger woman clearly wanted the fetters and benefits of matrimony. "It is not such an *easy matter* in *'these parts'* to *'pick up a Husband'* that *one can fancy"* she defensively told her brother in 1831.[51]

No family letters questioned Campbell's permanent singlehood—or Kollock's determination to avoid the same fate for that matter—but siblings, aunts, and cousins fretted excessively about Kollock's advancing age and lack of a husband. Although her Aunt Harriett's spinsterhood was acceptable to the family, Kollock's was not. The older woman was wealthy, eccentric, content, and a generation older than most of her family. She had accepted the call to single blessedness from an early age, at a time during the early nineteenth century when American women, particularly in the North but also in Savannah and Charleston, began to accept their responsibility to the country as moral leaders of children and, to some extent, of men. Moreover, many women, especially in the Northeast, began to pursue new intellectual and benevolent challenges. In small but increasing numbers, well-to-do American women of Harriett Campbell and Mary Telfair's generation began rejecting marriage for a number of reasons. Some believed they would never find a man who fit the "beau ideal." Others feared being tied to a man who could easily strip them of their dignity, wealth, and mobility. Then there were the mortal risks of childbirth. Especially for increasingly well-educated northerners, marriage threatened to extinguish intellectual creativity, self-exploration, and benevolent impulses. American culture and literature were beginning to celebrate the purity, dignity, and blessedness of the single life for women (chapter 2).

Why Kollock wanted so badly to marry, despite her aunt's example, probably comes down to personality differences and individual preference. It is also possible that by 1830 there was more pressure on southern women to marry than earlier in the century, even in cities. By then the South was gripped by mounting anxieties about northern economic, political, and social power; about antislavery movements in the North and slave rebellions in their midst; and about women's increasingly public roles, especially in the North. Kollock's contemporaries celebrated the southern family as the embodiment of a well-ordered, divinely ordained society, increasingly under attack.[52]

Another factor that likely differentiated Kollock and Campbell's situations

was wealth. When she was in her mid-twenties, Campbell had inherited her also-unmarried sister's sizable estate. The two sisters had shared ownership of a plantation in Richmond County, Georgia, and, perhaps knowing she might die soon, the older sister left Campbell her half of the plantation and all of the property with the exception of three slaves. She also named Campbell sole executrix. Probably, Campbell's independent wealth helped facilitate her inclinations against marriage. By contrast, Kollock's personality and preferences, in addition to her youth and era, caused her to desire a more customary path to maturity, and her fate still seemed malleable, particularly when she was in her twenties and lived with her aunt. The family believed she should have what they (and she) wanted for her: a loving companion and, hopefully, children. Because her father left her more than a third of his estate when he died, which was more than he left his sons who went on to be successful planters, she might have been able to live independently had she wanted that. But some combination of individual personality, family pressures, and possible social currents dictated otherwise. Although her Aunt Harriett was quite pleased with her own situation, she could not, or would not, alter her niece's fundamental dreams of marriage. Finally, in 1838, and at the relatively advanced age of thirty-two, Kollock married a widower, the Rev. Edward Neufville, an esteemed Episcopal minister in Savannah.[53]

In return for hosting her niece and generally playing the role of the good maiden aunt and surrogate mother throughout her adult life, Campbell, like her unmarried peers, expected that nieces and nephews would treat her with respect, kindness, and gratitude. She also assumed that younger relatives would indulge her various wishes. These requests and indulgences, plus her eccentricities, made Campbell easy prey for family jokes and raised eyebrows. She expected, for example, her nieces and nephews to oversee extremely detailed instructions for the maintenance of her house and its preparation for her return from extended trips away, and evidence suggests that they dutifully humored her elaborate requests. In the fall of 1829, when she was attending George Jones's college commencement, she requested her nephew Phineas Miller to manage her house slaves' work, write letters to overseers, and send allowances to the slaves. A couple of weeks later she sent him a lengthy list of additions to those requests: "[W]ill you be so good as to desire Rachael to send for a chimney sweeper & have *all* the chimneys in the house (with the exception of the front chamber in the *third* story) swept—say to her I wish it done *before* they commence to scour," she began. "As soon as the paint is cleaned, & the rooms scoured let the bedsteads be put up, then have the windows washed, the brasses cleaned, the furniture rub'd—after this is all finished desire Ned to let you know, when I will get you to write for Dicky, to come in, & assist them in shaking the Carpets [and] . . . putting

them down," she continued. But there was more. "The carpet for the stairs I wish put down likewise, but *not until* he has gotten through the rest of the business, as I know is very *slow*. do say to him, he must give an eye to Quash, that he does not slight any part of work he undertakes." Also, "Tell Rachel all the *house* work must be finished, before Quash is taken off to attend to the kitchen, & do say to them *all*, I shall *depend* upon their *industry*, in having *every* thing in *fine order* on my arrival." This letter and the ones that followed, particularly for the next several years, were filled with extremely detailed instructions of what was to be cleaned, by whom, and how.[54]

If the length of these to-do lists was not uncommon among wealthy traveling southerners who needed assistance with their properties, the procedural detail in Campbell's letters was exceptional. Moreover, her requests sometimes bordered on the trivial and bizarre. It appears that her family thought so, too. "You will laugh no doubt, at the request that I am now going to make, in behalf of Aunt H.," Mary Fenwick prepared her brother. "She begs you will bring out under *your protection* two pair of those large *Fowls* such as Miss W. Smith sent to Mrs. Jones; she hopes you will not *infer* from this that *Fowls cannot* be *procured* in Savannah, but those she wishes are of a peculiar kind and she wants them to send to the plantations. She begs you will *bring* and not *send* them as you will take better care of them than any one else."[55]

Another time Campbell caused a stir in her family when, according to her brother, she "introduced *gaslight* into her house & was about converting her library room into a bathing apartment, in having the water conveyed, I suppose by forcing pump, from the pump in her yard into the library room." Campbell may have wanted water available in the room where she spent most of her solitary time. Fortunately, her brother acknowledged, "I am more reconciled to this metamorphosis as my Sister's library is only an apartment *for* Books." Perhaps he meant to indicate that it was not fit for proper human company anyway.[56]

Occasionally, Campbell's curious ways caused more concern and anxiety than amusement. During the terrible yellow fever epidemic of 1854, Campbell's brother Edward wrote to his nephew on numerous occasions, expressing his hope that Campbell would abandon her stubborn plan to remain in Savannah. "I feel very anxious about my Sister. I have written her repeatedly, urging her to come up to me. She declines doing so as yet, I shall write her again tomorrow," Edward fretted. Campbell later apologized for ignoring everyone's well-meant advice. Admitting to her nephew that he had "every cause . . . for thinking me a very strange person" before he received her letter, she claimed that she never received his letters of concern and invitation. She said nothing of Edward's letter. Fortunately, she wrote, "I am thankful that the fearful Epidemic has nearly passed." She may have been

equally pleased that her family would stop telling her what to do for a while.[57]

Clearly, Harriett Campbell and Mary Telfair were independent, opinionated, and outspoken. Admittedly, as case studies they do not fit the southern female ideal (at least as historians have described it) of dutifully becoming wives and mothers. But what gave them their identities as proper southern ladies was their usefulness to their families. Especially as aunts (and surrogate mothers) they tried to cement their places within their families and sought satisfaction and pride from these relationships. Like mothers, they instructed young nieces and nephews. Like mothers, they monitored nieces' courtships. For some unknown reason those years were not particularly successful for either Mary Fenwick Kollock or for Berta, which may tell us something about their aunts' abilities in this area. But what is most significant for this discussion is that these aunts served as faithful guardians and did not keep the young women from wanting or eventually finding mates. Finally, despite their families' devotion to those maiden aunts, at least in Campbell's case, nieces, nephews, and siblings could not resist talking about an aunt and chuckling at her unusual ways.

* * *

Although they were occasionally the objects of gossip even in their own families, the well-to-do unmarried ladies of Charleston and Savannah often threw themselves into relationships with brothers, sisters, nieces, and nephews. Engaged in a mutual exchange of love, support, and sometimes judgment, antebellum southern spinsters and their families came to rely upon one another. These relationships gave meaning to unmarried women's lives and allowed them to keep their identities firmly and safely rooted in their families. Issues of dependency, misunderstanding, ingratitude, and personality conflicts clouded most relationships at one time or another, probably with greater frequency and intensity than the women and their relatives revealed in letters. But by and large the handful of well-to-do unmarried women whose lives can be reconstructed in some way found pleasure and purpose in service to their families. That these women for the most part enjoyed considerable wealth as members of an educated, mobile, slaveholding class certainly made their single state more palatable than it was for other women who were less fortunate. In addition, that they lived in Savannah and Charleston meant they could enjoy an active social, intellectual, and benevolent calendar with other like-minded women. Many even found opportunities for travel to the North and even to Europe. Yet all of these privileges would have been meaningless had they not had a sense of themselves as useful—indeed, indispensable—daughters, sisters, and aunts.

4. "To Know That *You* Still Love Me"
Female Friends and Female Friendships

Happiness is the natural design of all the world and every thing we see done is in order to attain it. My imagination places it in Friendship. By friendship I mean an entire communications of thoughts, wishes interests and pleasures being undivided; a mutual esteem which carries with it a pleasing sweetness of conversation and terminates in a desire to make each other happy without being forced to run into visits noise and hurry which serve to trouble, rather than compose the thoughts of any reasonable creatures.

—Mary Telfair, Commonplace Book, 1816–20

By her thirties Mary Telfair had concluded that happiness was the natural motivation and goal for everyone in the world, and friendships were her own chosen means of achieving that happiness. So central to her social and emotional well-being, friendships with other women gave Telfair community and communion, acceptance and empathy, and peace and stimulation. Indeed, Telfair was not alone. Friendships with other females were one of the most powerful influences in the lives of well-to-do nineteenth-century American women. Such relationships held a place in their lives second only to family bonds and influences. From the time young sisters played together, to the days when school girls exchanged love notes, to the years when aging matrons comforted one another through life's troubles, southern women developed lasting bonds with one another, particularly when they shared similar life experiences. Because they were not tied to the needs of a husband, his work, and their children, unmarried women had unique opportunities and needs to cultivate such bonds. In addition, they were free to choose and keep friends in ways no married woman could take for granted. Finally, those in the urban settings of Charleston and Savannah were specially situated to meet a variety of friends, develop bonds of different degrees, create a wide web of relationships with married and single, northern and

southern, elites, and access travel routes that helped them sustain ties with other women all along the East Coast.

For Mary Telfair, surely Savannah's best-known and most prolific never-married lady, as for most nineteenth-century women, the heart of good friendships lay in communication, whether face to face or through correspondence. Frequent and lengthy letters allowed female friends (especially unmarried ones with the time to write) the chance to keep in touch and proclaim their mutual affection. Direct communication, far easier for women in urban or vacation settings, nurtured friendships, cemented family interconnections, and engendered mutual dependencies. As Telfair commented in 1823, "The conversation of animated intelligent people possesses a charm to any other in the world." At age thirty-two she had surmised that women held the greater gifts for this all-important skill. "Nature has fitted Women for conversation. Their minds are more refined and delicate," she copied into her commonplace book. "Their imaginations more vivid; and their expressions more at command. When sweetness and modesty are joined to intelligence in this composition, the charms of their conversation are irresistible."[1] In fact, when one of Telfair's friends died in 1842 she was eulogized and celebrated for her "conversational powers" and excellence in correspondence because it was through these activities that she aided and enlightened so many people. To be sure, Mary Telfair was like countless other nineteenth-century American women who relied on pleasant conversations and meaningful friendships to sustain, occupy, and fulfill themselves.

* * *

Women's historians have been exploring women's friendships and the possibility of a shared culture among women since the 1970s, and it seems wise to outline this important debate briefly at the outset and suggest where the women of this study fit into the larger story. Carroll Smith-Rosenberg first described as "a female world of love and ritual" the matrix of mutual understanding, emotional connectedness, and even the possibility of passionate sensuality between middle- and upper-class American women. Bonds of womanhood flourished, especially in the nineteenth-century Northeast, as women found themselves and one another in increasingly sex-segregated physical spaces such as their homes and in certain vocational settings. They also found themselves united by such emotional contexts as the perceived notion that women had a unique potential for purity, morality, and sentimentality. Rigid twentieth-century distinctions between deviancy and normality, genitality and platonic love, and homo- and heterosexuality do not

easily apply to the rich and complex world of women's interaction during the nineteenth century or even earlier. Indeed, sexologists would not develop the term and concept *lesbianism* until the turn of the century; Freud's profound impact on American thinking about all love relationships would not be felt until well into the twentieth century. Recently, however, some scholars have questioned this distinction between nineteenth- and twentieth-century understandings of love. They have suggested that a specific homosexual, or lesbian, identity *was* possible in the eighteenth and nineteenth centuries—long before Freud.[2]

In either case, the women and men of this study, and their peers, acknowledged that love between women could be both passionately intense and spiritually pure and uplifting. Women especially appreciated that only with other women, at least certain women, could they be at their most free and honest. As Margaret Fuller reflected in her journal in the 1840s, "It is so true that a woman may be in love with a woman, and a man with a man." Homosocial bonds had the potential to be "purely intellectual and spiritual, unprofaned by any mixture of lower instincts, undisturbed by any need of consulting temporal interests."[3] Those "lower instincts" were the sexual obligations considered unattractive to many middle- and upper-class women, and those "temporal interests" were the practical and ignoble realities of choosing a mate. Platonic (although physical) love between women avoided all of that, plus much more, and could offer other benefits as well.

Scholars of the South also have explored the extent to which plantation mistresses, farm wives, and urban ladies had intimate female friendships, a shared culture, and a sense of community that scholars of the Northeast and Europe had identified. To what extent were southern women's relationships similar to or different from their contemporaries' in the industrializing North, where the "market revolution," industrialization, and urbanization fueled the practical and emotional separation of the sexes, separate spheres ideology, and the Cult of Domesticity? Pioneering studies saw few opportunities for southern women to maintain vibrant friendships, networks, and communities. Adult women had close female friendships, especially during school years, but relationships were governed by the isolation of farms and by the plantation economy. Other studies that had narrower overall focuses, however, revealed an important sense of community and friendship among well-to-do nineteenth-century southern women. From the time they were school girls, enjoying (and enduring) romantic relationships with each other, to their quieter mature years, southern women spent a great deal of time and energy thinking about, talking to, writing, and caring for their friends—women who were almost always of the same race, class, and gen-

eration. Most of the friendships described here were intimate and physically demonstrative. Only one was probably sexual.[4]

Female friendships served a variety of purposes throughout a woman's life, regardless of whether she married. Unmarried urban women in particular came to depend on a distinct female community that prospered in Savannah and Charleston and extended outward to those in the rural South and in other seaboard cities. Elite southern society did not associate these friendships with unseemly northern and largely middle-class trends. To the contrary, the society celebrated such relationships for a number of reasons. First, women gave other women important emotional support. The friendships also undoubtedly lessened pressure on family members who might otherwise be burdened by needy unmarried relatives. Finally, the relationships posed no perceptible threat to the institutions of marriage and motherhood. After all, the vast majority of women married, and those who did not aided their families in traditional ways.

By the middle of the nineteenth century, many elite southerners grew nostalgic about true female friendships, associating them with some golden age of moral rectitude, personal and spiritual purity, and elite exclusivity, all of which were increasingly under assault by the corrupting influences of commercial expansion and democratization. Contemporaries acknowledged that the relationships had risks, but those were usually individual or personal in nature (and relatively minor at that), as when a woman became too dependent on another for her happiness. Very few observers, or the women themselves, fretted that female friendships could threaten or preclude marriage altogether. Mary Telfair provides a case study of an urban, southern woman's friendship with one special person; with a network of unmarried friends; and with those who married and whose experiences were reminders of what she had avoided. She observed also how women's friendships could suffer when one friend married.

* * *

Whether or not women eventually married, their earliest and strongest ties to one another occurred in their natal families. Ties between sisters were powerful, and the marriage of one sister often threatened an abrupt end to a certain closeness between two, usually young, women (chapter 3). About the time Mary Telfair was reflecting in her commonplace book on the centrality of friendships to her happiness, she noted that one of her also-unmarried friends had lost her happiness because that woman's half-sister and best friend had decided to marry. Comparing the breaking pair to Adam and Eve, Telfair explained that her friend Harriet "was about creating a little Paradise"

for herself and her half-sister. "She [had] commenced building a House, designed a spot for a garden and looked forward to Sarah & herself inhabiting it like our first Parents in . . . Eden[,] culling flowers and enjoying a life of ease and tranquillity but the *tempter* came."[5] Female friendships, even those among seemingly like-minded sisters, were no more protected from a break in intimacy than heterosocial or heterosexual relationships. In fact, they were in many ways more vulnerable to loss. Two sisters would sometimes remain best friends, lifelong companions, and maiden women throughout their lives.

Because natal sisters shared such intense and loving bonds, nineteenth-century women often modeled friendships with other women after sororal relationships. Creating what one historian terms "fictive kin," particularly when they found themselves away from home, women leaned on one another for support, shared interests, and love. Sometimes they found that the new relationships provided a deeper level of intimacy than even family ties could offer. As seventeen-year-old Maria Lance of Charleston observed to a female confidant in 1837, "I know [that] instead of decreasing, my love for you appears to strengthen the more I reflect that in all probability we will never meet again on earth." Lance's friend, Anne Jemima Clough, had just boarded a ship for Liverpool, where she went on to become an important women's educator. "It is a startling & afflicting thought to me, Dearest Anne," Lance continued, "for there are times when I could pour out my soul to you upon subjects which I *cannot* converse upon even to my best earthly friend, my Mother."[6]

In part because most women did marry, their friendships occasioned few objections from parents and other relatives. Indeed, girls' and women's relationships with one another were "an essential aspect of American society" at this time, Smith-Rosenberg maintains. Most antebellum Americans realized that such alliances rarely precluded marriage in and of themselves. They believed that female friendships enriched women's lives before, during, or after marriage, or sometimes when a woman failed to marry for other reasons, but southern observers especially did not grant female friendships—or southern women in general, perhaps—that much power, or desire, to subvert such a fundamental institution. Common practice and common sense required that a southern wife would prioritize her relationship with her husband and children over friendships with other women. Moreover, men and women saw women's relationships with one another as part of a benign and often beneficial web of relationships among individuals of the same social class.[7]

For those without husbands, relationships among women were especially beneficial at times of personal loss. Ever-single Savannahian Mary Anne

Cowper, told the story of an unmarried female friend from the lowcountry whose mother had died recently, it was clear that an intimate relationship with another woman sustained the bereaved daughter: "[Miss Hunter] may prefer remaining in England with her small independance—her Mother, you know, was most decidedly against her living with her Brother—but I have a great notion he could persuade her to do any thing if he was to try—and she expects he will come to England whenever his intelligence reaches him," Cowper began the tale, passing it along to her cousin in 1813. "What Miss H's income is I do not know—but it remains the same as in her Mother's life & therefore must go farther for one than two." Miss H. was not alone. Cowper was pleased to report, "[Also,] there is a Lady in this House with whom Miss H is confidentially intimate & who has jointly with Miss H. taken the same apartments she occupied with her Mother—which we are all glad of as Miss Hunter sleeps with her &c—and Miss H. I trust will ere long recover her equanimity survival habits." The relationship, Cowper implied, could support and benefit Miss H. like no other. "She knows your repeated kind offers to her respecting a home," Cowper assured her Savannah cousin. "[B]ut she said that would never do, as it would offend her Brother."[8]

The unmarried narrator of this tale thought it ideal that Miss Hunter was financially independent and intimately connected to another woman. That the two intimate women shared a bed in addition to a life made Miss Hunter's bereavement more tolerable and her happiness more assured. Furthermore, Cowper had a low opinion of Miss Hunter's alternatives in Georgia: "I do not regret her opinion as I am very confident Georgia would not suit Her—She would not be pleased with the state of Society at best—& you and I know single women there are regarded as mere lumber and Miss H. could never be reconciled to being of no consequence."[9]

Some American literature of the nineteenth century reflected and fostered an increasingly positive view of unmarried women such that some decades later Cowper may not have seen Georgia, or at least Savannah, as a harsh sentence for her friend (or herself). Especially in the South, never-marrying women remained the clear demographic minority, but the female friendships they formed encouraged and busied them. There were, of course, limitations, most obviously those created when one or both of the women did marry.

Mary Anne Cowper's sister, Margaret, married at the relatively late age of thirty. Still, she maintained a close tie to the same Savannah cousin to whom her sister, Mary Anne, had written about Miss Hunter. Despite the pleasure Margaret derived from her friendship with the cousin, and in part because of it, she worried lest she become too dependent on the cousin's love and friendship. "Your society is a comfort & a pleasure when I can get it but must not

constitute the chief pleasure or I should be far more unhappy than you would wish me," she confided to Eliza Mackay around 1812. Perhaps in part because both she and Mackay were married and her cousin had children, Margaret struggled to restrain her natural inclinations and lean heavily on the friendship. Apparently, she had observed other women hurt by relying on female friendships. As she explained to Mackay, "I don't know if exclusive friendships occasion most pain or pleasure—Strong attachments which circumstances have embittered, has been the cause of sorrow & discontent to our Mothers, mine at least! the love of her friends was a misfortune in her lot & now disturbs her peace. Adieu my dear. I wish to love you not too well, but wisely."[10]

We cannot know why or how Margaret's mother was disturbed by her love for her friends, but most nineteenth-century Americans recognized that the best kind of female friendship demanded a great deal—honesty, selflessness, availability, affection, and consistency—to permit the kind of intimacy and mutual support of which they were capable. In fact, by the middle of the century, elite East Coast women increasingly lamented societal trends toward self-interest and social democratization, and that anxiety spilled into fears that disinterested, elevated friendships between like-minded women from established (perhaps blue-blood) families would become nearly obsolete. Ladies of the American aristocracy (of sorts) feared that new wealth and the new individuals entering monied society were eroding the intimate connections among them as well as the exclusivity and refinement that fostered those ties. Aging women in particular worried that their pure attachments to other women were in jeopardy. Mary Telfair, for example, pined for the days of old when in 1843 a female friend told her that she had a "romantic friendship" with another woman. Telfair remarked, "Such evidences of a romantic spirit in these days would appear ridiculous, for self interest appears the order of the day. Our community is entirely changed—the tone and standard very low." Part of what Mary Anne Cowper and Mary Telfair shared was disappointment with the individualism and personal selfishness they felt were part of the recent evolution of their society.[11]

Many antebellum southerners waxed nostalgic about the female friendships of the first part of the century. When Alicia Hopton Middleton of Charleston recorded her memoirs of life in antebellum South Carolina and the Northeast, she romanticized and eulogized the pairs of unmarried women in her family from a preceding generation. Unmarried herself, Middleton, who was born in 1848, described in glowing details her mother's two sisters, Martha and Eliza, who remained unmarried together and helped their parents keep the house and run the family business. Eliza was dignified, serious, and formal, betraying her "colonial days" upbringing. Perhaps explaining

her spinsterhood, she had been scarred and made deaf by smallpox as a young woman. Eliza's sister, by contrast, was Middleton's clear favorite. Martha had "[come] into youth just after the Revolution," and she was practical, heroic, interesting, lively, kind, cheerful, and modest. Middleton attributed her permanent singlehood to "an aversion to . . . matrimonial love," yet Middleton was grateful. "I do not think any man could tempt her into wedlock. It would be a most unpardonable monopoly if any one should; . . . a theft from the whole community."[12]

Similarly, Middleton admired her elderly cousin Harriot Pinckney, who was born in 1776. She respected as well Pinckney's long-term companion, Miss Lucas Rutledge, who also never married and was nearly forty years older than Alicia Middleton. Remembered as the perfect antebellum maiden, Harriot Pinckney was kind, benevolent, generous, intelligent, and wealthy if "plain." Her special friend, Rutledge, was also quite "plain," although she must have had other positive attributes to warrant her close connection to Pinckney. Together, the two women welcomed still more unmarried female pairs into their household. When the elites of Charleston fled the city during the latter half of the Civil War, Pinckney and Rutledge accompanied the Middleton family to the upcountry, securing living quarters together at each step along the journey. Indeed, Americans celebrated these relationships as embodiments of moral rectitude, commitment, self-reliance, and purity.[13]

It was not until later in the century, when the Civil War threatened to destroy southern society along with its fairly balanced sex ratios and traditional gender roles, that a few contemporaries worried about the implications of intense female friendships. At least one observer tried to blame female friendships for the number of young women in his Charleston family who remained unmarried during the war years. As his unmarried cousin Harriott Middleton told her cousin Susan Matilda Middleton, also unmarried, Cousin Will had paid her a visit, and "He gave a little lecture on female friendships to which he strongly objected, as being so satisfactory as to preclude marriage!" Harriott Middleton, amused and perhaps slightly annoyed, quipped, "We shall know now what to say to our great nieces and nephews when they ask us why we did not marry. It will sound more graceful than the lst answer I was obliged to give the question, 'bad taste in the men my dear.'" She and Susan Matilda Middleton had maintained a strong, lifelong relationship based on love, kinship, and compatibility; especially during the war, when they were in their thirties, they relied on a regular correspondence of gossip and mutual support. Still, the suggestion that their friendship had precluded their marrying seemed absurd.[14]

* * *

This study's most outspoken and revealing unmarried lady, Mary Telfair of nineteenth-century Savannah, wrote extensively of her single state and of her many female friends, but she, like the Middleton cousins in Charleston, would never have believed that there was a causal relationships between her lack of a husband and her plethora of close female friends. Indeed, her friends provided a forum to explore what it meant to be single, and they offered plenty of emotional support, intellectual stimulation, and purpose, making her single life far more enjoyable and meaningful than it would have been otherwise. Telfair's friendships were of three categories. The first was her lifelong, loving, and somewhat exclusive relationship with Mary Few. The second set of relationships was with other friends, many of whom were similarly unmarried for life and who offered Telfair companionship, empathy, and models. Finally, Telfair maintained many relationships with friends who did marry and who usually moved away from the close-knit circle that sustained Telfair on a day-to-day basis. The challenges these wives faced in their married lives served as useful reminders to Telfair of the risks she was effectively avoiding. These case studies of relationships provide a unique view of the range and significance of women's relationships in the urban South.

Mary Telfair and Mary Few became friends as young children in late-eighteenth-century Georgia, where their fathers were Revolutionary War heroes, delegates to the Constitutional Convention, and political leaders in other capacities as well. Col. William Few was a U.S. senator and Edward Telfair, a governor. Few's daughters, Frances and Mary, were born in 1789 and 1790, and Matilda, a few years later. Therefore, the Few girls were contemporaries of Mary, Sarah, and Margaret Telfair, born in 1791, 1792, and 1797. In 1799 the Fews moved to New York, where William successfully pursued law, banking, and politics. Mary Telfair soon followed the Few family north, living with them for a couple of years beginning in 1801 while she attended northern schools. The two Marys cemented a friendship during these formative years that sustained both women for the rest of their lives. When Telfair returned to Georgia, she wrote to Few, pining for their "*nocturnal orgies*" and assuring her, "I have never met with one who *chimed* more in unison with me." It already seemed unlikely that Telfair would find a man to meet or exceed those acclaims.[15]

Not surprisingly, each worried that the other would find, or fall prey to, a suitor who might disappoint one of them and cause the friendship's intensity to lessen. As Telfair praised Few in 1814 for remaining single, "Must I applaud *the Fair Nun of Kenwick Convent?* I think you are right not to make any rash vows, in this *chivalric* age, for it is probable some dauntless one of

mars might prove your heart not invulnerable, and by his graceful evolutions induce you to surrender after a *short* siege." Moreover, Telfair confessed, "I never saw a man formed for you ... do not let this compliment make you too vain for I dare say the Universe or rather the United States contains your *Kindred Spirit* only I have not been fortunate enough to encounter the *charming unknown.*" Telfair began to list the necessary characteristics of Few's mate but concluded that if she "continue[d] in this strain I shall present you with a *visionary* Hero and as *reality* is the order of the times that would never do." Perhaps, Telfair joked, they could find and marry "two *intellectual Slovens* with spirit enough to amuse our solitary hours—who will be satisfied with *the old & ugly club[;] we must try the effect of platonism."*[16] The two never found a willing male pair, and neither married.

Mary Few also expressed concern about Mary Telfair's marital prospects, but Telfair quickly put her mind at ease. "So you really believe I have experienced the pangs of Cupid's dart," Telfair teased Few. "The very idea makes me laugh. Oh! No I assure you I have never seen one that could cause my heart to palpitate one moment[;] all my affections I have to spare to that sex are centered in my brothers." Besides them, the principal recipients of her affections were women, and Few was her favorite. By 1814, at twenty-three, Telfair concluded, "[No one] has any chance of drawing me as a *prize* in the grand lottery of matrimony ... I am too great a lover of *liberty* to resign it ... besides I belong to a family devoted to 'single blessedness.'" Telfair lived with her two unmarried brothers until they had both died by 1832, with her prematurely widowed and childless sister until she died in 1845, and with her very late-marrying sister even after that sister married in 1842. Occasionally, Telfair complained, these family loyalties kept her from being geographically close to Mary Few. With the exception of regular visits (usually Telfair to Few), the two women always lived miles apart—Telfair in Savannah and Few in New York.[17]

Telfair's permanent singlehood did not spring solely from her friendship with Few. Her family held a strong hold on her affections and loyalties, and their social position, wealth, and composition surely contributed both to her ability to remain single and to her skeptical view of most suitors. Similarly, her sharp personality, intellect, disposition, reputation (including her professed love of liberty), and even her physical appearance may have predisposed her toward unmarried life. Her passport indicates that she was just five feet tall and had a high forehead, black eyes, a "Roman" nose, a "prominent" chin, a dark complexion, and an oval face. At least one observer was less objective and described her and her sisters as the "pumpkin faced Telfairs." Mary herself complained of her plain appearance. At one point she

promised to send Mary Few a picture, "notwithstanding my aversion to seeing my own ugliness." Another time, she thanked Few for a bonnet, which she appreciated "because it conceals or rather shades an ugly face; I am in hopes it will *frighten the pimples away as well as the freckles.*" When the Telfair sisters had their portraits made in 1834, Mary reported that while the artist captured good likenesses of Sarah and Margaret, "he cannot catch my ugly phiz. After five settings he erased mine, and commenced another, which looks so cross that I flatter myself it is unlike me. Sarah says mine is no face for Painting—to much I suppose of *abstraction* & *distraction* in it."[18] Daguerreotypes suggest that Telfair was a serious and imposing woman but not unlike many of her era; neither her friendships nor appearance could entirely account for why she remained single.

Undoubtedly, part of what made the two Marys' relationship special to them and supposedly purer than others was that it transcended attention to physical appearances. Theirs was a unity of minds and souls. As the two young women passed through their twenties, their relationship and Telfair's letters continued to reveal the passion and intensity typical of school-girl crushes. Yet despite their maturity, their relationship never waned. Telfair, at least, believed that she had found what twentieth-century observers might call her soul mate. "I have never known any one in all 'my wanderings through the world of care' whose heart beat more responsive to my own," she confessed to Few in 1817. The previous year Telfair had gushed, "to hear from *you*, to receive your opinions on various subjects and above all to know that *you* still love me will ever cause the chord of joy to vibrate through my heart." When the two women had to part, Telfair pined, "How much happiness I derived from being with my beloved Molly and how painful was the moment which separated me from one in whom I take such deep interest, and who occupies so large a portion of my heart." About the same time Telfair assured Few, "dear Mary there is not a Being in existence who I esteem more than I do you, and all my future *reveries* will be *gilded* by your presence[;] not a circumstance occurred while we were together which has not been treasured by your *absent* Mary."[19]

As the two women came into their thirties and forties their relationship deepened, and Telfair revealed pride in suggestions that it had evolved into a model of a true female friendship. When Telfair's sister, Sarah Haig, opined, "She never saw but *two unaffected Women, Mary Few & Mary Telfair* and in *her opinion* the only example of *female* friendship," Telfair exclaimed with pleasure, thinly veiled by cynicism. "What an opinion of our sex! that we should be the only female *Castor* & *Pollux* in the world." Employing another mythic allusion, she similarly claimed to Mary Few in 1828, "I think

we ought like Damon & Pythias to be immortalized in verse." After Mary Few must have expressed some concern about offending Mary Telfair, the latter promised, "You must change *your Nature* in order to offend me . . . for . . . not only the Lords but the *Ladies* of creation, says we furnish the only example of *female friendship* that has ever cheered [their] orbs in her sojourn through this vale of tears." Indeed, Mary appreciated their family and friends always "coupling" them and declared, "There is no one I am so willing to be united to in this world."[20]

Desiring a unity not just of souls but of physical selves and appearance, Mary Telfair delighted in others' noticing a resemblance between herself and Mary Few. She even reported about 1823 that numerous people had told her that she looked more like Few more than like her own sisters. "Well I am complemented for there is no body in the land of the living that I should prefer resembling." From time to time Mary referred to themselves as "Siamese twins" and observed, "You & I often see with *the same eyes*—a proof of our *twinship.*" A critical part of this union was their shared vision of life. "We have both done with Castle building—but we still live on recollections," Telfair explained in 1823. Neither needed or enjoyed the "*encumbrance,* which most women think absolutely essential to happiness."[21] That encumbrance was a husband.

There is no way of knowing how the two Marys expressed their love for one another in person, whether they found pleasure in sitting close together or sleeping in the same bed, but it is clear that their relationships elicited little concern on the part of loved ones and reflected the expectations and norms of the day. Similarly, it is difficult to gauge Mary Few's level of reciprocity to Mary Telfair because very few of Mary Few's letters remain to compare with Mary Telfair's voluminous writings. In 1818, however, Mary Few wrote in Telfair's commonplace book a poetic statement of her affection, a common practice among nineteenth-century girls and young women. It read, "like the evening Sun comes the Memory of past times o'er my soul . . . is my dear Mary associated with the pleasant recollections of my life—the Companion of thoughtless childhood—the chosen friend of my youth—and one to whose friendship I still look forward to smooth the downward path of life."[22] Given the length of their relationship, the continuance of correspondence, and their friendships with one another's sisters, it seems most likely that Mary Few valued Mary Telfair's friendship, love, regular visits, and more regular letters. She, too, felt specially connected to her friend.

* * *

Mary Telfair cherished her friendship with Mary Few and saved a special place for her in her life, but Telfair had other close female friends as well. Her inner

circle was based in Savannah, and she could enjoy their company often. Indeed, Telfair thrived among a "coterie" of like-minded Savannah friends, sharing frequent visits and countless conversations. Three of these friends never married and gave Telfair numerous opportunities to reflect on her identity as an unmarried southern lady. Moreover, her letters provide a window on the usually hard to uncover personalities of several unmarried Savannah women. Three of these friendships in particular reveal that staying single did not necessarily guarantee intimacy with another unmarried woman. An open, engaging disposition proved the most important element in a friendship, although Telfair generally admired most all her fellow Savannah maidens.

The first unmarried friend, and the one whom Telfair admired the most, was Anne Clay—strong, serious, erect, dignified, intelligent, pious, and benevolent. Indeed, Clay became Telfair's "beau ideal of a *public* unmarried woman," in other words, one who was well known, well traveled, and well

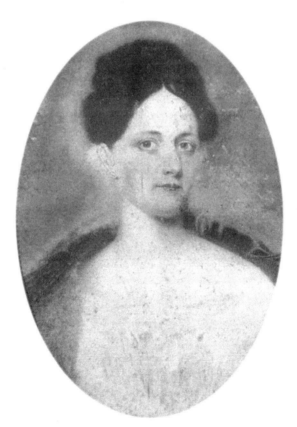

Anne Clay, 1796–1842. Miniature done probably in the mid-1830s. (Courtesy of Carolyn Clay Swiggart)

versed in the culture. Born five years after Mary in 1796 and dying relatively young in 1842, Clay, like Telfair, was part of a distinguished and affluent family. Her grandfather, Joseph Clay Sr. had been a business partner of Mary Telfair's father. Joseph Clay Jr., Anne's father, was a well-known Savannah attorney, judge, planter, and, much to the surprise of his Episcopal and Presbyterian peers later in life, Baptist minister. He was ordained in 1804 and shortly thereafter moved his family to Boston, where he was assigned the First Baptist Church. His wife and Anne's mother, Mary Anne Savage Clay, was the daughter of Thomas Savage, a merchant in Bermuda before the Revolutionary War who settled in Charleston, South Carolina. The couple had four surviving children: three daughters and one son. All moved to Bedford, Massachusetts, with their mother after their father died in 1810. The oldest child, Mary, married and began a family near Boston. The next children were Anne and Eliza, neither of whom married, and Thomas Savage Clay. Sometime after 1820, when Thomas completed his education at Harvard University, his widowed mother moved the family back to the family's Georgia plantation. Anne, however, continued to spend a great deal of time in the Northeast, returning to Savannah and the family homestead in Bryan County for extended winter and spring visits.[23]

Anne and Eliza Clay were frequent companions of the Telfair sisters, and Mary Telfair raved about Anne's "charming unity of dignity, grace, intelligence & vivacity." Telfair continued, "The World has sett her upon a high eminence & she has strength of character & mind enough to sustain her upon the elevated height without danger of becoming dizzy and tumbling head-long from it." Between trips north or to the family plantation, Anne Clay stopped by the Telfair's Savannah home to visit, and she sought out the Telfairs when they were all in the North. "Anne Clay passed several days in Town last week—she paid me two delightful *tete a tete* visits," Mary Telfair reported happily in 1833. "The freshness and originality of her mind is delightful—her conversation equal to an instructive and entertaining book not *'fresh memories'* but a fine moral essay . . . I love a *matronly* single woman." Not only was Anne matronly but she also seemed regal. "I never see Anne Clay without thinking of Queen Elizabeth and how well a crown would suit her head," Telfair commented in 1828. Perhaps Clay was too severe, however, as Telfair admitted, "I think her more formed to command esteem & admiration than to be beloved." Telfair's brother agreed that she "belongs to that class of women who . . . are better calculated for Queens than Wives."[24]

Despite Clay's eccentricities, or perhaps in part because of them, she gave Mary Telfair a unique opportunity to reflect on the qualities that well-to-do single southern ladies possessed, or ought to possess. First, Clay was ex-

tremely bright and articulate. "I do believe some Men are jealous of female talent. I do not think it very desirous to possess it unless it is usefully employed—Women *fear* it in their own sex though they profess to *idolize* it in Men," Mary observed after describing Anne's superior intelligence. "And yet I love it in all its variations—It is music to me from the *loud swell* to the *low wharble* and there is no accomplishment equal in my estimation to talking well." Second, Clay was benevolent, and Telfair admired her commitment to serving those less fortunate than herself, including the slaves at her family's plantation. "I . . . hear she is engaged in improving the minds & morals of their Slaves—her success I believe is not equal to her exertions," Telfair recounted to Mary Few in 1828. "She is one whose mind & character fit her for an extensive sphere of usefulness." In other words, Clay had the capacity to serve many people, including those outside her immediate family circle. Third, Clay was courageous, demonstrating real fortitude in traveling so extensively without a male escort. Telfair noted one March that the Clays had returned to Georgia via Wilmington and, remarkably, "They came without *a Man* or Man Servant—how desirable it is to be able to act independantly of the Lords of creation—I *commenced too late to ride alone in an omnibus*—which is the *acme* of my courage."[25]

Despite her admiration for Anne Clay, however, Telfair could not feel intimately connected to her, much to Telfair's frustration. Indeed, she could never connect intimately or emotionally with Clay for the same reasons that she admired her so much. She was so dignified, polished, and aloof. "Much as I admire her I could never love her as much as I do you," Telfair explained to Few in 1828, conceding Clay's one significant weakness as a female friend: "she wants tenderness & sympathy." Still, Telfair was pleased that Mary Few had the occasion to meet Clay because she esteemed them both so highly, albeit for different reasons. "I know no two people better calculated for each other & yet you are very different—She is all energy & you are all humility," Telfair wrote to Few in 1828. "She brings forward all her stock of information[;] you keep yours as a Miser does his hoard." Those outside the Telfair clan obviously felt similarly because otherwise confident men became tense in Clay's presence. One evening, Telfair told Few, "We had a delightful visit . . . from Anne Clay. . . . She was in her happiest mood and she made me for several hours *forget myself*." An acquaintance, Associate Justice of the Supreme Court James Moore Wayne, crashed the relaxed little party: "Unfortunately, Judge Wayne came in to interrupt our *Quarrette* [and] Anne became *stately* and he *Judicial*," Telfair observed. "I don't think he will ever say to her as he does to me '*My Child*'—or '*we pour* [poor] *Women*'—She certainly inspires profound respect in the Lords of creation."[26] Although

Telfair respected Clay's qualities, their friendship was constrained by personality differences. Perhaps Clay's manner predisposed her to the single life. Very likely, her way of staying above the fray protected her from the pain and emotional vulnerability that could be associated with spinsterhood.

Despite Clay's occasionally off-putting manner, she did receive calls from young men. In fact, when Anne was well into her thirties a brave suitor tried to secure her hand in marriage but ultimately failed, much to Mary Telfair's satisfaction. Apparently, the women's circle of friends was discussing the matter; Telfair told Few that she did not agree with Anne Wallace (another member of this informal circle) about the courtship. Wallace, a contemporary of the two Marys, was an unmarried cousin of Anne Clay's who had moved from her childhood home in Savannah to New York. Wallace thought that "Anne Clay's love of every thing *great* will lead her to marry Mr. Ward," Telfair related to Few, adding a softer appraisal of her own: "If she marries him I shall think it is from affection. . . . She knows him well, and though an unattractive man both in manners and appearance, he is benevolent, and liberal almost to munificence—and he *worships* her." In addition, "Anne is sufficiently *independant* in her circumstances not to desire wealth" and had little need for "worldy distinctions." Mary Telfair, perhaps from jealousy, self-interest, or prejudice, had little appreciation for Ward. "Mr. Ward is *desperate* and I give Anne credit for treating him with such civility, it requires amazing self control to keep *the Lover at a distance* and yet retain him as a friend. He is just the sort of Man I should be unchristian enough to *hate* if he loved me," Telfair wrote in 1836. Simply put, Clay was too good for him. "I wish he would look for some amiable '*housekeeper at home*' to gild the evening of his days. He is just *wise* enough to sigh for a Woman above his reach, but he will never *entre nous* obtain one unless she can swallow a golden pill." Believing that Clay was destined for loftier roles than to serve this man's every need, Telfair took some pleasure in her refusal of Ward. "We had also a visit from Mr. Ward who *looks* as if he had been *maltreated* in an affair of the heart," Mary remarked cooly. "Anne Clays *natural* cruelty has been productive of much misery."[27] Another unmarried woman remained safely within the sororal fold.

To read the eulogy of Anne Clay it appears that Telfair's assessment of her was correct, or at least corroborated, and her unmarried state unsurprising. Magestic, elegant, admirable, graceful, sober, well-read, intellectually brilliant, useful, charitable, chaste, humble, and devout, Clay embodied single blessedness and seemed to glide above and among her contemporaries like a firm but kind guardian angel. Of course, eulogies routinely depict flawed humans as near-perfect, but Clay was, at least by her friends' and acquaintances'

estimations both before and after her death, somehow above the rest of them. One of the causes she championed most vigorously (if Anne Clay could have been vigorous) was the religious instruction of slaves. At her family's plantation, she taught daily classes to slave children and youths for at least sixteen years and urged other slaveholders to provide the same for their slaves. "Wherever she has visited in the southern states," a contemporary noted, "she has not failed to accomplish something for the religious instruction of the negroes." Clay was praised widely as "a pillar . . . in the Temple of our community."[28] Perhaps that explains why Telfair respected Clay but failed to connect deeply and personally with her. Pillars are solid, strong, and cool, not embracing, warm, and soft.

Mary Telfair had less to say about Anne's also-unmarried sister Eliza, perhaps in part because the eighteen-year span between Eliza Clay and Mary Telfair meant that they spent less time together. Eliza Clay's personality was similar to her older sister's, and that, too, kept Telfair from an intimate connection with Eliza, something she would have enjoyed. Like her sister, Eliza was benevolent, demonstrating "unwavering devotion" to relatives in need. She was smart, if not beautiful, causing Telfair to predict that a potential suitor could not appreciate her, as she wrote to Few in 1837, because "beauty is the idol with him and I should sooner think of his becoming a slave to the *corporeal* charms of Miss Howard than the *mental* ones of Eliza Clay." Much as she pined for Anne Clay, Telfair confessed, "Eliza I could love *if she would let me,* but she retreats from my advances and you know I am more of a *retreating* character myself than an *advancing* one."[29] There was something about the Clay family's mentality that seemed to keep Telfair from the intimate connection she sought.

Very likely, Eliza Clay was too busy running her family's plantations to nurture the kind of relationship Telfair desired. Born in 1809, she contracted scarlet fever at the age of four and lost her hearing for the rest of her life. The infirmity, however, did not keep her from studying widely—especially her favorite subjects, botany and astronomy—and from acquiring plantation management skills. Eliza and her brother, Thomas, together ran the family's several plantations. After the brother's marriage in 1836, Eliza added to her responsibilities the care of his unhealthy wife and their five surviving children. When Thomas fell ill suddenly in 1849, his dying words were said to have been, "Tell Eliza I leave everything in her hands." At that point she took over the sole management of rice and cotton plantations with more than 230 slaves. By 1850 she was acting as the executrix of Anne's and Thomas's estates, and she refused her commission of $7,048.29 that year. Eliza continued to live with her brother's widow until the latter's death in 1869, and then with

Thomas's youngest daughter and son (neither of whom married, either) nearly until her own death in 1895. The Clay sisters had proven themselves to be able, useful, and powerful southern single women but, not surprisingly, not the easiest of girl friends.[30]

Sarah Cecil, another of Mary Telfair's closest unmarried friends in Savannah, was someone with whom she felt more at ease than with the Clays. Unfortunately, however, such comfort meant that Telfair had much less to say about Cecil. By all accounts Sarah Cecil was a quiet friend of the Telfair sisters, and Mary's letters make frequent if brief mention of her. Cecil joined the Telfairs for countless days and evenings, for trips north and back again, and for church activities at Savannah's Presbyterian Independent Church. Born in 1791, the same year as Mary Telfair, and dying three years after Telfair in 1878, the two were lifelong friends. Sarah was the youngest of three children, all daughters, to survive adulthood and the only one not to marry. Natives of England, her father was the Hon. Leonard Cecil, and her mother was Harriot Browning Cecil. Her father purchased Burleigh Hall, a plantation on Wilmington Island near Savannah. He died in 1792, only a year after Sarah's birth, and her mother remained at Burleigh Hall, presumably with her two youngest daughters, Eliza and Sarah. In 1796 Harriot Cecil married Capt. George Haist, an Englishman who fought in the Revolutionary War and was a Savannah merchant.[31]

Unfortunately, most information about Sarah Cecil comes from very limited genealogical information and details in Mary Telfair's letters. Cecil never married, but Telfair revealed that she had come close to doing so on at least one occasion. Probably around 1820, Telfair reported to Few that "[Sarah Cecil,] it is thought will leave the *lonely* and *narrow* path of single blessedness for the land of Matrimony[;] her Admirer is a widower with four [children]." Fortunately, the children were "all young and may be *moulded* to her wishes." Sarah later (and much to Telfair's satisfaction) gave up this potential husband and possibly others as well. Apparently, when Cecil was not spending time with the Telfairs she poured her energies into her family. As Telfair indicated in 1837, "Sarah Cecil is living life over again in her great Nieces & Nephews—*lucky for her.*"[32]

Of course, not all of Telfair's female friends remained unmarried, and those countless friends and acquaintances who became spouses gave her a myriad opportunities to hold forth on the institution of marriage and what it meant for women in particular. It was more than sour grapes when Telfair related story after story of marital conflict and women's disappointments in marriage. She counted herself fortunate and wise not to be bound to a man who, as her husband, would have so much power over her life. Her friends'

choices in marriage proved particularly disturbing and reinforced her choice or at least her circumstances.

As time passed, Telfair saw more and more friends marry and many friends die, and she grew philosophical about her losses. She even lumped the two occurrences together into one category that helped explain her increasingly chronic depression. "As our friends drop off by marriage & by death and society loses all its attractions . . . we require the varied occupations of domestic life to keep us from listlessness and despondency."[33] Sadly, she found the daily routine of domestic duties boring and the task of making new friends tiring. Meanwhile, Telfair could conflate those who married with those who died, not only because she lost some degree of intimacy with them but also because she keenly observed that the friends lost their former lives, independence, and control over their fates. Three in particular faced unforseen challenges as wives, and, not incidentally, their relationships with Telfair necessarily diminished somewhat.

The first, Sarah Jones Cuthbert, was Mary Telfair's first cousin and the daughter of Dr. George Jones and Mary Gibbons Jones. Born in 1789 and married in 1823 to Alfred Cuthbert, an eccentric planter and political figure, Sarah was the woman Telfair described as having disappointed her half-sister, Harriett Campbell, by deciding to marry. According to Telfair, Sarah's husband was difficult, cerebral, and self-absorbed. The only thing that seemed to make Sarah's married life enjoyable was her bright young son, who was named for his father. As Telfair reported to Few in 1834, "Sarah Cuthbert is still here—her son is quite a wonder—he talks like a Man & acts like a child. She returns to her solitude in April[.] I think she is happy with a man that could have made no other woman so." Telfair concluded that Cuthbert's happiness could be explained only "by looking at her child[;] he is every thing to her—He is a prodigy for his age—he forms his own opinions and supports them with great ability—he is already *fierce for conversation*." Later that year, Telfair wrote to Mary Few, "Poor Sarah Cuthbert looks wretchedly ill. She leaves here on Monday for her home—The label is again required." Cuthbert was pregnant with her second child, but Telfair saw little cause for celebration. "She looks very formidable and has reason to dread *the ides* of September. I hope for her sake it will be a daughter. The Father will have less to do with it—I hope it will be exclusively the mothers."[34]

In fact, Telfair's foreboding proved accurate. Sarah did not survive her pregnancy and died delivering a stillborn child in July of 1834. Telfair was devastated. As she confided in Few, "I have been so depressed my dear Mary in consequence of the sad intelligence I received from Georgia a week since, that it has deterred me from writing to you . . . although from the state of

her health such an event ought to have been expected, still it was a great shock." As for Sarah's widower, "I hope her loss and the manner of her death will make a serious impression upon him," she wrote. "I believe he has strong feelings, and if any event in his life could make him feel the necessity of resting his hopes upon something higher than this troubled state of existence." Probably, Sarah's husband had not been a religious man. In any case Telfair and the rest of the relatives worried about the young boy, Alfred. As another Savannah contemporary and unmarried woman observed, "I hope Alfred will be left with one of his Aunts, for his Father, engrossed as he is with his plantation, cannot bestow that attention on him which he requires. Poor little fellow! He is just the age that I was when I lost my dear Mother."[35] Obviously, the ladies of Savannah knew about Mr. Cuthbert's proclivities. They all knew of Sarah's plight while she was married to him and worried about little Alfred's lot after she died.

Despite deaths such as Sarah Cuthbert's, most young southern women of Telfair's social circle married and had children. Telfair and many of her acquaintances judged plenty of these marriages unwise. One year, for example, she reported that her friend Eliza Hunter "is positively engaged to Le Count, she is twenty one and he acknowledges forty five—the world says *he is full fifty two* but the World always adds to years and detracts from the merit of those who enlist under the banners of Hymen." For her part, Telfair endeavored to defend her friend, "I can be reconciled to strange matches if the party's concerned are attached or *fancy* themselves so—We have no right to sit in judgment upon others." Perhaps she was not judging the couple, but she did admit, "If Eliza was a Girl of any enthusiasm of character or endued with an unusual share of sensibility I should lament her choice." Not a particularly sensible or innocent young woman, Hunter was "a Woman of the World, and will get along very happily with a Man more than double her age." She needed to marry stature and wealth, so it was fine that her future husband was a former attorney general, a father of seven, and a grandfather, thirty years Hunter's senior. "She seems," Telfair surmised, "insensible to every thing but the glory of being his Wife.—Ambition is a rock upon which too many women split and what different views people take of Grandeur."[36] Hunter was obviously not called to the moral high ground of single blessedness; she wanted status and attention from a husband.

It is not surprising that such a woman would behave dramatically at her wedding. As Telfair reported to Few in 1833, the bride became "so overcome" that she lay her head "upon the Bridegrooms shoulder during the ceremony" and promptly fainted after the vows were exchanged, such that her husband had to carry her over to a sofa. Once she had recovered, the bridegroom

"lifted her veil and kissed her (*between us*) what a scene!" Telfair chalked it up to the fact that "they are both *public* characters and when *display* is a ruling principle we can never wonder." Telfair and her contemporaries knew, however, that the drama of an engagement and wedding soon turned to routine caretaking as brides became wives and mothers. Later, Telfair reflected on how changed and mundane her friend's life had become: "Eliza Hunters marriage seemed to herself and family the very acme of human glory & felicity—she is involved now in a host of cares—her situation awakens the deepest anxiety." Presumably the young bride knew beforehand that her husband had "an Idiot Son of three or four & twenty," and he became Eliza's "constant companion." As was often the case for young belles-turned-wives, "she who but a year ago lived only for admiration & conquest is now called upon to minister to the wants of others." Remarkably, Eliza rose to the occasion, and Telfair praised her because she "seems without system to *shuffle* along as smoothly as the most experienced Matron—There is a vulgar but true phrase—the back is fitted to the burden—I never see her without thinking of it."[37]

A third friend of Telfair's married around the time of Sarah Cuthbert's death and Eliza Hunter's marriage. Catharine Hunter became Mrs. Jones Bulloch in 1834, beginning a union that left her unhappy and displaced. Naturally, Telfair chronicled the affair. "I had a great shock upon my arrival to hear of the marriage of Catharine Hunter, which had it been a *suitable* one would have afforded me real pleasure, but she has made a strange unaccountable choice," Telfair wrote to Few in 1834. "She has married Jones Bulloch twelve years her junior—without a cent in the world—she broken down in spirits & in constitution." Bulloch was his young wife's cousin, and Telfair speculated that the two must have developed their relationship when Sarah was mourning the suicide death of her brother, Wimberly Hunter, the previous March. "He is very religious, and has sympathized most deeply in her sorrows," Telfair wrote of her friend's new spouse. "[But] that is the only excuse I can make for her." Furthermore, it seemed to Telfair that her friend, who had been "such a slave to the world's opinion" and "ridiculed unequal marriages," was being hypocritical.[38]

Apparently, the rest of polite society looked askance at the match as well. "The public I understand deal *unmercifully* towards her," Telfair reported pessimistically in 1834. The bride, who had "stood very high both for intellect & character," disappointed her peers by entering into "an unequal marriage." "I hope she will be happy, but I doubt it," Telfair proclaimed. Even the close-knit circle of female friends that included the Telfair sisters and Sarah Cecil disapproved of the match, remaining "*unreconciled* to the marriage," accord-

ing to Telfair. She had viewed "Catharine as a Madame de Stael." Telfair reflected, "We never know how high we stand until we fall. I had no idea that her reputation for intellect was so high. I have never thought her mind soared above mediocrity except as regards originality & humor." Hunter's poor choice caused Telfair to think about the woman's character. "As a companion she was delightful—She never possessed that strength & independence of character that distinguishes some of my friends. She always rested too much upon the worlds opinion."[39]

Some years after Catharine Hunter Bulloch's dubious marriage, Telfair admitted that her friend was "very happy & now perfectly contented with her lot. She is devoted to her duties and her *gleams* of vivacity has a *sunny* effect upon his dull mind." Apparently, Bulloch was a very simple man, too much so for Telfair and for the other women in their circle. Still, Telfair admitted, "If he never says a brilliant thing, he never utters a foolish one, and is in every relation of life a most exemplary character." Telfair took it upon herself to reach out to the man. As she boasted to Few in 1836, "I have contrived to *thaw* his impenetrable reserve[;] how do you suppose I commenced by *asking a favor* viz to pay a charitable subscription for me. It was the *dawn* of sociability since then we have become great friends." Very likely, Bulloch had sensed Telfair's superior attitude, but she tried to find a way to pay him the respect he needed. Of course, this interpretation comes only from Telfair's words. It is impossible to know exactly what Bulloch thought of his wife's opinionated friend.[40]

Unfortunately, Telfair's self-proclaimed breakthrough with Bulloch was cut short, and her earlier predictions of Catharine's marital unhappiness proved correct. If the young wife had worried about others' opinions before she married, she must have been overcome when her husband suffered financial ruin and committed a crime, or at least a fiduciary indiscretion, which destroyed the couple's reputation. In 1843 Telfair told Few, "Catharine Bullock is again called upon to bear up under a new trial. Mr. Bulloch left her to seek employment in the west—He got as far as Philadelphia." Telfair felt sure that he should not return to Savannah, declaring, "Here he ought not to remain. If I were in her situation, I would rather be where I was unknown and pursue the humblest occupation than live here with suspicion resting upon him." The following month, Telfair continued to fret about her friend's plight. "I have not seen Catharine B for some weeks. . . . [She and her mother] are very anxious to leave this state and I do not wonder at it. It seems like madness for them to think of going to Philadelphia without some Capital to commence with—besides every nook is filled there." Catharine and her mother considered opening a boardinghouse to support themselves,

which Telfair thought a good idea. "[T]hey are both competent to the task and I recommend St. Augustine." Telfair went on to sing the praises of the resort town, not the least of which was, "They will have no Savannians there *to gossip about them,* and poor Catharine may look up a little there—Here she never can, and much as I shall miss her, I feel anxious for her to go." Telfair requested Few to ask around about "an opening for a private boarding House." She had made it her *"hobby"* to find a solution for Catharine, "and yet I feel that I shall be broken up in accomplishing it." As much as she wanted to aid her friend, Telfair hated for Catharine to move away.[41]

Separation was an unsurprising result of a friend's marriage. Female friends and friendships were chronically vulnerable to marriage, to a husband's whim or folly, and to the physical risks of childbearing. Some single women might have preferred the realities of married life to those of unmarried life, but many others counted themselves lucky to have meaningful relationships with family members and female friends and be without the limitations and risks imposed by husbands and children. Despite the inherent liabilities of any human relationship, especially those between two southern women expected to think and act first as daughters, sisters, wives, and/or mothers, antebellum women shared intense, meaningful, and lasting bonds. In the absence of husbands and children, especially in the closely knit circles of antebellum cities, these relationships occupied the stage, the characters, and the plots that dominated unmarried women's lives.

Naturally, some female friendships were intense and passionate, whereas others were more distanced, based usually on one woman's admiration for another. For an unmarried woman, the respect of one's peers stemmed principally from her devotion to parents, siblings, nieces, or nephews. Second to these familial relationships, however, were friendships that sustained and occupied unmarried women and posed no real threat to the institution of marriage at large. After a southern woman fulfilled her obligations to family and then developed critical female friendships she could extend her care, attention, and usefulness to others in the community. Just as Mary Telfair had praised Anne Clay she lauded another friend, Maria Hull Campbell, whose "benevolence is of the most active character." After telling Mary Few about Campbell's myriad efforts to teach her slaves the Bible, sew clothes for the poor, and feed the physically and spiritually hungry, Telfair drew the two friends together, concluding, "She is after your own heart." Indeed, family, friendships, and a third strand, benevolence, were sewn together to create the tapestry of unmarried women's lives in antebellum Savannah and Charleston.[42]

5. Seeking an "Extensive Sphere of Usefulness"

Women's Benevolence in Antebellum Savannah and Charleston

In September 1850 a well-to-do, forty-four-year-old unmarried woman in Charleston, South Carolina, began a letter to her brother in Sumter County. She was quite annoyed with him because he had not yet informed her of arrangements for her upcoming visit to him and his family. She begged that he write to her with his plans "so that I may make *mine*, not respecting *pins* and *needles*, but Society business, for instance." Obviously, her brother did not appreciate that she had numerous benevolent commitments, so she elaborated: "I am visiting on the 'Ladies Benevolent Society' for three months, and if I go away I must get a visitor, in my place, also I am bound to get a Teacher for my Sabbath class &c &c now you know this cannot be done in a *moments* warning."[1]

Like many other unmarried women in Charleston and Savannah, Ann Reid had integrated herself into the web of women's benevolent organizations. These activities, including Sunday school classes and the Ladies Benevolent Society, provided a sense of purpose, community, independence, and a public role, which was especially attractive to aging women without husbands. Benevolent work offered valuable opportunities for friendship, leadership, and usefulness to women who did not have the preoccupations or fulfillments of spouses and children. Two years before the irritating episode with her brother, Reid was reflecting on how content she was, working on various benevolent causes, living in the city, and watching her nieces and nephews grow.[2]

Reid was one of countless American women and men who joined, created, or led the quickly multiplying voluntary organizations of the early nineteenth century. It was, as the *Charleston Observer* noted in 1827, "the age

of benevolence." Largely in response to rapid economic development, ur-
banization, denominational proliferation, revolutionary and republican
principles, and Anglican disestablishment (particularly in the South), urban
centers boasted countless organizations intended to Christianize the heathen,
convert seamen, nurse the sick poor, and serve many other causes as well.
Evangelicals especially believed that God demanded their active participation
in bringing about his kingdom on earth. A true Christian was, according to
one Southern Baptist leader, "a useful Christian," and benevolence proved
piety. This Baptist preacher could have been speaking also for the busy
Charleston or Savannah Episcopalians or Presbyterians when he continued,
"[Be] a laborer with Christ": "The sick may be visited and relieved. The wants
of the poor may be supplied; the ignorant may be instructed. . . ; the vicious
may be reclaimed. . . ; [and] the weak may be strengthened."[3]

<p style="text-align:center">* * *</p>

Historians have long explored the breadth and significance of the century's
benevolent and philanthropic work. Northern scholars initiated the analyses
by examining the wave of largely evangelical benevolent work that gripped
the Northeast during the early nineteenth century. Many found that religious
work gave women in particular newfound independence and mobility and
led them into social reform work. These historians have diverged, however,
on the extent to which middle- and upper-class women's exposure to the
lives of poor women fostered a sense of shared identity or sisterhood that
superseded allegiances to, and privileges from, class.[4]

Southern scholars' examinations of antebellum philanthropic and be-
nevolent work has explored the extent to which this predominantly rural,
relatively insular, and patriarchal society could permit women's organiza-
tional efforts at all. Many pathbreaking studies conservatively estimated that
relatively few such organizations could exist. Yet other, often more recent,
scholarship has suggested that a surprising number of southern benevolent
organizations included or were run by women. The extent to which the
organizations deviated from the northern paradigm has been a subject of
further debate, but most scholars agree with Anne Scott's observation that
the organizational impulse in nineteenth-century America was more than a
response to industrialization or modernization. After all, rural southern
women formed benevolent organizations, often within their churches.[5]

Women and men of Charleston and Savannah initiated benevolent work
similar to that of their northern counterparts, but the rhetoric of proslavery
sentiment, the personalism of southern social relations, and the power of
the racial divide shaped the meaning and extent of that work. Slavery forced

southern Christians to focus on individual efforts to ameliorate suffering rather than take on "social welfare" that would have challenged the fundamental structure of the society, including its linchpin, slavery. Barbara Bellows, who has examined the benevolent work among the (mostly male) elite of Charleston, adds that wealthy southern whites creatively turned urban social problems into opportunities to further individual political careers and reputations and foster social control and cohesion. Unlike their northern counterparts, the elite of Charleston embraced a hierarchical vision of life that was clearly undemocratic and accepted their God-given responsibility to the poor. Sounding much like an urban paternalism to impoverished whites (like paternalism to slaves), the ethic of care made the poor beholden to the wealthy. In this exchange, the wealthy who volunteered gained a sense of personal fulfillment, social participation, and enhanced responsibility in society. Moreover, moral reforms never evolved into far-reaching social reforms, as they did in the North.[6]

The southern women who participated in these organizations, and in many cases led their own efforts, also enjoyed the fruits of personal fulfillment and respectability. Unlike their northern counterparts, however, who were forming organizations to solve similar urban problems, southern women remained dutiful members of the southern, slaveholding, middle and upper class. Motivated by religion, patriotism, a desire for usefulness (especially among the unmarried), and even by personal desire, boredom, or greed, southern ladies very rarely expressed fundamental disagreements with the men of their class. They often worked on problems and issues near and dear to a woman's heart—those regarding children and mothers, the church, and their heritage. And they used the language and the skills of a nineteenth-century woman's experience. But they did not develop a vision of their world that countered prevailing male assumptions about class structure, gender conventions, or race. Slavery and slaves allowed these women the luxuries to leave their families and homes behind for meetings and other activities. Slaveholding women generally saw no moral disconnect between wiping the brow of a poor, sick, white seamstress with the same hand used to beat a black house slave. If slavery seems oddly missing from discussions of southern white benevolence it is because do-gooding whites who held slaves recognized almost no moral contradictions in their actions. [7]

* * *

The unmarried women among these busy volunteers were especially suited to the range of benevolent work that their cities offered in abundance. Those from well-to-do slaveholding families could throw themselves whole-heart-

edly into charitable organizations without the distractions of finding a husband or keeping one happy. The wealthiest women did not have the same pressures to marry as did women of lesser means. Often with ample resources in their own names, sometimes with houses of their own and time on their hands, these women were uniquely situated to devote time and money to relief efforts. In particular, those passed the age of courtship and likely matches had time and inclination to devote a great deal of energy to benevolent work. The leaders of charitable organizations and churches recognized that fact and often appointed single women to specific roles and cultivated the women's interests and allegiances. One writer in the *Southern Literary Messenger* in 1837, for example, commended the "old maids [who] . . . are *silent* and *active* doers of good."[8] In addition, these "disengaged" women, as one Charleston church described them, often had an unusual degree of freedom, from both male control of their activities and caretaking responsibilities. A century and a half later, it is often challenging for a historian to identify never-marrying women specifically, but an examination of Charleston and Savannah's benevolent organizations reveals many of their names on membership rosters and records.

With the requisite time, financial and emotional resources, and relative freedom from family responsibilities, women without husbands could choose among a myriad of organizations in Charleston and Savannah. To them, they could devote their energies and find usefulness and purpose. During the first three decades of the nineteenth century the citizens of Charleston alone created and populated more than sixty organizations devoted to aid, evangelism, and reform, many of which offered women opportunities to serve. Within their churches, for example, females could teach Sunday school, raise money for church rebuilding efforts, and distribute religious tracts. In the secular world they joined other organizations, including the Female Seamen's Friend Society, the Fuel Society (which gave wood to poor families supported by women), and the Juvenile Industry organization (which clothed poor infants). During the 1820s, urban southerners regarded Charleston as a model of southern benevolent activity because the city offered so many private and public relief efforts, from aiding the poor in a range of ways, to educating Indian children, to assisting Jews who were ostracized for adopting Christianity. That year, the city coffers alone spent $50,000 in support of the Orphan Asylum, Poor House, and Marine Hospital. The smaller seaport of Savannah had a slightly shorter but still impressive list of city institutions and charitable organizations, including church-sponsored efforts, the Female Seamen's Friend Society of Savannah, the Female Asylum Society, and the Infant School Society. During the early nineteenth century roughly one-

quarter of Savannah's adult white population subscribed to at least one of three charitable institutions: the Savannah Female Asylum, the Union Society, or the Savannah Free School.[9]

Women's benevolent activity fell into four categories of charitable work in both cities. First, many women, such as Ann Reid of Charleston, became involved in church work and organizations such as Sunday schools, tract societies, and church homes. Second, many of the same women took up work that was not a part of the church structure but had origins in Christian evangelism or church teachings, as with most benevolent societies. Third, women worked collectively on secular causes such as historic preservation and orphan care, issues that the city, state, or national government already had attempted to address. And, finally, many women who may not have been able or willing to participate in organizational efforts took on individual cases or causes for the poor, their slaves, and their white servants. Antebellum southern women who were active in public and private benevolent work felt compelled to such activism. Unmarried women also found unique and important roles within benevolent activities. Although the Civil War was a watershed in women's public involvement, inviting and forcing them into new roles of charity and organization, the ladies of Charleston and Savannah embraced a compelling ethic of usefulness, benevolence, and reform long before the firing on Fort Sumter.[10]

* * *

The most common means for women to participate in benevolent work throughout the South during the antebellum period was through organizations and causes that their churches offered. After all, as numerous historians have documented, religion and the church, especially during the first half of the nineteenth century, beckoned a hugely disproportionate number of women who found within these institutions new opportunities for introspection, purpose, emotional support, and community. Although church leadership was almost always male, southern women filled the rosters and pews each Sunday. In Charleston's leading Episcopal churches, St. Philip's and St. Michael's, female communicants outnumbered male ten to one. Women at the city's Circular Congregational Church outnumbered men five to one. At St. John's Lutheran Church, the ratio was six to one; at Second Presbyterian, three to one.[11]

Within these churches, women found not only a female majority and a benevolent impulse but also spiritual sustenance in the form of theology, sermons, classes, and volunteer work, all of which supported them as Christians. That there were many more women than men in the pews seemed

unsurprising to most nineteenth-century Americans who acknowledged that women were the more religious sex and, in some cases, even possessed moral superiority over men. In turn, women took seriously their duty as spiritual models for others and routinely engaged in the self-scrutiny their ministers instructed. The evangelical faiths especially, but even many urban Episcopalian churches, urged people to examine their minds and hearts, an exercise that almost always left Christians feeling unworthy and disturbed. Many southern women were overwhelmed with a nebulous sense of sinfulness as they failed to submit their will to God's, perhaps as some wives struggled to submit their will to their husband's. Churches not only pointed out the problem of wilfulness as sin but also offered the solution: the forgiveness of sins, including those unladylike emotions of pride, resentment, and rebelliousness that were particularly vexing for well-to-do white women in the South.[12]

In addition to the forgiveness of sins, churches offered some women a theology that promised them Christ as a "heavenly Bride groom," according to one southern woman in 1822. Judith Lomax never married but devoted herself increasingly to God and to saving herself for him. Born in 1774 in Virginia, Lomax, an Episcopalian, prayed fervently, "Oh aid me to keep my lamp ready trim'd! Let me be the wise Virgin, all in readiness" for "[my] spouse" in heaven. Estranged from her family but comforted by spirituality, Lomax recorded her passion for God in a Sabbath journal. Many other southern women also kept religious diaries, using them to record each Sunday's activities, preaching, and prayers along with their personal relationships with God. Described as "love mysticism" by her biographer, Lomax's experience of intimacy with God is not typical of southern women, but scholars are beginning to identify others who used journals to talk to God and explore their mystical relationship with the divine. Some women married and others did not. In either case their experiences indicate that when women focused on spirituality and their relationship with Christ they might find a purpose and an entity that could supplant having a mortal husband.[13]

Religion offered women something else, too—entry into benevolent work, especially in urban areas like Charleston and Savannah. Scholars have debated, however, the extent to which southern churches and their religious doctrine led women to public activities, including reform and benevolent causes. In Savannah and Charleston at least, religious institutions created countless opportunities for not just individual salvation and religious instruction but also social interaction with peers within and outside of women's homes and for active, hands-on work among the city's poor and unchurched. As one scholar has observed, "Religion was the key loophole

through which most white women, southern and northern, entered public life." Of course, public activities had to retain church sanction and male approval to enjoy longevity, but there were many ways to achieve the goals of Christian outreach and at the same time respect prevailing gender conventions. Not only was the church an acceptable forum within which to practice benevolence in general but it also created an important and unique place for single women. The single female members whom Charleston and Savannah churches cultivated were, by and large, seeking an avenue to usefulness and piety. To that end they offered the potential for countless hours and dollars in service. As they did in their homes, unmarried women had a special role to play in their church families and benevolent organizations.[14]

Attracting sizable numbers of female parishioners and exercising greatest control over city affairs, St. Philip's Episcopal was Charleston's most influential church. Dating from the colonial era, when it was the primary agent of social welfare in the region, St. Philips's was probably the city's principal site for philanthropy and charity, and its rosters included the most powerful local families. When the Anglican Church was established in South Carolina around the turn of the eighteenth century its vestrymen became the agents of tax collection and almsgiving in the state. By the antebellum period the church was a mighty institution that had a deeply rooted sense of place, purpose, and philanthropy. Although some women might flock to St. Philip's for its social stature, they could also find personal fulfillment there by taking on important roles on behalf of the city's poor.[15]

Another unmarried woman from this congregation who accepted the church's invitations to serve was Anne Lesesne, born in 1809. On many mornings Lesesne would leave the front steps of her Society Street home, bound for church services, meetings, and Sunday School classes, which she taught. Shortly after the destructive 1835 fire at St. Philip's, Lesesne joined what she called the "working society" that raised money to rebuild the church. As she noted in her diary, "I sent out the basket containing the Society work to day and collected $2.37 ½ cts." Barely a month later she attended the last meeting of the society, reporting sadly that "the Society is now dissolved." She regretted that "in the last year they have made not quite 200 dollars which is to be sent to the vestry of St. Philip's Church to aid the rebuilding of the Church, I am sorry that we have been able to do so little for the Church in the building of which we all feel warmly interested, but our Society was but a very small one."[16] As with many church organizations from this period, it is not clear exactly who else worked in the society or why it was relatively short-lived.

Still other church organizations and efforts made use of Lesesne's energies, including a Sunday school program that provided religious instruction to

the city's poor children. Later that summer she hurried from a family dinner because she "was obliged to . . . attend a meeting of the Sunday School Teacher[s], which was held at the Superintendent's." She recorded in her journal that night that "the object of this meeting was to endeavour to arrange each class to the satisfaction of its teacher." Because teachers at the meeting "all appeared satisfied with the arrangement of their respective classes," the superintendent spoke for some time about his "religious opinions & expressed the manner in which he thought the Christian doctrine should be imparted to the children." Although the person in charge was male, women and girls dominated the emerging Sunday school movement in America, both as teachers and as students. Southern women found in the work an important degree of religious and moral authority; one-on-one contact with the urban poor; and the opportunity to serve God, the church, and the larger city community. Lesesne, for example, built on this successful experience of benevolent work to raise money for church missionaries and to attend Temperance Society meetings. The church provided well for both Anne Lesesne and Ann Reid. It gave them a place to do important work and helped make single life in Charleston reasonable and even enjoyable.[17]

Both Lesesne and Reid, along with dozens of other Charleston women, married and unmarried, devoted years of service to another organization that drew members from St. Philip's as well as from other churches. The Female Episcopal Bible, Prayer Book, and Tract Society was organized in 1827 to disseminate "approved books" and religious tracts to the families of the church. Tailored specifically for women, the organization provided an opportunity to participate directly in a key component of advancing Christianity. (According to the society's founders, the other two components were direct missionary work and the ministry, which largely excluded women.) With church sanction and encouragement, numerous women each year visited church families, both in the city and in surrounding areas, and gave them religious reading material. Within its first year the popular, well-populated organization had eleven life members and 111 annual subscribers. Three years later, in 1831, there were twenty-six life members and 175 annual subscribers. During its first three years, the society distributed 235 Bibles, 283 prayer books, and 6,342 tracts. By 1858 it had distributed 9,133 tracts and thirty copies of sailors' manuals. Clearly, the society provided yet another organization for women of the church to work within appropriate gender norms to fulfill the desire and obligation to be useful. Dozens of married and unmarried women left their homes and gathered to distribute tracts to other families in the church.[18]

Another of St. Philip's benevolent projects employed the efforts of eager

female parishioners and at the same time created special roles for single members—the Episcopal Church Home, the equivalent of a long-term shelter. Established in April 1850, the home had three objectives, all involving women. The first was to "provide a retreat for destitute and deserving females" (called "beneficiaries"). These struggling women were required to find employment and care for the younger members of the home. The second objective was to offer vocational, moral, and religious training to poor white girls who needed to be self-sufficient; the third drew on the labor and availability of numerous well-to-do, often single or widowed, ladies in the church. These disengaged women were sent to visit the homes of the poor and hospital wards and were also to assist with the instruction of the home's orphans. Obviously, the church's leadership saw an opportunity to marry the poor's need for Christian assistance with the need for what it described as a "legitimate field of labor for *ladies,* who being sufficiently disengaged from the more urgent claims of natural and social duty, and desirous of finding the most satisfactory employment for the time and talents, which God has given them." In other words, unmarried women had the time, availability, and motivation to serve the poor. The home's founders assured parishioners that they were offering the women an opportunity to devote themselves to a "work of Christian love . . . without the dangerous entanglement of vows." The plan for the home made clear that it would not take mothers from children or wives from husbands but would offer women without such relationships or responsibilities an avenue to exercise womanly piety. Of course, the church would not compensate them financially but rather would provide "a place of rendezvous, and opportunity of co-operation." At the same time, the church had seized upon a deep reservoir of untapped unmarried female energy, time, and money.[19]

Almost from the outset, however, the home faced opposition and sparked debate about women's work for the poor and the appropriate spheres of women's influence. Wary conservative critics decried the plan's public roles for women and employed anti-Catholic sentiments to criticize the all-female, and therefore conventlike, structure of the institution. In their defense, the church priests and the home's supporters countered that the time had come for the church to employ and celebrate women's Christian benevolence. As the Rev. Charles Hall told his Charleston congregation at St. Michael's Episcopal Church, "We cannot much longer avoid regarding this subject as we have done, by citing such texts as. . . . 'Let your women keep silence in the Churches' as if that settled the whole question. It has nothing to do with it." The church, he maintained, must show "reverence" for the charitable work of women, who had demonstrated that they were entitled to "better work

and a higher sphere in the Church, than the needle and scissors afford." "Female piety," Hall insisted, belonged not solely to the family circle but "to the Church" as well. Hall and his supporters hoped that the home would allow women, particularly available single ones, to make the church their family without the trappings of "vows and scapularies." Thus the church benefited from the labor of its women; beneficiaries received the assistance; and the women themselves appreciated and enjoyed the work, social and philanthropic outlets, and sense of a female community.[20]

The plan and its defenders suggest several important characteristics of the relationships between Charleston's elite women, the role of the Episcopal Church, and the perceived needs of each. First, a significant number of women, many of them single, were available to form such a corps of visitors—or at least enough to believe that such a corps was plausible. Second, these women wanted to participate more fully in the life of their church generally and in its charitable endeavors specifically. Third, church leaders wanted to make use of women's availability and interest and at the same time serve the women's needs for community, family, and usefulness. Fourth, the church was a place for women to interact and work with one another. Finally, elite churchwomen had direct interaction with the poor, or at the least they had the church's sanction to do so. Evidently, urban centers offered a setting and realm of possibilities for women that more rural settings did not and that historians are only beginning to appreciate.

Regrettably, few records remain to elucidate the work of those remarkable lady visitors and the recipients of their care. Histories indicate that the home's overall plan ultimately fell short of Reverend Hall's expectations. The inmates of the home could not live together peaceably and had to be separated, and the active cadre of disengaged visiting women dwindled during the 1850s. The faithful few who remained "Lady Associates" were, according to Bellows, "legatees from another age," presumably those born before or around the turn of the century. The evangelical reform movement as a whole withered across the eastern seaboard as early as the 1830s. The decline was due to the perception of failure in changing public morality, diminished interest in social stability and unity, denominational divisions, and sectionalism, all of which limited national efforts and southern reform work. Nevertheless, eleven years after its inception, board members thanked the lady volunteers at the anniversary celebration and meeting in 1861 for "their frequent visits and advice and suggestions." At a minimum, women were still keeping an eye on the day-to-day operations of the church home and reporting monthly to the operating council. If Hall's hopes had not been realized, a number of women still retained interest and involvement in the home throughout

the 1850s. Very likely, many put their efforts into some of the city's many other charitable organizations.[21]

Christian women were not the only urban ladies venturing into benevolent work and inching into male-dominated concerns. The Jewish women of antebellum Savannah, like their Gentile counterparts, had relatively little power in public arenas such as politics but were exceptionally successful at raising money for synagogue projects and Hebrew school education. In 1843 they organized a community fair (as Christian women often did) and raised more than sixteen hundred dollars, which they requested to be used to maintain a regular rabbi for the congregation. The male board agreed. The women also established Sunday school classes, which they usually taught themselves, and in 1853 they established the Ladies German Benevolent Society of Savannah, which offered assistance with medical bills and other needs to dues-paying members. They also set aside money for destitute Jewish women. Leaders still had to defer to the male benevolent society for approval, but they orchestrated considerable efforts nonetheless.[22]

* * *

In addition to church organizations like those of St. Philip's, other city groups served Charleston's and Savannah's needy through the labor of wealthy Christian women who were unmarried or similarly disengaged from familial obligations. As churches encouraged female members to volunteer their time and energy and find avenues for usefulness, women and men formed other charitable organizations that had no direct religious affiliation but did have Christian origins and goals. St. Philip's Church, for example, sent many of its elite members into service with the city's nonsectarian Ladies Benevolent Society, which claimed in 1941 to be the oldest American women's organization in continuous operation. Founded after the War of 1812, which drew the attention of Charleston's wealthy to the suffering of the city's poor, the society provided home health care. Much like the lady visitors of the Episcopal Church Home, the Ladies Benevolent Society drew on volunteers and funds from the community in order to send privileged white women— young and old, married and single—into the poor districts. There they provided home nursing to male and female whites and free blacks who were underprivileged, ill, and out of work. Each year numerous churches, including other Episcopal parishes, the Methodist Episcopal and Presbyterian churches, and the Jewish synagogue, devoted one sermon and collection offering to the society. Boasting between three and four hundred members, the Ladies Benevolent Society became a very popular and well-supported organization in antebellum Charleston—one more example of antebellum

women organizing, fostering leadership skills, and contributing to the public good.[23]

According to the society's constitution, members met regularly from eleven to three o'clock, four times each year, at the Charleston Orphan House. Annual dues were $5, and a life membership was $50. The officers, women of prominent Charleston families, included a superintendent, a junior superintendent, and a secretary-treasurer, all of whom had to be residents of Charleston. In addition, the treasurer had to be an "unmarried lady." As was the custom with many southern women's organizations, the woman who managed the organization's funds should not be subject to the direction, persuasions, and legal liabilities of a husband and the constant demands of children. The organization must have included sufficient numbers of single women to permit this stipulation; of the roughly 425 who had joined by 1861, approximately 315 had married, and 110, about one-fourth, were not married. Of course, any number of those who were unmarried at the time of joining the organization may have subsequently married, and those who had married may have been widowed. But the rosters, along with the unmarried treasurer stipulation, indicate that the organization was a place where significant numbers of single women could gather to serve, socialize, and lead. Single women provided much of the leadership of the organization over the course of its existence; in addition to serving as secretary-treasurers, unmarried women were named superintendent at least three times between 1844 and 1856.[24]

The Ladies Benevolent Society undertook many causes over the course of its long tenure, including the operation of several charity schools. One of its most important causes during the antebellum period was the establishment of a visiting and distributing committee—a corps of women, appointed by the board of managers who would "assist . . . visit . . . [and] send relief" to the sick poor. Based on the premise that "every system of charity, which takes the rich among the poor, must . . . improve the condition of one party, the feelings of the other, and the virtues of both," the society proudly sent its members where ladies did not usually tread. Rotating among the city's wards so as to inhibit the sort of familiar relationships that might foster "the keeping on of patients against the spirit of the Society," visiting committee members congratulated themselves for entering "scenes of distress, want, misery, and woe, scarcely to be conceived by those who have never entered the frail and unsheltered tenements of this city, where poverty, sickness and wretchedness dwell."[25]

In a typical year the society's pensioners included poor white women, an emaciated blind woman with leprosy, crippled free black women, and infants

too young for the orphan asylum. In their efforts to aid these people, lady visitors took with them a strict ration of weekly provisions: a pound of brown sugar; a pound of coffee or a quarter pound of tea; a pint of lamp oil or candles; grits, rice, meat, or milk; arrowroot or barley; wool; soap, flannel, and a blanket; and 37 ½ cents. If the patient was attended by a physician or nurse, that person would receive the money. To ensure their worthiness, patients had to present the society with a certificate from either a dispensary or a physician, testifying to their illness. To prevent dependency, recipients received visits for only one week after a physician released them from care, or until they were "out and about." Those with chronic diseases such as "rhumatism" were not eligible for services. This was to be a short-term form of assistance, one that would cultivate long-term self-sufficiency. But, remarkably, all these decisions were made by the ladies themselves, which more than once may have caused conflicts with male officials about who should receive care and how long.[26]

One of the society's best-known visitors was Mary Grimké, mother of Sarah and Angelina Grimké, who abandoned Charleston society to pursue abolitionist and woman's rights work in the North. In 1839 fellow society members eulogized Grimké for being "discriminating in her intercourse with the class of people with whom she had to deal, firm and decided in her dealings with them, [and] untiring in her visits." Obviously, the society valued restrained compassion as well as stamina. (Grimké's daughter Angelina, also a society member before she left Charleston, later criticized the society's hypocrisy. She remembered that once a lady visitor refused to pay her free black servant while that woman nursed her husband, even though it was the organization's policy to pay a nurse's wages to families of poor whites who were subsequently without income.) Angelina's criticism notwithstanding, the board of managers praised female visitors in 1824: "You have visited the sick and forlorn in their wretched Hovels, without once shrinking from the inclemency of the weather.—In this world you receive a reward *in the act*— and in the next, you will receive a greater, according to it."[27] Praise in this life, along with the promise of eternal bounty, likely sustained many women.

In spite of such benefits, the organization had chronic problems recruiting enough active visitors. Its annual report of 1820 chided those members who were "willing to contribute *money* but object to the plan of *personally visiting the sick.*" The visits, it advised, are "the most important and essential duty of your institution, the neglect of which would occasion innumerable evils, entirely defeat every good purpose, and eventually prove its destruction." The "ladies of opulence and leisure . . . [should] visit the poor" to be reminded of their blessings. They had serious responsibilities to their organi-

zation that they could not possibly fulfill without seeing firsthand those who needed assistance and learning of their situations. It was essential to "obtain correct information respecting [the poor's] actual and diversified sufferings, [by] repairing to their dwellings." Apparently, too few heeded the call. Four years later the board again lamented that for the previous decade it had *"difficulty of obtaining Visiting Committees"* and entreated its 346 members, particularly those who had "not young, or large families," to "come forward and visit in Committees." Again, it beckoned to unmarried women, wives with grown children, and wealthy widows. The report reminded that "Christ has set us an example of visiting the sick and needy.—He has pointed it out to us as the Christian's duty, equally obligatory on all; and to fulfill this duty was our Society expressly instituted." Although many of the city's elite took pride in contributing funds to the organization and having their names on its membership rosters, it is very likely that fewer donned their coats and gloves and went out into the wards.[28]

Despite these functional challenges, records of the organization's members, subscribers, and benefactors reveal that the Ladies Benevolent Society was an enormously popular and well-supported body. The names of Charleston's elite proliferate on its lists, including the Draytons, Grimkés, Horrys, Legares, Manigaults, Middletons, Petigrus, Pinckneys, Ravenels, and Rutledges. The society's endowment was similarly fortunate, yielding an annual income of $4,000 in 1861. Many well-to-do members were active in numerous benevolent organizations simultaneously.

One study of the sixty-six women who held leadership roles in one or more of five key Charleston organizations between 1828 and 1843 found that fully one-fourth of the women were wealthy in their own right and 85 percent were either married or widowed. Their husbands were professional men in 40 percent of the cases and merchants in another 20 percent. Only four women were married to planters, and two were planters themselves.[29]

The same study of benevolent women contrasted the sixty-six in Charleston with a comparable group in Boston at the time to find that the northern women were generally less wealthy, more middle-class, and more interested in a diversity of philanthropic opportunities. Not surprisingly, they ventured into reform efforts that challenged the status quo in ways that worried conservative, elite southerners. Still, women in both the North and the South were participating in a nineteenth-century effort to control the unpleasant by-products of urban growth. Women of Boston, Charleston, and Savannah provided relief to the sick poor, supported temperance homes for wayward sailors, and sought aid, especially for indigent widows and children.[30]

Beyond financial statements and membership rosters, it is difficult to un-

cover the personalities, opinions, and attitudes of the visiting women and the board of overseers of the Ladies Benevolent Society. One remnant that remains suggests that leadership and public power ran in families and could be as intoxicating for women as for men. Three wealthy, unmarried Drayton women, Hannah (b. 1764), Sarah Motte (b. 1773), and Hester Tidyman (b. 1797), all served on the board of the Ladies Benevolent Society. Hester's tenure was particularly noteworthy because it extended into the war years when the society mobilized to support the war effort. According to another member of the society who also remained unmarried, Hester was known for her "tricks [of] . . . downright bribery and corruption." In one instance she supposedly insulted another society member whose entire family subsequently withdrew its support and membership from the organization. Later, Hester received an application from an army captain for clothing for his company. She responded that she was currently gathering clothing for another company but would "see what she could do for him." The next day she wrote to him again, indicating that she had been saving some clothing for her nephew's company, but because her nephew had subsequently left his company and "she had *no further interest* in it," she would send the captain those clothes, "provided he would *give her nephew an office* in the company." Ultimately, the captain declined Hester's offer and procured the clothing from two other relief organizations.[31]

Despite the typical managerial issues of inflated egos and recruitment challenges, this organization of charitable Christian women existed for decades and maintained a membership list that read like a who's who of antebellum Charleston. Some of the women visited the wards, but many more supported the work financially and through their membership. The city's elite male leaders implicitly and explicitly supported the work as well, contributing financially and allowing the women of their families to participate. The organization provided yet another opportunity for urban women to contribute publicly to their communities, control sizable funds, and travel into the poor wards of the city to visit the sick poor. Women in this organization and similar ones proliferating in the seaboard cities elected female presidents and boards, wrote constitutions, and invested and managed money, all with the approval, even gratitude, of prominent southern religious leaders. Members also developed friendships and a heady sense of purpose. Such benefits would be particularly meaningful to women who did not have the customary duties, emotional sustenance, and societal sanction associated with marriage and motherhood.[32]

Although the size, influence, and longevity of Charleston's Ladies Benevolent Society were extraordinary, it did not stand alone as an instrument

of well-to-do women's charitable work and cross-class interaction in the urban South. Within Charleston itself, two other women's groups formed to extend the work of the society. The (Episcopal) Sisters of Charity formed in 1817 to aid the "aged, infirm, and destitute" who were not eligible for care from the Ladies Benevolent Society because they were not ill. That organization included numerous single women, including Maria Drayton, whose death in 1859 meant the "two-fold loss of a Manager and a subscriber" noted the annual report. Another organization, the Female Charitable Association, for the Relief of the Sick Poor of Charleston Neck, formed in 1824 to carry out the work of the Ladies Benevolent Society in outlying districts. In many other southern cities, including Richmond, Columbia, Annapolis, Georgetown, Fayetteville, Raleigh, and St. Louis, women's benevolent organizations blossomed during the second and third decades of the nineteenth century. Savannah had no Ladies Benevolent Society equivalent to Charleston's, but it, too, boasted numerous societies of women who did benevolent work. The Savannah Dorcas Society, for example, in 1816 assisted about a hundred people in that city with "clothing and nourishment." In 1822 the Widow's Society formed there to "supply the wants of destitute infirm widows and single women of good character."[33]

* * *

Another popular cause that took hold in American port cities during the early nineteenth century was conversion of, and aid to, seamen. After all, on these sailors' shoulders rested a nation's mercantile and economic strength. According to eighteenth- and nineteenth-century British tradition, sailors constituted one of the nation's most important, and at the same time pitifully abandoned, human resources. Social critics decried that American society in general had long thrown its collective hands in the air and assumed that seamen, despite their importance to national power, were an incorrigible, hopeless, and scandalous lot, always prone to violence, drinking, theft, and general trouble-making. As turn-of-the-century urban missionaries began door-to-door efforts to convert the poor, however, the idealistic young evangelicals found that sailors were ideal candidates for conversion, instruction, and moral uplift. Before long, port cities along the Atlantic and Gulf coasts had organized marine bible societies and other organizations to serve, convert, and remake the country's seamen.[34]

Charleston and Savannah were no exceptions, and during the first half of the nineteenth century both men and women formed organizations aimed at providing seafaring men with religious instruction and Christian shelters for rest and sleep. They also extended aid for the widows and children of

seamen. As with the Ladies Benevolent Society and the Episcopal Church Home, often the same elite Christian women enjoyed the opportunity to extend the reach of their domestic usefulness to young men who might otherwise stray from God and contribute to civic disorder. After all, these young men had left their homes and mothers and could, the women feared, easily fall prey to the evil temptations of the city. Indeed, when Savannah's ladies met at the Independent Presbyterian Church in 1844 "in behalf of the seamen of this port" to draw up their constitution as the Female Seamen's Friend Society of Savannah, they explained, "The objects of this association shall be to maintain a Sailor's-home in this city and to meliorate the temporal condition and improve the moral and religious character of Seamen."[35]

The Charleston Ladies' Seamen's Friends Society similarly described their mission as providing a sailors' home "for so important a class of persons." The home would be "a refuge . . . from the temptations of those who would engulph them in all the horrors of intemperance, for the sordid and iniquitous purpose of defrauding them of their hard earned wages." (Never mind that the sailors may have enjoyed what their money could buy in town.) Still, these women of Charleston rejoiced because the home, which they sponsored and which no-nonsense, working-class matrons managed, offered "not only a refuge, but a calm and tranquil haven, where the desirable restraints of religion and morality were thrown around them—where, at the family altar and the social meeting, the impressions of earlier years might be revived." In other words, the women of both cities spread their moral influence—and mothered from an appropriate distance—young male visitors who had left behind maternal authority, and in some cases wives, and found themselves tempted by urban vice.[36]

Well-to-do white women championed the cause of these wayward men because work on their behalf blended mothering, moral reform, and civic responsibility. Moreover, just as urban seaports, especially Charleston, increasingly struggled to compete with northeastern and Gulf Coast ports, prosperous women of both cities acknowledged their economic ties to these workers. Charleston and Savannah's prosperity rested on laboring seamen, but when they were off-duty, drunk, and in search of a good time the sailors presented a threat to order and moral sensibility. Reform work on their behalfs reveals how religious impetus, economic and class-based incentive, and gender roles coalesced, providing a place for well-to-do white women—both married and single—to organize, socialize, and contribute meaningfully and publicly to their cities. Congratulating themselves, the Charleston society's annual report of 1845, for example, celebrated the "harmony" and

"kind feelings" palpable at the meetings and the "bond of union . . . formed by those who co operate in this good work."[37] Presumably, the bond unified well-intentioned men and women with one another, not necessarily with their poorer beneficiaries.

Both city's societies boasted religious origins and, initially, exclusively female membership. Savannah's society held its 1844 inaugural meeting at the Independent Presbyterian Church, probably the city's most prestigious congregation, but made clear in the first line of its minutes that the "ladies [were] of the different religious congregations of Savannah." Older than Savannah's by a couple of decades, the Charleston seamen's society grew out of the Circular Church, an Episcopal body closely connected to the city's St. Philip's. Some women of the Circular Church formed the Female Domestic Missionary Society and offered services for seamen at the wharf. These women were quickly joined by men, however, and other new organizations that wanted to contribute to the efforts. In 1820, for example, a committee of men began collecting money for a mariners' church, where the pulpit was built to look like the prow of a boat. Three years later the Charleston Port Society, the members of which were male, organized to promote Christianity among the seamen and provide a list of ministers willing to rotate among the sailors. In 1826 women reorganized to form the Ladies Seamen's Friend Society, which established a temperance house for seamen. Very likely, they were responding to pleas from leading religious leaders and commentators, who wrote in popular religious periodicals. As one 1821 essay explained, "A Seaman comes into port, and he is driven by his ignorance into a place where . . . virtue is banished, no wonder he falls a victim." As a remedy, the writer urged, "Let a house be opened for seamen where . . . virtue [is] respected." The women complied. Twenty-five years later, in 1851, the seamen's chaplain celebrated numerous "cases of conversion," praised the singing in the Mariner's Church, and boasted that nearly six thousand men had signed the pledge book, forswearing "all intoxicating liquors." He delighted his pious supporters with stories and letters of young sailors who credited generous benefactors for their newfound religion and faith, temperance and integrity.[38]

Throughout the history of the movement in Charleston, various groups formed and disbanded, organized and collapsed, in an ongoing effort to help and control the city's seamen. It is a challenge to isolate the efforts of the city's women exclusively; various women's groups organized over the course of the century, although they often worked in conjunction with men's organizations. Most likely, Charleston's well-to-do white females were involved principally in efforts to establish homes for sailors, an appropriate domestic

sphere of women's moral influence. Moreover, the city's numerous unmarried women found in this cause a way to be useful, needed, and involved. One of Charleston's best-known unmarried women, Harriott Pinckney, rented a portion of her property to finance the erection of an Episcopal home for sailors in 1853. The unmarried Angelina Grimké served for a time as secretary of the Female Seamen's Friend Society. Beyond anecdotal evidence, however, it is impossible to ascertain the marital status of most benevolent women or know the extent to which they acted in fellowship and organization with one another. It is clear, however, that they worked in conjunction with men of their class to extend their spheres of usefulness and domesticity to young men whom they deemed needy and worthy. (It is clear also that they stopped well short of transforming their work into a broader reform issue as did their Boston counterparts, who turned to improving the lives of the seamen's wives, widows, and daughters by working to raise the wages of local seamstresses.)[39]

The Female Seamen's Friend Society of Savannah, by contrast, seems to have worked more or less in isolation from male efforts on the sailors' behalf. A year before the women formed the organization, a male-led Savannah Port Society organized to manage the city's rowdy seamen and build a church for them. The women's organization made no mention of the men's efforts, however, and pushed forward with their own agenda: the establishment of a home for sailors. The women's society maintained consistent and exclusive female leadership and membership and nearly exclusive female sponsorship. In February 1845 the society celebrated the opening of its Sailors' House, which was overseen by a respectable naval officer who reported to the society. That year a Captain Duncan took the helm as superintendent of the home, which, the society boasted, had been "furnished with every suitable comfort for Seamen, to the extent allowed by the friends of the Society— Good order & sobriety have been invariably maintained—religious worship daily observed." Two months later, upon Captain Duncan's resignation for some unknown reason, the women expressed hope that having established the Sailors' Home would "in some measure remove the reproach that has so long rested upon the community" for not having one. It is not clear who was keeping score and judging Savannah remiss for lacking a proper Sailors' Home, but it is likely that self-conscious Savannahians worried about lagging behind their more developed seaboard neighbor Charleston. In addition, well-traveled Savannahians surely observed that many other American port cities had established homes two decades earlier, during the 1820s. It is also possible that sailors made their sense of relative neglect known. In any case, the women of the city were relieved to provide "this noble class of fellow

men, [who] are so justly entitled" with a proper home. By the end of 1847 more than four hundred men had been entertained at the home, and many had signed the pledge of total abstinence. Most attended religious worship, participated in the prayer time held at a set hour each day, and recuperated from illness while in the home. The following year, more than 1,100 boarders and lodgers benefited from the home and, according to the women, got religion, stopped drinking, and made personal moral improvements.[40]

Although impossible to determine exactly how many single and never-marrying women participated in this organization, it is clear that many organized, met, and worked on behalf of Savannah's seamen—and without male leadership. The few remaining rosters indicate that a small but significant proportion of the group's leaders and subscribers were single women. Seventeen women members of the board of directors in 1848, for example, were married, and three were single; the 1849 board included fifteen married and three single women. Regardless, all the women were extending their moral influence to men clearly outside their social circles and class, but they remained safely within their primary communities. Savannah's ladies actively and publicly contributed to their city's well-being while remaining within the bounds of acceptable female behavior. Their work on the seamen's behalf demonstrates urban southern women's civic participation, their moral reform convictions and impulses, their long-standing cooperation with one another, and their able administration of a public home.[41]

Of course, much of what motivated well-to-do and well-traveled urban women was a growing concern in America's eastern cities about alcohol consumption, especially among the growing numbers of working poor, including sailors. Anxiety about the illicit and potentially disruptive activities of sailors on leave went hand in hand with a largely middle-class and urban movement toward temperance for themselves and for others. Especially in the North, antebellum evangelical Christians focused on the deleterious moral, social, and economic effects of drinking and drunkenness. In cities such as Charleston and Savannah, temperance efforts were more modest than in the Northeast, working largely to control African American access to alcohol. In Charleston, for example, city ordinances and state laws attempted to stop slaves and free people of color from drinking, but most black people who imbibed crossed Boundary Street into "the Neck" at the northern end of the peninsula, where enforcement was much looser. When the city's white women involved themselves in temperance work it was almost always through male-dominated organizations. By the early 1830s the temperance movement was so tainted by associations with northern reform work, abolitionism, and the American Anti-Slavery Association that the

numbers of temperance organizations dwindled in the South generally. (Moreover, temperance societies' limited successes led many southern evangelicals to conclude that the temperance movement had relied too heavily on human agency; only with God's grace and intervention would intemperance be eradicated.) Savannah and Charleston women might support the cause of sobriety among the cities' sailors, but they focused their energies almost entirely on establishing homes for the men. Homes, of course, were acceptable, appropriate, and therefore effective vehicles through which southern women could exert lasting influence.[42]

* * *

While many women in antebellum Savannah and Charleston created and joined numerous church organizations and religiously motivated societies, other women worked on more secular causes. The Orphan House offered an arena for philanthropic involvement in Charleston. Opened in 1792 as a refuge for the abandoned and homeless children of the city, the Orphan House provided its inmates a home, an education (academic for boys and mostly vocational for girls), and moral instruction. One expert on the Orphan House suggests that the institution also offered the elites of Charleston opportunities to effect some social control under the guise of benevolence. Describing the male administrators and benefactors, Barbara Bellows explains that particularly during the antebellum period, when Americans "equated fatherhood and patriarchy with power and control, serving as surrogate parents to the poor children of the city had irresistible appeal." Through the Orphan House, Charleston's well-to-do men developed understanding of class relations within their slave society. Their female counterparts, however, had "only marginal roles" in the asylum's operation, whether as "Lady Commissioners" or philanthropic benefactors.[43]

Although their roles may have been peripheral to men's, as Bellows argues, elite women still maintained influence over the operations of the Orphan House. They gave money, took on limited leadership roles, and altered the men's plans from time to time. Sometime around the turn of the nineteenth century, for example, the "Gentlemen Commissioners" decided to use part of the Orphan House property, then being used as a garden for the children, as a cemetery to bury the institution's deceased. The self-described "ladies superintending the female economy of the Orphan House" disapproved of such a plan. After some thought, they concluded "that it is not going beyond the line of their duty to express their disapprobation of such a measure." They then laid out three objections to the plan. First, they felt that the "health-

iness" of the institution would be "jeopardized" by building a cemetery so close to the home. The home's physician, they added, agreed with them. Second, the children enjoyed their garden and benefited from the nourishment it provided. Indeed, "the Ladies would recommend an increase instead of a diminution of vegetable diet in the Institution" (children need their vegetables). And, finally, they suggested that the commissioners instead reappropriate a part of the city land that had already been used as a cemetery to inter the unfortunate former inmates. Five women signed their first and last names to the petition. The men's brief response indicated that they would "yield without hesitation to the opinion of the ladies, and unanimously agree to rescind the Resolution." Obviously, the ladies did wield some influence, even from the margins.[44]

Less affluent women had even more influence on students within the institution. The male commissioners may have "ruled their institution like oriental despots," according to Bellows, but they simultaneously created a community populated principally by women. Moreover, this was a time when few orphans' homes admitted girls. With the exception of the boy's schoolmasters and steward, white women had all the jobs within the Orphan House. Matrons were elected by the city council and sometimes came from the ranks of the female orphans. One matron, Miss Ellen King, entered the home when she was two years old and stayed for seventy years. In addition, the home employed other middle- and working-class women, including matron assistants, teachers, a sewing mistress, nurses, and laundresses. In fact, one forward-thinking female superintendent initiated a program in 1854 to keep the brightest girls as teachers in the education department. This particular superintendent, Agnes K. Irving, an unmarried northerner by birth, is credited as "the most influential factor in the overwhelming success of the Charleston Orphan house" by the institution's historians. Born in New York City in 1831, Irving moved to the home in 1854 at the request of Jefferson Bennett, a member of the board of commissioners. For the next fifty-six years she remained, serving as teacher, superintendent, and de facto director of the Orphan House.[45]

Those who worked within the walls of the Orphan House maintained an important influence over the lives of their charges. The elite women, although probably hemmed to the margins of management and influence by the male board of directors, still exerted some control over the institution's policies and decisions; many provided financial backing for Orphan House operations. Although impossible to delineate the specific work of single and/or married women at the Orphan House, it is clear that it was yet another place

where the city's women, whether married or single, could find usefulness in service to the city's poor and a role in the effort to control, or at least to manage, them.

Savannah's women also took up the cause of poor orphans. On December 17, 1801, an unprecedented number of the city's women gathered at Savannah's Presbyterian church to consider how they wanted to address the needs of the city's girls who were poor. Inspired by the organized benevolent activities of women in the Northeast, they established the Savannah Female Asylum, a long-term shelter for orphans and other vulnerable children. In part because the city's Union Society, a men's organization since its founding in 1750, had claimed responsibility for destitute boys, and also because the women felt "most deeply penetrated by the suffering of our own sex," the ladies at the first meeting elected to focus on female orphans between the ages of three and ten and on other equally deserving daughters of impoverished mothers. Although they might accept financial and other assistance from "gentlemen," they concluded, they would limit membership to women. Annual dues were set at $3, and a board of fourteen trustees would oversee the asylum's management. (Anne Clay was elected first directress of the organization throughout the 1810s.) A relative diversity of religious affiliations predominated on the board and in the ranks of the organization; wealthier Episcopalian and Presbyterian members served and contributed money alongside the less affluent Baptists and Methodists. As for the day-to-day care of the girls, a governess oversaw their care, education (reading, writing, and sewing), and religious instruction. The young girls also were bound out to learn occupations.[46]

Those poor children who were not destitute enough or otherwise eligible for the asylum but lacked the means to secure a privately funded education could attend a range of lowcountry free schools and academies funded by city money and private contributions. By around 1820 the Savannah Female Asylum and the Savannah Free School cared for or educated nearly one-third of the entire female population in the city under the age of twenty-one. The impact of these institutions was wide; the commitment on the part of the city's elite, significant; and the role of women, integral. In the case of the asylum, board members took control over the lives of the girls who lived there, even those whose mothers were living. Although most of the asylum's thirty residents were orphans, the board admitted daughters of destitute or deserted mothers on a case-by-case basis. Records indicate that struggling mothers had mixed feelings about such control and care, but it is clear that the women on the board exercised remarkable power and were often genuinely concerned about the institution's charges. Other women participated

on a more indirect level. As Mary Telfair reported to a friend one winter, "There is to be a fair on Tuesday given by the Ladies of Savannah for the benefit of the Orphan Asylum—All the talent & industry of the *fair* Ladies has been elicited on this occasion."[47]

* * *

Again and again, women of the nineteenth century took up benevolent causes on behalf of individuals and institutions they felt had been abandoned or neglected. While some championed the cause of the orphans, others drew on the same assumptions about women's moral superiority to work for the preservation of historic national symbols. One unmarried South Carolina woman single-handedly spearheaded a major effort to restore George Washington's home through an organization she created, the Mount Vernon Ladies' Association. Born in 1816 in Laurens County, South Carolina, Ann Pamela Cunningham took up the cause of preserving Mount Vernon in 1853, shortly after her widowed mother described to her the desolation and disrepair of President Washington's home. According to legend, Mrs. Cunningham proposed that American women should purchase and preserve Mount Vernon. Her thirty-seven-year-old unmarried daughter accepted the call, despite significant physical limitations that were the result of a devastating riding accident when she was nineteen.[48]

For approximately fifty years American leaders, tourists, and the Washington family had struggled over who was entitled to George Washington's remains and to his beloved home. At mid-century, just as the family was considering selling and northern and southern politicians squabbled over the sectional implications of the sale, Cunningham stepped in. She began her campaign to buy the nation's homeplace and restore it with an appeal to the "Ladies of the South" in a letter published by the *Charleston Mercury* on December 2, 1853. "A descendant of Virginia, and now a daughter of Carolina, moved by feelings of reverence for departed greatness and goodness, by patriotism and a sense of national, and above all, of Southern *honor,* ventures to appeal to you in behalf of the 'home and grave' of Washington," she beckoned. Drawing on sectional pride, mounting disgust with northern industry, and assumptions about male greed, she went on to describe Mount Vernon as choking on the pollution pouring from northern smokestacks. Mount Vernon was becoming, she portended, "the seat of manufacturers and manufactories; noise and smoke, and the 'busy hum of *men.*'" Playing on mounting anxiety about northern aggression, she praised the "shrine of true patriotism" and begged forgiveness for allowing it to be "surrounded by blackening smoke and deafening machinery, where money,

money, only money ever enters the thought, and gold, only gold, moves the heart or moves the arm!"[49]

Cunningham went on to castigate the negligent members of Congress who had failed to buy and preserve Mount Vernon. She railed about the "jobbers and bounty-seekers, of office aspirants and trucklers, of party corrupters and corrupted—all collecting like a flock of vultures to their prey." Most egregious to southern readers, she warned, "schemes are on foot for its purchase by Northern capital" who would certainly defame the property for "money making purposes." The "Ladies of the South," in sharp contrast, their hearts "fresh, *reverential,*" and pure, had to raise the money themselves to purchase the sacred property and have it conveyed in trust to the president of the United States and governor of Virginia. Then, "at least the mothers of the land and their indignant children might make their offerings in the cause of greatness, goodness, and prosperity of their country."[50]

Cunningham's initial strategy was for her southern sisters to raise $200,000 and make a purchase offer to the proprietor, John Augustine Washington, a descendant of the first president. Initially, Washington refused, claiming that he prefered to sell to the state or federal government, something that was increasingly difficult in the emerging national crisis. To allow women to purchase it, he explained, would cause him "mortification" and demonstrate "the degeneracy of myself and the men of our land." In the meantime, the northern press began to follow Cunningham's efforts, northern women began clamoring to join the cause, and Cunningham decided that by including women "from Maine to Texas" she would strengthen her case. Ultimately choosing wider support over sectional allegiances, Cunningham quickly appointed vice-regent representatives from each participating state. In fact, in a jarring turnabout, the Mount Vernon Association (the MVA as it was soon renamed) quickly became a self-styled instrument of sectional unity. One impassioned orator in 1855 praised MVA women for "still[ing] the angry passions . . . of man" and "reviving those fraternal sentiments which in by gone days constituted us in interest and feeling—in hope and fear one people."[51]

After much organizing and fund-raising (which included pitching tents on the Charleston Battery to solicit contributions), the women of the Mount Vernon Association convinced the Virginia legislature to pass a bill that incorporated the MVA. The bill also authorized the MVA to purchase Washington's estate and hold it in perpetuity. Cunningham then took it upon herself to "charm the bear" and persuade the owner to sell, which eventually he did. "I held out my hand—he put his in mine; then, with quivering lips, moist eyes, and a heart too full to speak, our compact was closed in

silence," she remembered. Cunningham and her association set about the repairs and restoration work. The association took formal possession of the property in February 1860, roughly a year before the country plunged into civil war.[52]

About that time, a South Carolina editor published Cunningham's name and indicated that she supported secession. She told a friend that she was horrified at seeing her name in print, an unacceptably public forum for most ladies, and felt outraged that "the South Carolina editor [threw] such a fire-brand into our woman's camp . . . [what] a crime." Distancing herself from her initially partisan pleas for support and contradicting the accusations of partisan favoritism, Cunningham insisted that the women of the association "need not have anything to do with politics . . . no sectional divisions should affect our position."[53]

After the war, Cunningham's last great triumph for Mount Vernon was convincing members of the U.S. Congress, most of them northern, to grant the women an indemnity for the use of the Mount Vernon boat during the four years of war. Just after the war, Cunningham visited numerous legisla-tors in their offices and persuaded them to support the bill, which would provide the organization with necessary funds. She had to meet even with the infamous Sen. Charles Sumner of Massachusetts, remembering dra-matically, "I writhed under the necessity of sending for Sumner, but I did it, and did not hold back my hand when he held out his. Whether the touch of a South Carolinian had some charm in the triumph of the thing to him, I know not, but he was charming." Sumner promised to support her bill, which eventually passed. Cunningham was able finally to resign from the regency in 1874. She left Mount Vernon and, exhausted, returned to Rosemont, where she died the following year.[54]

Cunningham might now be considered an astute political strategist. To save a national institution she deftly coopted southern nationalism, nation-al pride, women's perceived moral superiority and civic purity, and her per-sonal disability. Her unique activism began as a southern-style version of republican motherhood whereby her region's mothers and daughters had to save the nation's birthplace from northern industry and aggression. Yet it quickly blossomed into a national, gendered movement, demonstrating the power of antebellum female influence channeled "appropriately" and the central role only a single woman could play. Cunningham's single status gave her the flexibility and mobility to orchestrate and manage a nationwide movement for twenty-one years; it also obliterated suspicions that she was the foil for some self-interested male. Behind the veil of invalidism, which she frequently discussed and displayed and which, conveniently, made her

even less threatening as a reformer, this single southern woman was best positioned to argue that northern and southern women—pure, disinterested, and moral—together must protect and preserve George Washington's home from male greed and weakness. They were also working to preserve an important *home,* an obvious and celebrated domain for nineteenth-century women.

* * *

At the heart of Cunningham's efforts, and those of countless other nineteenth-century women affiliated with charitable organizations, was a desire to be good and useful. Unmarried women in particular sought the activity, purpose, and fellowship that benevolent work offered them. But some women, including Mary Telfair, prefered individual acts of charity to organized ones. In Telfair's case, her family were members of Savannah's prominent Independent Presbyterian Church, a body that made frequent institutional efforts to assist the city's working poor and drafted several members of the Telfair family into its efforts. Telfair, however, was more inclined to attend services and contribute funds than join visiting committees or tract societies. Born in 1791 and indoctrinated by notions of noblesse oblige, the aristocratic Telfair preferred to dispense charity from her very comfortable family mansion on St. James Square. For example, she placed her name at the top of the list when "The Ladies of the Congregation of the Independent Presbyterian Church of Savannah" pledged personal funds for "erecting a Parsonage for the residence of their Minister." She and her sister Margaret each pledged $500 that spring of 1853, only two of five who promised that much. The other eighty members pledged between $100 and $200.[55]

Telfair believed whole-heartedly in the value of reminding oneself of the plight of the poor and doing what one could to help them. Such a philosophy not only afforded a sense of moral rectitude but also redirected self-pity and despondency. When a friend suggested that the mother of a seriously depressed young girl take the girl "to visit the poor," Mary agreed. "[I]t is only by comparing our lots with those less favored that we can bear up under the afflictions of life, and realise the idea that the gifts of Providence are equally distributed[;] if we have not that which we value most, it is in Mercy denied to us." Very likely, Telfair's working-class, white servants provided ready reminders of her own good fortune and easy avenues for her benevolent impulses.[56]

Although the recipients of her interest may have resented her meddling attitude, they readily took whatever spoils they could. On one occasion the Telfair sisters provided a young destitute Irish woman with "an assylum

across the street" as well as food and washing services. The woman paid for her room at a cost only 20 percent of its actual value and received plenty of *"wholesome* advice" from Telfair. It seemed that the young woman, despite life's injustices, retained what Telfair deemed a foolish romanticism and idealism that would surely carry her into the arms of a man (probably not the first) who might provide love and excitement but not practical financial support. "[S]he is so full of romance & poetry that I fear she will look upon me as a *calculating Monster*," Telfair observed, admitting that the woman was likely to succumb to the temptations of the *"marrying age,"* abandoning concerns for *"suitability."*[57]

Three months later Telfair continued to complain about her charge and boasted of how she had suffered on the woman's behalf. "She was the source of such anxiety to *poor me* that I kept vigils for three nights trying to improve her condition—Such a *lump* of Romance I never encountered," Telfair ranted. "I tried to infuse a little common sense into her brain, but there was no reservoir for it, every crevice was crammed with Byrons poetry." Telfair recommended that her well-read friend begin reading the pious Hannah Moore to counter Byron's deleterious effects, and she soon secured for her a job as a seamstress in Augusta, Georgia. Regrettably, the situation quickly soured. Exasperated and frustrated, Telfair concluded that the unwise woman was "too romantic to marry for convenience," in other words to marry a man who could provide for her. Telfair thus acknowledged that the difference in wealth and class that separated herself from the Irish woman also destined them for profoundly different marital options. In any case, Telfair gave up on her project and would henceforth focus her attentions on "my few relatives & friends." The "more I retire from [this sort of charity] the better for me," she concluded. She was finished with making efforts that went unappreciated and were unsuccessful.[58]

Telfair's frustration with individual acts of benevolence and her ambivalence about group benevolent work went hand-in-hand with spiritual dissatisfaction, a deeper longing for a spiritual contentment that seemed to sustain many of her friends in their benevolent efforts. Observing women like Anne Clay and reading the work of religious writers like Hannah More, Telfair acknowledged that she lacked the sort of consistent and intimate relationship with God that motivated many of her peers. She respected Mary Few for joining the church but lamented, "I wish I was worthy of following your example but though my most ardent desire is to become an exemplary Christian, I feel that I have made very little progress towards it." She reported having tried to read the Bible "with attention," as Few had suggested, but still despaired of finding the peace and comfort that many of her friends

found in their religious lives. "I feel," she explained, "that I want the support of religion and I almost dispair of ever attaining that rest which in a world like this the christian only can enjoy."[59]

As with other things, perhaps, Telfair approached religion with her mind rather than with her heart, so it is little wonder that faith was outside her grasp. She believed strongly that religion was the most important resource for unmarried women because, like intelligence, it "strengthens the mind" and forces one to focus "above those petty feelings which are so much indulged in by the ignorant."[60] In other words, religion made one resilient, erect, and correct, but she could not allow it to make her emotional, weak, or powerless. In all practical terms, Telfair's religious life was about piety, reserve, benevolence, and propriety but not about emotional intimacy with God.

Still, Telfair's sense of religion and noblesse oblige caused her to make sizable contributions to benefit her city and its people throughout her life, and most dramatically when she died in 1875. In her lengthy will she made specific and generous gifts to female friends and to Savannah's less fortunate. Among many other bequests she provided land to the Union Society of Savannah for a school and land to the Widows' Society. She left railroad stock to her "faithful colored servant George." She also allocated her home, books, sizable art collection, furniture, and papers to the Georgia Historical Society, which was to establish the Telfair Academy of Arts and Sciences, still in existence. Not surprisingly, Mary Telfair listed numerous stipulations about how that facility could and could not be used. She also specified that a carved stone sign in front of the building have the word *TELFAIR*, to be spelled in large letters, occupying a separate line above its other words. Telfair gave generously as well to the Independent Presbyterian Church as long as the trustees would "promote the cause of religion among the poor and feeble churches." She further required that they "keep in good order and have thoroughly cleaned up every spring and autumn, my lot in the Cemetery of Bonaventure." No other person could be put in the vault or enclosure of the lot. Finally, in addition to still more bequests, Telfair posthumously provided for the erection and endowment of a hospital for "sick and indigent Females," to be named Telfair Hospital for Females.[61] Mary Telfair had internalized the ethic of benevolence, and she stipulated that her sizable estate support individuals and causes she deemed worthy, including education, religion, and financial relief for poor women.

Although she self-consciously preferred a hands-off approach to charity, leaving money and property posthumously, Telfair still admired female friends who dirtied their hands in service to the poor. One of her best friends

who also never married, Anne Clay, provided religious instruction to the slaves on her family's plantation (chapter 4). Telfair, quite impressed, commented, "She is one whose mind & character fit her for an extensive sphere of usefulness." Another friend, Maria Hull Campbell, similarly taught Christianity to the slave children on her plantation. Mary Telfair remarked, "On Sunday afternoon I attended Mrs. Campbells School for black children—it is kept in her wash-room, and she instructs about forty-five or fifty blacks." Revealing as much about her own values as the woman's activities, Telfair continued, "Mrs. Campbell possesses a great deal of quiet energy, and like Ann Clay has both a passion and a talent for pouring instruction into the minds of children. . . . Her benevolence is of the most active character." In other words, an ideal Christian woman—married or not—had the mental and physical fortitude to serve. Maria Campbell also provided clean bed linens for the poor and offered nutritional and spiritual sustenance to the weak. "[S]uch a woman is an ornament to the Christian profession—how few act up to the requirements of the gospel!" Telfair observed. Her opinions paralleled the assumptions of her Christian society: Women should be useful to others. If they had wealth and health, they should minister to the poor and weak. Such usefulness defined a good, Christian woman such that it was especially important for a single woman—whose sphere of usefulness might have been less obvious without a husband or children—still to find avenues to serve her family and community.[62]

Another well-known Savannah spinster generously served her city's poor outside the rubric of traditional organization. Mary Lavinder was a midwife and doctor who, her November 1845 obituary maintained, "was one of the most extraordinary women which our state has produced." The obituary continued, "Early in life she devoted herself to the study of medicine, but not content with such information as she could gather from books, she went to Philadelphia, placed herself as a private pupil . . . [with a professor at] the University of Pennsylvania," where she continued her medical education. Subsequently, she returned to Savannah, where she treated both the city's well-to-do, who usually wanted her assistance with labor and childbirth, and the poor, who gratefully took whatever assistance she offered. Praised as "the true friend of the poor," Lavinder daily went into the poor wards to care for those who badly needed the medical care and other essentials she provided. Carried in her old-fashioned "chair" that was drawn by an aging white horse, Lavinder went from house to house, even during the most fearful epidemics. She brought not only medical care but also coffee, sugar, tea, grits, mattresses, and blankets to her needy patients. Masterfully fulfilling the nineteenth-century expectation that women be useful to others, Lavinder earned

praise for having a "life-long course of thoughtful consideration for others, and denial of her own personal comforts."[63]

An anomaly in the antebellum South, where ladies of the propertied classes were expected to marry or at least serve their families or communities in less public and iconoclastic ways, Mary Lavinder was nonetheless accepted and appreciated by the city's elite. At the other end of the social spectrum, the poor she nursed doubtless had few complaints about her deviation from conceptions of refined southern womanhood. "She was not blessed with gentle manners," the obituary conceded, "her exterior was rather forbidding than otherwise, and she despised every sort of finery." Moreover, "Her words too, were not selected for their softness and their euphony, but were short, blunt and to the purpose." Her plain exterior, indeed her "contempt for all courtly accomplishments . . . limited the sphere of her usefulness." Nevertheless, mourners celebrated her remarkable life, remembering how she "fought the good fight" and died trying to aid one last mother and sick child.[64]

Admittedly, Mary Lavinder was an eccentric in her southern city, where the propertied class lived lives of some leisure and propriety typically kept upper-class women from making routine visits to poorer neighborhoods without the sanction of some organization. But Lavender's life had deviated from those of her peers when she was only a child. She had been orphaned at a young age and placed in the Bethesda Home for Girls when she was thirteen. Her father, Benjamin Lavinder, had had a small plantation on Burnside Island, but his estate was valued at a mere 250 colonial pounds upon his death. Mary Lavinder's early life was not privileged, obviously, but she circulated along the peripheries of well-to-do social circles. When she was sixteen, wealthy friends removed her from the Bethesda Home and supported her study with the esteemed Dr. Lemuel Kollock, a prominent Savannah physician. After Lavinder had spent a few years practicing medicine and midwifery in Savannah, her reputation reached Boston, where a physician asked Kollock to persuade her to take over his obstetric practice. He promised Lavinder $1,000 for the first year and more in later years. Lavinder refused the offer but still managed to provide quite well for herself. At the time of her death she had accumulated holdings exceeding $16,000, along with twenty-three slaves and a home and office on East York Street near the court house.[65]

* * *

Certainly, elite white women of the urban lowcountry knew how to organize and orchestrate benevolent endeavors, usually without offending most nineteenth-century sensibilities about southern women's roles. Because they did

not challenge the status quo—in other words the conservative, male-dominated slave society that allowed them the leisure, freedom, and wealth to work on philanthropic projects—society accepted and even exploited their efforts. Churches especially, and the society more generally, benefited enormously from urban women's contributions. Unmarried women, of which there were surprisingly significant numbers, were best situated to work on behalf of the poor, scurry between organizational meetings, distribute religious tracts, raise money for church repairs, take meals to the sick poor, and establish homes for wayward sailors. Their churches knew this, too. Single women were also especially positioned to enjoy the sense of usefulness, camaraderie, and purpose that came from benevolent work. Very likely, most of the women involved, both married and single, found satisfaction in exerting moral influence over the poor, even over male counterparts from time to time. They also managed sizable funds, orchestrated complex efforts, and ventured boldly into the poorest sections of their cities. Both single-handedly, as in the case of Dr. Mary Lavinder and Mary Telfair, and as part of organizations such as St. Philips Episcopal Church, the Ladies Benevolent Society, the seamen societies, and the Mount Vernon Association, women of Charleston and Savannah created an antebellum ethic of benevolence and female organization to enhance their lives and benefit their communities. As one religious leader promised, "The children of coming generations shall rise up and call you blessed."[66] This was particularly inviting to unmarried women in search of blessedness and to childless women wanting a legacy. When civil war ripped apart their country and families, these southern women and the next generation would draw on their antebellum experiences to remake old organizations and launch new ones. They would fashion also a revised, renewed rhetoric about unmarried women's lives.

6. "Such a Strong Personal Love of the Old Place"

Enclaves Undone in Civil War Charleston and Savannah

For women who sought the title of blessed and the immortality of a legacy, the American Civil War offered an unrivaled opportunity for far-reaching usefulness. As the heroine of Augusta Jane Evans's southern wartime novel *Macaria; or, Altars of Sacrifice* considered her role in the emerging national calamity she searched for a way to be useful, noble, and dutiful. The beautiful and benevolent Irene Huntington told an aging friend of the family, "There are seasons when I regret my incapacity to accomplish more; but at such times, when disposed to lament the limited sphere of woman's influence, I am reminded of Pascal's grand definition: 'A sphere of which the centre is everywhere, the circumference nowhere.'" Speaking for herself and for countless other southern women gearing up to support the Confederacy, she continued, "I feel encouraged to hope that, after all, women's circle of action will prove as sublime and extended." Admitting that her own particular circumstances, coupled with the war, meant that she would never marry, Irene reassured a worried friend, "If I am content with my lot, who else has the right to question?"[1]

Over the course of the past century, historians of the Civil War have moved beyond discussions of battles and military leaders to examine women's experiences of war, the widening circles of their action and influence, and the extent to which they were content with their lots, as Irene professed to be. Early studies by scholars of southern women turned their focus to the material contributions women made to the war, such as psychologically and pragmatically supporting husbands, running plantations, forming sewing societies, making flags, becoming nurses in Confederate hospitals, sometimes spying, and, occasionally, disguising themselves as men and joining the army.[2]

More recent studies have reexamined these material contributions and extended the scholarship to explore what the war meant for the women themselves. In many cases white southern women were overcome with feelings of uselessness at the outset of the war. This frustration quickly led them to efforts at organization. Stepping up their antebellum benevolent work and drawing on renewed patriotism and duty, women across the South took on their male kin's farming and business tasks, formed sewing societies and countless other organizations, and raised money for the cause. Some became refugees when the fighting forced them to flee their homes, and a sizable number began formal teaching careers, which was a new step for the majority of them. Southern women moved into other paid occupations as well, including nursing and clerkships. They made these first steps into new arenas first because there was such a need and later because they had grown weary and increasingly disillusioned with their men. Rural women are even credited (or blamed) for contributing to the Confederacy's ultimate demise by pleading with their husbands late in the war to abandon the cause, come home, and help feed their families. Finally, newer studies explore how women leaned increasingly on one another; how they turned to reading and writing to understand their changed lives and identities; how slave-owning women began to reevaluate the institution of slavery; and how many women observed and initiated an across-the-board reassessment of marriage (as so many men were killed). Overall, this wave of scholarship breaks new ground in that it explores how the war profoundly challenged and at the same time cemented southern gender, racial, and class divides.[3]

An explosion of impressive scholarship provides a framework for this study because unmarried white southern women were uniquely situated to experience and sometimes initiate profound shifts. At the most obvious level, women without husbands were especially prone to feelings of uselessness. They had the time, inclination, and, especially in the cities, a strong tradition of antebellum benevolent work that led them directly to work for the war cause. They created and joined war-born organizations and quickly transformed antebellum societies into instruments of the war effort. All the while, unmarried women were especially tuned to the evolving public discourse about women's roles, marriage, and single blessedness. Like nothing before it, the war forced unmarried women to face their singlehood and come to terms with what that meant in both public and private realms. Many observed with a tinge of jealousy and a degree of disdain the frenzied buzz as other well-to-do young women rushed into quick marriages, lowering their standards not a little.

Although some women hurried to marry, many others who remained

unmarried expressed increasing disillusionment with men in general; the younger ones in particular accepted that they would not marry. All of these developments, in addition to the eventual end of slavery, began to alter many women's lives. Moreover, fears about security meant that many unmarried women had to leave the stimulation and camaraderie that coastal cities had offered and reluctantly follow married friends and relatives to supposedly safer upcountry areas. Never was it clearer that antebellum cities offered a sort of enclave for unmarried women than when they could no longer stay there.[4]

This, then, is the story of unmarried women in Charleston and Savannah during the war years. It is less the familiar tale of women volunteering for the war effort (although there is some of that) and more about what the war meant to the mental and material lives of unmarried women in the urban South. Many of the familiar voices from earlier chapters grew quiet during the war years, perhaps due to advancing age, disruption of antebellum routines, or difficulties with the mail. Mary Telfair's extant correspondence for the war years is strikingly slim, although we know that she spent time in Savannah and in North Carolina.

The voices that do emerge differ from those in earlier chapters. The women here are generally younger and less affluent; they were deeply affected by the war and its implications for their lives. These young women volunteered enthusiastically yet clung to their prewar lives in Savannah and Charleston. As the war forced new consideration of women without husbands, their society increasingly regarded them and their unmarried state with concern. Two women discussed in this chapter were not from Charleston or Savannah, but their wartime experiences merit inclusion because the compelling stories expose how the meaning of southern single blessedness changed as a result of the war and what Charleston and Savannnah offered well-to-do women throughout the antebellum and Civil War period.

* * *

Antebellum Savannah and Charleston were interesting cities for unmarried women who found one another and often found themselves there. They could keep abreast of the developing political, social, and literary ideologies of the day and from time to time make significant contributions to those ideologies as writers themselves. In these fluid, well-connected cities, well-to-do ladies grounded themselves in their families and also reached out to connect with northern friends and travel, even to European destinations. They drew on the close-knit nature of urban living to develop sustaining friendships with other women and formed remarkable and numerous be-

nevolent organizations to meet the needs of the city's poor and take on other worthy causes. When sectional conflict erupted into war, especially women with ample resources and no husbands and children could throw themselves into the burgeoning wartime organizations. The war was a watershed for southern women's sense of themselves and for their imperative to organize with one another, but Charleston and Savannah's histories demonstrate that war-inspired introspection and public participation had rich and varied precursors in southern cities before the war. When the conflict began, urban southern women, especially well-to-do single ones, were poised to continue a tradition of usefulness, female companionship, and work that had already begun.[5]

By the end of the war, however, disgruntled and weary, many of these unmarried women found that the legacy of antebellum single blessedness and benevolent activity was not enough to sustain them in the new economic, social, and political landscape. Many assessed their lives and changed circumstances and began to wish for independence from family burdens—and from being a burden on their families. The war created opportunities to pursue this independence and also made plain the limits of nineteenth-century autonomy for southern women. Gone were beloved fathers, brothers, and nephews, anchors to their fundamental sense of being helpmeets to their families. Gone were many of the young and eligible men who may have made brides of younger single women. Gone were the special roles reserved for single women; now *all* women needed to venture out into new roles and responsibilities.

The relative permissiveness, or blind-eye attitude, about spinsterhood was shattered, too. Only a couple of months into the conflict new scrutiny of women's choices and marital prospects took unmarried women out of the margins, where they were often quite busily and happily existing, often unnoticed, and forced them under the microscope of public discourse, debates on the roles of single women, and hand-wringing over their lots. Moreover, nearly all suffered financially as the war emancipated the slaves who had provided them and their families with wealth and comfort. Many unmarried women who had previously enjoyed lives of relative leisure quickly had to find paid employment. Finally, to varying degrees the war took away the cities they had come to love. When unmarried women had to evacuate their urban homes, they found themselves living the isolated, lonely, pitied existence they had so effectively avoided by residing in Charleston and Savannah. Without their urban roles, statuses, friends, and cultures it became clear that those cities had been the key to relatively attractive lives for well-to-do antebellum single southern women.[6]

<p style="text-align:center">* * *</p>

Just as they had been during the antebellum years, Charleston and Savannah were unique and important political, social, and economic centers during the Civil War era. It was in Charleston, for example, that the Democratic National Convention met in late April 1860 to choose a candidate for the upcoming presidential election. And it was there and then that the party split irrevocably down sectional lines over the issue of slavery. Delegates from eight southern states walked out of the convention when the northern wing of the party refused to protect slavery's expansion into the territories. Talk of secession spread from the city to the outlying countryside. In nearby Savannah just two months later, secession again was the rallying cry of angry southerners. The editor of the main newspaper in Savannah observed, "The people of the South have been too long dependent on their Northern neighbors for every conceivable thing, from a clothes-pin to a fancy buggy. We have talent and industry, and capital enough at the South to render us independent of those who would rob us of our property, and we bid God-speed to every effort at 'Southern independence.'" By that point Savannah's streets were filled nearly every night with boisterous crowds, clamoring for secession. They carried torches and banners, cheered impassioned speakers, and demanded an end to "Yankee tyranny." Savannah and Charleston were poised as the country began the long and bloody drama of the Civil War.[7]

Not surprisingly, unmarried southern women were often the most available and most prolific observers of the frenzied goings-on. In Charleston, for example, the Pinckney sisters so well embodied the city's overwhelming support for state sovereignty and nullification (which preceded the calls for secession) that political rallies and parades frequently culminated under their balcony. Maria Pinckney's published essay *Quintessence of Long Speeches Arranged as a Political Catechism* became a standard text in the nullification discourse. Of course, a few unmarried women, like their male kin, observed the dangers of emotional and partisan reactions to national political developments. Eliza Caroline Clay in Savannah noted in her journal in November 1860, "We . . . have no sympathy with the Republican party—but I am mortified & disgusted at the Spirit of some of our southern men. They seem like children with a box of matches—throwing them here & there, perhaps into the water where they are harmless, possibly into a barrel of gunpowder." Perhaps considering herself a better judge, she added, "They are ignorant of all parts of the country but their own corner that they miscalculate the strength of the North & narrate the importance of their individual opinions."[8]

When Clay penned these criticisms she had just returned from her usual summer vacation in New Haven, Connecticut. Indeed, even as war clouds gathered, the elite of Charleston and Savannah, plenty of unmarried ladies among them, continued to travel north and maintain close ties to the North-

east. In August of 1859, for example, Mary Telfair and her sisters vacationed as usual in Newport, this time at the Ocean House on Bellevue Avenue, surrounded by great numbers of other well-to-do southerners and northerners. The next year the Telfairs summered in Saratoga, New York, much like summers before. It was not until the summer of 1861 that they limited their northern forays to Flat Rock, North Carolina, where, Telfair noted, they mingled among the "Charleston aristocracy." Similarly, Alicia Hopton Middleton, an unmarried Charlestonian, remembered that she and her family were visiting their Rhode Island relatives during the summer and fall of 1860 and did not sail for Charleston until late November 1860. By then, she observed, "the die had been cast" because Abraham Lincoln had been elected president on the sixth of that month. Meanwhile, another branch of the Middleton clan was entertaining northern relatives in Charleston even as the first shots of war were fired. These northerners also scurried home.[9]

Notwithstanding a few stragglers here and there, most well-to-do residents of Charleston and Savannah remained at home as the country plunged toward war. In fact, coastal cities were electric with excitement over southern independence. When South Carolina seceded from the Union on December 20, 1860, Charlestonians proudly and loudly led the way to war. As one unmarried woman from Charleston, Emma Holmes, described it, "The city seemed turned into a camp. Nothing was heard but preparations for war, and all hands were employed in the good cause." A month later, Georgia followed South Carolina and seceded from the Union. Both Charleston and Savannah became centers for war preparations as hundreds of state troops flooded the cities within a couple of weeks. Only three months later, the first shots of the Civil War were fired in Charleston's harbor as Confederate troops attacked the region's federal Fort Sumter on April 12, 1861. Charleston was enthralled with the specter of battle and the heady promise of quick success. "The whole afternoon & night the Battery was thronged with spectators of every age and sex, anxiously watching and awaiting . . . the war of cannon opening on the fort or on the fleet," Holmes noted in her journal on April 11. Two days later the city was still on edge as she noted, "the scene to the spectators in the city was intensely exciting. The Battery and every house, housetop and spire, was crowded." She and others jockeyed around telescopes to watch as "shots . . . struck the fort and the masonry crumbl[ed]." When the fighting was through, thirty-three hours after it had commenced, bells rang, celebratory salutes were fired by Confederate ships, and Charlestonians celebrated "one of the most brilliant & bloodless victories in the records of the world." They were ready for a quick and victorious war.[10]

* * *

Throughout the South, daughters, wives, sweethearts, and sisters responded to the war by working to meet the needs of male kin in battle. In Savannah, Mayor Charles C. Jones Jr. observed as early as April 1861, "The ladies of Savannah are not idle. They are daily engaged singly and in concert in the preparation of cartridges both for muskets and cannon. Thousands have been already made by them, and the labor is just begun." Women were busy sewing for the soldiers, too. "Others are cutting out and sewing flannel shirts," Jones boasted. "Others still are making bandages and preparing lint. Their interest and patriotic efforts in this cause are worthy of all admiration."[11]

Not surprisingly, these visible and increasingly organized efforts by white southern women impressed their male contemporaries and, for a number of good reasons, generations of historians thereafter. First, women's group efforts, such as those to sew flags, make uniforms, knit blankets, or raise money, have been relatively easy to document because women left records in organizational and personal papers. Emma Holmes, for example, recorded in her journal how the flag that she was making was progressing. Second, the efforts represented women's support for the Confederacy in both material and mental ways. And, finally, this kind of work signified a shift from the antebellum tradition that may have discouraged women's public involvement and organization, at least in rural areas. In cities, however, this organizational impetus was a natural outgrowth of an already vibrant benevolent culture made all the more critical by women's need to claim a role in the conflict.[12]

Moreover, women's feelings of uselessness during the war led to new identities and new organizational efforts. War work initially took the form of sewing societies, then knitting societies, and eventually evolved into large-scale fund-raising projects that sometimes, remarkably, involved public performances by the women themselves. Some efforts were designed to support a stronger defense of the coastal cities. Emma Holmes recorded in her wartime journal, "The concert given on Thursday night by [six women] and other amateurs for the [Charleston] gunboat fund was so crowded that it was repeated last night." On both nights the audience was so large that many were turned away. Later, Holmes attended the Ladies Gunboat Fair, which, presumably, sought to raise money for the same cause of defense.[13]

Unmarried women especially complained of frustration at the outset of the war and, drawing on their extensive experience with urban benevolent work before the conflict, flocked to wartime organizations. Those without husbands and children could remain in the cities, where much of the organizing was taking place, for much longer than women who had responsibilities to young families. After all, a wife had to look after her husband's

property, including slaves and plantations, and protect her children. Unmarried women also candidly expressed disappointment with men as they watched the Confederacy weaken. They, especially, would be transformed by war.[14]

Emma Holmes, for example, threw herself into organized war work and quickly observed considerable changes within herself. In July of 1861 she joined 191 other women to form the Ladies Volunteer Aid Society of Charleston. Drawing on a long-standing tradition of women's benevolent work in that city, Holmes and her friends were redefining their sense of themselves and the contributions they could make to the war. With "nearly $1000 collected from subscriptions and donations" the group felt proud of their efforts to support the Confederacy. Simultaneously, they found pleasure in the activity itself, as Holmes acknowledged. "The ladies all seemed to enjoy seeing their friends as well as the purpose for which they came," she declared. The initial and primary goal of the society was to sew clothing for southern soldiers. Within a week Holmes reported that she "[s]pent the morning learning to work the machine & made nearly a whole flannel shirt," probably her first. It marked an important shift in Holmes's sense of self and personal limits. She admitted that working the sewing machine and making clothing were "Both . . . my particular dislike." In fact, "it needed all my patriotism to bring me to 'the sticking point.' I've always declared I would not learn to make men's clothes, shirts especially, so everybody laughs at me now." Within a few days, however, she was pleased to report, "Finished my first pair of 'drawers' today. I could not help laughing at the idea of my being able to teach Lila how to put them together. I do not find the machine as hard to manage as I expected and can sew on it pretty well." Within a month's time, Holmes and her fellow society members had made 2,301 flannel shirts and drawers that supplied "two or three companies." Undoubtedly, many of the women, like Holmes with ample resources, domestic slaves, and urban lifestyles, had never before needed to sew men's clothing.[15]

Holmes's identity as a southern single woman was changing as she participated in this effort, acquired new skills, and experienced that all-important sense of being needed. As she confidently noted in her journal in September 1861, "My list of accomplishments is constantly increasing. I can not only make flannel shirts & drawers, the latter being my principal occupation, a pair every morning, but I can load & clean pistols as well as clean them & knit stockings." Holmes was carrying on the noble tradition of American women on the home front, sewing and knitting for valiant soldier-sons, brothers, and fathers, all of whom were defending that very homeland. She proudly invoked her connection to Revolutionary War foremothers when

she observed, "[Knitting stockings] also indeed has become so fashionable that the girls carry their knitting when they go to take tea out just like our great grandmothers." Yet loading and cleaning pistols had by and large been men's work, and Holmes betrayed pride in the mastery of that unconventional skill as well.[16]

A couple of months later a minister confirmed the value of the women's work, filling Holmes and the other association members with more pride. The Rev. R. W. Barnwell spoke before the ladies' group and made a "most eloquent appeal in behalf of the soldiers, to the ladies." He informed them that their generous contributions had amply stocked the hospitals. Indeed, South Carolina alone had raised $45,000. Now, Barnwell insisted, the women themselves were needed in the hospitals, "not so much as nurses, as to superintend the different departments, to read to them & in fact to supply all the charms of home to soothe the sick beds of our noble soldiers." Barnwell requested that twelve or fifteen women from Charleston go to Virginia hospitals, "if only for a month or six weeks, for the ladies there were exhausted & [so were] all the Virginia ladies within twenty miles of the hospital. . . . Any over eighteen could be of service." Perhaps drawing on interstate competition, he told them that "the Va. ladies had done & given everything they could & that, when the war was over, they would not have more in their houses, of house linen etc., than they could barely get on with." Barnwell's conclusion was resounding and inspiring, and Holmes capitalized a quotation from him: "'WITHOUGH YOU, THIS WAR COULD NOT HAVE BEEN CARRIED ON, FOR THE GOVERNMENT WAS NOT PREPARED TO MEET ALL THAT WAS THROWN UPON IT.'"[17] Barnwell told the women what they believed and needed to hear.

Holmes did not go to a Virginia hospital—or to any other—probably because she needed to stay with her widowed mother and several sisters, one of whom was emotionally disturbed. Fortunately for her, the sewing work provided a distraction from the emotional upheavals of her strained home life and from what appeared to be a slow evolution into permanent singlehood. War work gave her a focus. "It is time for me," she said, "to lay aside all romance & come down to the practical, illustrated by red flannel shirts & homespun drawers for soldiers."[18]

Holmes did not spend all of her time working, however, and the exciting urban social environment provided still more welcome distractions. In 1861 and 1862 she attended festive parties, joined sailing excursions to survey the harbor, and reviewed companies of soldiers with surprising regularity. In June 1861 she seemed slightly defensive when she noted in her journal, "I never imagined the city would be so gay when war is impending & so many

of our friends are away among the combatants, but it seems to be a reaction after the long depression of the winter and absence of our friends on duty on the islands." She admitted, "During the last month a great many parties have been given, almost all however small, but often two or three on the same night." Now a social butterfly (a role she had not played to such a degree before the war), Holmes also assumed the heady task of surveying troops. "Another memorable day of pleasure," she reported the following spring. "All of us . . . went to see the review of [John] Waties company in White's Battalion, [Palmetto Battalion Light Artillery] at Simon's Landing. As we passed the Major's [Edward B. White] headquarters, Prevost's farm, he rode out with his staff & several other officers." Sounding as though she knew how to judge the men, she commented confidently, "We first had a review of two companies of infantry, lately mustered in, and quite an awkward squad." The war had given Holmes new opportunities for social interaction among those who remained in the city and a sense of being knowledgeable, well-connected, and valuable. Without the paradigm of beaux and belles, suitors and sought that had dominated the antebellum social scene of elite young people, women were more likely to band together for work and play.[19]

When not occupied with sewing work, social activities, or military reviews, Holmes and her also-unmarried female friends organized reading club sessions, after which they went for long, carefree walks around the city. She seemed almost giddy when she described in February 1862, "This afternoon after our reading club, we nine girls . . . went to walk, but commenced & ended it by a race, down the broad gravel walk of Flinn's [Second Presbyterian] Church Square, which we all enjoyed very much." The city's relative desertion emboldened and intrigued the unattached young women. "It is so quiet & secluded there among the beautiful mock oranges. We felt almost as free as if in the country. Our walk was only around the Citadel Square, but I told the girls I felt quite reconciled to living up town, if we could enjoy such freedom and frolics."[20] The war had opened Charleston in new ways to its eager young women. At the outset of the conflict at least, Holmes and others like her were content, with plenty to do and other women with whom to do it.

* * *

Still, these romps through the city could not entirely distract Holmes from one significant negative about the social life in war-charged Charleston. It seemed to her that nearly all of her acquaintances were getting married and she was not. At age twenty-three she confided to her diary in 1861, "What a bundle of contradictions I am—I wonder if anyone ever *really* loved me. The

pretense of some I soon found out." Many other contemporaries observed also a social frenzy about marriage despite (or perhaps because of) the war. One unmarried Charlestonian described the situation as "a perfect mania for marriage prevailing throughout the country." All the talk of engagements and weddings forced Holmes and other unmarried women to reflect on the unlikelihood of marriage for themselves. As she commented wryly in March 1861, "The prospect of war certainly does not tend to depress love-affairs, for during the last three or four days I've heard of numerous engagements." That June she reported again, "In the last two months Rosa, Fan [Garden], & Carrie have become engaged all apparently sudden[ly] and quite surprising to 'the world.' "[21]

As for Holmes, she speculated that a wedding of her own was not forthcoming: "I wonder whose turn will come next, not mine I'm sure, for I do not think there is anyone who cares particularly for me & I have not seen anyone whom I like as much as my cousins, and I would not marry any of them." She concluded gravely for a twenty-three year-old, "I think I was always meant either to be an old maid (I hope not a disagreeable one) or to die young. As I have never found life very happy, the latter would be preferable. I often amuse myself and my friends with descriptions of my old maid's establishment." Given Holmes's family history of emotional imbalance and her tendency to brood, it is likely that her depression grew out of something deeper than not marrying. Later that year she observed, trying to sound detached, "almost all are either engaged or in love. . . . It is very pleasant and interesting to me to stand a spectator with, but not of them, for I'm too old to *belong* to 'their set' and watch the undercurrent of life gliding swiftly past."[22]

Much of what surprised discriminating maiden-observers like Holmes was that others like them seemed to have lowered their standards, ostensibly in an effort to avoid the fate that still-unmarried women had accepted for themselves. Commenting on a friend's engagement in April 1861, Holmes reported, "almost all of her friends are disappointed in her choice. We had hoped against it. For he is by no means a favorite, from his arrogant supercilious manners, although he can make himself agreeable when he chooses to." This phenomenon continued as the war raged on and marriage seemed all the more elusive for many women, if increasingly possible for previously undesirable men. Holmes's disparaging commentary on the subject continued apace throughout the war, and as late as 1865 she noted marriage after marriage that seemed to be spawned by some war-born fear. In July of that year she observed, "Weddings are as numerous as during the war." In October: "All the youths of twenty-one or twenty-two are crazy on the matrimo-

nial question. Uncle Henry [Gibbes] says Alester has done the same foolish thing &, like all of them, want[s] to be married immediately without a cent in the world or any prospect of maintenance for themselves much less a family." The women especially disappointed her because it seemed to have become fashionable for them to take younger husbands "as if the girls were willing now to take any offer, without regard to suitability." Moreover, the males took advantage of the turn: "The boys & young men are crazy on the subject of marriage now—constant new engagements here." Years later Holmes reported disapprovingly, "Matrimony is raging everywhere. Youths from eighteen to twenty seem deeply smitten—their only cure wives several years older."[23]

Two thirty-something maiden cousins from Charleston observed the same wave of engagements and marriages, along with what they especially considered women's lowered standards. These correspondents, however, expressed more sympathy than Holmes did for young women in their early twenties who found themselves in the midst of war just as they had expected to marry. "My young friends tell me they are fully persuaded that no one ever marries their first love. The young girls nowadays are certainly more sensible than they were in my far away young days. My dear, we were very, very foolish were we not? It is better to be sensible," Harriott Middleton queried her cousin, Susan Matilda Middleton, in 1862. Unlike Holmes, who was only twenty-three at the war's outset, the Middleton cousins considered themselves well past the age and mentality of expectant marriage. By the end of the war they were into their mid-thirties and had greater resources than Holmes to cushion their single lifestyles. Nevertheless, they enjoyed lively discussions about marriage and the changes war had wrought on the matrimonial scene in lowcountry society. In a subsequent letter, Harriott explained to Susan Matilda that she was not being cynical when she reported that no one married their first loves anymore. "You quite misunderstood what I said of the opinion of my young friends on the subject of first loves," she wrote. "It was not that they did not prefer first loves, but they thought life so dreadfully constituted that they never could marry their first loves, and so might as well make up their minds to take some one else," she clarified in 1862. "What I think sensible is a person's quietly acquiescing in what is inevitable and not throwing away happiness and usefulness in vain regrets. However I am too old to have an opinion on the subject." Realistic young women were making the most of what life offered, just as these slightly older cousins had done. Perhaps Harriott considered herself fortunate not to be in the position of many a young woman during the war, who, she said, "engages herself to a fine, handsome young man, and is very apt to *marry* a

cripple or disfigured person! . . . what a fascination there is about men (to young women!) even in a disabled state."[24]

What made these seemingly careless marriages important for unmarried women like the Middletons and like Holmes was that they drew attention to their permanent spinsterhood, a choice or a circumstance that had previously gone largely overlooked or unquestioned. When Harriott Middleton reported to Susan Matilda that their cousin Em had expressed her "fears for the present generation of young girls," Harriott revealed a new focus of attention on single women. Cousin Em had said that "these young girls . . . were the portion of the community to be pitied [because] they would have no chance of getting married." By implication, then, perhaps Harriott and Susan Matilda were to be pitied, too. In a similar vein, Harriott told Susan Matilda of a Charleston lady, Anna Drayton, who had commented "that no woman is a real woman until she is married." Not surprisingly, Susan Matilda, the more sensitive of the two cousins, betrayed her increasing self-consciousness a few months later when she admitted, "I always feel a little *shy* about going to see married people whom I fancy all absorbed in their husbands and children, and indifferent about those of my condition." She added unpersuasively, "Perhaps I am mistaken." The war had turned a bright new light on women who may have passed the point of marriage comfortably some years before the war.[25]

<center>* * *</center>

Anxieties about the number of available men and the need to marry, as well as the perceived need to avoid hurried, poorly considered marriages, developed among southern women because so many men were dying in battle and from diseases contracted while fighting or recuperating. Although residents of Charleston and Savannah began the war with heady confidence about a quick, relatively bloodless victory, it was not long before the realities of battle casualties and Union encroachment upon the cities made all southerners more sober about war. By May of 1862, just thirteen months after Emma Holmes described the festival-like atmosphere in Charleston during and after the firing upon Fort Sumter, she admitted that Charlestonians were far less sanguine about the security of their city. Indeed, many residents expected a full-fledged attack any day. "Everybody in town has a face 'two miles long,'" she observed. "They report an attack upon the city is expected very soon & gentlemen are sending away their families." Indeed, most well-to-do families had evacuated the city by that summer.[26]

In Savannah, federal troops had made early advances toward the city, prompting many women to take their children and slaves and relocate to the

upcountry. Within ten months of Georgia's secession on January 19, 1861, federal troops had landed only twenty-five miles from Savannah. By the first of December the city faced a complete blockade. Fort Pulaski was cut off from the city by February 1862, and in April of that year Union troops began a steady bombardment of the fort. To the surprise of both sides, it fell within twenty-four hours, bringing scarcity, inflation, and fear to the city.

Both Savannah and Charleston were blockaded as Union ships tried to keep the South from importing from, and exporting to, Europe. Residents of these previously lavish cities found that food and other goods were hard to come by and ridiculously expensive. Having federal troops so near only added to the mounting anxiety. As Charlestonian Harriott Middleton confided to her cousin, "Do you not hope that Charleston may be saved. I don't mind our house but I can't bear to give up the old streets and buildings, and the churches. I feel such a strong personal love of the old place." The city itself had become the possession most treasured. Susan Matilda heartily agreed with Harriott, lobbying her father to sell his plantations and slaves "when peace comes! and [begin] at once to build in town."[27]

Meanwhile, the civilians who remained in Savannah and Charleston witnessed a significant change in the composition of their cities. All across the South, urban centers became havens for those displaced by war, including refugees. Troops also flooded the cities and set up military camps throughout the area and on the islands of the lowcountry. In Charleston, people complained that guards and patrols had made the city into an armed camp. In Savannah as well, major demographic shifts transformed the city when well-to-do white mothers and children left and white male troops and impressed black slaves arrived. Unmarried women who remained in the cities found themselves surrounded by a different and diverse set of people. Emma Holmes, for example, described the "mobocracy" that "turned out in great strength [along the Battery], utterly regardless of taste and expense. We were almost ashamed to be seen in such a common crowd." Holmes was careful to make note of the Battery's decline but not too scandalized to remain in the fray, probably surrounded by men and women from a range of class levels and places of origin, people with whom she had never before mingled.[28]

Of course, the multitude of soldiers and the social turbulence in Savannah and Charleston betrayed the increasing vulnerability of the port cities. Savannah's weakness was obvious, with federal troops occupying nearby Fort Pulaski with relative ease by April 1862. And Charleston, "the nursery of disunion" and "the cradle of rebellion," according to the northern press, was an extremely attractive target for federal naval advances. As the *New York*

Tribune observed, "Doom hangs over wicked Charleston. If there is any city deserving of holocaustic infamy, it is Charleston."[29]

Given the cities' increasing vulnerability, their importance for well-to-do women, and Confederate losses across the larger fields of battle, it is not surprising that many southern women admitted to being disappointed and disillusioned with their men. As they found themselves not just sewing shirts and flags but also taking over family businesses and plantations, managing slaves single-handedly, and even raising money for coastal defense, they complained bitterly of "trying to do a man's business," as one southern woman put it. Emma Holmes observed dryly, "How queer the times—the women can't count on the men at all to help them." Unmarried women in particular could be especially candid about men's deficiencies for a variety of reasons. They had no husbands or sons to protect, their personalities often predisposed them to a critical stance, and they felt the need to justify their unmarried state.[30]

Emma Holmes, for example, admitted to her journal in 1863 that her sister considered Emma's "favorite topic—the Equality of the Sexes—for it always makes me indignant to hear men arrogate to themselves such vast superiority over women, mentally and well as physically." Holmes considered herself fortunate to have an intelligent, open-minded male friend with whom to discuss this topic. At the end of an extended conversation with this friend about the issue of men's and women's comparative strengths and weaknesses, Holmes concluded, "He has done me more good than he can know." He told her that he had been observing her and that she had "an originally fine, noble character, but much warped." If only Holmes could unleash the "fund of generosity at the depth of [her] heart." Having prepared his path with ample praise, Holmes's advisor concluded what is probably obvious now: "He had said my standard of what a man ought to be was too high." Holmes's exacting standard probably would have led her to permanent singlehood regardless of the war, but the national calamity prompted her to reflect more carefully on her life experiences as it brought the topics of gender roles and expectations to the fore.[31]

Predictably, Holmes had trouble putting her confidant's advice into practice. The following year she delineated in her journal the several men who had sorely disappointed her. Her most promising male friend (and possibly a suitor), Dr. James Morrow, "has proved a sot and libertine, and I do not recognize him any longer when we meet," she reported in 1864. And then, "Bengie [Guerard] fell from what I hoped," she complained in the same journal entry. A Captain Earle also fell from grace, and Holmes despaired, "It pains me to hear his name, associated by me with all that is noble, intel-

lectual & attractive, made a byword for brutality." Her last hope of young
male rectitude was Captain Hayden, whom she wanted to believe "may retain
his high pedestal or I shall lose all the faith in man which a few specimens
had inspired me with." Even he was not perfect, however, as "Carrie told me
he is a Catholic, & though I felt disappointed, I cannot help admiring him."
Still, it did not look good for Hayden or any of Holmes's male acquain-
tances. As even she admitted, "'To make idols and to find them clay' has been
my lot ever." The war allowed women who may have secretly harbored such
feelings of disillusionment with men to verbalize these feelings and gave
them a language to explain their unmarried state and reassess traditional
gender roles. Of course, they were also the most likely to feel the need to
justify their increasingly definite and increasingly discussed unmarried
state.[32]

Not all unmarried white women criticized men, however. Harriott Middle-
ton, for example, acknowledged that some "think men infirm to women,"
but that, she concluded, was ridiculous. "Alas, we could not act and die as
they do." Two months later she reiterated, "certainly men are braver than
women!" And in her following letter to Susan Matilda: "Those unselfish,
single hearted men, how I admire them! heroes whether known to fame or
only their friends, and to me so infinitely above what a woman can ever attain
to." But despite Harriott's high praise of men, she seemed quite satisfied not
to be married to one, self-confidently suggesting that "a new meaning should
be appended to the term 'old maid.' Instead of describing a vinegar looking
old woman, ill tempered and scandalous, it ought to mean the superior being,
which so many of *us* my dear have introduced into the sisterhood!" Indeed,
this unmarried woman took pride in her moral fortitude, independent and
stern management of her slaves, and political acumen. Commenting on the
rumor of an important Confederate battle loss, she noted, "All the sensible
men, *myself* included! think it must be a hoax." Although her intent was to
amuse her cousin with the suggestion that she was one of the sensible men,
it is clear that Harriott counted herself among the city's well-educated, clear-
headed, and knowledgeable observers. She had probably exhibited that sense
of self even before the war, but the conflict and the great societal changes it
brought gave her new fodder for discussion and new opportunities to excel
even as it drew new attention to her unmarried state.[33]

* * *

Counting herself among the sensible men, Harriott Middleton remained in
Charleston for most of the war aside from a brief period in May of 1862 to
take many of the family's slaves to her sister's place in Flat Rock. Betraying

the erosion of slavery, particularly in the cities, she reported to her cousin, "The agitation amongst the servants in town was becoming very unpleasant and we did not care to subject ourselves to it any longer." But Harriott returned to Charleston as soon as she could. Susan Matilda, by contrast, had moved to the supposedly safer upcountry town of Albemarle, near Columbia, South Carolina, by January of 1862. Sooner or later nearly all well-to-do families left the city, which was increasingly under siege from federal gunboats off the coast.[34]

The process of leaving the lowcountry cities was especially unpalatable for the unmarried ladies of Charleston and Savannah because they had to leave the friends and activities that made their lives enjoyable and meaningful in an urban setting. Southern refugees in general tended to be wealthier than those whom they joined in the upcountry; the refugees were the ones who had the ability and option to move. Naturally, their presumed superiority engendered a great deal of hostility from the local people upon whom they intruded. Being a refugee consumed one's resources rapidly, causing many to relinquish what had defined them as aristocratic. Naturally, unmarried women remained in their city homes as long as they could, usually much longer than their married and mothering sisters could and did, and when they had to leave they did so with heavy hearts. The women knew that refugeeing in the upcountry was expensive, lonely, and boring, particularly for those who had grown accustomed to a busy urban routine.[35]

"This is certainly exile although we are in Carolina," Susan Matilda Middleton complained to her cousin, "but it is *so* different, in every way." She continued, "The people, from what I hear, for we have seen very few of them, are so much more narrow, and self-centred, than ours, and this miserable petty jealousy of the sea-coast is so very contemptible, that I will not talk about it." She would talk about other deficiencies, however: "Then, there are no sunsets—the sun never *sets* here, he only goes down, and the change is from comparative to complete darkness." The next month Susan Matilda was a bit more optimistic, if still condescending, about "the Columbia people [who] are very charming, but they . . . give us but little opportunity of verifying the same by personal experience." She explained, "When we first came up they stared at us like curiosities—we had been 'burnt out,' and they looked at us as the Assyrians did at Shadrack, Meshack and Abednego—people who had passed through the fire, and they examined closely to see if our hair was not singed. But now they have become quite accustomed to the miracle!" Two months later Susan Matilda had resumed her criticism: "There is so much difficulty here, in this mean little town, in finding a place of refuge, even at an exorbitant price, the extortions which are practiced upon

the low-country refugees, by the so-called '*best* people in Columbia,' are enough to disgrace the place forever." She continued, "I heard a lady not long ago say with the bitterest indignation: 'I do believe, if we had gone to the heart of Connecticut, we sh[ou]ld not have fallen among such a set of *screws!*'"[36] With such unflattering appraisals, it was no wonder that locals resented their lowcountry visitors.

* * *

While literature had been a formative and sustaining part of literate women's lives and identities before the war, reading took on new importance for white southern women during the war, especially when they were isolated by the refugee experience. Unmarried refugeeing women were even more likely to rely on novels and biographies to pass the time; they had no children of their own to care for and fewer men in need of their care. Eagerly, they poured themselves into literature, for entertainment and for connection to one another and to a wider world. The Middleton cousins were no exception, filling their wartime letters with discussions of the books they were reading while apart from one another. "I am deep in 'Consuelo,'" Susan Matilda reported to Harriott in January 1862. Apparently, "Consuelo" might be considered an inappropriate choice for a nice southern lady, so Susan Matilda assured her cousin, tongue in cheek, "don't think of giving me up as no longer a reputable acquaintance—a woman of my age can read anything—as Mr. . . . had the imputance to tell me." (The candid "Mr." who insulted Susan Matilda had previously suffered a reprimand from her for sending her "such books as 'Guy Livingstone' and 'Sword and Gown.'") Although she claimed that she "should be sorry to read many such books," Susan Matilda had to admit, "['Consuelo'] is wonderfully clever and well written, and draws you on and holds you fast, interesting, disgusting you and shocking you all the time."[37]

By the end of the following year, in November 1863, however, Harriott, too, had to leave Charleston for the upcountry, but she found that even novels could not ward off the boredom and frustration she had avoided for so long by remaining in her beloved city. "I am more stupid than your mind can conceive of," she reported from Flat Rock, North Carolina. To prove how out of sorts she felt, she complained, "I don't take any interest in books, there is little in the newspapers, and I just live on from day to day." Harriott longed "to get to some paradise where one has no daily worries, and there is an abundance of strong black tea! We consider that a soother of all worldly cares."[38]

Even Emma Holmes, who had been so riveted by goings-on in Charleston for the first part of the war, had to evacuate. By May of 1862 anxieties about

the war and Charleston's vulnerability had reached such a level to cause Holmes's mother to decide to move her daughters to Camden, South Carolina. It was not an easy transition for Emma. "Last week I was dreadfully homesick for the old familiar haunts and faces," she complained later that fall. "Here we feel 'we are strangers in a strange land,' for though we are surrounded by neighbors and acquaintances, they do not seek us sociably to walk or ride in the afternoons or come over to see us after tea." The following March she continued, sounding much like the Middleton cousins, "It is a bitter disappointment to be obliged to remain here, like a caged bird, vainly beating its wings against its prison bars and pining for freedom & its old companions." Holmes was bored with reading and knitting all day, and one year later, in May 1863, she reflected, "Food of every kind is enormously high there [in Charleston], but I would rather live there on the humblest fare than up here in abundance, though that is by no means the case now." She continued, "I am so homesick & heartsick all the time that many a night I go to bed early just to indulge and relieve myself with a quiet cry, unknown to the others." Unstimulated, lonely, and fatigued, she complained, "Here everything is so utterly stagnant & monotonous that I have absolutely nothing to interest me. I read & sew & knit, till my brain & arm are weary and I have no one who sympathizes with my tastes or pursuits, who can enter into my feelings, or enjoy what I do." In an effort to stave off the boredom, Holmes joined a sewing society and even started a reading club, but there was nothing like being in the city.[39]

During this difficult time, Holmes, too, turned to literature, and it was there (and only there) that she found the sort of male hero whom she could not find in day-to-day life. The character of Arthur Rutledge was her "ideal of the male [she] would marry." He was "intellectual, kind-hearted & so tender and loving." This fictional character could inspire Holmes with "that indefinable 'something' which makes you feel you have met a master spirit, such a one, as *even I* should love to obey—to feel that it would be a pleasure to do his wishes—one whom I could reverence as a superior, yet love devotedly."[40]

Fortunately for Holmes, she was able to return to Charleston for a brief but exciting visit in July of 1863. Only three months prior, the Union had begun its long and symbolically charged siege of Charleston. In April 1863 the most powerful armada of any war to date forged into Charleston Bay and began to shell first Fort Sumter and then the city. The Confederates stood ready with ironclad steamrams, submarines, torpedo boats, mines, and well-placed fortifications, effectively repelling the Union invaders. Undaunted, even enthralled, Holmes reveled in the excitement of observing firsthand

war activity as only a woman without a husband and children could do. She saw a few friends, walked along the Battery again, and ardently watched the Union war ships off the coast. "I spent a good part of the day with an excellent spy glass watching the [*New*] *Ironsides* and four Monitors," she recorded in her journal. "I could see almost every discharge &, when the Yankee shells struck, the earth . . . [sent] up a tall column of sand." She was clearly pleased with herself and perhaps secretly pleased with the imminent danger. "I did not feel at all alarmed or excited; I had become so accustomed to the cannonading—but watched everything with intense interest." By the middle of August 1863, it was clear that the shelling of Charleston had escalated to the point that Holmes and her sister would have to leave again. "Today the bombardment was really terrific," she noted as she reluctantly packed her things.[41]

<p style="text-align:center">* * *</p>

Back in the quieter upcountry, Holmes did what many other unmarried white southern women did during the war era: She began to teach. Like many women, Holmes wanted to earn money to contribute to her family's tightening financial situation. After all, nearly all property holders in the South were vulnerable to the destruction of war and to slavery's demise. Even families like Holmes's, without large plantations or farms, relied indirectly on slavery as the basis for the economy and for the value of their property, including real estate, stocks, bonds, and savings in Confederate currency. As formerly leisured ladies went to work, female teachers came to outnumber male teachers by 1880. Beyond the financial gains teaching offered, part of its appeal for Holmes was a sense of "doing something for [myself], especially in these times." Happily, she envisioned herself "a schoolmistress in a pleasant village among friends." Holmes approached teaching with youthful zeal and optimism, seeing in the job and in the war the opportunities to be useful, challenged, and content.[42]

Unmarried women who were a little older than Holmes were less likely to approach the war, and its opportunities for new identities, with such enthusiasm. Harriott Middleton, for example, reflected that "to be middle aged it is less trying for our hopes and dreams are over, and we have yet strength enough to go on with the battle of life, without fainting." Yet at thirty-four she found herself in the midst of a national crisis that significantly altered her plans for a quiet, comfortable, and pampered middle life. "I wonder if your life seems to you as strangely inconsistent as mine sometimes seems to me," she queried her also-unmarried cousin in 1862. "The realities of my life and the situations in which I have been placed have been so strangely differ-

ent from what my character and the early promise of my life would have led one to expect." Specifically, she lamented that "anxiety, responsibility and independence of thought or action are what are peculiarly abhorrent to my nature, and what has been so often required of me."[43]

For women like Middleton, the war made life more difficult and unpleasant as it demanded new tasks and new mentalities of them. A single woman's mantra to be useful came to mean something new and different; it demanded service to one's region, to its massive, unprecedented needs, and to its countless fallen and displaced. Perhaps these slightly older women feared they would lose their status as respected, appreciated, and adored maiden daughters, sisters, and aunts unless they could adapt to wartime demands.

Holmes's youthful confidence was short-lived. Having secured a position in a school, she concluded quickly, "teaching [is] the easiest work I ever undertook." Her first paycheck of $300 was similarly welcome: "It was with a new & peculiar feeling of independence that I received my earnings, or rather the 'earnest' of future exertions." Still the dutiful daughter, Holmes sent most of the money to her mother, who was, like the majority of southerners in 1863, "short of funds at present." But the young teacher looked forward to her next paycheck, when she could spend her earnings on herself. She really wanted a new watch. Unfortunately, however, the position ended within the year, and Holmes began searching for another teaching job. This time she would not be so pleased. As a governess for a wealthy family with thirteen children, ten miles from her family in Camden, Holmes quickly grew disgusted with the ill-mannered children and angry with their mother. When she asked the children's mother to pay her in part with provisions, which Holmes could then give to her mother because Confederate currency was useless, the woman refused. Eventually, Holmes left the family and waited for her back pay for many months. When the money finally came it was far less than she expected. Her hopes of long-term independence and a pleasant community had proven elusive.[44]

In fact, it was not long before Holmes had to take on labor far more arduous than teaching. As domestic slaves began to leave their former owners at the war's end, she and other white women like her found themselves performing some of the hard labor that their slaves had been able—finally—to abandon. Holmes took lessons from a former slave of hers on "how to iron gentlemen's collars." Later, she described washing her family's clothing: "Though of course it was fatiguing, standing so long, it was not near as difficult nor as hard work as I fancied. Indeed, since our wardrobes have diminished, so has our washing list." The next month Holmes and her sisters decided to take in sewing. Holmes admitted that her sewing fees would not

pay for "much . . . for I've always considered seamstresses as a dreadfully ill-paid class & always declared I would never take sewing as my means of livelihood, for it would soon kill me or at least make me feel like committing suicide." But Holmes surprised herself by keeping a positive attitude. She was grateful for the novel they read aloud as they sewed and for the sugar and soap they earned for their labors. "Of course, we should much prefer money, but, that being scarce, barter is the order of the day." Later, Holmes did receive cash for her work, and she pooled those earnings with money she made by selling "a pair of Confed. shoes that did not fit" and a blank writing book. Happily, she "bought . . . the long wished for purple calico—really a very pretty one."[45]

Through all of these challenges and triumphs Holmes longed to return to Charleston. Soon after she had last left the city in August of 1863, Union troops had begun shelling the lower part of the city itself, destroying buildings and igniting fires. The Confederate Army, however, forced a stalemate in Charleston harbor and did not surrender the city for a year and a half longer, after Sherman's army cut a devastating swath through Georgia from Atlanta to Savannah in its infamous march to the sea. In December 1864 Savannah surrendered quickly to incoming Union troops and experienced thereafter a remarkably peaceable occupation. Expecting an attack on Charleston next, many lowcountry elites from that region sent their valuables to Columbia, but, ironically, it was there that Sherman's army marched after its stay in Savannah, bypassing the difficult and circuitous route to Charleston, a city that was effectively defeated already. The Confederate Army finally abandoned Fort Sumter and Charleston in February 1865, just two months before Gen. Robert E. Lee surrendered at Appomatox and the war was over.[46]

With the slaves emancipated and the war-weary soldiers returning to their devastated cities and countryside, white Charlestonians and Savannahians worried even more about their homes, their futures, and the region. By the summer of 1865 Holmes reported with concern, "Our beloved city has become pandemonium." Still in the upcountry, she had heard about "daily altercations between whites & blacks" and various "insurrections having been found out." The possible danger notwithstanding, Holmes wanted very much to return to Charleston: "I cannot but hope we will be able to return to the city with the New Year. . . . People are daily returning, some from here already gone, & others going as soon as the cool weather comes on." In the fall, she wrote sadly, "Charlestonians are gathering back to their beloved town, but there are no prospects of our speedy return, for rents are enormous, $800 being the lowest being mentioned, so many houses having been de-

stroyed or injured." She hoped that her family might move to Main Street in Charleston, "where we will have near & pleasant neighbors." Still the refugee, she complained, "Here we are lonely &, in case of need, almost without protection when the boys are away." Eventually, Holmes moved back to Charleston, where she spent the rest of her life. "Thank God, Charleston is my home. Amidst all her woes, that glorious distinction is hers: she was the Cradle of Secession," Holmes penned in 1866.[47]

What Holmes really wanted to do in Charleston was to translate for her vocation. Specifically, she inquired with several publishers about her translation of *The Life of Bayard*, which, she exclaimed, "would be a labor of love to me," but she could find no takers. The mostly northern publishers claimed that the scarcity of cotton made paper an expensive commodity and the only significant publishing demands were for school books "to supply the educational needs of their free colored brethren." So Holmes returned to teaching and tutoring instead, which she did until her death in 1910.[48]

<p style="text-align:center">* * *</p>

While the women of Charleston and Savannah were clamoring to return to their beloved cities where they could reunite with friends and resume their activities, less elite women from upcountry towns were more ambivalent about returning to prewar activities and assumptions. White southern women in general were determined never to be as helpless and dependent as they had been before the war. At the same time, southern men's dominance over white women was all that kept them from sinking to the inferior status of their women. Often impoverished by the war, overwhelmed by crumbling families, and desperate to reconcile antebellum notions of domesticity and home life with postwar realities, white women in all but the most fortunate families struggled to rebuild tattered lives and reestablish identities.[49]

Unmarried women, especially those without ample resources or urban stimulation and distraction, and of a younger age, were especially vulnerable to frustration and uncertainty but most eager to map new lives for themselves. The lives of two young unmarried women, one from South Carolina and the other from Georgia, whose towns were smaller and perhaps less exciting than Charleston and Savannah, demonstrate what antebellum urban society had offered and how the war both blessed and burdened young unmarried women in general. Grace Brown Elmore of Columbia, South Carolina, and Josephine Varner of Indian Springs, Georgia, were close in age to Holmes, and they, too, turned to teaching during the war to earn money and create a sort of independence from familial conflicts and responsibilities. In contrast to the busy but relatively content aunts in antebellum Charleston and Savannah,

these small-town women found themselves mired in familial obligations and without the social and benevolent outlets.

Born in 1839, a year after Emma Holmes, Elmore came from a family that was well-to-do before the war. Her father was a well-connected lawyer, member of Congress, and bank president whose work took the family to Charleston in 1840. Sadly, his death and the subsequent financial struggles his family suffered caused Elmore's mother to move herself and her eight children to Columbia in 1850. Although she did not become a refugee (like Holmes and the Middleton cousins), Elmore experienced many of the same feelings and frustrations that characterized other young unmarried women of the lowcountry.

As with Holmes, war seemed to seal Elmore's fate as a spinster. Her personality, her feelings about most men, the domestic unrest within her family, an inheritance of real estate and slaves before the war, and a deep longing for independence made it seem unlikely that she would have married, even had the war not occurred. "I am getting unamiable, irritable and bad tempered," she observed in November 1861. Moreover, she deemed herself physically unattractive, admitting, "I know that I am plain, that personal beauty is not mine, but I often see others with not even the personal advantages that I have posess a high place in the hearts of others." Waxing philosophical, she continued pessimistically, "Beauty is as beauty does is the old maxim, but I have never found it so, beauty finds a way to the heart quicker than any thing else." Elmore was drawn more to opportunities to serve the needy rather than a husband. "I have often thought that if I were a Catholic, the Sisters of Charity would be my choice of all the positions of life. I have longed to go to the poor and needy. I've wanted an interest of that kind in life, but there has been no opening," she noted.[50] The war, and teaching, might provide that opportunity.

Perhaps most important, and distinguishing herself from the dutiful daughters and doting aunts portrayed in this study, Elmore wanted to untangle herself from her troubled family and secure her own home. As she reflected in 1862 at the age of twenty-three, "I shocked one of my sisters very much once, by saying that married or not I hoped and trusted I would one day have my own establishment independent of every one else." In addition, Elmore had concluded that marriage was not for her. "Marriage has precious little share in my plans for the future, in the first place because no one has ever asked me yet, and in all probability a man whom I would marry never will, and in the second, marriage to me would hardly be a happy state." She considered her personality to be a poor fit with the institution of marriage. "I am not trusting enough, to let myself be guided by a human creature,"

she observed, "nor do I believe any more in my power to retain than in power to gain love. I am reacting & dreadfully proud, so that I could scarcely be happy with any man." Fortunately, Elmore was not discouraged because "I do not consider this the only means of happiness, if one has an aim in life whether married or single, in that aim does her happiness consist, many people marry for the one interest to which they wish to devote their life, but my desire and will is to find an interest without the appendage of a husband." Elmore was not sure of where to begin her search for independent contentment, but she knew that "the starting point must be a house, and that house mine." She recognized that she would never emerge from the morass of family conflicts and obligations until she lived separately from her difficult sisters and mother. Two years later, however, Elmore's dreams were unrealized. She was still living, unhappily, with her troubled family, "an outcast from all affection at home." Sounding much like the frustrated, single, and rural women in *An Evening When Alone* (and in chapter 1), she observed, "[If] I were a man, long ago would I have left the nest."[51]

Similar to Holmes and other unmarried women, Elmore's determination and hoped-for independence sprang from her conviction that there were far too few good men, a perception that the war likely exacerbated. Once, in 1864, she had the good fortune to meet "an intelligent man" who believed that "a woman's opinions and thoughts [were] equal [to men's] and worthy of attention." Still, he was the exception. As she reflected, "How much more agreeable and profitable society would be if such men were more frequently met." In their absence, Columbia did offer Elmore the chance to serve in hospitals, but she was distracted from the business of caring by the difficulty of distinguishing between Yankee and Confederate soldiers. Overall, what the war offered Elmore was purpose, a distraction from self-absorption, and, according to her diary's editor, "the chance to participate in society as an adult without having to marry." As she observed in 1864, "One does not have much time to indulge in such [self-pitying] thoughts now, the time has come when almost every moment is filled with action, when individual life is lost in that of the mass, and the fretting cares and needs of the souls, in every day life, is forgotten in the immense anxiety in which we are now lost."[52]

Much of Elmore's unhappiness lay in her tense domestic situation. "If I were to live a hundred years in this house, I would never have a settled object, a life giving interest, there is no need of me here, I have no work to do, my place had just as well be vacant," she surmised in 1862. The Elmore women, mother and daughters, chronically bickered and sulked. "I could leave this house as an inmate tomorrow, and my absence would not cause the slightest

inconvenience to heart of body of any except Mother." Elmore felt both unappreciated by her sisters in the house and obligated to look after their aging mother. At long last, Elmore hoped, she could occupy center stage of her own life drama.[53]

While Elmore waited in vain for personal liberation from her family, and for southern liberation, too, she looked to God to fill the roles missing from her life: father, often mother, close friend, and even the South's salvation from northern aggression. At the outset of the war, Elmore, a devout Episcopalian, praised God for defeating the enemy and blessing the southern people. As familial strife continued to plague her, God became her "Father, Mother, All in all." At other times, God was her companion, a friend, which was "a sublime honor" in itself. As the war progressed, Elmore observed, "everything is crumbling around our feet." But still she counted herself among the fortunate because she had God, "the Rock upon which to place [my] feet and stand firm in the storm." It did not seem inconsistent with her Christianity that she wished to "witness the death of each of those wretches [Yankee soldiers]" and prayed that "they may suffer in their homes, their wives their children as they have made us suffer." Sadly, by the end of her journal in 1868, she lamented that "life has at best been a weary waste" and admitted that she longed now for "the shores of Eternity."[54]

Before she reached those eternal shores, Elmore tried and failed to secure the kind of personal autonomy that she had wanted. While the war had created opportunities for teaching and some independence for her, the poverty that gripped the postwar South in general and her little family in particular kept her moving from place to place in search of satisfying teaching positions. As she noted in November of 1867, "'Tis hard to realize we are really poor, and cannot afford even to write as often as we please, or spend a pitiful twenty-five cents in candy." At the beginning of 1868, she reflected, "A year more of half life, a year longer before the life of which I've dreamed, and for which I've so longed . . . I do so crave having my affairs entirely separate from the affairs of others." Elmore knew, "'tis not likely I will ever feel at home in any [home] but the one of which I am mistress," although she was happy to include her brother Albert in her imaginary abode, as "He is the only one I am willing to love." Albert, however, moved to Mississippi and later to Florida, and Elmore spent most of her remaining years living with her sisters, one with whom she taught school and, later, one who was widowed with five children in 1880. Elmore did find success as a writer after the war, working on revising her diary in hopes of publication and even contributing to *South Carolina Women in the Confederacy,* which was published in 1903. But her angst during the war and her continued discomfort

within her family's fold reveal several truths: the tight grip of family obliga-
tions on southern women even after the war, the hard reality of postwar
economic survival for many previously well-to-do families, and the height-
ened experience of frustration among unmarried women outside of the
bustling Savannah and Charleston. Elmore died in 1912 in Jacksonville, Flor-
ida, where her favorite brother, Albert, and his sons then lived.[55]

Another unmarried upcountry woman who found opportunities for pur-
pose and usefulness in the war through teaching but also came to understand
the powerful pull of familial obligations was Narcissa Josephine Varner. Born
just two years before Elmore, Varner was twenty-four when the war began
in 1861, and by that time she had already taken the nickname, "Miss Joe," a
male spelling that may have foreshadowed her independence and same-sex
relationships later in life. In any case, the Varner family was a few rungs
below the elite families of Charleston and Savannah but well-off by upcoun-
try standards. Narcissa Josephine was born in Jasper County, where her father
operated a plantation until about 1849, when he moved his family to Indian
Springs, Georgia, and bought the Indian Springs Hotel, later named Varner
House. From the beginning of this enterprise all family members worked at
the hotel, but time and resources did allow the children formal educations.
Joe and her younger sister, Amanda, attended Eatonton Female Academy
and LaGrange College in LaGrange, Georgia, but they dutifully returned to
Indian Springs to run the hotel when their parents' ill health demanded it.
The war heightened the family's distress as the two eldest sons died in battle
in 1862. Management of the hotel, along with care of their parents, fell to Joe
and Amanda. (The remaining brother taught school nearby, and the other
sister had married.)[56]

It was during these war years that Varner, like Elmore and Holmes in South
Carolina, struggled with what the war offered and how it burdened her. To
sort through the tangled skein of duty and depression, along with opportu-
nity and hope, Varner began a diary, which she simultaneously acknowledged
might be of interest to later students of the war years. Still, what filled Varner's
journal pages as much as war developments were deep feelings of depression,
uselessness, and frustration, which were eventually ameliorated by glimmers
of personal independence and hope for a more fulfilling life. In January 1862
she observed, "I believe the most worthy man extant were he to propose to
me just now, would get an emphatic No. for the simple reason that I have not
energy or life enough to execute anything just now." Similarly, she continued
a couple of weeks later, "It does seem that I have more unnecessary disapoint-
ments than any body else." Part of Varner's discouragement lay in not having
a way to focus on and improve herself as a result of the war. "In the beginning
of this war, I thought what a golden opportunity it would be in the absence

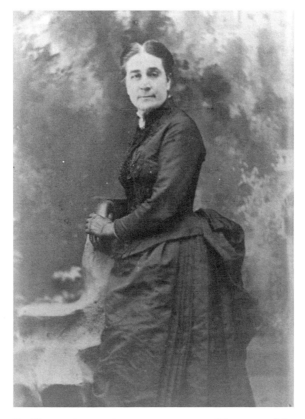

Joe Varner, 1837–1928, as a young woman. (Courtesy of the
Georgia Historical Society, Savannah)

of our friends to improve myself by . . . studying," she admitted in July 1862.
"I hoped when the troubles were over to be ready for teaching, but now, I am
farther from attaining my object than ever."[57]

Fortunately for Varner, she did not have to wait until the war's end to
begin teaching because numerous opportunities presented themselves dur-
ing the war years. And just as with Elmore, Holmes, and many other unmar-
ried women who were not among the lowcountry's most elite, teaching was
the most promising avenue to usefulness, purpose, and independence. "Last
week ended my first adventure in teaching," she reported in March 1863 from
her new residence in Macon, Georgia. "So far I have enjoyed my little school
very much. I love the children already, which makes me more patient, & then
they are bright & sprightly which makes it a pleasure to teach them." Still,
Varner would not allow herself to grow too comfortable in the position:
"How long I shall stay here, I have not the most remote idea, but so long as

I can be usefull . . . & am not needed at home, & can keep my health I shall stay." It was clear that Varner hoped she could stay in town and that the position was good for her. She acknowledged as much the following month, noting, "I feel altogether better than I have in some time."[58]

Varner was finding a happy independence for herself and becoming involved in her new urban community. She helped to organize a Sabbath school, "which I hope will prove a blessing to this community," she wrote in 1863. She was grateful that friends at home had not forgotten her, observing, "My friends are so kind to write & send me sweet messages of love, it is enough to keep me away just to receive them." But that was not all that kept Varner away; she was pleased with her new life. "Unless called home on some providential occasion, I shall stay just as long as I wish. It may be wicked[,] it may be weak, but I greatly enjoy being Mistress of my own movements," she admitted. Now was the time that she could make her own way successfully, "if I am to steer my boat alone all through life, and grant that I may dock it cheerfully, as I feel that I can now." The town of Macon, although it was no Charleston or Savannah in terms of size, diversity, or connections to the Northeast, provided new opportunities for usefulness, new relationships, and independence.[59]

Sadly, Varner was not able to hold onto this life for very long. Like Elmore and Holmes, she was compelled by familial obligations to leave her position and return to an ailing parent. She found another teaching position in her hometown, but her deflated attitude suggested that it was not merely teaching that had sustained her in Macon. It had been the town and her independence there. "I expect now to begin teaching with Mr. Willis Monday Morning," she recorded in June of 1863. "[H]ow I will succeed here time can only tell. this is rather a bad community for a new beginner. I am disposed to discharge my duty faithfully, both to myself & pupils whether or not my efforts will be appreciated in this community I can't yet say." Perhaps longing for the urban stimulation and intellectual rigor of her life in Macon, she complained, "It is a plain truth & I had as well acknowledge it that an element of *vulgar* ignorance pervades this whole community, which cannot be done away with in a long time."[60]

Varner stayed at home for the remainder of the war as her mother grew increasingly ill. Without access to the kind of life she wanted, Varner drew within herself. As she confided in her journal in 1864, "I am entirely alone tonight except a head ache, which is not a pleasant companion, what a great pleasure it is sometimes to be all to one's self be that self never so uninteresting & interested." She admitted, however, that "We are all social beings, I am more so than more people, [and I] love my friends dearly." But something

about her home and its rural setting left her unfulfilled and melancholy. Guiltily, she turned to solitude for a reprieve. "[T]here are times in my life when to be alone affords me the sweetest relief imaginable." Even Varner herself could see that the extroversion, contentment, and autonomy she enjoyed in Macon contrasted sharply with her introversion, depression, and interdependence at home in Indian Springs. The war had given her the chance to escape her rural roots and try the opportunities of a small city. There she had a taste of the life some unmarried women enjoyed in full in Charleston and Savannah.[61]

Throughout her life, especially during the difficult war years, Varner did what many historians have noted about white southern women at the time: She turned increasingly to female friends for love and support. One of her most ardent admirers and devoted friends was Alice Baldy, another woman born in the 1830s who never married and taught school to support herself and her family. Living in Griffin, Georgia, just west of Indian Springs, Baldy also found herself playing the role of Atlas, holding up a crumbling family. Two sons had died, another son contributed nothing to the family, and the last son was quite young. The eldest sister, Mary Jane, was going blind, and the younger sisters had married, died, or were still children. The father, William H. Baldy, had died in 1856, and the mother was increasingly ill. Much of what kept Baldy going during these difficult years was her deep and loving friendship with Joe Varner. As she wrote in January 1870, "Dear Josie I am pining for a sight of you. Will the time ever come when your voice, so low & sweet & musical, yet so clear & distinct, will be the last sound I hear every night, & your face the first object I see every morning?" Baldy dreamed of running a school with Varner during the days and sharing a home (and bed) with her by night. In the meantime, Baldy regretted that she could not be with Varner more often. "I love you and *want* to take care of you—I would do it if I could, & save you every contact with anything rough, or harsh," she explained. "I don't like it myself, but I can stand it better than you, I think."[62]

Baldy envisioned herself as the stronger member of the pair, as she instructed Varner that in public, "I want you to be a *wide-awake, energetic, business woman & do wonders.*" In private, however, she was to "be the soft, passive, charming embodiment of sweetness & loveliness that I love with a passionate tenderness & intensity that I cannot describe." Again professing her love for Varner, Baldy insisted, "I am only a woman like yourself, yet you never had, & never can have a more devoted, sincere & constant lover than you have in me; and mine, my dear, is a love that will never tire." For unknown reasons the letters from Alice Baldy to Joe Varner stopped abruptly

after 1877. In one of the final ones, Baldy indicated that she had read through Varner's letters and burned many of them, at Varner's request. Later in life Baldy confided to her brother that she had once written about her personal feelings but now knew better. "When I was young I used to write things I would not like seen, but I am more prudent and careful now."[63]

Although Varner and Baldy were women of the upcountry, far from the lowcountry social whirl and wartime frenzy, Varner's brief but revelatory stay in Macon and the two women's intense relationship demonstrate how the war allowed many southern women to experience the purpose and the friendships that elite women of the lowcountry had been enjoying during the antebellum period. Indeed, throughout the nineteenth century the southern urban environment offered many unmarried women their best hope of finding purpose, stimulation, and community. Moreover, especially in the absence of these settings, relationships among women sustained and enriched the lives of many. When the war took away male kin, thrust women into new roles and activities, destabilized the economic and social foundation of the region, and freed the slaves, urban enclaves and female friendships became even more critical as unmarried women tried to make sense of life. There was much work to be done, their families were often weakened financially and spiritually, and their choices were unclear and uncharted.

∗ ∗ ∗

One of the most important and stirring guides for women, especially unmarried white women trying to understand and plan their lives at the end of the war, was Augusta Jane Evans's *Macaria; or, Altars of Sacrifice*. A best-selling novel, which a huge number of southern women read and commented upon in their diaries and letters, *Macaria* even captured the attention of Emma Holmes, who noted, "I like the book very much." Published in 1864, it was the story of two young women, Irene Huntington and Electra Grey, who refuse loveless matches, embrace unmarried life, devote their lives to the Confederate cause, and find identities through Confederate nationalism. The plain and modest Electra volunteers in Confederate hospitals and later throws herself into creating art that glorifies the southern war effort. The beautiful and affluent Irene works with poor factory operatives and then sets up a school of design for women to learn the new skills and occupations needed after the war. Evans's heroines embrace their unmarried state in a way that was explicit, bold, and new. Instead of marrying men, they piously and zealously married their work for the Confederate cause. The Greek-to-English translation of Macaria is *blessed,* and Electra is *wed.*[64]

Toward the end of Evans's novel and the war, the two women sit together by a parlor window, rolling bandages for the wounded and pondering the

"important influence [the women of the South] must exercise . . . in determining our national destiny." Having given this serious thought, Irene concludes that she, as an unmarried woman, has a special responsibility to serve the Confederate legacy. "I have no ties to prevent me from giving my services . . . [to] aid the cause for which my father died. I feel it a sacred duty." Some time later she explains to Electra, sounding much like the antebellum aunts and benevolent ladies of Charleston and Savannah, "it is very true that single women have trials for which a thoughtless, happy world has little sympathy. But lonely lives are not necessarily joyless; they should be, of all others, most useful." Comparing the busy wife and mother to the single woman, Irene concludes, "Doubtless she is happier, far happier, than the unmarried woman; but to the [unmarried woman] belongs the privilege of carrying light and blessings to many firesides—of being the friend and helper of hundreds; and because she belongs exclusively to no one, her heart expands to all her suffering fellow-creatures." Claiming a celebratory definition of "'Old Maids'" rooted in prewar, largely urban rhetoric, Irene (and Evans behind her) urges the unmarried southern women of the war generation to "prove themselves social evangels of mercy, as an uncrowned host of martyrs." She continues, "Remember that the woman who dares to live alone, and be sneered at, is braver, and nobler, and better than she who escapes both in a loveless marriage." Distancing themselves from emerging northeastern notions of personal independence, Evans's new heroines insist upon their loneliness. They want not to sound happy with the implications of Confederate defeat or forced autonomy and simultaneously claim that their lives hold much promise: "It is true that you and I are very lonely, and yet our future holds much that is bright." Electra has her art and the management of Irene's School of Design, and Irene has numerous philanthropic endeavors in addition to the domestic responsibilities of caring for two elderly men. She and Electra look hopefully toward the future without husbands. As Irene concludes, "beyond this bloody baptism [are] open vistas of life-long usefulness."[65]

After the staggering casualties of the war, especially for the South, many had no choice but to look to a future without husbands and hope for usefulness as something other than wives. The lives of this generation of would-be war brides—women whose prospects of marriage were shattered by war—would be both a continuation of and a departure from those of their maiden aunts. Building on their antebellum experiences, women across the South continued to help with family farms and businesses, devote themselves to church work, and increasingly to teach school, especially with the expansion of public education in the South during Reconstruction.

As they had before the war, women continued to lean on one another and

work on various causes, including the ultimate Lost Cause. Indeed, southern women worked hard to memorialize the Old South, the Confederacy, and its fallen men. Ironically, as they looked backward to a life that used to be they were simultaneously creating new roles in a New South. Historians have long noted how the Civil War taught southern women about their strength and gave them the confidence and organizational skills to move into the public sphere. Once again, unmarried women would be specially poised to take on leadership roles, write, organize, and reflect prolifically on the changes in their society and in their lives.

* * *

Perhaps few women enjoyed the limitless postwar vistas that Irene in *Macaria* had promised. Savannah's surrender had left it largely unscathed, but Charleston was devastated. In September 1865 a northern reporter described it as "a city of ruins, of desolation, of vacant homes, of widowed women, of rotting wharves, of deserted warehouses, of weed-wild gardens, of miles of grass-grown streets." Not surprisingly, some of the wealthiest women who returned to the city from being refugees saw the destruction and guiltily left for other urban settings. Alicia Hopton Middleton, for example, set sail for Massachusetts as soon as the war was over. She and her siblings looked forward to seeing long-missed Rhode Island relatives and continuing their northern educations, but they dutifully tarried over Charleston's ruin beforehand. "It was inexpressibly hard for us to leave our beloved land in the day of her dire trouble, and the kind friends we left behind bade us a sorrowful goodbye," she remembered. Middleton's brother Nathaniel Russell Middleton also remorsefully explained that the reason for their speedy departure was "my mother's great desire . . . to see her mother once more, and it was the general wish of the family to see again their uncles, aunts, and cousins, for whom they had always had such warm affection." Middleton insisted that he could not shake the image of his beleaguered Charleston even as he found himself swept into familial and educational activities. He was especially struck by "the untouched wealth and prosperity on every side [in the North], in contrast with the absolute ruin which we had just left at Charleston, and the poverty almost to starvation of its conquered people."[66]

In Savannah, although the architecture remained intact and Sherman's occupation had been largely nonviolent, a pervasive sadness fell over white residents. Mary Telfair's brother-in-law William Hodgson described the "marked effects of moral depression" and added that southern men had become distracted, preoccupied, and melancholy. As Mary Telfair observed one year after the surrender of Savannah, "The south has been shorn of its

beams. The climate is all that is left of its glory. The inhabitants look very sad." She went on to describe with pride "young men belonging to the old aristocracy of South Carolina supporting themselves by fishing and cutting wood for the government. I admire them as heroes." For her part, Telfair and her sister and brother-in-law left their woodcutting and fishing contemporaries behind and traveled to Europe in July 1866. "Paris is filled with Americans. We only associate with Confederates," Margaret Telfair Hodgson noted, holding tight to her southern allegiance. The trio returned to Savannah in the spring of 1867, but despite their disgust with "Yankee land," as Margaret described it, they were back in New Port, Rhode Island, by the summer of 1868, enjoying an idyllic, leisured vacation that is hard to distinguish from the many other visits they had there before the war. Mary Telfair basked in the "polished and agreeable" friends and acquaintances there and greatly enjoyed the "enchanting Bay."[67]

* * *

When the Civil War ended, more than four million slaves were emancipated, and the white South had been conquered, militarily, economically, and spiritually. The unmarried women of Charleston and Savannah, like many Americans, had been forever changed by the war. These women had ventured boldly into new roles by building on their urban antebellum experiences of benevolent work. Individually in their families, they took on the management of plantations, farms, and businesses. Collectively, they banded together to sew clothing, make flags, and raise money. Many women gained a new political awareness and lost their idealism about their men. Urban southern women had witnessed a transformation of their cities and reluctantly left those unique enclaves for supposedly safer, although definitely less stimulating, upcountry refuges.

Women without husbands observed also a shift in the way southern society viewed them. Suddenly more than an able and available, beloved or humored, part of the family and community, these women had become analyzed and pitied, and at the same time a crucial resource in a war that killed more than 260,000 southern men and demanded the service of more than a million others. There were vistas of usefulness, to be sure, in the war-torn, battered South, as the novelist Augusta Jane Evans had indicated, but Charleston's and Savannah's well-to-do women knew that their lives had been rich with opportunities for usefulness within their families, churches, and communities long before the fighting broke out. Sustained by these meaningful roles, powerful friendships with one another, and an ideology that accepted, even celebrated, their places in an otherwise restrictive, limit-

ing society, these women had embodied many of the ideals of southern single blessedness. The postwar South may have held new possibilities for them, but the economic uncertainties of the period made the promise of independence elusive for those who needed it most and irrelevant for those who did not.[68]

Notes

Introduction

1. Mary Telfair to Mary Few, July 24, no year (item 292), and Jan. 7, 1828 (item 28), both in the William Few Collection, Georgia Archives, Morrow (hereafter WFC).

2. Ann Reid to William Moultrie Reid, June 2, 1848, William Moultrie Reid Papers, South Caroliniana Library, Columbia, S.C. (hereafter Reid Papers).

3. Elizabeth Fox-Genovese, *Within the Plantation Household: Black and White Women of the Old South* (Chapel Hill: University of North Carolina Press, 1988), 271–73; Sarah Grimké, *Letters on the Equality of the Sexes, and the Condition of Woman* (Boston: Isaac Knapp, 1838), quoted in Jane H. Pease and William H. Pease, *Ladies, Women, and Wenches: Choice and Constraint in Antebellum Charleston and Boston* (Chapel Hill: University of North Carolina Press, 1990), 17; George Fitzhugh, *Sociology for the South; or, The Failure of Free Society* (1854), quoted in Kent Anderson Leslie, "A Myth of the Southern Lady: Antebellum Proslavery Rhetoric and the Proper Place of Women," *Sociological Spectrum* 6, no. 1 (1986): 44. On southern women's early marriages, see Joan Cashin, *Our Common Affairs: Texts from Women in the Old South* (Baltimore: Johns Hopkins University Press, 1996), 14; Jane H. Pease and William H. Pease, *A Family of Women: The Carolina Petigrus in Peace and War* (Chapel Hill: University of North Carolina Press, 1999), 3; Bertram Wyatt-Brown, *Southern Honor: Southern Ethics and Behavior in the Old South* (New York: Oxford University Press, 1982), 203–5; and Jane Turner-Censer, *North Carolina Planters and Their Children, 1800–1860* (Baton Rouge: Louisiana State University Press, 1984), 21. For a discussion of marriage as central to national identity and place, see Nancy F. Cott, "Marriage and Women's Citizenship in the United States, 1830–1934," *American Historical Review* 103 (Dec. 1998): 1440–74.

4. Stephanie McCurry, *Masters of Small Worlds: Yeoman Households, Gender Relations, and the Political Culture of the Antebellum South Carolina Low Country* (New York: Oxford University Press, 1995), 214–25; Leslie, "A Myth of the Southern Lady," 31–49.

5. J. L. Dawson and H. W. DeSaussure, *Census of the City of Charleston, South Carolina,*

for the Year 1848 . . . (Charleston: J. B. Nixon, 1849), 25–28; Cynthia M. Kennedy, "Braided Relations, Entwined Lives: Charleston, South Carolina, Women at Work and Leisure, and the Social Relations of Urban Slave Society, 1780–1860," Ph.D. diss., University of Maryland, 1999, 178–79; Pease and Pease, *Ladies, Women, and Wenches,* 1–21; Michael O'Brien, ed., *An Evening When Alone: Four Journals of Single Women in the South, 1827–67* (Charlottesville: University Press of Virginia for the Southern Texts Society, 1993), 2–3; Catherine Clinton, *The Plantation Mistress: Women's World in the Old South* (New York: Pantheon Books, 1982), 232; Lee Chambers-Schiller, *Liberty, a Better Husband: Single Women in America: The Generations of 1780–1840* (New Haven: Yale University Press, 1984), 5.

6. O'Brien, ed., *An Evening When Alone,* 1–3.

7. "The Lyceum, No. II: Old Maids," *Southern Literary Messenger* 3 (Aug. 1837): 473–74. Because marriage was central to southern culture and ideology, I most often use the term *unmarried* to describe women who were not married or who never did so. Occasionally, I use the term *spinster,* as my subjects did. Nineteenth-century Americans sometimes used it as a disparaging term, but occasionally the women without husbands appropriated the term themselves and used it to describe themselves in a positive light. Recently, scholars of single women have begun using the phrase *ever-single* to describe women who never marry without assuming the centrality of marriage. Jennifer Baumbusch, "Health Care and the Ever-Single, Older Woman: A Critical Feminist Analysis," M.A. thesis, University of Western Ontario, London, Ont.

8. Historian Michael O'Brien (*An Evening When Alone,* 1) agrees that "the study of antebellum Southern women has concentrated on the married. . . . At the center of our understanding has grown to be the plantation mistress. We have been offered varying versions of her . . . but her centrality has been assumed."

9. Chambers-Schiller, *Liberty, a Better Husband,* esp. 22–28, 67. For a discussion of the southern twist on domesticity ideology, see Marli F. Weiner, *Mistresses and Slaves: Plantation Women in South Carolina, 1830–1880* (Urbana: University of Illinois Press, 1998), 55–61, and Fox-Genovese, *Within the Plantation Household,* 59–66.

10. Chambers-Schiller, *Liberty, a Better Husband,* 5–7. For a later reexamination of "elective" spinsterhood in the nineteenth-century Northeast, see Zsuzsa Berend, "Cultural and Social Sources of Spinsterhood in Nineteenth-Century New England," Ph.D. diss., Columbia University, 1994. Berend maintains that an ethic of usefulness, rather than self-interest or autonomy, led women to callings other than marriage. The historiography on southern women's opportunities as a result of the Civil War is detailed in chapter 6.

11. On southern women's identities being rooted in family, see Elizabeth Fox-Genovese, "Family and Female Identity in the Antebellum South: Sarah Gayle and Her Family," in *In Joy and In Sorrow: Women, Family, and Marriage in the Victorian South, 1830–1900,* edited by Carol K. Bleser (New York: Oxford University Press, 1991), 15–31. Joan Cashin adds that southern women's lives differed from those of northern women in experiences of racial violence, miscegenation, earlier marriage, higher mortality in childbirth, fewer and flimsier legal rights and protections, and less freedom of conduct (*Our Common Affairs,* 13–16, 43). Joyce Broussard's dissertation on unmarried women in mid-century Natchez, Mississippi, argues that women served their families and community in exchange for security, purpose, and belonging. This was at the heart of what Broussard describes as the "servant ideal" in "Female Solitaires: Women Alone in the Lifeworld of

Mid-Century Natchez, Mississippi, 1850–1880," Ph.D. diss., University of Southern California, 1998.

12. Drew Gilpin Faust, *Mothers of Invention: Women of the Slaveholding South in the American Civil War* (Chapel Hill: University of North Carolina Press, 1996), 151. A study that argues that historians have overstated southern distinctiveness is Cynthia A. Kierner, *Beyond the Household: Women's Place in the Early South, 1700–1835* (Ithaca: Cornell University Press, 1998), 7.

13. Anne Firor Scott, *The Southern Lady: From Pedestal to Politics, 1830–1930* (Charlottesville: University Press of Virginia, 1970); Barbara Welter, "The Cult of True Womanhood: 1820–1860," *American Quarterly* 18 (Summer 1966): 151–74; Linda Kerber, "Separate Spheres, Female Worlds, Woman's Place: The Rhetoric of Women's History." *Journal of American History* 75 (June 1988): 9–39; Carroll Smith-Rosenberg, "The Female World of Love and Ritual: Relations between Women in Nineteenth-Century America," *Signs* 1 (Autumn 1975): 1–30; Nancy Cott, *The Bonds of Womanhood: "Woman's Sphere" in New England, 1780–1835* (New Haven: Yale University Press, 1977); Suzanne Lebsock, *Free Women of Petersburg: Status and Culture in a Southern Town, 1784–1860* (New York: W. W. Norton, 1984), xviii, 112–45. The next wave of scholarship questioned the existence of a southern female culture and included Clinton, *The Plantation Mistress;* Jean Friedman, *The Enclosed Garden: Women and Community in the Evangelical South, 1830–1900* (Chapel Hill: University of North Carolina Press, 1985); and Fox-Genovese, *Within the Plantation Household.* More recent examinations that suggest a more tentative, problematized culture among women include Victoria Bynum, *Unruly Women: The Politics of Social and Sexual Control in the Old South* (Chapel Hill: University of North Carolina Press, 1992), 90–110; Christie Anne Farnham, *The Education of the Southern Belle: Higher Education and Student Socialization in the Antebellum South* (New York: New York University Press, 1994), 11–120; Steven Stowe, *Intimacy and Power in the Old South: Ritual in the Lives of Planters* (Baltimore: Johns Hopkins University Press, 198) xvii–xviii; and, at least tentatively, Joan E. Cashin, "'Decidedly Opposed to *the Union*': Women's Culture, Marriage, and Politics in Antebellum South Carolina," *Georgia Historical Quarterly* 78 (Winter 1994): 735–59, and Cashin, *Our Common Affairs,* 1–30.

14. Cashin, *Our Common Affairs,* 1–30; Anya Jabour, "It Will Never Do for Me to Be Married': The Life of Laura Wirt Randall, 1803–1833," *Journal of the Early Republic* 17 (Summer 1997): 193–236.

15. Ann Reid to William Moultrie Reid, Feb. 18, 1848, Reid Papers.

Chapter 1: "Upon Those Shady Banks . . . to Stand and View the Busy World"

1. A number of scholars recently have produced rich studies of nineteenth-century American cities. Many of them focus on urban women's experiences. Consider Cynthia M. Kennedy, "Braided Relations, Entwined Lives: Charleston, South Carolina, Women at Work and Leisure, and the Social Relations of Urban Slave Society, 1780–1860," Ph.D. diss., University of Maryland, 1999; Karin Wulf, *Not All Wives: Women of Colonial Philadelphia* (Ithaca: Cornell University Press, 2000); Edward J. Cashin and Glenn T. Eskew, eds., *Paternalism in a Southern City: Race, Religion, and Gender in Augusta, Georgia* (Ath-

ens: University of Georgia Press, 2001); Mary Ryan, *Democracy and Public Life in the American City during the Nineteenth Century* (Berkeley: University of California Press, 1997); Gregg D. Kimball, *American City, Southern Place: A Cultural History of Antebellum Richmond* (Athens: University of Georgia Press, 2000); Perry Duis, *Challenging Chicago: Coping with Everyday Life, 1837–1920* (Urbana: University of Illinois Press, 1998); Elizabeth Jane Enstam, *Women and the Creation of Urban Life: Dallas, Texas, 1843–1920* (College Station: Texas A&M University Press, 1998); Carolyn J. Lawes, *Women and Reform in a New England Community, 1815–1860* (Lexington: University Press of Kentucky, 2000); Christine Stansell, *City of Women: Sex and Class in New York, 1789–1860* (Urbana: University of Illinois Press, 1987); and Kathy Peiss, *Cheap Amusements: Working Women and Leisure in Turn-of-the-Century New York* (Philadelphia: Temple University Press, 1986).

For examinations of the lowcountry region surrounding Savannah and Charleston, see Mart A. Stewart, *"What Nature Suffers to Groe": Life, Labor, and Landscape on the Georgia Coast, 1680–1920* (Athens: University of Georgia Press, 1996); Betty Wood, *Women's Work, Men's Work: The Informal Slave Economies of Lowcountry Georgia* (Athens: University of Georgia Press, 1995) and Wood, *On Gender, Race, and Rank in a Revolutionary Age: The Georgia Lowcountry, 1750–1820* (Athens: University of Georgia Press, 2000); William Dusinberre, *Them Dark Days: Slavery in the American Rice Swamps* (New York: Oxford University Press, 1996); Stephanie McCurry, *Masters of Small Worlds: Yeoman Households, Gender Relations, and the Political Culture of the Antebellum South Carolina Lowcountry* (New York: Oxford University Press, 1995); and James Bagwell, *Rice Gold: James Hamilton Couper and Plantation Life in the Georgia Coast* (Macon: Mercer University Press, 20).

2. Mary Telfair to Mary Few, Jan. 6, [1830] (item 204) and Jan. 27, [1830] (item 201), both in the William Few Collection, Georgia Archives, Morrow (hereafter WFC). For an examination of a more structured and official community of nineteenth-century unmarried women, see Johanna Miller Lewis, "Equality Deferred, Opportunity Pursued: The Sisters of Wachovia," in *Women of the American South: A Multi-Cultural Reader,* edited by Christie Farnham (New York: New York University Press, 1997), 74–89.

3. Mary Telfair to Mary Few, Aug. 12, 1832 (item 227), WFC.

4. *Charleston Courier,* June 12, 1818, quoted in Michael Johnson, "Planters and Patriarchy: Charleston, 1800–1865," *Journal of Southern History* 46 (Feb. 1980): 45–72, esp. 51; Judge H. V. Johnson, "Address by the Honorable H. V. Johnson at the Commencement Exercises of the Wesleyan Female College, Macon, Georgia, on the 14th of July, 1853 (Macon, Ga., 1853)," quoted in Elizabeth Fox-Genovese, *Within the Plantation Household: Black and White Women in the Old South* (Chapel Hill: University of North Carolina Press, 1988), 257. See also Marli F. Wiener, *Mistresses and Slaves: Plantation Women in South Carolina, 1830–1880* (Urbana: University of Illinois Press, 1998), 64–65.

5. Alicia Hopton Middleton, *Life in Carolina and New England During the Nineteenth Century* (Bristol, R.I.: privately printed, 1929), 61–62.

6. Middleton, *Life in Carolina,* 61–62, 177–78.

7. Mary Telfair to Mary Few, Jan. 17, [1814] (item 124), WFC.

8. John Wallace to Margaret Wallace, Sept. 1, 1814, in Mary Savage Anderson, ed., "The Wallace Letters," *Georgia Historical Quarterly* 17 (June 1934): 189; "The Great Will Case," *Savannah Morning News,* Jan. 15, 1877.

9. Mary Telfair to Mary Few, Dec. 2, 1842 (item 156), WFC.

10. Gerda Lerner, *The Grimké Sisters from South Carolina: Rebels against Slavery* (Boston: Houghton Mifflin, 1967, repr. New York: Oxford University Press, 1998), 24; Charles J. Johnson Jr., *Mary Telfair: The Life and Legacy of a Nineteenth-Century Woman* (Savannah: Frederic C. Beil, 2002).

11. Michael O'Brien, ed., *An Evening When Alone: Four Journals of Single Women in the South, 1827–67* (Charlottesville: University Press of Virginia for the Southern Texts Society, 1993), 24, 153–220; see also Johnson, "Planters and Patriarchy," 45–72; and Charlene Boyer Lewis, "Ladies and Gentlemen on Display: Planter Society at the Virginia Springs, 1790–1860," Ph.D. diss., University of Virginia, 1997.

12. Catherine Clinton, *The Plantation Mistress: Woman's World in the Old South* (New York: Pantheon Books, 1982), 16–35; Fox-Genovese, *Plantation Household,* 116–30; Anne Firor Scott, *The Southern Lady: From Pedestal to Politics, 1830–1930* (Charlottesville: The University Press of Virginia, 1970), 27–44; Marli F. Weiner, *Mistresses and Slaves: Plantation Women in South Carolina, 1830–1880* (Urbana: University of Illinois Press, 1998), 30–49 (quotation, 30).

13. Robert Mackay, *The Letters of Robert Mackay to His Wife, Written from Ports in America and England, 1795–1816,* edited by Walter Charlton Hartridge (Athens: University of Georgia Press, 1949), 30; Mrs. David Hillhouse to David Hillhouse, April 25, 1818, in *The Alexander Letters,* edited by Marion Alexander Boggs (Athens: University of Georgia Press, 1980), 49. For a discussion of women shaping the social season and the eventual diminution of urban partying due to evangelical criticism, see Cynthia A. Kierner, *Beyond the Household: Women's Place in the Early South, 1700–1835* (Ithaca: Cornell University Press, 1998), 50–53, 146.

14. Mary Telfair to Mary Few, Feb. 17, 1816 (item 9), WFC.

15. Elizabeth Moss, *Domestic Novelists in the Old South: Defenders of Southern Culture* (Baton Rouge: Louisiana State University Press, 1992), 40–41; Steven M. Stowe, "City, Country, and the Feminine Voice," in *Intellectual Life in Antebellum Charleston,* edited by Michael O'Brien and David Moltke-Hansen (Knoxville: University of Tennessee Press, 1986), 296, 319–21.

16. William H. Pease and Jane H. Pease, *Ladies, Women, and Wenches: Choice and Constraint in Antebellum Charleston and Boston* (Chapel Hill: University of North Carolina Press, 1990), 161.

17. Mary Telfair to Mary Few, Oct. 19, [1812] (item 6), WFC.

18. Mary Telfair to Mary Few, no date [summer 1826] (item 265), Feb. 17, [1828] (item 207), Jan. 29, [1830] (item 201), June 11, 1832 (item 46), Jan. 15, [1838] (item 169), and Feb. 23, no year (item 203), all WFC.

19. Elizabeth W. Allston Pringle, *Chronicles of Chicora Wood* (Boston: Christopher Publishing House, 1940), 57–60.

20. Susan Matilda Middleton to Harriot Middleton, March 2, 1862, Middleton Family Papers, South Carolina Historical Society, Charleston.

21. O'Brien, ed., *An Evening When Alone,* 107–52, 221–382, esp. 45–46.

22. Lewis, "Ladies and Gentlemen on Display"; Mackay, *The Letters of Robert Mackay,* 45, 57, 61.

23. Mackay, *The Letters of Robert Mackay,* 88.

24. Mary Telfair to Mary Few, Sept. 27, no year, WFC.

25. Mary Telfair to Mary Few, March 27, [1828] (item 281), WFC; E. Brooks Holifield, *The Gentlemen Theologians: American Theology in Southern Culture, 1795–1860* (Durham: Duke University Press, 1978). For examinations of emigration and planter mobility, consider Joan E. Cashin, *A Family Venture: Men and Women on the Southern Frontier* (New York: Oxford University Press, 1991); and James David Miller, *South by Southwest: Planter Emigration and Elite Ideology in the Slave South* (Charlottesville: UVA, 2002).

26. Barbara L. Bellows, *Benevolence among Slaveholders: Assisting the Poor in Charleston, 1670–1860* (Baton Rouge: Louisiana State University Press, 1993), 27–29; William H. Pease and Jane H. Pease, *The Web of Progress: Private Values and Public Styles, 1828–1843* (Athens: University of Georgia Press, 1991), 130–32.

27. Margaret Cowper to Eliza McQueen, Feb. 2, 1807, and Feb. 4, 1806, Mackay and Stiles Family Collection, Southern Women and Their Families in the Nineteenth Century Microfilm Series.

28. Daniel Kilbride, "Philadelphia and the Southern Elite: Class, Kinship, and Culture in Antebellum America," Ph.D. diss., University of Florida, 1997; Daniel Kilbride, "Travel, Ritual, and National Identity: Planters on the European Tour, 1820–1860," *Journal of Southern History* 69 (Aug. 2003): 549–84; Lewis, "Ladies and Gentlemen on Display"; Angela D. Mack, "In Pursuit of Refinement: Charlestonians Abroad, 1740–1860," *Carologue* 15 (Spring 1999): 16–19; Maurie D. McInnis and Angela D. Mack, *In Pursuit of Refinement: Charlestonians Abroad, 1740–1860* (Columbia: University of South Carolina Press, 1999); Johnson, *Mary Telfair*, 56–72. Another study of southern participation in a transatlantic literary and market culture is Jeffrey Robert Young, *Domesticating Slavery: The Master Class in Georgia and South Carolina, 1670–1837* (Chapel Hill: University of North Carolina Press, 1999). On nineteenth-century women's transatlantic networks, specifically among northern and European reformers, see Margaret H. McFadden, *Golden Cables of Sympathy: The Transatlantic Sources of Nineteenth-Century Feminism* (Lexington: University Press of Kentucky, 1999).

29. Una Pope-Hennessy, *The Aristocratic Journey: Being the Outspoken Letters of Mrs. Basil Hall Written during a Fourteen Months' Sojourn in America, 1827–1828* (New York: G. P. Putnam's Sons, 1931), 226; Mackay, *The Letters of Robert Mackay*, 92. Hartridge, Mackay's editor, adds (291) that it was not until the spring of 1810 that the city made an effort to beautify the squares.

30. Sara Hathaway, *Old Homestead* (1891), quoted in Mills Lane, *Savannah Revisited: History and Architecture* (Savannah: Beehive Press, 1994), 46; Thackeray quoted in Lane, *Savannah Revisited*, 119.

31. Eugene C. Tidball, "A Northern Army Officer in Antebellum Savannah: The 1849 Memoirs of Second Lieutenant John C. Tidball," *Georgia Historical Quarterly* 34 (Spring 2000): 116–38.

32. Emily Burke, *Pleasure and Pain: Reminiscences of Georgia in the 1840s* (Savannah: Beehive Foundation, 1991), 7, 17–18; William Harden, *Recollections of a Long and Satisfactory Life* (New York: Negro Universities Press, 1943), 5–16, 21.

33. Preston Russell and Barbara Hines, *Savannah: A History of Her People since 1733* (Savannah: Frederic C. Beil, 1992), 82; see also Richard Haunton, "Savannah in the 1850s,"

Ph.D. diss., Emory University, 1968; Mark Reinberger, "Oglethorpe's Plan of Savannah: Urban Design, Speculative Freemasonry, and Enlightenment Charity," *Georgia Historical Quarterly* 81 (Winter 1997): 839–62; and Stewart, *"What Nature Suffers to Groe,"* 38–47.

34. *Census for 1820* (Washington: Gales and Seaton, 1821); *Sixth Census; or, Enumeration of the Inhabitants of the United States in 1840* (Washington: Blair and Rives, 1841), 232–33, 226–27; Paul M. Pressly, "The Northern Roots of Savannah's Antebellum Elite, 1780s-1850s," *Georgia Historical Quarterly* 87, no. 2 (2003): 157–99. Pressly warns against too easily painting Charleston and Savannah with the same brush.

35. Walter J. Fraser Jr., *Savannah in the Old South* (Athens: University of Georgia Press, 2003), 258; *Population of the United States in 1860* (Washington: Government Publishing Office, 1864), 452; Lane, *Savannah Revisited,* 119–21; Whittington B. Johnson, *Black Savannah, 1788–1864* (Fayetteville: University of Arkansas Press, 1996), 55–56; David R. Goldfield, "Pursuing the American Urban Dream: Cities in the Old South," in *The City in Southern History: The Growth of Urban Civilization in the South,* edited by Blaine A. Brownell and David R. Goldfield (Port Washington: Kennikat Press, 1977), 58–61. For the perspective that Savannah's manufacturing operated at "an extremely low level," exporting "little but cotton, lumber, and rice," see Allan Pred, *Urban Growth and City-Systems in the United States, 1840–1860* (Cambridge: Harvard University Press, 1980), 115.

36. David R. Goldfield, *Region, Race, and Cities: Interpreting the Urban South* (Baton Rouge: Louisiana State University Press, 1997), 202; Mark I. Greenberg, "Creating Ethnic, Class, and Southern Identity in Nineteenth-Century America: The Jews of Savannah, Georgia, 1830–1880," Ph.D. diss., University of Florida, 1997, 25–40; Mackay, *The Letters of Robert Mackay,* 91, 97. Mackay went on to compare Savannah to Norfolk; he found the latter to be "without exception the dirtiest hole that ever was built" (197). See also Charles Seton Henry Hardee, *Reminiscences and Recollections of Old Savannah* (privately printed, 1928).

37. *The Tenth Census of the United States: 1850* (Washington: Robert Armstrong, 1853), 339; *Population of the United States in 1860* (Washington: Government Publishing Office, 1864), 452; Mary Telfair to Mary Few, June 11, 1832 (item 46), WFC. Gregg Kimball points out that southern cities were relatively unconnected to each other as they became increasingly connected to, and dependent upon, northern cities (*American City,* xvii).

38. Ivan Steen, "Charleston in the 1850's: As Described by British Travelers," *South Carolina Historical Magazine* 71 (1970): 36–45; Eugene P. Moehring, *Urban America and the Foreign Traveler, 1815–1855* (New York: Arno Press, 1974), 34; Mary Gallant, "Recollections of a Charleston Childhood, 1822–1836," *South Carolina Historical Magazine* 98 (Jan. 1997): 56–74; Harriet R. Holman, ed., "'Charleston in the Summer of 1841': The Letters of Harriott Horry Rutledge," *South Carolina Historical and Genealogical Magazine* 46 (1945): 1–14. Consider also Erskine Clarke, *Wrestlin' Jacob: A Portrait of Religion in the Old South* (Atlanta: John Knox Press, 1979), 85–95.

39. Robert N. Rosen, *A Short History of Charleston* (Columbia: University of South Carolina Press, 1982, 1992, 1997), 21–28; Frederick P. Bowes, *The Culture of Early Charleston* (Chapel Hill: University of North Carolina Press, 1942), 94–117.

40. Johnson, "Planters and Patriarchy"; Michael O'Brien and David Moltke-Hansen, *The Intellectual Life of Antebellum Charleston* (Knoxville: University of Tennessee Press, 1986), esp. x, 7–8, 19–20; Stanley Kenneth Deaton, "Revolutionary Charleston," Ph.D.

diss., University of Florida, 1997; George C. Rogers Jr., *Charleston in the Age of the Pinck-neys* (Columbia: University of South Carolina Press, 1969); John Francis Marion, *The Charleston Story: Scenes from the City's History* (Harrisburg: Stackpole Books, 1978); Gary Phillip Zola, *Isaac Harby of Charleston, 1788–1828: Jewish Reformer and Intellectual* (Tuscaloosa: University of Arkansas Press, 1994). For an examination of Charleston's scientific community, see Lester D. Stephens, *Science, Race, and Religion in the American South: John Bachman and the Charleston Circle of Naturalists, 1815–1895* (Chapel Hill: University of North Carolina Press, 2000).

Less is written, and there is probably less to say, about Savannah's intellectual culture, but see Pressly, "Northern Roots," 152; William Harden, *A History of Savannah and South Georgia*, vol. 1 (Chicago: Lewis Publishing, 1913); Patrick Allen, *Literary Savannah* (Athens: Hill Street Press, 1998); and Michael E. Price, *Stories with a Moral: Literature and Society in Nineteenth-Century Georgia* (Athens: University of Georgia Press, 2000).

41. Walter J. Fraser Jr., *Charleston! Charleston! The History of a Southern City* (Columbia: University of South Carolina Press, 1989), 233–35. The scholarship examining the role of merchants in the antebellum South includes Robert Sobel, *Machines and Morality: The 1850's* (New York: Crowell, 1974); Harold D. Woodman, *King Cotton and His Retainers: Financing and Marketing the Cotton Crop of the South, 1800–1925* (Columbia: University of Missouri Press, 1990); Lacy K. Ford Jr., *Origins of Southern Radicalism: The South Carolina Upcountry, 1800–1860* (New York: Oxford University Press, 1988); Steven Hahn, *The Roots of Southern Populism: Yeomen Farmers and the Transformation of the Georgia Upcountry, 1850–1890* (New York: Oxford University Press, 1983); and Vicki Vaughn Johnson, *The Men and the Vision of the Southern Commercial Conventions, 1848–1871* (Columbia: University of Missouri Press, 1992).

42. Pease and Pease, *Ladies, Women, and Wenches;* Pease and Pease, *The Web of Progress;* Frederic C. Jaher, *The Urban Establishment: Upper Strata in Boston, New York, Charleston, Chicago, and Los Angeles* (Urbana: University of Illinois Press, 1982), 340; Steen, "Charleston in the 1850's," 36; Fraser, *Charleston, Charleston!* 22–35. On Charleston's heyday, see especially Rogers, *Charleston in the Age of the Pinckneys,* and Bowes, *The Culture of Early Charleston.*

For Charleston's relationship to the North, see David Goldfield, *Region, Race, and Cities: Interpreting the Urban South* (Baton Rouge: Louisiana State University Press, 1997), 23, and Pred, *Urban Growth,* 116. See also Don H. Doyle, *New Men, New Cities, New South: Atlanta, Nashville, Charleston, Mobile, 1860–1910* (Chapel Hill: University of North Carolina Press, 1990).

43. Fraser, *Charleston! Charleston!* 235–36; Jaher, *The Urban Establishment,* 320; Robert N. Rosen, *The Jewish Confederates* (Columbia: University of South Carolina Press, 2000), 31; Michael P. Johnson and James L. Roark, *Black Masters: A Free Family of Color in the Old South* (New York: W. W. Norton, 1984), 178–79, 266–70.

A wave of more recent scholarship concerns working-class and immigrant antebellum southerners. On Savannah, see Greenberg, "Creating Ethnic, Class, and Southern Identity," and Mark I. Greenberg, "Savannah's Jewish Women and the Shaping of Ethnic and Gender Identity, 1830–1900," *Georgia Historical Quarterly* 32 (Winter 1998): 751–74; Timothy Lockley, *Lines in the Sand: Race and Class in Lowcountry Georgia* (Athens: University of Georgia Press, 2000); Timothy Lockley, "'A Struggle for Survival': Non-Elite White

Women in Lowcountry Georgia, 1790–1830," in *Women of the American South: A Multi-Cultural Reader,* edited by Christie Farnham (New York: New York University Press, 1997), 26–42; Timothy Lockley, "The Strange Case of George Flyming: Justice and Gender in Antebellum Savannah," *Georgia Historical Quarterly* 34 (Summer 2000): 230–53; Michele Gillespie and Susannah Delfino, eds., *Neither Lady Nor Slave: Working Women in the Old South* (Chapel Hill: University of North Carolina Press, 2002); Dennis C. Rousey, "From Whence They Came to Savannah: The Origins of an Urban Population in the Old South," *Georgia Historical Quarterly* 79 (Summer 1995): 311–36; Edward Matthew Shoemaker, "Strangers and Citizens: The Irish Immigrant Community of Savannah, 1837–1861," Ph.D. diss., Emory University, 1990; and Herbert Weaver, "Foreigners in Antebellum Savannah," *Georgia Historical Quarterly* 37 (March 1953): 1–3.

On Charleston, see Michael Everette Bell, "Regional Identity in the Antebellum South: How German Immigrants Became 'Good' Charlestonians," *South Carolina Historical Magazine* 100 (Jan. 1999): 9–28; James W. Hagy, *This Happy Land: The Jews of Colonial and Antebellum Charleston* (Tuscaloosa: University of Alabama Press, 1993); and Dennis C. Rousey, "Aliens in the WASP Nest: Ethnocultural Diversity in the Antebellum Urban South," *Journal of American History* 79 (June 1992): 52–64.

44. Johnson and Roark, *Black Masters,* 39–40, 170, 203–9; Michael P. Johnson and James L. Roark, *No Chariot Let Down: Charleston's Free People of Color on the Eve of the Civil War* (New York: W. W. Norton, 1984); Timothy Lockley, "Spheres of Influence: Working Black and White Women in Antebellum Savannah," in *Neither Lady nor Slave: Working Women of the Old South,* edited by Susan Delfino and Michele Gillespie (Chapel Hill: University of North Carolina Press, 2002), 102–20; Whittington B. Johnson, "Free African-American Women in Savannah, 1800–1860: Affluence and Autonomy amid Adversity," *Georgia Historical Quarterly* 76 (Summer 1992): 260–83. Johnson's *Black Savannah,* 55–83, deliniates ways in which Savannah's African American population was distinct from those of other southern cities.

45. Lane, *Savannah Revisited,* 123–24; Moehring, *Urban America,* 35–44. For the interaction between slaves and free people of color in Charleston, see Johnson and Roark, *Black Masters,* esp. 207, 209, 226–27; and Clarke, *Wresalin' Jacob,* 91–95. See also *Designs against Charleston: The Trial Record of the Denmark Vesey Slave Conspiracy of 1822,* edited by Edward A. Pearson (Chapel Hill: University of North Carolina Press, 1999), 1–164; and Fraser, *Savannah in the Old South,* 301–10.

46. Theodore D. Weld, *American Slavery as It Is: Testimony of a Thousand Witnesses* (New York: American Anti-Slavery Society, 1839), quoted in Gerda Lerner, *The Grimké Sisters from South Carolina: Pioneers for Women's Rights and Abolitionism* (New York: Oxford University Press, 1998), 29.

47. Lane, *Savannah Revisited,* 120–24.

48. Two of the most useful (and contrasting) analyses of urban slavery are Richard C. Wade, *Slavery in the Cities: The South 1820–1860* (New York: Oxford University Press, 1964), and Claudia Dale Goldin, *Urban Slavery in the American South, 1820–1860* (Chicago: University of Chicago Press, 1976). Wade offers a very descriptive account of the fluidity, flexibility, and disarray of slavery in southern cities, which, he maintains, made slavery less manageable and attractive for white owners and prospective owners. For Goldin, slavery and city life were not incompatible, and other factors, including the cost

of maintaining slaves in the cities, account for the decline in numbers of slaves in certain cities. My study benefits most from Wade's description of a southern urban environment that allowed slaves, and perhaps well-to-do white women as well, greater mobility, fluidity, and independence and at the same time placed greater public scrutiny and consequences on their indiscretions than their rural counterparts experienced.

See also Pearson, *Designs against Charleston;* Lane, *Savannah Revisited,* 124; Bernard E. Powers Jr., *Black Charlestonians: A Social History, 1822–1885* (Fayetteville: University of Arkansas Press, 1994), 9–26; Timothy J. Lockley, "Trading Encounters between Non-Elite Whites and African-Americans in Savannah, 1790–1860," *Journal of Southern History* 66 (Feb. 2000): 25–48; Ulrich Bonnell Phillips, "The Slave Labor Problem in the Charleston District," *Political Science Quarterly* 22 (Sept. 1907): 416–39, reprinted in *Plantation, Town, and Country: Essays on the Local History of American Slave Society,* edited by Elinor Miller and Eugene D. Genovese (Urbana: University of Illinois Press, 1974), 7–28; and Fraser, *Savannah in the Old South,* 151–52, 231–306.

Other useful examinations of slavery in urban areas include Robert C. Reinders, "Slavery in New Orleans in the Decade before the Civil War," *Mid-America* 44 (Oct. 1962): 211–21, reprinted in *Plantation, Town, and Country,* edited by Miller and Genovese, 365–76; Midori Takagi, *Rearing Wolves to Our Own Destruction: Slavery in Richmond, Virginia, 1782–1865* (Charlottesville: University Press of Virginia, 1999); T. Stephen Whitman, *The Price of Freedom: Slavery and Manumission in Baltimore and Early National Maryland* (Lexington: University Press of Kentucky, 1997); Tommy L. Bogger, *Free Blacks in Norfolk, Virginia, 1790–1860: The Darker Side of Freedom* (Charlottesville: University Press of Virginia, 1997); and Kimberly S. Hanger, *Bounded Lives, Bounded Places: Free Black Society in Colonial New Orleans, 1769–1803* (Durham: Duke University Press, 1997).

49. Powers, *Black Charlestonians,* 9–27, esp. 9–10, 24; Lane, *Savannah Revisited,* 124.

50. Goldin, *Urban Slavery in the American South,* 40.

51. Rosen, *A Short History of Charleston,* 98; Robert N. Rosen, *Confederate Charleston: An Illustrated History of the City and the People during the Civil War* (Columbia: University of South Carolina Press, 1994), 16; Powers, *Black Charlestonians,* 32–33; see also Clarke, *Wrestlin' Jacob,* chapter 7.

Chapter 2: "A Glory Such as Marriage Never Gave"

1. The historiography on southern women's reading and writings is growing. See, for example, Elizabeth Moss, *Domestic Novelists in the Old South* (Baton Rouge: Louisiana State University Press, 1992); Anne Goodwyn Jones, *Tomorrow Is Another Day: The Woman Writer in the South, 1859–1936* (Baton Rouge: Louisiana State University Press, 1981); Elizabeth Moss and Susan V. Donaldson, eds., *Haunted Bodies: Gender and Southern Texts* (Charlottesville: University Press of Virginia, 1997); and Drew Gilpin Faust, *Mothers of Invention: Women of the Slaveholding South in the American Civil War* (Chapel Hill: University of North Carolina Press, 1996), ch. 7. Consider also Cathy N. Davidson, *The Revolution and the Word: The Rise of the Novel in America* (New York: Oxford University Press, 1986); Richard H. Brodhead, *Culture of Letters: Scenes of Reading and Writing in Nineteenth-Century America* (Chicago: University of Chicago Press, 1993); Mary Kelley, *Private Women, Public Stage: Literary Domesticity in Nineteenth-Century America* (New York: Oxford University Press, 1984); and Mary Kelley, "Reading Women/Women Read-

ing: The Making of Learned Women in Antebellum America," *Journal of American History* 83 (Sept. 1996): 401–24.

2. John Gregory, *A Father's Legacy to His Daughters* (Providence: Bennett Wheeler, 1782), 28–32.

3. Peter Atall, *The Hermit in Philadelphia: Second Series Containing Some Account of Young Belles and Coquettes; Elegantes and Spoiled Children; Dandies and Ruffians; Old Maids and Old Bachelors; Dandy Slang and Lady-Slang; Morning Visits and Evening Parties; Dress and Ornaments; Female Slanderers and Male Exquisites; Long Branch Letters and Prices Current; Lotteries and Quacks; Billiards and Pharo; Gambling and Sporting; Elections and Amusements; Theatricals and Horse Racing; Wife Selling and Betting; Boxing and Cocking; Dog Fighting and Bull Baiting, &c. &c. &c.* (Philadelphia: J. Maxwell and Moses Thomas, and New York: Haley and Thomas, 1821), 45, 112–16, 124–25. For the assertion that epithets about unattractive unmarried women date from the seventeenth century, or earlier, to the mid-twentieth century in Anglo-American culture, see Rosalind Moss, "Reinventing Spinsterhood: Competing Images of 'Womanhood' in American Culture, 1880–1960," Ph.D. diss., University of Minnesota, 1988, esp. ch. 1.

4. Ann Martin Taylor, *Retrospection, A Tale* (Philadelphia: Collins and Croft, 1822).

5. Mary Telfair to Mary Few, Oct. 14, 1827 (item 30), William Few Collection, Georgia Archives, Morrow (hereafter WFC).

6. Peter Gaskill, Miss Farrington, and J. P. Poud, *Old Maids; Their Varieties, Characters, and Conditions* (London: Smith, Elder, 1835), vi, 4, 46–47.

7. Gaskill, Farrington, and Poud, *Old Maids,* 27, 51, 28, 84, 213, 163–64, 191–92, 217, 220.

8. For an introduction to the Cult of Domesticity, see Carl Degler, *At Odds: Women and the Family in America from the Revolution to the Present* (New York: Oxford University Press, 1980); Daniel Scott Smith, "Family Limitation, Sexual Control, and Domestic Feminism in Victorian America," in *Clio's Consciousness Raised: New Perspectives on the History of Women,* edited by Mary S. Hartman and Lois Banner (New York: Harper and Row, 1974), 119–36; Mary Ryan *Cradle of the Middle Class: The Family in Oneida County, New York, 1790–1865* (New York: Cambridge University Press, 1981); Nancy F. Cott, *The Bonds of Womanhood: "Woman's Sphere" in New England, 1780–1835* (New Haven: Yale University Press, 1977, 1997); and Kathryn Kish Sklar, *Catharine Beecher: A Study in American Domesticity* (New Haven: Yale University Press, 1973).

9. On the "reserve army" of single female relatives, see Lee Chambers-Schiller, *Liberty, a Better Husband: Single Women in America: The Generations of 1780–1840* (New Haven: Yale University Press, 1984), esp. 39–40, and Lee Chambers-Schiller, "'Woman Is Born to Love': The Maiden Aunt as Maternal Figure in Ante-bellum Literature," *Frontiers* 10, no. 1 (1988): 30–43. Chambers-Schiller adds (43) that after the Civil War, the literature turned on maiden aunts, portraying them in an increasingly dark fashion as socially and spiritually stunted, pitiful, and unnecessary. Consider also Katharine Moore, *Cordial Relations: The Maiden Aunt in Fact and Fiction* (New York: Humanities Press, 1967); and Katharine Ottaway Kittridge, "'Tabby Cats Lead Apes in Hell': Spinsters in Eighteenth-Century Life and Fiction," Ph.D. diss., SUNY, Binghamton, 1991. A full discussion of the role of the maiden aunt in Charleston and Savannah's antebellum southern families appears in chapter 3.

10. Susan Koppelman, "Introduction," *Old Maids: Short Stories by Nineteenth-Century United States Women Writers* (Boston: Pandora Press, 1984), xv, 3, 5. See also Susan R. Gorsky, "Old Maids and New Women: Alternatives to Marriage in Englishwomen's Novels, 1847–1915," *Journal of Popular Culture* 7 (1973): 68–85.

11. "The Lyceum, No. II: Old Maids," *Southern Literary Messenger* 3 (Aug. 1837): 473–74.

12. Catherine Kerrison, "The Novel as Teacher: Learning to Be Female in the Early American South," *Journal of Southern History* 69 (Aug. 2003): 513–48.

13. Mary Telfair to Mary Few, Aug. 30, ca. 1828 (item 254), WFC.

14. The ideal of nineteenth-century companionate marriage is documented and explored in the Introduction as well. Degler, *At Odds;* Jean Friedman, *The Enclosed Garden: Women and Community in the Evangelical South, 1830–1900* (Chapel Hill: University of North Carolina Press, 1985), esp. 35–37; Linda Kerber, "Separate Spheres, Female Worlds, Woman's Place: The Rhetoric of Women's History," *Journal of American History* 75 (1988): 9–39; Elizabeth Fox-Genovese, "Family and Female Identity in the Antebellum South: Sarah Gayle and Her Family," in *In Joy and In Sorrow: Women, Family, and Marriage in the Victorian South, 1830–1900,* edited by Carol K. Bleser (New York: Oxford University Press, 1991), 15–31; Elizabeth Fox-Genovese, *Within the Plantation Household: Black and White Women of the Old South* (Chapel Hill: University of North Carolina Press, 1988), 58–71, 78–80; Anya Jabour, *Marriage in the Early Republic: Elizabeth and William Wirt and the Companionate Ideal* (Baltimore: Johns Hopkins University Press, 1998).

15. Mary Kelley, "A Woman Alone: Catharine Maria Sedgwick's Spinsterhood in Nineteenth-Century America," *New England Quarterly* 51 (June 1978): 209–25; Mary Kelley, *Private Women, Public Stage: Literary Domesticity in Nineteenth-Century America* (New York: Oxford University Press, 1984), 240–46.

16. "The Lyceum," 474.

17. Catherine Maria Sedgwick, *Married or Single* (New York: Harper and Brothers, 1857), vi–vii, 81; Kelley, *Private Women, Public Stage,* 210; Harriett Martineau quoted in Katharine Moore, *Cordial Relations: The Maiden Aunt in Fact and Fiction* (New York: Humanities Press, 1967), 168.

18. Mary Telfair to Mary Few, July 14, 1828 (item 223), Jan. 30, 1835 (item 66), and Aug. 2, 1839 (item 84), all WFC; Mary Alden Hopkins, *Hannah More and Her Circle* (New York: Longmans, Green and Col, 1947), 1–9. See also other more recent biographies of More, including Elizabeth Kowaleski-Wallace, *Their Father's Daughters: Hannah More, Maria Edgeworth, and Patriarchal Complicity* (New York: Oxford University Press, 1991); Charles Howard Ford, *Hannah More: A Critical Biography* (New York: P. Lang, 1996); and Patricia Demers, *The World of Hannah More* (Lexington: University Press of Kentucky, 1996).

19. Mary Telfair to Mary Few, Feb. 7, no year (item 209), WFC; Jeffrey Robert Young, *Domesticating Slavery: The Master Class in Georgia and South Carolina, 1670–1837* (Chapel Hill: University of North Carolina Press, 1999), 178–80; Eva Figes, *Sex and Subterfuge: Women Writers to 1850* (New York: Persea Books, 1982), 1–2. See also Davidson, *The Revolution and the Word* and Jane Tompkins, *Sensational Designs: The Cultural Work of American Fiction, 1790–1860* (New York: Oxford University Press, 1985).

20. Mary Telfair to Mary Few, Feb. 7, no year (item 209), WFC.

21. The framework of southern ideology based on plantation households is laid out

by Fox-Genovese in *Within the Plantation Household,* esp. 70–79. See also Stephanie Mc-Curry, *Masters of Small Worlds: Yeoman Households, Gender Relations, and the Political Culture of the Antebellum South Carolina Low Country* (New York: Oxford University Press, 1995), 214–19, 261 (quotation); and Linda K. Kerber, *No Constitutional Right to Be Ladies: Women and Obligations of Citizenship* (New York: Hill and Wang, 1998).

22. Sarah R. Rutledge, *The Carolina Housewife; or, House and Home: By a Lady of Charleston* (Charleston: W. R. Babcok, 1847).

23. Rutledge, *The Carolina Housewife;* Mary Bray Wheeler, *Chosen Exile: The Life and Times of Septima Sexta Middleton Rutledge* (Alabama: Rutledge, 1980). Rutledge was a wealthy woman, particularly after her stepmother's death in 1839. Mrs. Rutledge named Sarah Rutledge her residuary legatee and executrix.

24. Moss, *Domestic Novelists in the Old South,* 2; George Armstrong Wauchope, *The Writers of South Carolina* (Columbia: State Company, 1910), 60.

25. Steven Stowe, "City, Country, and the Feminine Voice," in *Intellectual Life in Antebellum Charleston,* edited by Michael O'Brien and David Moltke-Hansen (Knoxville: University of Tennessee Press, 1986), 302–8.

26. Wauchope, *The Writers of South Carolina,* 12–13.

27. Mary Elizabeth Lee, *Social Evenings; or, Historical Tales for Youth* (Boston: Marsh, Capen, Lyon, and Webb, 1840).

28. Catherine Gendron Poyas, *The Huguenot Daughters* (Charleston: J. Russell, 1849); Catherine Gendron Poyas, *The Convert, a Sketch* in *The Huguenot Daughters* (Charleston: J. Russell, 1849); Catherine Gendron Poyas, *The Year of Grief* (Charleston: Walker, Evans, and Cogswell, 1869); Wauchope, *The Writers of South Carolina,* 33–34.

29. Maria Henrietta Pinckney, *A Notice of the Pinckneys* (Charleston: Evans and Cogswell, 1860). Maria, who told the genealogy and related stories of family members, praised the pious, humble manner of her grandmother, Eliza Lucas Pinckney (1723–93), famous for her revealing letterbooks and her introduction of indigo into the South Carolina economy. Perhaps contrasting her grandmother with the busy and benevolent ladies of her own time and city, Maria insisted that Eliza Lucas Pinckney "[h]ad she lived at period when benevolent societies and all the other philanthropic societies were the fashion, she would not have supposed that a strict attention to these and the mere outward forms of religion would have entitled her to the name of Christian, had she not exhibited the fruits of Christianity by her self-control, forgetfulness of self, charity towards others, and humility of deportment" (7).

30. Maria Henrietta Pinckney, *The Quintessence of Long Speeches, Arranged as a Political Catechism; by a Lady, for Her God-Daughter* (Charleston: A. E. Miller, 1830), 3–24; William H. Pease and Jane H. Pease, *Ladies, Women, and Wenches: Choice and Constraint in Antebellum Boston and Charleston* (Chapel Hill: University of North Carolina Press, 1990), 168.

31. Among the most persuasive new studies that argue for antebellum women's political participation are Elizabeth Varon, *We Mean to Be Counted: White Women and Politics in Antebellum Virginia* (Chapel Hill: University of North Carolina Press, 1998), and Anne M. Boylan, *The Origins of Women's Activism: New York and Boston, 1797–1840* (Chapel Hill: University of North Carolina Press, 2002). See also Susan Zaeske, *Signatures of Citizenship: Petitioning, Antislavery, and Women's Political Identity* (Chapel Hill: Uni-

versity of North Carolina Press, 2003), and Moss, *Domestic Novelists in the Old South,* 23. On British Harriet Martineau's literary and ideological clash with the Charleston writer Gilmore Simms over slavery in 1837, see Young, *Domesticating Slavery,* 1–3.

32. Michael O'Brien, "Introduction," in Louisa Susanna Charles McCord, *Political and Social Essays,* edited by Richard C. Lounsbury (Charlottesville: University Press of Virginia, 1995), 1–2.

33. Michael O'Brien, ed., *An Evening When Alone: Four Journals of Single Women in the South, 1827–67* (Charlottesville: University Press of Virginia for the Southern Texts Society, 1993), 174; Fox-Genovese, *Within the Plantation Household,* 244.

34. Fox-Genovese, *Within the Plantation Household,* 243–89; O'Brien, "Introduction" to McCord, *Political and Social Essays,* 1–11.

35. Augusta Jane Evans, *Beulah,* edited by Elizabeth Fox-Genovese (Baton Rouge: Louisiana State University Press, 1992), ix–xxxvi; Evans, *Inez* (New York: Harper and Brothers, 1855).

36. Augusta Jane Evans, *Macaria; or, Altars of Sacrifice,* edited by Drew Gilpin Faust (Baton Rouge: Louisiana State University Press, 1992), viii–xxvi. Chapter 6 examines *Macaria* at greater length.

37. Quoted in "Introduction" to Evans, *Beulah,* xxi.

38. Jane H. Pease and William H. Pease, *A Family of Women: The Carolina Petigrus in Peace and War* (Chapel Hill: University of North Carolina Press, 1999), 75–79.

39. Jane H. Pease and William H. Pease, "Introduction," in Susan Petigru King, *Gerald Gray's Wife and Lily: A Novel,* edited by Jane H. Pease and William H. Pease (Durham: Duke University Press, 1993), vii–xviii; Pease and Pease, *A Family of Women,* 75–79; Wauchope, *The Writers of South Carolina,* 58–59, 223.

40. Susan Petigru King, "Old Maidism vs. Marriage," in *Busy Moments of an Idle Woman* (New York: D. Appleton, 1854), reprinted in *Old Maids: Short Stories by Nineteenth Century U.S. Women Writers,* edited by Susan Koppelman (Boston: Pandora Press, 1984), 65–70.

41. King, "Old Maidism," 70–82, quotation 78.

42. Ibid., 82–85.

43. Pease and Pease, ed., "Introduction" to King, *Lily,* xiii; Pease and Pease, *A Family of Women,* 81.

44. Steven Stowe, "City, Country, and the Feminine Voice," 309–13; Koppelman, ed., *Old Maids,* 62–63.

45. Koppelman is the one scholar who alleges Susan Petigru King's traitorous past as a southerner (*Old Maids,* 63); Pease and Pease go only so far as to confirm Bowen's notoriety ("Introduction," x, xi).

Chapter 3: "At Home Where I Am a Very Important Personage"

1. Harriett T. Campbell to George Jones Kollock, Aug. 24, 1843, Edith Duncan Johnson, ed., "The Kollock Letters, 1799–1850," *Georgia Historical Quarterly* (hereafter *GHQ*) 31 (Dec. 1947): 318–19.

2. Mary Telfair to Mary Few, March 6, 1832 (item 202), William Few Collection, Georgia Archives, Morrow (hereafter WFC); Bertram Wyatt-Brown, in *Southern Honor: Ethics and Behavior in the Old South* (New York: Oxford University Press, 1982), 251–53, in-

dicates that brothers, for their part, turned to sisters as surrogate mothers because fathers were absent, physically and emotionally, and mothers were either too effusive or too cold. For a discussion of women's vicarious enjoyment of male kin's lives, see Stephen Berry, "More Alluring at a Distance: Absentee Patriarchy and the Thomas Butler King Family," *GHQ* 81 (Winter 1997): 896. More recent studies have emphasized the importance of sibling relationships during the eighteenth and nineteenth centuries. See Lorri Glover, *All Our Relations: Blood Ties and Emotional Bonds among the Early South Carolina Gentry* (Baltimore: Johns Hopkins University Press, 2001); and Annette Atkins, *We Grew Up Together: Brothers and Sisters in Nineteenth-Century America* (Urbana: University of Illinois Press, 2001).

3. Mary Telfair to Mary Few, June 24, 1818 (item 129), WFC; Drew Gilpin Faust, *Mothers of Invention: Women of the Slaveholding South in the American Civil War* (Chapel Hill: University of North Carolina Press, 1996), 32.

4. Mary Telfair to Mary Few, Aug. 4, ca. 1812 (item 142) and Oct. 19, 1812, both WFC. Faust maintains that "[n]early every female Confederate diarist at some point expressed the desire to be a man" (*Mothers of Invention*, 231).

5. Henry Middleton to Harriott Middleton, April 9, 1847, Middleton Family Papers, from the Collections of the South Carolina Historical Society, Charleston (hereafter MFP). For another example of South Carolina brother-sister relationships sustained through correspondence, see *The Leverett Letters: Correspondence of a South Carolina Family, 1851–1868,* edited by Frances Wallace Taylor, Catherine Taylor Matthews, and J. Tracy Power (Columbia: University of South Carolina Press, 2000).

6. Taylor, Matthews, and Power, eds., *The Leverett Letters,* March 14, 1852; Harriott Middleton to Susan Matilda Middleton, Feb. 6, 1862, MFP.

7. Mary Kelley, "A Woman Alone: Catharine Maria Sedgwick's Spinsterhood in Nineteenth-Century America," *New England Quarterly* 51 (June 1978): 213–15 (quotations); see also Mary Kelley, *Private Woman, Public Stage: Literary Domesticity in Nineteenth-Century America* (New York: Oxford University Press, 1984), 240–46.

8. Mary Telfair to Mary Few, Dec. 23, [1818] (item 127), no date, ca. 1815 (item 146), Jan. 17, [1814] (item 124), and Nov. 26, [1814] (item 7), all WFC.

9. Emma Holmes, *The Diary of Miss Emma Holmes, 1861–1866,* edited by John F. Marszalek (Baton Rouge: Louisiana State University Press, 1979, 1994), 224–25 (Jan. 21, 29, 1863); Susan Matilda Middleton to Harriott Middleton, Feb. 22, 1862, MFP.

10. Ann Reid to William Moultrie Reid, Nov. 27, 1837 and Sept. 21, 1850, William Moultrie Reid Papers, South Caroliniana Library, Columbia (hereafter Reid Papers).

11. Mary Scudder to John Scudder, July 20, 1856, and Mary Scudder to Ephraim Scudder, Nov. 30, 1859, Scudder Family Papers, Georgia Historical Society, Savannah.

12. Mary Bray Wheeler, *Chosen Exile: The Life and Times of Septima Sexta Middleton Rutledge* (Alabama: Rutledge, 1980), 76, 73–74, 93.

13. Mary Telfair to Mary Few, March 15, [1815] (item 128) and Dec. 15, no year (item 161), WFC; Joan E. Cashin, "'Decidedly Opposed to *the Union*': Women's Culture, Marriage, and Politics in Antebellum South Carolina," *GHQ* 78 (Winter 1994): 748–49. On the need for a male escort, particularly for plantation women, see Catherine Clinton, *The Plantation Mistress: Woman's World in the Old South* (New York: Pantheon Books, 1982), 176.

14. Jane H. Pease and William H. Pease, *A Family of Women: The Carolina Petigrus in Peace and War* (Chapel Hill: University of North Carolina Press, 1999), 12–17, 92, 177, 214–15. For more information on the Petigru family and Badwell, see William H. Pease and Jane H. Pease, *James Louis Petigru: Southern Conservative, Southern Dissenter* (Athens: University of Georgia Press, 1995).

15. Mary Amanda Lee, "Henrietta Augusta Drayton and Drayton Hall: A Case Study for the Interpretation of Women at a Historic House Museum," M.A. thesis, University of South Carolina, 2003, 15–22.

16. "Will of Charles Drayton," Wills of Charleston County, Will Book F, 1818–26, South Carolina Department of Archives and History, Columbia, quoted in Lee, "Henrietta Augusta Drayton," 32–33.

17. Lee, "Henrietta Augusta Drayton," 34–36.

18. "Will of Henrietta Augusta Drayton," Wills of Charleston County, Will Book F, 1856–62, Vol. 49, 795–97, South Carolina Department of Archives and History, Columbia, quoted in Lee, "Henrietta Augusta Drayton," 36–37. Consider also Dorothy Gail Griffin, "The Eighteenth Century Draytons of Drayton Hall," Ph.D. diss., Emory University, 1985. I thank Barbara Orlitz, who has written about Drayton Hall and facilitated this discussion.

19. Malcolm Bell Jr., *Major Butler's Legacy: Five Generations of a Slaveholding Family* (Athens: University of Georgia Press, 1987), 213–15, 225–32, 317.

20. James Henry Hammond, *Secret and Sacred: The Diaries of James Henry Hammond, a Southern Slaveholder,* edited by Carol Bleser (New York: Oxford University Press, 1988), 173 (Dec. 9, 1846); Drew Gilpin Faust, *James Henry Hammond and the Old South: A Design for Mastery* (Baton Rouge: Louisiana State University Press, 1982), 241–42.

21. Hammond, *Secret and Sacred,* 171 (Dec. 9, 1846); Faust, *James Henry Hammond,* 241–45; Virginia G. Meynard, *The Venturers: The Hampton, Harrison, and Earle Families of Virginia, South Carolina, and Texas* (Easley, S.C.: Southern Historical Press, 1981), 173–74, 526.

22. Faust, *James Henry Hammond,* 242; Benjamin F. Perry, *Reminiscences of Public Men, with Speeches and Addresses,* 2d ser. (Greenville, S.C.: Shannon, 1889), 110, quoted in Faust, *James Henry Hammond,* 290.

23. Meynard, *The Venturers,* 528, 530–31, 562.

24. Julia Wright Sublette, "The Letters of Anna Calhoun Clemson, 1833–1873," Ph.D. diss., Florida State University, 1993, 12, 188, 206.

25. Marion Alexander Boggs, ed., *The Alexander Letters, 1797–1900* (Athens: University of Georgia Press, 1980), 95–96.

26. Boggs, ed., *The Alexander Letters,* 101–3. The emerging ideal of companionate marriages and the relevant historiography is discussed in the Introduction and chapter 2.

27. Ibid., 170–72; *The American Magazine of Useful and Entertaining Knowledge* [1835], 350, quoted in Lee Chambers-Schiller, *Liberty, a Better Husband: Single Women in America: The Generations of 1780–1840* (New Haven: Yale University Press, 1984), 245.

28. Boggs, ed., *The Alexander Letters,* 174–75. For discussions of the love and devotion between sisters, consider Clinton, *The Plantation Mistress,* 54, 128–31; Chambers-Schiller, *Liberty, a Better Husband,* 128–31; Carole Lasser, "'Let Us Be Sisters Forever': The Sororal Model of Nineteenth-Century Female Friendships," *Signs* 14 (Autumn 1988): 158–69; Melinda S. Buza, "'Pledges of Our Love': Friendship, Love, and Marriage among the

Virginia Gentry, 1800–1825," in *The Edge of the South: Life in Nineteenth Century Virginia,* edited by Edward L. Ayers and John C. Willis (Charlottesville: University Press of Virginia, 1991), 18–19.

29. Martha Foster Crawford Diary, American Women's Diaries, Southern Women and Their Families in the Nineteenth Century Microfilm Series; original at Rare Book, Manuscript, and Special Collections Library, Duke University, Durham, N.C.

30. Mary Telfair to Mary Few, Nov. 16, ca. 1839 (item 157), April 14, 1844 (item 102), and April 28, 1844 (item 103), all WFC. For an example of genealogical evidence of multiple single sister pairs, see Taylor, Mathews, and Power, eds., *The Leverett Letters.*

31. Mary Telfair to Mary Few, June 9, [1815] (item 138), WFC.

32. Mary Telfair to Mary Few, Dec. 23, 1823 (item 22), WFC. For the remarkable story of one nineteenth-century unmarried Virginia woman who became a missionary in Athens, Greece, and who felt such responsibility both to her Christian work there and to her family at home that she moved her just-widowed sister and nieces and nephews to Greece rather than move home herself, see Joanna B. Gillespie, "Mary Briscoe Baldwin (1811–77), Single Woman Missionary and 'Very Much My Own Mistress,'" *Anglican and Episcopal History* 57 (1988): 63–92.

33. Mary Telfair to Mary Few, July 2, 1842 (item 97), WFC; Cashin, "'Decidedly Opposed to *the Union,*'" 774.

34. Gerda Lerner, *The Grimké Sisters of South Carolina: Rebels against Slavery* (Boston: Houghton Mifflin, 1967); Gerda Lerner, *The Feminist Thought of Sarah Grimké* (New York: Oxford University Press, 1998); Chris Dixon, *Perfecting the Family: Antislavery Marriages in Nineteenth-Century America.* (Amhert: University of Massachusetts Press, 1997).

35. Mary Telfair to Mary Few, April 29, [1823] (item 18), WFC; Ann Reid to William Moultrie Reid, Feb. 18, 1848, Reid Papers.

36. Mary Telfair to Mary Few, July 4, ca. 1825 (item 222) and Nov. 28, 1837 (item 79), WFC; Harriett T. Campbell to George Jones Kollock, Jan. 3, 1828, Colonial Dames Collection, Georgia Historical Society, Savannah.

37. Margaret Williford to Martha (Williford) Service, July 23, 1849; Carrie Holmes to Martha (Williford) Service, Sept. 3, 1849, Emma Maria Service Papers, Southern Historical Collection, Wilson Library, University of North Carolina at Chapel Hill.

38. Mary Helen Johnston to George Jones Kollock, Sept. 14, 1841, Kollock Family Papers, Georgia Historical Society, Savannah (hereafter KFP); Harriett T. Campbell to George Jones Kollock, Aug. 20, 1859, Kollock Collection, Hargrett Rare Book and Manuscript Library, University of Georgia, Athens.

39. Margaret Cowper to Eliza Mackay, July 21, 1809, Mackay and Stiles Family Collection, Southern Women and Their Families in the Nineteenth Century Microfilm Series. For a discussion of maiden aunts as the most selfless, steadfast, good-hearted, and clearminded caregivers, see Lee Chambers-Schiller, "'Woman is Born to Love': The Maiden Aunt as Maternal Figure in Ante-bellum Literature," *Frontiers: A Journal of Women's Studies* 10, no. 1 (1988): 34–43.

40. Harriett T. Campbell to Phineas Miller Kollock, Feb. 25, 1823, *GHQ* 30 (Sept. 1946): 239.

41. Harriett T. Campbell to George Jones Kollock, Dec. 30, 1828, KFP.

42. Mary Telfair to Mary Few, no date, [1826], 1830 (item 265), WFC.

43. Mary Telfair to Mary Few, Jan. 1, ca. 1825 (item 201), July 14, no year (item 223), Feb.

5, 1828 (item 32), Jan. 7, 1827 (item 28), no date, 1826 (item 265), Feb. 5, ca. 1828 (item 32), and Feb. 17, 1828 (item 207), all WFC.

44. Mary Telfair to Mary Few, Dec. 2, 1842 (item 156), and July 4, ca. 1844 (item 111), both WFC.

45. Mary Telfair to Mrs. Terrell, Feb. 1, 1848, William and Eliza Rhodes Terrell Family Papers, Rare Book, Manuscript, and Special Collections Library, Duke University, Durham, N.C. (hereafter TFP).

46. Mary Telfair to Mrs. Terrell, Feb. 1, 1848, TFP.

47. Mary Telfair to Mrs. Terrell, March 27, 1848, and May 4, 1852, TFP.

48. Mary Telfair to Mrs. Terrell, Feb. 9, 1856, TFP; Kathryn J. Kirkpatrick, ed., "Introduction" to *Belinda* by Maria Edgeworth (New York: Oxford University Press, 1994), xix–xx.

49. Mary Fenwick Kollock to George Jones Kollock, Oct. 8, 1827, *GHQ* 30 (Sept. 1946): 318; Mary Fenwick Kollock to George Jones Kollock, Dec. 22, 1828, KFP.

50. Mary Fenwick Kollock to George Jones Kollock, Oct. 8, 1827, *GHQ* 30 (Sept. 1946): 318; Harriett T. Campbell to George Jones Kollock, Jan. 3, 1828, KFP; Sarah Jones to George Jones Kollock, March 11, 1828, *GHQ* 30 (Sept. 1946): 322.

51. Mary Fenwick Kollock to George Jones Kollock, July 2, Sept. 13, 1831, both KFP.

52. Chambers-Schiller, *Liberty, a Better Husband*, 1–3. For the importance of marriage to the defense of the South and slavery, see Stephanie McCurry, *Masters of Small Worlds: Yeoman Households, Gender Relations, and the Political Culture of the Antebellum South Carolina Low Country* (New York: Oxford University Press, 1995), 214–19, 261; and Elizabeth Fox-Genovese, *Within the Plantation Household: Black and White Women of the Old South* (Chapel Hill: University of North Carolina Press, 1988), esp. 70–79.

53. Will of Martha G. Campbell, signed Jan. 21, 1813, and probated Feb. 6, 1815; and Will of Lemuel Kollock, signed April 8, 1822, and probated July 12, 1823. Both in the Chatham County (Ga.) Will Records.

54. Harriett T. Campbell to Phineas Miller Kollock, Sept. 18, 1829, *GHQ* 31 (March 1947): 36; Harriett T. Campbell to Phineas Miller Kollock, Oct. 29, 1830, KFP; see also Harriett T. Campbell to Nephews, Oct. 20, 1829, April 8, 1830, April 16, 1830, and Aug. 30, 1837, all KFP.

55. Mary Fenwick Kollock to George Jones Kollock, Sept. 21, 1832, *GHQ* 31 (June 1947): 131.

56. Edward F. Campbell to George Jones Kollock, Aug. 30, 1849, *GHQ* 33 (Dec. 1849): 353.

57. Edward F. Campbell to George Jones Kollock, Sept. 3, 1854, *GHQ* 34 (June 1950): 139; see also Edward F. Campbell to George Jones Kollock, Aug. 22, 1854, *GHQ* 34 (June 1950): 138–39; and Harriett T. Campbell to George Jones Kollock, Oct. 8, 1854, *GHQ* 34 (June 1950): 139–40.

Chapter 4: *"To Know That* You *Still Love Me"*

1. Mary Telfair to Mary Few, March 22 [1823] (item 219), William Few Collection, Georgia Archives, Morrow (hereafter WFC); Mary Telfair, Commonplace Book, 1816–20, William Eliza Rhodes Terrell Family Papers, Rare Book Manuscript, and Special Collections Library, Duke University, Durham, N.C. (hereafter TFP).

2. Carroll Smith-Rosenberg, "The Female World of Love and Ritual: Relations between Women in Nineteenth-Century America," *Signs* 1 (Aug. 1975): 1–29; Barbara Welter, "The Cult of True Womanhood, 1820–1860," in *Dimity Convictions: The American Woman in the Nineteenth Century* (Athens: Ohio University Press, 1976), 21–41; Nancy F. Cott, *The Bonds of True Womanhood: "Women's Sphere" in New England, 1780–1835* (New Haven: Yale University Press, 1977); Lillian Faderman, *Surpassing the Love of Men: Romantic Friendship and Love between Women from the Renaissance to the Present* (New York: William Morrow, 1981); William Taylor and Christopher Lasch, "'Two Kindred Spirits': Sorority and Family in New England, 1839–1846," *New England Quarterly* 36 (March 1963): 23–41. For the argument for lesbian identities before the twentieth century, see Anna Clark, "Anne Lister's Construction of Lesbian Identity," *Journal of the History of Sexuality* 7 (July 1996): 23–50.

3. Margaret Fuller, quoted in Faderman, *Surpassing the Love*, 160. Faderman explains later that the term *Boston marriage* was not used until late in nineteenth-century New England to describe the long-term, monogamous relationships between two unmarried women, relationships that were increasingly commonplace in the region's urban centers. These women were usually feminists, "New Women," pioneers in a profession, and involved in social movements. Henry James's novel *The Bostonians* (New York: Macmillan, 1886) described a typical Boston marriage (190–98).

4. This debate is explored in the Introduction. Here, consider Elizabeth Fox Genovese, *Within the Plantation Household: Black and White Women of the Old South* (Chapel Hill: University of North Carolina Press, 1988), esp. 41–45; Catherine Clinton, *The Plantation Mistress: Woman's World in the Old South* (New York: Pantheon Books, 1982), 175; and Jean Friedman, *The Enclosed Garden: Women and Community in the Evangelical South, 1830–1900* (Chapel Hill: University of North Carolina Press, 1985). Studies that suggest a sense of female community include Suzanne Lebsock, *The Free Women of Petersburg: Status and Culture in a Southern Town, 1784–1860* (New York: W. W. Norton, 1984); Joan Cashin, "Introduction: Culture of Resignation," in *Our Common Affairs: Texts from Women in the Old South* (Baltimore: Johns Hopkins University Press, 1996); Joan Cashin, "'Decidedly Opposed to *the Union*': Women's Culture, Marriage, and Politics in Antebellum South Carolina," *Georgia Historical Quarterly* (hereafter *GHQ*) 78 (Winter 1994): 735–59; and Anya Jabour, "Albums of Affection: Female Friendship and Coming of Age in Antebellum Virginia," *Virginia Magazine of History and Biography* 107 (Spring 1999): 125–58.

For discussions of school-girl friendships, see Christie Anne Farnham, *The Education of the Southern Belle: Higher Education and Student Socialization in the Antebellum South* (New York: New York University Press, 1994), 155–67, and Melinda S. Buza, "'Pledges of Our Love': Friendship, Love, and Marriage among the Virginia Gentry, 1800–1825," in *The Edge of the South: Life in Nineteenth Century Virginia,* edited by Edward L. Ayers and John C. Willis (Charlottesville: University Press of Virginia, 1991), 9–36. Other examinations of southern female friendships include Steven Stowe, "'The *Thing* Not Its Vision': A Woman's Courtship and Her Sphere in the Southern Planter Class," *Feminist Studies* 9 (Spring 1983): 113–30; Cashin, "'Decidedly Opposed to *the Union*'"; and Mary S. Hoffschwelle, "Women's Sphere and the Creation of Female Community in the Antebellum South: Three Tennessee Slaveholding Women," *Tennessee Historical Quarterly* 50 (1991):

80–89. Several of these works suggest the importance of city, town, or even county communities to the preservation of female friendships

5. Mary Telfair to Mary Few, May 26, [1823] (item 15), WFC. Consider also the Dogan sisters of Unionville, South Carolina, in Cashin, "'Decidedly Opposed to *the Union*.'"

6. Maria Lance to Anne J. Clough, Oct. 7, 1837, in Mary Gallant, "Recollections of a Charleston Childhood, 1822–1836," *South Carolina Historical Magazine* 98 (Jan. 1997): 73; Carole Lasser, "'Let Us Be Sisters Forever': The Sororal Model of Nineteenth-Century Female Friendships," *Signs* 14 (Autumn 1988): 158–69.

7. Smith-Rosenberg, "The Female World," 1. For the lack of parental, or other, objections to these friendships, see Farnham, *The Education of the Southern Belle*, 156; and Buza, "'Pledges of Our Love.'" Charlene Marie Lewis observes this web of relationships and women's friendships at the Virginia Springs in "Ladies and Gentlemen on Display: Planter Society at the Virginia Springs, 1790–1860," Ph.D. diss, University of Virginia, 1997, 580–94.

8. Mary Anne Cowper to Eliza Mackay, Oct. 22, 1813, Mackay and Stiles Family Papers (hereafter MSFP), Southern Women and Their Families in the Nineteenth Century Microfilm Series.

9. Mary Anne Cower to Eliza Mackay, Oct. 22, 1813, MSFP.

10. Margaret Cowper McQueen to Eliza Mackay, c. 1812, MSFP.

11. Mary Telfair to Mary Few, Dec. 19, [1843] (item 108), WFC. For an excellent and thorough discussion of this anxiety among the seaboard elite, see Daniel Kilbride, "Philadelphia and the Southern Elite: Class, Kinship, and Culture in Antebellum America," Ph.D. diss., University of Florida, 1997. See also Daniel Kilbride, "Cultivation, Conservatism, and the Early National Gentry: The Manigault Family and Their Circle," *Journal of the Early Republic* 19 (Summer 1999): 221–91.

12. Alicia Hopton Middleton, *Life in Carolina and New England during the Nineteenth Century* (privately printed, 1929), 14–15.

13. Middleton, *Life in Carolina*, 123, 135.

14. Harriott Middleton to Susan Matilda Middleton, March 12, 1862, Middleton Family Papers, South Carolina Historical Society, Charleston.

15. Mary Telfair to Mary Few, Dec. 8, [1820] (item 289), WFC.

16. Mary Telfair to Mary Few, Jan. 17, [1814] (item 124), WFC.

17. Mary Telfair to Mary Few, Nov. 25 and Dec. 10, no year (item 136), and Nov. 26, [1814] (item 7), WFC.

18. Mary Telfair passport, TFP; John Wallace to Sarah Wallace, Sept. 1, 1814, in Mary Savage Anderson, ed., "The Wallace Letters," *GHQ* 17 (June 1934): 189; Mary Telfair to Mary Few, Feb. 17, 1816 (item 9), (postmark) April 16, [1816 or earlier] (item 133), and Dec. 11, 1834 (item 65), all WFC.

19. Mary Telfair to Mary Few, June 19, [1817] (item 8), Feb. 17, 1816 (item 9), and postmarked Dec. 8, ca. 1815 (item 139), all WFC.

20. Castor and Pollux are the two stars of the constellation Gemini, also known as the Twins. Mary Telfair to Mary Few, Dec. 14, [1836] (item 116), (postmark) Feb. 17, [1828] (item 207), and Aug. 3, ca. 1835 (item 230), all WFC.

21. Mary Telfair to Mary Few, no date, ca. 1823 (item 275), April 5, 1840 (item 88), and May 15, [1823] (item 217), all WFC.

22. Mary Telfair, Commonplace Book, 1816–20, TFP.

23. Mary Telfair to Mary Few, March 18, 1833 (item 49), WFC. Biographical information on the Clays comes from the Clay Family Papers, Georgia Historical Society, Savannah (hereafter CFP); Carolyn Clay Swiggart, *Shades of Gray: The Clay and McAllister Families of Bryan County, Georgia, during the Plantation Years* (Darien: Two Bytes Publishing, 1999); and Rev. Charles Colcock Jones, "Life and Character of Miss Anne Clay," delivered at her funeral service, Jan. 2, 1843, Collection of Carolyn Clay Swiggart (hereafter CCCS).

24. Mary Telfair to Mary Few, Feb. 28, 1826 (item 26), March 18, 1833 (item 49), and March 27, [1828] (item 281), all WFC.

25. Mary Telfair to Mary Few, Jan. 3, no year (item 189), March 27, [1828] (item 281), and Dec. 15, [1839] (item 161), all WFC.

26. Mary Telfair to Mary Few, June 29, [1828] (item 104), and Dec. 24, ca. 1828 (item 163), both WFC. Apparently, the Clays were impressive of stature as well. A contemporary observed, "Socially high, these four Clay children were also physically high, both the son and the sisters being of commanding bodily proportions," Rev. John Winn, newspaper article on Thomas Savage Clay, *The Christian Observer,* Louisville, Ky., Sept. 8, 1880, CFP.

27. Mary Telfair to Mary Few, Oct. 20, [1833] (item 54), Sept. 11, 1836 (item 72), and Aug. 1, [1834] (item 63), all WFC.

28. Jones, "Life and Character of Miss Ann Clay," CCCS

29. Mary Telfair to Mary Few, Nov. 14, 1836 (item 73), Sept. 30, 1837 (item 78), and May 23, [1843] (item 110), all WFC.

30. Swiggart, *Shades of Gray,* 15–16, 26–30, 87, 104.

31. John MacPherson Berrien Papers, Georgia Historical Society, Savannah.

32. Mary Telfair to Mary Few, Jan. 16, ca. 1820 (item 13), Nov. 12, ca. 1810 (item 137), and Nov. 28, 1837 (item 79), all WFC.

33. Mary Telfair to Mary Few, April 6, 1837 (item 74), WFC. Other scholars have documented women's comparison of loss by death and by marriage. See, for example, Jabour, "Albums of Affection."

34. Mary Telfair to Mary Few, June 1, [1834] (item 200), WFC.

35. Mary Telfair to Mary Few, Aug. 1, 1834 (item 63), WFC; Mary Fenwick Kollock to George Jones Kollock, Aug. 2, 1834, Edith Duncan Johnson, ed., "The Kollock Letters, 1799–1850," *GHQ* 31 (June 1947): 156. For a discussion of maternal mortality, see the Introduction.

36. Mary Telfair to Mary Few, Dec. 23, no year (item 284) and May 13, 1833 (item 52), both WFC.

37. Mary Telfair to Mary Few, July 28, 1833 (item 58) and March 21, no year (item 173), both WFC.

38. Mary Telfair to Mary Few, Nov. 3 [1834] (item 177), WFC.

39. Mary Telfair to Mary Few, Nov. 3, [1834] (item 177) and Dec. 11, [1834] (item 65), both WFC.

40. Mary Telfair to Mary Few, (postmarked) Dec. 14, [1836] (item 116), WFC.

41. Mary Telfair to Mary Few, Jan. 26, 1843 (item 99) and Feb. 27, [1843] (item 112), both WFC.

42. Mary Telfair to Mary Few, July 28, 1833 (item 58), WFC.

Chapter 5: Seeking an "Extensive Sphere of Usefulness"

1. Ann Reid to William Moultrie Reid, Sept. 21, 1850, William Moultrie Reid Papers, South Caroliniana Library, Columbia (hereafter Reid Papers).

2. Ann Reid to William Moultrie Reid, June 2, 1848, Reid Papers.

3. *Charleston Observer*, March 3, 1827, and J. B. Jeter, *The Mirror; or, A Delineation of Different Classes of Christians, in a Series of Lectures. With an Introduction, by Rev. A. M. Poindexter* (New York, 1855), 61–63, both quoted in Anne C. Loveland, *Southern Evangelicals and the Social Order, 1800–1860* (Baton Rouge: Louisiana State University Press, 1980), 160–61.

4. The books on this topic are numerous. Consider Nancy F. Cott, *The Bonds of Womanhood: "Woman's Sphere" in New England, 1780–1835* (New Haven: Yale University Press, 1977); Barbara Berg, *The Remembered Gate: Origins of American Feminism: The Woman and the City, 1800–1860* (New York: Oxford University Press, 1978); Caroll Smith-Rosenberg, *Religion and the Rise of the American City: The New York City Mission Movement, 1812–1870* (Ithaca: Cornell University Press, 1971); Mary P. Ryan, *Cradle of the Middle Class: The Family in Oneida County, New York, 1790–1865* (New York: Cambridge University Press, 1981); Nancy Hewitt, *Women's Activism and Social Change: Rochester, New York, 1820–1872* (Ithaca: Cornell University Press, 1984); Anne M. Boylan, *The Origins of Women's Activism: New York and Boston, 1797–1840* (Chapel Hill: University of North Carolina Press, 2002); Christine Stansell, *City of Women: Sex and Class in New York, 1789–1860* (Urbana: University of Illinois Press, 1987); Lori D. Ginzberg, *Women and the Work of Benevolence: Morality, Politics, and Class in the Nineteenth-Century United States* (New Haven: Yale University Press, 1990); and Kathleen Waters Sander, *The Business of Charity: The Woman's Exchange Movement, 1832–1900* (Urbana: University of Illinois Press, 1998).

5. Studies that conservatively estimate the number and significance of southern women's benevolent activities include Elizabeth Fox-Genovese, *Within the Plantation Household: Black and White Women of the Old South* (Chapel Hill: University of North Carolina Press, 1988); Jean Friedman, *The Enclosed Garden: Women and Community in the Evangelical South, 1830–1900* (Chapel Hill: University of North Carolina Press, 1985); Barbara L. Bellows, *Benevolence among Slaveholders: Assisting the Poor in Charleston, 1670–1860* (Baton Rouge: Louisiana State University Press, 1993); Drew Gilpin Faust, *Mothers of Invention: Women of the Slaveholding South in the American Civil War* (Chapel Hill: University of North Carolina Press, 1996); Lee Ann Whites, *The Civil War as a Crisis in Gender: Augusta, Georgia, 1860–1890* (Athens: University of Georgia Press, 1995); Stephanie McCurry, *Masters of Small Worlds: Yeoman Households, Gender Relations, and the Political Culture of the Antebellum South Carolina Low Country* (New York: Oxford University Press, 1995); and Gail S. Murray, "Charity within the Bounds of Race and Class: Female Benevolence in the Old South," *South Carolina Historical Magazine* 96 (Jan. 1995): 54–70.

Other scholarship that argues for the importance and relative extensiveness of southern women's benevolent organizations includes Anne Firor Scott, *Natural Allies: Women's Associations in American History* (Urbana: University of Illinois Press, 1991); Suzanne Lebsock, *Free Women of Petersburg: Status and Culture in a Southern Town, 1784–1860*

(New York: W. W. Norton, 1983); Cynthia A. Kierner, *Beyond the Household: Women's Place in the Early South, 1700–1835* (Ithaca: Cornell University Press, 1998); Anya Jabour, "'Grown Girls, Highly Cultivated': Female Education in an Antebellum Southern Family," *Journal of Southern History* 64 (Feb. 1998): 23–64; Elizabeth R. Varon, *We Mean to Be Counted: White Women and Politics in Antebellum Virginia* (Chapel Hill: University of North Carolina Press, 1998); Timothy Lockley, "'A Struggle for Survival': Non-Elite White Women in Lowcountry Georgia, 1790–1830," in *Women of the American South: A Multi-Cultural Reader,* edited by Christie Farnham (New York: New York University Press, 1997), 26–42; John Christie Dann, "Humanitarian Reform and Organized Benevolence in the Southern United States, 1780–1830," Ph.D. diss., College of William and Mary, 1975; Frederick A. Bode, "A Common Sphere: White Evangelicals and Gender in Antebellum Georgia," *Georgia Historical Quarterly* 79 (Winter 1995): 775–809; and Elna C. Green, ed., "Introduction," in *Before the New Deal: Social Welfare in the South, 1830–1930* (Athens: University of Georgia Press, 1999), xi–xv.

6. Donald G. Mathews, *Religion in the Old South* (Chicago: University of Chicago Press, 1977), 77–80; Loveland, *Southern Evangelicals and the Social Order,* 161–62; Bellows, *Benevolence among Slaveholders,* esp. 8–9, 30–31.

7. Bellows, *Benevolence among Slaveholders,* 44–47; Lee Ann Whites, "The Charitable and the Poor: The Emergence of Domestic Politics in Augusta, Georgia, 1860–1880," *Journal of Social History* 17 (Summer 1984): 601–16.

8. *The Plan and Objects of the Proposed Institution to Be Called the Church Home with Fundamental Rules for Its Management and Government* (Charleston: Miller and Browne, 1850); "The Lyceum, No. II: Old Maids," *Southern Literary Messenger* 3 (Aug. 1837): 473–74.

9. J. King, "Female Domestic Missionary Society," *Southern Evangelical Intelligencer* 3 (1821): 146; Jane H. Pease and William H. Pease, *Ladies, Women, and Wenches: Choice and Constraint in Antebellum Charleston and Boston* (Chapel Hill: University of North Carolina Press, 1990), 116–23; Dann, "Humanitarian Reform," vi, 462–76; Bellows, *Benevolence among Slaveholders,* 31; Lockley, "'A Struggle for Survival,'" 31.

10. For a substantial discussion of the Civil War, women's involvement, and the historiographical developments, see chapter 6.

11. Pease and Pease, *Ladies, Women, and Wenches,* 116.

12. Mathews, *Religion in the Old South,* esp. 113; Fox-Genovese, *Within the Plantation Household.* esp. 249, 232; Pease and Pease, *Ladies, Women, and Wenches,* 116.

13. Judith Lomas, *The Sabbath Journal of Judith Lomax (1774–1828),* edited by Laura Hobgood-Oster (Atlanta: Scholars Press, 1999), 25 (Jan. 26, 1823), 99; Laura Hobgood-Oster, *She Glanceth from Earth to Heaven: The Phenomenon of Love Mysticism among Women in Antebellum Virginia and Maryland* (New Orleans: University Press of the South, 1998), esp. 143–55.

14. Kierner, *Beyond the Household,* 141–46, 181. The scholarly debate about the role of churches and religion in the lives of southern women parallels the divide over the extent of southern reform and benevolent organizations. Those who conservatively estimate the role of the churches as gateways to benevolent or reform work include Fox-Genovese, *Within the Plantation Household,* 44–45; Elizabeth Fox-Genovese and Eugene D. Genovese, "The Religious Ideals of Southern Slave Society," *Georgia Historical Quarterly* 70 (Spring

1986): 1–16; Friedman, *The Enclosed Garden;* and McCurry, *Masters of Small Worlds.* Others who observe a greater benevolent impulse among church-going women include Kierner, *Beyond the Household;* Bode, "A Common Sphere"; and Loveland, *Southern Evangelicals and the Social Order.* Consider also Christine L. Heyrman, *Southern Cross: The Beginnings of the Bible Belt* (Chapel Hill: University of North Carolina Press, 1997).

15. The nineteenth-century novelist and social critic Augusta Jane Evans expressed disgust with the benevolent ladies who participated in certain churches only because they were fashionable. See "Introduction" to Augusta Jane Evans, *Beulah,* edited by Elizabeth Fox-Genovese (Baton Rouge: Louisiana State University Press, 1992).

16. Anna Caroline Lesesne Journal, Jan. 18, Feb. 25, 1836, from the Collections of the South Carolina Historical Society, Charleston (hereafter SCHS); St. Philip's Episcopal Church, Charleston, Vestry Minutes, 1832–51, Feb. 5, 1842, St. Philip's Church Archives, Charleston, S.C.

17. Anna Caroline Lesesne Journal, June 16, Feb. 23, 1836, SCHS; Kierner, *Beyond the Household,* 184; For an excellent discussion of the Sunday school movement and its transition from a service to poor children to one for children of all classes, see Dann, "Humanitarian Reform," 240–46. Varon offers a compelling discussion of white southern women's contributions to black education through Sunday schools (*We Mean to be Counted,* 27). See also Anne Boylan, *Sunday School: The Formation of an American Institution, 1790–1880* (New Haven: Yale University Press, 1988).

18. Female Episcopal Bible, Prayer Book and Tract Society Members and Subscribers, St. Philip's Church, Charleston, Records, SCHS; Albert Sidney Thomas, *A Historical Account of the Protestant Episcopal Church in South Carolina, 1820–1957* (Columbia: R. L. Bryan, 1957), 668–69; Pease and Pease, *Ladies, Women, and Wenches,* 119. For an examination of rural tract societies, see John W. Quist, "Slaveholding Operatives of the Benevolent Empire: Bible, Tract, and Sunday School Societies in Antebellum Tuscaloosa County, Alabama," *Journal of Southern History* 62 (Aug. 1996): 481–526.

19. *The Plan and Objects of the Proposed Institution.*

20. Charles H. Hall, "A Sermon, Preached at St. Michael's Church, Charleston, in Behalf of the Church Home, . . . 11th June, 1852," *Gospel Messenger* 29 (Oct. 1852): 193–94, quoted in Bellows, *Benevolence among Slaveholders,* 168. Bellows provides an insightful analysis of Hall and the Plan but does not indicate how Hall's message was received (167–69). Just as Episcopal priests advocated women's contributions to benevolent work, southern religious periodicals defended the intellectual equality of the sexes, which further supported the cause of women's social and religious activities. Dann, "Humanitarian Reform," 412–13. Varon, too, observes the bold defense and celebration of women's evangelical leadership by evangelical writers in Virginia (*We Mean to Be Counted,* 25).

21. *Church Home: The Sermon and Reports at the Eleventh Anniversary Celebration of the Church Home* (Charleston: A. E. Miller, 1861), Woodruff Library, Special Collections, Emory University, Atlanta; Bellows, *Benevolence among Slaveholders,* 169; Thomas, *A Historical Account,* 748–751; Dann, "Humanitarian Reform," 312–75.

22. Mark I. Greenberg, "Savannah's Jewish Women and the Shaping of Ethnic and Gender Identity, 1830–1900," *Georgia Historical Quarterly* 82 (Winter 1998): 751–74.

23. "The Sesquicentennial Celebration of the Ladies Benevolent Society of Charleston, South Carolina," SCHS; Margaret Simons Middleton, "The Ladies Benevolent Society

of Charleston, South Carolina," in *Yearbook of the City of Charleston, 1941* (Charleston: City Council, 1942), 216–18, SCHS. For other churches' contributions, see "The Ladies Benevolent Society," *Charleston Yearbook 1896*, 418–19, SCHS. Numerous scholars have examined the Ladies Benevolent Society. See, for example, Pease and Pease, *Ladies, Women, and Wenches*, 120–22; Bellows, *Benevolence among Slaveholders*, 47–49; Murray, "Charity within the Bounds of Race and Class"; and Kierner, *Beyond the Household*, 190–91.

24. "The Sesquicentennial Celebration."

25. Middleton, "The Ladies Benevolent Society," 216–18; Ladies Benevolent Society, "Annual Report (1820)," *Southern Evangelical Intelligencer* 2 (1820–21): 244–47, quoted in Dann, "Humanitarian Reform," 149; "Regulations for the Visiting Committee" in Middleton, "The Ladies Benevolent Society," 218–20; Ladies Benevolent Society, "Second Annual Report (1819)," 215, quoted in Dann, "Humanitarian Reform," 148; Kierner, *Beyond the Household*, 191.

26. Ladies Benevolent Society, Charleston, Ms. Journal (1824–70), 1825, SCHS, quoted in Dann, "Humanitarian Reform," 149; "Regulations for the Visiting Committee" in Middleton, "The Ladies Benevolent Society," 218–20. Gail Murray indicates that there were conflicts with male officials, but she does not elaborate. Murray, "Poverty and Its Relief in the Antebellum South: Perceptions and Realities in Three Selected Cities: Charleston, Nashville, and New Orleans," Ph.D. diss., Memphis State University, 1991, 180–81.

27. Bellows, *Benevolence among Slaveholders*, 49; "Annual Report of the Board of Managers to the Ladies' Benevolent Society, 1824" in Middleton, "The Ladies Benevolent Society," 225.

28. "Annual Report of the Board of Managers of the Ladies' Benevolent Society, 1820," *Southern Evangelical Intelligencer* 2 (Sept. 1820): 244; "Annual Report of the Board of Managers to the Ladies' Benevolent Society, 1824" in Middleton, "The Ladies Benevolent Society," 225.

29. Pease and Pease, *Ladies, Women, and Wenches*, 123.

30. Ibid., 123–24.

31. Emma Holmes, *The Diary of Miss Emma Holmes, 1861–1866*, edited by John F. Marszalek (Baton Rouge: Louisiana State University Press, 1979, 1994), 103 (Dec. 4, 1861).

32. Kierner, *Beyond the Household*, 192.

33. Dann, "Humanitarian Reform," 149–50; "Report of the Sisters of Charity of St. Michael's Church," *Southern Episcopalian* 4 (Feb. 1860): 585, *Savannah Gazette*, Jan. 25, 1817, and *Daily Georgian*, Jan. 28, 1823 and Jan. 5, 1828, all quoted in Lockley, "'A Struggle for Survival,'" 37. See also Walter J. Fraser Jr., *Savannah in the Old South* (Athens: University of Georgia Press, 2003), 185.

34. Dann, "Humanitarian Reform," 251–57.

35. Constitution of the Female Seamen's Friend Society of Savannah, Burroughs Collection, Georgia Historical Society, Savannah (hereafter GHS).

36. Ladies' Seamen's Friends' Society, "Annual Report," *Charleston Courier*, May 21, 1845, 3.

37. Ibid.; Bellows, *Benevolence among Slaveholders*, 115; William H. Pease and Jane H. Pease, *The Web of Progress: Values and Public Styles in Boston and Charleston, 1828–1843* (Athens: University of Georgia Press, 1991), 153–54.

38. "Constitution of the Female Seamen's Friend Society of Savannah, Georgia," Bur-

roughs Collection, GHS; King, "Female Domestic Missionary Society," 146; William B. Yates, *An Historical Sketch of the Rise and Progress of Religious and Moral Improvement among Seamen in England and the United States, with a History of the Port Society of Charleston, South Carolina* (Charleston: A. Burke, 1851); Thomas, *A Historical Account,* 694–96; "Chaplain's Report" in Yates, *An Historical Sketch.*

39. Thomas, *A Historical Account,* 695; Pease and Pease, *Ladies, Women, and Wenches,* 123–26.

40. Minutes, Correspondence, and "Constitution of the Female Seamen's Friend Society of Savannah, Georgia," Burroughs Collection, GHS; For mention of the male-led Port Society, see William Harden, *Recollections of a Long and Satisfactory Life* (New York: Negro Universities Press, 1943), 35–36.

41. Harden, *Recollections.*

42. Pease and Pease, *The Web of Progress,* 165; Richard C. Wade, *Slavery in the Cities: The South 1820–1860* (New York: Oxford University Press, 1964), 153–54; Kierner, *Beyond the Household,* 199–201; Varon, *We Mean to Be Counted,* 33; Lebsock, *Free Women of Petersburg,* 229; Loveland, *Southern Evangelicals and the Social Order,* 130–58. For an argument that southern temperance was more successful and more like northern efforts than previous scholars have assumed, see Douglas W. Carlson, "'Drinks He to His Own Undoing': Temperance Ideology in the Deep South," *Journal of the Early Republic* 18 (Winter 1998): 659–91; and John W. Quist, *Restless Visionaries: The Social Roots of Antebellum Reform in Alabama and Michigan* (Baton Rouge: Louisiana State University Press, 1998).

43. Bellows, *Benevolence among Slaveholders,* 122–23.

44. Mrs. St. Julien Ravenel, *Life and Times of William Lowndes of South Carolina, 1782–1822* (Boston: Houghton Mifflin, 1901), 45–47.

45. Bellows, *Benevolence among Slaveholders,* 155–57; Gene McKnight, *The Charleston Orphan House, 1790–1951* (privately published, 1990), 4–7.

46. Henry Holcombe, "The Georgia Analytical Repository," 1 (July–Aug. 1802): 68–74, quoted in Betty Wood, *Gender, Race, and Rank in a Revolutionary Age: The Georgia Lowcountry, 1750–1820* (Athens: University of Georgia Press, 2000), 57–65; Savannah Free School Society Minutes, Dec. 9, 1816, GHS, quoted in Lockley, "'A Struggle for Survival,'" 29–31.

47. Savannah Free School Society Minutes, Dec. 9, 1816, GHS, quoted in Lockley, "'A Struggle for Survival,'" 29–31; Mary Telfair to Mary Few, Feb. 5, no year (item 183), William Few Collection, Georgia Archives, Morrow (hereafter WFC); Wood, *Gender, Race, and Rank,* 74–81. Consider also Peter Wallenstein, "Laissez Faire and the Lunatic Asylum: State Welfare Institutions in Georgia—the First Half-Century, 1830s-1880s," in *Before the New Deal,* edited by Elna C. Green, 3–21; and Fraser, *Savannah in the Old South.*

48. The South Carolina diarist Jane Caroline North visited Mount Vernon and its owner in 1851 and made no mention of the disrepair. Michael O'Brien, ed., *An Evening When Alone: Four Journals of Southern Women in the South, 1827–1867* (Charlottesville: University Press of Virginia for the Southern Texts Society, 1993), 183–84.

49. For a recent and nuanced analysis of the struggle over Mount Vernon, particularly before Cunningham's arrival on the scene, see Jean B. Lee, "Historical Memory, Sectional Strife, and the American Mecca: Mt. Vernon, 1783–1853," *Virginia Magazine of History and Biography* 109, no. 3 (2001): 255–300.

50. Lee, "Historical Memory." Lee describes the endless stream of visitors to Mount Vernon from the time Washington returned there after the American Revolution.

51. Elswyth Thane, *Mount Vernon Is Ours: The Story of Its Preservation* (New York: Duell, Sloan and Pearce, 1966). Elizabeth Varon offers an informative and insightful analysis of the organization and its role in sectional politics (*We Mean to Be Counted*, 124–36). See also Beverly Wellford Jr., "Address Delivered before the Ladies' Mount Vernon Association, July 4, 1855," *Southern Literary Messenger* 21 (Sept. 1855): 563–66, quoted in Varon, *We Mean to Be Counted*, 127.

52. Alicia Hopton Middleton, *Life in Carolina and New England During the Nineteenth Century* (Bristol, R.I.: privately printed, 1929), 95; Thane, *Mount Vernon Is Ours;* Varon, *We Mean to be Counted*, 128–34.

53. Mount Vernon Ladies Association of the Union, *Historical Sketch of Ann Pamela Cunningham, Founder of the Mount Vernon Ladies Association* (Jamaica, N.Y., 1911).

54. Mount Vernon Ladies Association of the Union, *Historical Sketch.*

55. Telfair Family Papers, GHS. Marli Weiner observes that many antebellum southern writers urged women in individual, charitable efforts rather than in collective endeavors; see *Mistresses and Slaves: Plantation Women in South Carolina, 1830–1880* (Urbana: University of Illinois Press, 1998), 68.

56. Mary Telfair to Mary Few, Jan. 20, no year (item 117), WFC.

57. Mary Telfair to Mary Few, Dec. 11, 1834 (item 65), WFC.

58. Mary Telfair to Mary Few, March 5, 1835 (item 67), WFC.

59. Mary Telfair to Mary Few, Jan. 25, 1828 (item 31), and Nov. 12, no year (item 208), both WFC.

60. Mary Telfair to Mary Few, Oct. 14, 1827 (item 30), WFC.

61. Will of Mary Telfair, WFC.

62. Mary Telfair to Mary Few, March 27, ca. 1822 (item 281), and July 28, 1833 (item 58), both WFC. Marli Weiner explains that numerous southern women writers encouraged their peers to turn their benevolent impulses toward their slaves (*Mistresses and Slaves*, 69). For a discussion of slavery and religion in the South and whites' efforts to evangelize slaves in rural Georgia and Charleston, South Carolina, see Erskine Clarke, *Wrestlin' Jacob: A Portrait of Religion in Antebellum Georgia and the Carolina Low Country* (1979, repr. Tuscaloosa: University of Alabama Press, 2000).

63. Mary Lavinder Obituary Notice, transcribed in Victor H. Bassett, "Two Women Doctors of Georgia in the First Half of Nineteenth Century," *Savannah Morning News*, April 26, 1936, Savannah Historical Research Association Papers (hereafter SHRA), GHS; Robert Manson Myers, ed., *The Children of Pride: A True Story of Georgia and the Civil War* (New Haven: Yale University Press, 1972), 1590; Mrs. Charles Hartridge to Mrs. John Davidson, Dec. 28, 1845, Walter C. Hartridge Collection, GHS.

64. Lavinder Obituary.

65. Lee Ann Rebl, "Doctor Mary Lavinder," 3, 6–7, SHRA, GHS; Dr. J. C. Warren to Dr. Lemuel Kollock, March 21, 1818, Lemuel Kollock Papers, GHS.

66. King, "Female Domestic Missionary Society," 147.

Chapter 6: "Such a Strong Personal Love of the Old Place"

1. Augusta Jane Evans, *Macaria; or, Altars of Sacrifice*, edited with an Introduction by Drew Gilpin Faust (Baton Rouge: Louisiana State University Press, 1992), 318.

2. These pioneering studies include Francis Butler Simkins and James Welch Patton, *Women of the Confederacy* (Richmond: Garrett and Massie, 1936); Mary Elizabeth Massey, *Bonnet Brigades: American Women and the Civil War* (1966), reprinted as *Women in the Civil War* (Lincoln: University of Nebraska Press, 1994); H. E. Sterkx, *Partners in Rebellion: Alabama Women in the Civil War* (Rutherford: Fairleigh Dickinson University Press, 1970); and Bell Irvin Wiley, *Confederate Women* (Westport: Greenwood Press, 1975).

The scholarship on women disguising themselves as men and fighting and/or spying,in the Civil War is surprisingly vast and long-running. Some of the more recent work includes Loretta and William Galbraith, eds., *A Lost Heroine of the Confederacy: The Diaries and Letters of Belle Edmondson* (Jackson: University of Mississippi Press, 1990); Elizabeth D. Leonard, *All the Daring of the Soldier: Women of the Civil War Armies* (New York: W. W. Norton, 1999); Massey, *Women in the Civil War;* Janet E. Kaufman, "'Under the Petticoat Flag': Women Soldiers in the Confederate Army," *Southern Studies* 23 (Winter 1984): 363–75; DeAnne Blanton, "Women Soldiers of the Civil War," *Prologue* (Spring 1993): 27–33; Sarah Rosetta Wakeman, *An Uncommon Soldier: The Civil War Letters of Sarah Rosetta Wakeman, alias Private Lyons Wakeman, 153rd Regiment, New York State Volunteers,* edited by Lauren Cook Burgess (Pasadena: Minerva Center, 1994); Oscar A. Kinchen, *Women Who Spied for the Blue and the Gray* (Philadelphia: Dorrance, 1972); Frank Moore, *Women of the War: Their Heroism and Self-Sacrifice: True Stories of Brave Women in the Civil War* (New York: Blue Gray Books, 1997); Ruth Scarborough, *Belle Boyd: Siren of the South* (Macon: Mercer University Press, 1983); and Belle Boyd, *Belle Boyd in Camp and Prison,* foreword by Drew Gilpin Faust and introduction by Sharon Kennedy-Nolle (Baton Rouge: Louisiana State University Press, 1998).

3. Civil War historiography is immense, and studies of women's war experiences are increasingly numerous. One of the most comprehensive overviews is Drew Gilpin Faust, *Mothers of Invention: Women of the Slaveholding South in the American Civil War* (Chapel Hill: University of North Carolina Press, 1996). Faust emphasizes the myriad and profound changes that southern women created and experienced as a result of the war. Her study builds on George Rable's seminal work *Civil Wars: Women and the Crisis of Southern Nationalism* (Urbana: University of Illinois Press, 1989), which suggested these changes within the psyches of southern women but concluded more conservatively that after the war whatever gains women made were quickly lost as they returned to antebellum notions of domesticity and celebrations of the Lost Cause. Consider also Faust's earlier collection of essays, *Southern Stories: Slaveholders in Peace and War* (Columbia: University of Missouri Press, 1992), and *The Creation of Confederate Nationalism: Identity and Ideology in the Civil War South* (Baton Rouge: Louisiana State University Press, 1988). See also *Divided Houses: Gender and the Civil War,* edited by Catherine Clinton and Nina Silber (New York: Oxford University Press, 1992), which contains numerous significant and pioneering essays, and Lee Ann White's work, including *The Civil War as a Crisis in Gender: Augusta, Georgia, 1860–1890* (Athens: University of Georgia Press, 1995). Catherine Clinton's other studies of the Civil War include *Civil War Stories* (Athens: University of Georgia Press, 1998); *Tara Revisited: Women, War, and the Plantation Legend* (New York: Abbeville Press, 1995); and *Taking Off the White Gloves: Southern Women and Women Historians,* edited by Clinton with Michele Gillespie (Columbia: University of Missouri Press, 1998). Consider also Laura Edwards, *Scarlett Doesn't Live Here Anymore: Women of*

the Civil War Era (Urbana: University of Illinois Press, 2000); James Marten, *The Children's Civil War* (Chapel Hill: University of North Carolina Press, 1998); and *Writing the Civil War: The Quest to Understand,* edited by James M. McPherson and William J. Cooper Jr. (Columbia: University of South Carolina Press, 1998).

4. Faust argues persuasively and originally that gender and women's roles were topics for debate and increased public scrutiny as the war began (*Mothers of Invention,* 17–20). In a related vein, Elizabeth Varon discusses the emergence of this political womanhood in *We Mean to Be Counted: White Women and Politics in Antebellum Virginia* (Chapel Hill: University of North Carolina Press, 1998), esp. ch. 5.

5. Drew Faust has made the case that the war spawned unprecedented activities and independence for southern women (*Mothers of Invention,* esp. 20).

6. Faust notes the quick turn of attention to women's roles and identities once the war began. Ibid.

7. Derek Smith, *Civil War Savannah* (Savannah: Frederic C. Bell, 1997), 8–9.

8. Jane H. Pease and William H. Pease, *Ladies, Women, and Wenches: Choice and Constraint in Antebellum Charleston and Boston* (Chapel Hill: University of North Carolina Press, 1990), 167–68; Eliza Caroline Clay Journal, Nov. 17, 1860, quoted in Carolyn Clay Swiggart, *Shades of Gray: The Clay and McAllister Families of Bryan County, Georgia, during the Plantation Years* (Darien: Two Bytes Publishing, 1999), 50.

9. Charles J. Johnson, *Mary Telfair: The Life and Legacy of a Nineteenth-Century Woman* (Savannah: Frederic C. Beil, 2002), 329–30, 341; Alicia Hopton Middleton, *Life in Carolina and New England during the Nineteenth Century* (privately printed, 1929), 105, 180.

10. Emma Holmes, *The Diary of Miss Emma Holmes, 1861–1866,* edited by John F. Marszalek (Baton Rouge: Louisiana State University Press, 1979, 1994), 3 (Feb. 13, 1861), 25 (April 12, 1861), 27 (April 13, 1861), 29 (April 14, 1861); Smith, *Civil War Savannah,* 21.

11. Mayor Jones quoted in Smith, *Civil War Savannah,* 27.

12. Holmes, *The Diary of Miss Emma Holmes,* 41 (May 2, 1861).

13. Ibid., 138 (March 22, 1862), and 160 (May 10, 1862). Faust suggests that activities like these fund-raisers were among women's first expressions of widespread disappointment with men and their inability to protect southern women (*Mothers of Invention,* 17–29). On southern Jewish women's war work, see Robert N. Rosen, *The Jewish Confederates* (Columbia: University of South Carolina Press, 2000), 226–27.

14. Rable (*Civil Wars,* 136–53) emphasizes the conservative nature of these organizations, but even he acknowledges that women generally became more politically aware and militant as a result of this collective experience.

15. Holmes, *The Diary of Miss Emma Holmes,* 68 (July 23, 1861), 73–74 (Aug. 1, 1861), 76 (Aug. 5, 1861), and 83–84 (Aug. 26, 1861). Faust comments on well-to-do women's forays into domestic cloth production (*Mothers of Invention,* 46–51).

16. Holmes, *The Diary of Miss Emma Holmes,* 90–91 (Sept. 16, 1861); see also Anne Sarah Rubin, "Sixty-six and Sixty-one: Confederates Remember the American Revolution," in *Where These Memories Grow: History, Memory, and Southern Identity,* edited by W. Fitzhugh Brundage (Chapel Hill: University of North Carolina Press, 2000), 85–105.

17. Holmes, *The Diary of Miss Emma Holmes,* 90–91 (Sept. 16, 1861).

18. Ibid., 77 (Aug. 5, 1861).

19. Ibid., 56 (June 8, 1861), and 149–50 (April 23, 1862). See Jane H. Pease and William H. Pease, *A Family of Women: The Carolina Petigrus in Peace and War* (Chapel Hill: University of North Carolina Press, 1999), 198, 202, for a discussion of these parties, especially toward the end of the war in Columbia and Charleston.

20. Holmes, *The Diary of Miss Emma Holmes,* 126 (Feb. 25, 1862).

21. Ibid., 101–2 (Dec. 2, 1861), 16 (March 14, 1861), and 59 (June 22, 1861).

22. Holmes, *The Diary of Miss Emma Holmes,* 76–77 (Aug. 5, 1861).

23. Holmes, *The Diary of Miss Emma Holmes,* 40 (April 30, 1861), 463 (July 26, 1865), 471 (Oct. 6, 1865), 482 (Nov. 16, 1865), and 483 (Jan. 15, 1866). On this topic, see Faust, *Mothers of Invention,* 148, and Rable, *Civil Wars,* 271.

24. Harriott Middleton to Susan Matilda Middleton, Feb. 20, Feb. 27, Nov. 2, 1862, Middleton Family Papers, South Carolina Historical Association, Charleston (hereafter MFP).

25. Harriott Middleton to Susan Matilda Middleton, Feb. 20, 1862, MFP; Susan Matilda Middleton to Harriott Middleton, Aug. 29 and 30, 1862, MFP.

26. Holmes, *The Diary of Miss Emma Holmes,* 158 (May 2, 1862).

27. Harriott Middleton to Susan Matilda Middleton, May 8, 1862, quoted in Robert N. Rosen, *Confederate Charleston: An Illustrated History of the City and the People during the Civil War* (Columbia: University of South Carolina Press, 1994), 85; Susan Matilda Middleton to Harriott Middleton, March 2, 1862, MFP; Mills Lane, *Savannah Revisited: History and Architecture* (Savannah: Beehive Press, 1994), 183–94; Smith, *Civil War Savannah.*

28. Emma Holmes, quoted in Rosen, *Confederate Charleston,* 121, 98–99; Clarence L. Mohr, *On the Threshold of Freedom: Masters and Slaves in Civil War Georgia* (Athens: University of Georgia Press, 1986), 190–91; consider also Mary A. DeCredico, *Patriotism for Profit: Georgia's Urban Entrepreneurs and the Confederate War Effort* (Chapel Hill: University of North Carolina Press, 1990); and Don H. Doyle, *New Men, New Cities, New South: Atlanta, Nashville, Charleston, Mobile, 1860–1910* (Chapel Hill: University of North Carolina Press, 1990).

29. Rosen, *Confederate Charleston,* 99.

30. Lizzie Neblett, quoted in Drew Faust, "'Trying to Do a Man's Business': Gender, Violence, and Slave Management in Civil War Times," in *Southern Stories,* edited by Faust, 174–92; Holmes, *The Diary of Miss Emma Holmes,* 87 (Feb. 11, 1865); Faust, *Mothers of Invention,* 6, 59, 247; Scott, *The Southern Lady,* 90.

31. Holmes, *The Diary of Miss Emma Holmes,* 291–93 (Aug. 8, 1863). Faust addresses single women's critical view of wedlock in the wake of lost opportunity as well as women turning to one another (*Mothers of Invention,* 140–41, 172, 142–45, 151–52).

32. Holmes, *The Diary of Miss Emma Holmes,* 373–74 (Sept. 3, 1864).

33. Harriott Middleton to Susan Matilda Middleton, Feb. 18, April 1, April 10, March 7, and Feb. 18, 1862, all MFP.

34. Harriott Middleton to Susan Matilda Middleton, May 8, 1862, MFP. For discussions of the southern refugee experience, see Rosen, *Confederate Charleston,* 99, and Faust, *Mothers of Invention,* 43–45.

35. Faust, *Mothers of Invention,* 43–45.

36. Susan Matilda Middleton to Harriott Middleton, Feb. 9–10, March 23, and May 16, 1862, all MFP.

37. Susan Matilda Middleton to Harriott Middleton, Jan. 26, 1862, MFP.

38. Harriott Middleton to Susan Matilda Middleton, Nov. 27, 1863, MFP.

39. Holmes, *The Diary of Miss Emma Holmes,* 197 (Sept. 15, 1862), 235 (March 7, 1863), 236 (March 9, 1863), 251 (May 1, 1863), 222 (Jan. 13, 1863), 201 (Sept. 23, 1862), and 202 (Sept. 27, 1862).

40. Holmes, *The Diary of Miss Emma Holmes,* 200–201 (Sept. 20, 1862).

41. Holmes, *The Diary of Miss Emma Holmes,* 279–81 (July 10, 1863), 283 (July 18, 1863), and 295 (Aug. 17, 1863).

42. Faust, *Mothers of Invention,* 251; Holmes, *The Diary of Miss Emma Holmes,* 172 (June 6, 1862).

43. Harriott Middleton to Susan Matilda Middleton, Feb. 22, 1862, MFP.

44. Holmes, *The Diary of Miss Emma Holmes,* 316 (Oct. 17, 1863), 325 (Nov. 21, 1863), and 373–430 (Sept. 3, 1864–April 7, 1865).

45. Ibid., 454, 456 (June 15, 1865), 461–62 (July 17, 1865), and 474–75 (Oct. 18, 1865).

46. Lane, *Savannah Revisited,* 183–94; Smith, *Civil War Savannah,* 225; Rable, *Civil Wars,* 168–69. Consider also E. Milby Burton, *The Siege of Charleston, 1861–1865* (Columbia: University of South Carolina Press, 1970).

47. Holmes, *The Diary of Miss Emma Holmes,* 455 (June 15, 1865), 462 (July 17, 1865), 463 (July 21, 1865), 466 (Aug. 15, 1865), 472 (Oct. 4, 1865), and 485 (Feb. 7, 1866).

48. Ibid., 465 (Aug. 15, 1865), and 475 (Oct. 21, 1865).

49. Faust, *Mothers of Invention,* 251; Whites, *The Civil War as a Crisis in Gender,* 136. See also Faust, *Mothers of Invention,* 249–57; Whites, *The Civil War as a Crisis in Gender,* 146–50; Rable, *Civil Wars,* 270–72; and Scott, *The Southern Lady,* 91–100. Consider as well Peter Winthrop Bardaglio, *Reconstructing the Household: Families, Sex, and the Law in the Nineteenth-Century South* (Chapel Hill: University of North Carolina Press, 1995); and *Divided Houses,* edited by Clinton and Silber, especially Nina Silber, "Intemperate Men, Spiteful Women, and Jefferson Davis," 283–305; and Victoria Bynum, "Reshaping the Bonds of Womanhood: Divorce in Reconstruction North Carolina" (320–33).

50. Grace Brown Elmore, *A Heritage of Woe: The Civil War Diary of Grace Brown Elmore, 1861–1868,* edited by Marli F. Weiner (Athens: University of Georgia Press, 1997), 13 (Nov. 14, 1861), 16–17 (Nov. 29, 1861), and 20 (Dec. 3, 1861).

51. Elmore, *A Heritage of Woe,* 40 (Sept. 13, 1862), and 74 (Sept. 30, 1864); Michael O'Brien, ed., *An Evening When Alone: Four Journals of Single Women in the South, 1827–67* (Charlottesville: University Press of Virginia for the Southern Texts Society, 1993), 45–46, 107–52, and 221–382.

52. Elmore, *A Heritage of Woe,* 76 (Oct. 1, 1864), 82 (Dec. 4, 1864), xxxvi, and 86 (Dec. 28, 1864).

53. Ibid., 40 (Sept. 13, 1862).

54. Ibid., 29 (Dec. 23, 1861), 59 (Feb., 1864), 50 (April 26, 1863), 88 (Jan. 2, 1865), and 172 (April 26, 1868).

55. Ibid., 160 (Nov. 21, 1867), and 165 (Feb. 9, 1868), 179–83.

56. Varner Collection of Family Papers, Georgia Archives, Morrow (hereafter VFP); Varner-Rountree Collection, Georgia Historical Collection, Savannah.

57. Journal of Narcissa Josephine Varner, Jan. 14, Jan. 27, and July 1, 1862, all VFP.

58. Ibid., March 28, April 7, 1863.

59. Ibid., April 26, 1863.

60. Ibid., June 19, 1863.

61. Ibid., March 3, 1864.

62. Elizabeth W. Knowlton, "'Only a Woman Like Yourself'—Rebecca Alice Baldy: Dutiful Daughter, Stalwart Sister, and Lesbian Lover of Nineteenth-Century Georgia," in *Carryin' On in the Lesbian and Gay South,* edited by John Howard (New York: New York University Press, 1997), 38–39, 40. On women leaning on each other during and after the war, see Faust, *Mothers of Invention,* 142–52.

63. Knowlton, "'Only a Woman Like Yourself,'" 45, 47.

64. Holmes, *The Diary of Miss Emma Holmes,* 369 (Aug. 15, 1864); Faust, *Mothers of Invention,* 168–74.

65. Evans, *Macaria,* 363, 376, 412–14. Consider also Drew Gilpin Faust, "A War Story for Confederate Women: Augusta Jane Evans's *Macaria,*" in *Southern Stories,* edited by Faust, 160–73.

66. Sidney Andrews, quoted in Walter J. Fraser Jr., *Charleston! Charleston! The History of a Southern City* (Columbia: University of South Carolina Press, 1989), 275; Rosen, *Confederate Charleston,* 142; Alicia Hopton Middleton, *Life in Carolina and New England during the Nineteenth Century* (Bristol, R.I.: privately printed, 1929), 135, 177, 179.

67. William Hodgson Journal, Nov. 22, 1864–Jan. 29, 1865, Charles Colcock Jones Collection, Hargrett Rare Book and Manuscript Library, University of Georgia, Athens; Mary Telfair to Isabella Caroline Hamilton, no date [1865], no date [1867], and July 11, [1868], all Isabella C. Hamilton Papers, Georgia Historical Society, Savannah.

68. A recent and promising exploration of well-to-do southern women's lives after the war is Jane Turner Censer, *The Reconstruction of White Southern Womanhood, 1865–1895* (Baton Rouge: Louisiana State University Press, 2003).

Index

CHRISTINE JACOBSON CARTER is a visiting lecturer at Georgia State University and the editor of *The Diary of Dolly Lunt Burge, 1848–1879*.

Women in American History

The University of Illinois Press
is a founding member of the
Association of American University Presses.

Composed in 10.5/13 Minion
at the University of Illinois Press
Manufactured by Thomson-Shore, Inc.

University of Illinois Press
1325 South Oak Street
Champaign, IL 61820–6903
www.press.uillinois.edu